BAD BOY

BAD BOY

My Life On and Off the Canvas

ERIC FISCHL
AND
MICHAEL STONE

Arcade Publishing • New York

10 9 8 7 6 5 4 3 2 1

Library of Congress Cataloging-in-Publication Data

Names: Fischl, Eric, 1948- author.
Title: Bad boy : my life on and off the canvas / Eric Fischl and Michael Stone.
Description: First paperback edition. | New York : Arcade Publishing, 2016. | Includes index.
Identifiers: LCCN 2016036539 | ISBN 9781628727302 (paperback)
Subjects: LCSH: Fischl, Eric, 1948- | Painters--United States--Biography. | BISAC: BIOGRAPHY & AUTOBIOGRAPHY / Artists, Architects, Photographers. | ART / American / General. | ART / Individual Artists / General.
Classification: LCC ND237.F434 A2 2016 | DDC 759.13 [B] --dc23 LC record available at https://lccn.loc.gov/2016036539

Cover design by Laura Klynstra
Cover illustration *Self-Portrait: An Unfinished Work* © 2011 by Eric Fischl

For my father, who stayed and did whatever was necessary to make sure we would be okay.

—ERIC FISCHL

For Fiona

—MICHAEL STONE

CONTENTS

BAD BOY

MR. LAUGHTER

SPRING 1986

THE vanity plate on the bumper of his beige Caddy identified him as Mr. Laughter. But I didn't notice that detail at first, and anyway, there was nothing funny about Mr. Laughter. He'd been riding my rear end for several blocks, flashing his lights, honking, and nudging my fender. What the hell did he want? Even at this hour—ten P.M. on a weekday evening—the crosstown traffic was hardly moving. There was no place to go.

"Pull over," my girlfriend, April, seated beside me in our dowdy VW wagon, said.

We were on our way home from a dinner in my honor. That night had been the opening of my retrospective—actually a survey of my early work—at the Whitney. Or maybe it was a preview. I don't remember. I'd been drinking steadily since four P.M.—Jack Daniel's, wine, Armagnac chased down with lines of cocaine. I was blasted. Everything that happened that evening until my encounter with Mr. Laughter was a blur. What should have been the most memorable night of my professional life had already become a black hole.

It wouldn't be hard, though, to piece together the evening at the Whitney. The show covered the museum's entire third floor—twenty or thirty of my early psychosexual suburban paintings, including *Sleepwalker* and *Bad Boy*. I would have camped myself at the periphery of the room, my face sore from the obligatory smiling, saying "thank you, thank you," to a nonstop stream of well-wishers. They would have been part of an eighties mixed-bag art crowd identifiable by their uniforms—a few old-timers, trickle-downs from the Alex Katz opening on the floor above mine, dressed in threadbare jackets and ties; Carl Andre and Chuck Close types who were big into workmanlike costumes; the downtown seventies holdovers in jeans and scrubby tees; the current crop of rock-star artists who embraced the fusion of art and fashion in their Armani suits and silk tees; Wall Street denizens, media and real estate collectors in tailored business suits, their wives in designer frocks; gallery girls in their little black dresses; and a raft of actors, models, It-girls, and eccentrics in feathers, scarves, and pirate outfits.

I had on one of those shapeless Italian jackets, something that would have been lost on Mr. Laughter but that I hoped would appeal to the different strata of the crowd—hip, casual, affecting a confident indifference. The retrospective was a great honor, of course, but not one I felt sure I deserved. What's more, any retrospective—even one based on just five years of painting—draws a line around your work, defines you as a certain kind of artist, creates expectations among your patrons and followers that make it difficult later for you to break outside the boundaries of your comfort zone.

But there wouldn't have been much talk about art this evening. Openings aren't the time or place, and even in the most intimate settings, collectors rarely ask me about my paintings. At most, they'd have told me what they owned and their plans for their collections. And then periodically I'd have escaped to the ground-floor bar— drinks weren't allowed in the galleries—or hit the men's room to freshen up my high.

. . .

B EHIND Lincoln Center, I felt something jostling against my fender, pushing me out into the intersection, and I stepped on the accelerator. Mr. Laughter did too. The Caddy's windshield ballooned in my rearview mirror and the "slow downs" and "let him passes" inside the VW became more vehement—until I snapped. I rarely initiate confrontation. But when it finds me, I hunker down. As I made the left onto West End, Mr. Laughter pulled out to pass me and I swerved right and left, blocking his efforts.

"Are you crazy?" April shouted. "He could have a gun."

Actually, given the circumstances, I wouldn't have been surprised if he *did* have a gun. I was scared out of my mind. But I was also imploding with rage. And there was yet another part of me—a kind of professional detachment—taking in the whole scene with a mixture of wonder and bemusement. Or maybe it was the alcohol and cocaine talking.

Halfway down the block I spotted a couple of cops on the uptown side of the street patting down some guy. I hit the brakes, made a U-turn, and parked alongside them. April implored me to stay in the car. Much to my surprise, Mr. Laughter had angled his Caddy into the spot next to mine. Now he chased after me as I scrambled over to the nearest officer.

"This guy's mad," I yelled. "He's trying to kill me!"

"He's nuts," my would-be assassin rejoined. "He's driving like an idiot!"

One of the cops got between us. You could tell he wasn't happy being interrupted in the middle of an arrest. But he let us vent, hoping, I guess, it would defuse the situation.

"Do you know who I am?" Mr. Laughter barked at me. "Do you know who you're fucking with?" I was suddenly curious. He was short, barrel-chested, and permatanned, with gelled, wavy jet-black

hair. He wore a cream-colored double-knit suit, an open-necked dress shirt with one of those wide, oversize collars, and a barrage of gold rings on either hand. Maybe he was a mobster—or an Atlantic City entertainer of some kind.

It was at that moment, in the middle of us screaming at each other, that I first noticed the lettering on his vanity plate. Meanwhile Mr. Laughter kept telling the cop and me that he was some kind of big shot. Looking at my scruffy car, downtown attire, and soft, bespectacled features, Mr. Laughter told me, "You're a nobody. A big fuckin' nobody."

ATER I thought the whole thing was pretty funny. There was the irony of the situation—my encounter with Mr. Laughter wasn't the least bit humorous. Then there was the business of him calling me a nobody. I was experiencing my fifteen minutes of fame, wrestling with a celebrity that I neither trusted nor felt I'd earned. My income was making me rich beyond my dreams. *Vanity Fair* had run a generous six-page feature on me. And now the premier museum of American art was giving me a retrospective.

I wasn't worried about being a nobody, but about what kind of somebody I was, where I fit in with my more successful peers. I wanted my work accepted and compared to the work of the best painters of my generation. Two years earlier I'd joined the Mary Boone Gallery so I'd be viewed in the context of my contemporaries—Julian Schnabel (who left for Pace shortly after), David Salle, Ross Bleckner, and the somewhat older Germans Anselm Kiefer, Georg Baselitz, and Sigmar Polke. I wanted to spark a conversation between my paintings and theirs. I wanted to be relevant—or, as Mr. Laughter might have put it, a somebody.

Of course in Mr. Laughter's world, where men are judged by the make of their automobile or the quantity of their bling, I really was a nobody. And that was fine with me. What troubled me, though,

was a dawning suspicion that the values of *my* world—the world of high-priced contemporary art—weren't any more admirable or less arbitrary than Mr. Laughter's.

I'm not an ivory-tower artist. I understood the value of building a career and getting my work out in front of the public. I was grateful for the recognition I'd gotten. And I was glad not to be poor. I'd worked hard all my adult life, sometimes at two or three jobs. I didn't complain when money was scarce. I refused to feel guilty now that my pictures were selling for six figures.

But success wasn't making me as happy as I should have felt. If anything, it was pressuring me to produce more of the same kind of work I'd been making. When I moved to New York in 1978, my goal had been to earn enough from my painting to be able to focus on my work and not feel as though I had to make art to support a lifestyle. A few years later when a patron offered to subsidize my expenses, I figured my budget was $1,000 per month. Now April and I were going to restaurants like the Quilted Giraffe, where the cost of a meal could easily exceed that number.

Celebrity, I found, is like a centrifuge. It tosses off all those parts of your life inessential to its care and feeding, and prioritizes people and activities that contribute to its growth. And of course the faster the centrifuge spins, the harder it is to escape.

Worse, I was getting hammered most nights and beginning to experience my life at a distance—at a time I should have been intensely present. It was my way of dealing with success and masking my insecurities, the nagging sense that I was a fraud. I came from a family where alcoholism dominated our lives. I knew I didn't want to go too far down that road. Yet what surprised me was how long I'd been on it. I tried to remember a time before drinking had become an essential part of my social life. I had to go back to when I was twelve years old.

Even more troubling was how much cocaine I used. I'd tried it a few years ago and loved the way it made me feel. More than the

alcohol, it triggered feelings of euphoria that synced with my increasingly manic life. And combined with the alcohol, it erased the stresses of making art and sharpened the pleasure of becoming a successful young artist. Even I knew I was out of control.

"He's got cocaine," I blurted out to the cops, pointing at Mr. Laughter. "Just look at him—he's as high as a kite. Check out his car."

I have no idea why I said that. I had no evidence that Mr. Laughter was carrying or doing cocaine. I wasn't even sure that *I* didn't have a vial or two stashed away in the VW.

But it did the trick. Though the cops held their ground—apparently my wild accusations didn't constitute probable cause—Mr. Laughter suddenly quieted down, and the officer who'd been refereeing our scrap seemed satisfied that the temperature between us had cooled sufficiently to send Mr. Laughter on his way.

"You stay here," he said to me, holding me back until Mr. Laughter had made his getaway.

In the moments before Mr. Laughter's taillights disappeared in the stream of downtown traffic, I realized how ridiculous my latest escapade had been. And on this of all nights. I could have been shot or arrested. Worse, I'd put April in danger. The surreal events of that night were just the latest in a series of self-destructive episodes. So far I'd managed to keep the chaos in my personal life out of the studio. I showed up to work hungover but sober. I held no cocaine parties—a fad at the time in the art world—and created no cocaine art. I had erected a firewall between the temptations of the marketplace and my decisions about what to paint. But my encounter with Mr. Laughter threw up a big red flag.

The last six years had been a rush, a series of memorable firsts—my first group show in New York, my first solo show, my first four-star restaurant, my first summer in the Hamptons, my first museum exhibition. All those events were exhilarating and chimed

with the high-flying spirit of the times. But I'd begun to notice a rift between the tone and the values of the coke-fueled scene outside my studio and the reality of the work I was doing inside. The afternoons spent drinking with friends, the nights out, and the newly expensive lifestyle had been fun, and very seductive, but it was all starting to have a pernicious effect on who I was and my ability to function. April had tried to warn me, especially about the drinking, and now Mr. Laughter had brought my excesses and aspirations into sharp relief, made me understand that the success I'd worked so hard to achieve wasn't healing my deeper insecurities, was in fact mocking my efforts to mask them with a different kind of glitz. For the first time I could clearly see the yawning chasm between the celebration of me as an artist, and the miserable, belligerent guy I had become standing in front of those cops. And I knew that if I didn't stop barreling down that road, my recklessness would bleed onto my canvases, and my life would truly go into free fall.

CHILDHOOD

1948 — 1965

T0 all outward appearances, I had an idyllic childhood. Born in Manhattan in 1948, I grew up in and around Port Washington, a leafy suburb on the north shore of Long Island. My father, Karl Fischl, worked as a salesman for an industrial filmmaker. He made the daily forty-five-minute commute to the city and traveled frequently to trade fairs. My mother, Janet, stayed at home and tended me, my older sister, Holly, and our two younger siblings, Laurie and John.

Our family lived on the cusp of privilege, part of the postwar nation's vast, aspirational middle class. We weren't rich. But we joined the local yacht club and took holidays together in places like Myrtle Beach, affecting affluence a little above our means.

I had no special talents or affinities growing up. An indifferent student, I attended public schools, played sports, and whiled away summers with friends at nearby beaches. My chief distinguishing traits, apart from an early command of sarcasm, were a short attention span and a quick, unpredictable temper.

But our decorous middle-class trappings among the manicured lawns and impressive housefronts, the church and club memberships, and all the conventions of a prosperous suburban life were a sham. Even my temper, ascribed to normal growing pains and the chaos of teenage hormones, was a lie, part of an elaborate ruse designed to paper over our family dysfunction.

The fact is, my mother was a ferocious alcoholic. When I was in elementary school, my parents fought all the time. My sisters and I would be sent to our rooms, from where we heard the familiar sounds of their brawls: the raised and suddenly muffled voices, the banging doors and toppled furniture, the thud of slaps and punches. I was too young to grasp what was happening. But I was terrified, maybe more so than if I'd been able to see them fighting, to attach concrete images to the ominous din echoing through the house.

During one fight over my mother's drinking—I was eight at the time—my father stomped out of the house. Moments later I heard a noise at my door. I found my mother lying on the floor in the hallway, slurring her speech, her eyes imploring me to help. Then she passed out. I had no idea what to do. I jumped over her and went to get my sister. We stood there frozen, helplessly staring at her, her arms and legs akimbo. I remember us laughing at her, making jokes by imitating her strange sounds. What else could we do? We didn't want to touch her. We didn't want her to be our mother. We stood there until my father returned in the car. I ran to the garage to get him, screaming for him to hurry up, something was wrong with Mom. "I think she's drunk," I said. It was the first time I had used that word; I wasn't even sure what it meant.

"She's sick," he said as he came up the stairs. We helped him drag her to their room, where he could clean her up and get her to bed. As we left, he slammed the door behind us.

• • •

W HEN I was growing up on Long Island, alcoholism was something that was never talked about. It was a family taboo, something you kept out of the public eye. I grew up amid a dual reality. Inside, our household was frightening and tumultuous and violent. It made me feel dirty and disgusting. But there was something heroic about our lives as well. My father, my sisters and brother, and I were all trying to cope with a devastating situation. Outside, the tree-lined village rose among the boarded-up estates of Long Island's Gold Coast, with their nicely kept yards and upper-middle-class decorum.

At first Dad tried to gloss over Mom's condition with us. He'd tell us she was having a bad day or she was sick, as though she'd come down with the flu. But my sisters and I knew better. After that first incident, her drinking was more out in the open. I'd come home from school and find my mother passed out on the couch. Worse were the violent fights I witnessed between my parents. They had an unusually intense, passionate, volatile relationship. And the abuse was both verbal and physical.

Once when my mother was pregnant with my brother—I was nine—I woke up at four one morning and heard a commotion coming from my parents' bedroom. I found their room covered in blood. At first I thought my father had finally killed my mother. As it turned out, my mother had gone into premature labor and he was trying to save her. But the fact that I'd jumped to the conclusion that my father was killing her suggests the kind of terror we lived through.

Eventually my father sat my sisters and me down and in a rare moment of candor described my mother's alcoholism to us. It was an illness, he said, quoting the latest medical thinking. And like many an illness, it could be cured with treatment and patience on our part. But he added that it should remain "our little secret." We weren't to discuss it outside the immediate family. And it was this secretive nature of it that planted a seed of shame and deceitfulness that snaked through my childhood like a toxic vine.

Port Washington's buttoned-down sensibility added to the stigma

on our family. Everyone was trying to live an Edenic dream. There was this post–World War II optimism about the future, a need to project a public sense of well-being.

Even at home, conversations about my mother's illness or my parents' fighting were rare. You circle the wagons and try to protect what you have. Back then nobody talked about the problem. You went to your doctor and he prescribed you Miltown or phenobarbital.

I began to experience a profound, dizzying sense of disassociation. I became acutely aware of the disconnect between appearance and reality, between people's emotional needs and desires and the status symbols and objects they surrounded themselves with. The suburbs were a culture big on superficial images. Everyone wanted the same cars, the same kitchen, the same clothes. I became increasingly aware of the differences between what things looked like and how I felt as my world spun erratically and dangerously off its axis. It would later form the basis for much of my art. Almost all of my early paintings dealt with the fallout from middle-class taboos, the messy, ambivalent emotions couples felt, the inherent racism, the sexual tensions, and the unhappiness roiling below the surface of our prim suburban lives. Meanwhile I was a suburban bad boy—cynical, sarcastic, contemptuous of all authority.

B Y the sixties, beneath Port Washington's veneer of Republican propriety, a libertarian impulse had taken hold. The town experienced a kind of Cheeveresque cosmopolitanism in which recreational drugs and casual infidelity became the currency of social intercourse. My parents' friends were bridge players, yacht clubbers, people who liked to have fun. It was a way to not be who they were when they were at work. They loved to throw theme parties. I remember my mother going to a Come as You Are party in only her slip. She said it was what she had been wearing when she got the invite. I remember another party at our house in which all the men were asked to

take off their pants and stand behind a sheet. Each wife was to guess which pair of legs was her husband's. Then they switched places. I could hear the howls of laughter from my room.

I don't think my folks were into wife swapping, though I can't say for sure. But sexual liberation was definitely the topic du jour. For my parents and their crowd, it was a tough time to be middle class. From what I could see, the middle class was a transitional status; it was not where you wanted to end up. Ideally it was a brief stop along the way to success and prosperity. The people we lived among were in a constant state of upward mobility. It is why their attachment to things and appearances was so complicated and fraught with meaning. My parents walked an uncertain line between propriety and pushing the edges. Sexual posturing was part of that. Though they were pretty hidebound in public, they were surprisingly relaxed in their behavior around the house. They talked to us kids openly about sex and lounged around their bedroom—where we'd visit after dinner to watch TV—completely naked. Growing up, I found it pretty confusing. There were these opposite things going on, the secretiveness about my mother's drinking and yet this openness toward things that in every other family I knew were private.

By the time I hit puberty I was a mess. I was desperately trying to figure out who I was, but I kept bumping up against my family's contradictions, my dad's stoic silences and my own teenage rage.

Surprisingly, my mother was my anchor, to the extent that I had one. I was very close to her, probably too close. I was the creative child, her presumptive favorite. But I was competing against the bottle for her attention and loyalty, constantly adapting to her quicksilver moods.

My mother had been beautiful when she was young. And she was still extraordinarily handsome despite the ravages of heavy drinking and smoking. Full-figured, voluptuous even, she had a long, straight nose, thick brown hair that she wore fashionably short, and brilliant

blue eyes. As a teenager interested in women and girls, I found her everyday nudity an awkward and unavoidable physical fact.

As a result I increasingly spent time outside the house and formed a second family with my friends. Because of the way the school districts broke down, I had friends who were Italian kids from blue-collar Manorhaven, as well as rich, mostly Jewish friends from Sands Point. The families of both had a natural way of relating to each other, a kind of straightforward physical intimacy that I envied. And as more of an observer in their homes than an integral part, I was less caught up in their arguments and attachments. I could breathe easier.

Later, as times changed and divorce became common, I became part of a group of smart, funny friends who had unstable homes similar to mine. I used to joke with them about alcoholism or their moms bringing other men home.

No amount of humor, however, could insulate me from the drama playing out at home. My mother had stopped drinking for a time when my brother was born and was on the wagon until I was fifteen. But when she fell again, she fell hard. I knew my mother suffered terribly over her drinking and felt ashamed and guilty over her attempts at recovery. She tried so many times to stop, and each time she failed she was more distraught.

Today I think my mother would be diagnosed as bipolar. Once she fell off the wagon, she couldn't stop, or even moderate, her drinking. And the changes that came over her scared me. Physically she seemed transformed. Her lovely blue eyes would become wider than usual and take on a look of glazed rage. Her whole face seemed pinched and pulled back. Her artificial expression, a Kabuki-like mask, reminded me of a terrifying drag queen. It was impossible to predict what she might do. She could be catatonic one day, or act out like a banshee on another. One time the cops picked her up running through our neighborhood stark naked.

I was hardly stable myself, subject to temper tantrums that

became deeper and more frequent as I became older. Anything could set them off. No one, including me, could predict their triggers. At times I'd bang my head against the wall until it bled.

But not all of my time with my mother was chaotic and troubled. Even during those periods when she was drinking heavily, we shared the same sense of the world. Or perhaps I inherited mine from her. Passionate, volatile, and artistic, she drew me into the orbit of her lively imagination. She had that rare artist's ability to transcend the dullness of her surroundings, to transform and enliven even the most quotidian aspects of our suburban lives. She was always making up games. On drives into town, we used to describe the colors of the scenery to each other—the purple trunks, say, in a stand of trees by the road. We'd find colors within colors. At other times, she'd concoct little dramas while running errands and take on character roles, becoming a street person or a fancy lady shopping for delicacies in the grocery store. And I always played along.

But the good days, as magical as they were, made her relapses all the more troubling. Our family united in trying to deal with her alcoholism. I spent a lot of time trying to be wise beyond my years. My mother's drinking created all kinds of challenges for me. I had trouble with authority, especially my father, whom I resented for not being able to save or even control her. To this day I have a hard time viewing other women in a balanced or realistic way. But taking care of my mother, trying to cope with her disease, also helped me to develop empathy for others. Later, my willingness to assume the burden of other people's pain would become a staple of my creativity.

Growing up as a kind of amateur caretaker tore a hole in my childhood and brought me face-to-face with the deceptions and hypocrisy, desire and anxiety behind the smiley-face routines of my parents' marriage and suburban life.

· · ·

PHYSICALLY imposing, my father was six foot two, rawboned with soft, dark eyes, large, shapely hands that he was quite proud of, and a distinctive jaunty gait. When my mother and I picked him up at the train station, we could spot him at once among the crowd of commuters in his narrow-brimmed fedora and with his loose-limbed, confident stride. He always carried a rolled-up newspaper that he slapped against his thigh as he walked.

But all my father's grace and self-possession dissolved in his confrontations with my mother—sometimes to comical effect. Once when she stormed out drunk, he paced the house for hours screaming: "Call the fire, call the fire." He meant, of course, the fire department, but he was too agitated to speak in complete sentences. Another time he sought out my big sister, hiding in the laundry room, and rammed the door with such force he knocked her headlong into the open dryer.

Often my parents' spats ended in violence. My father hated my mother when she drank and she parried his efforts to rein her in with a cruelty of her own. As a young man during the Depression, my dad had sacrificed his chance to go to college so his younger brother could. My uncle went on to become a doctor. But my father always regretted abandoning his education. What should have been a point of pride became a source of insecurity in the battles between my father and my mother. When drunk, my mother never failed to bring up my father's missing diploma.

My father was a bit of a klutz. For all his salesman's finesse, he was lost outside of a business suit. He'd load up the family wagon for vacation, battening down the roof with suitcases and sports equipment, then not be able to fit the car through the garage door. Or after a picnic he'd pack up the grill with hot coals still in it. Under his earnest administration, cars balked and smoked; luggage flew down the highway.

But my mother's brief against my father was more serious. After each episode, she blamed him for her drinking. In her view he was

a typical American businessman, narrow-minded and materialistic. Not only was he a klutz, he was intellectually inferior to her, lacking in imagination. She would claim that she was suffocating in their marriage and talked about leaving him. I couldn't understand their attachment. It would take years for me to appreciate how my father held our family together. At the time I took my cue from my mother—her wild imagination and dismissiveness toward my father became my own. I wanted desperately to be like her. And just as desperately to not be like him.

HOLLY FISCHL GILOTH

We were eleven months and twenty days apart,
what people used to call Irish twins. Still, I
was older, so I became the responsible one, and
Eric—well, he didn't. He was out there having a
good time. But he wasn't a bad kid. He was inde-
pendent, spirited, and he had a temper that could
go off at any time. I think he was born with it.
As a young child, he was a headbanger. His fore-
head would get all black-and-blue, and our mother
had to take him to the doctor. She was afraid
people would accuse her of being abusive.

Eventually Eric learned to control his anger, in
part by channeling it inward, which I'm not sure
was always a healthy thing. No matter how crazy
things got, Eric was my protector. We had a re-
ally strong bond, maybe because we were so close
in age or because of what we were dealing with at
home. Whatever the reason, he was like my guard
dog. At my fifth birthday party, when Eric was
just four, a kid was bothering me—neither of
us can remember why—but Eric took offense and
pushed his face into the birthday cake. That was
the end of the party, but I didn't mind. I think
our dog ate the cake.

LAURIE FISCHL WHITTLE

Eric is five years my senior, and for this he paid a price. I was definitely the middle child, the tagalong sister. He was my shelter from the storm. Eric raised me, though he doesn't know that. He stepped in and took charge when our mother wasn't able to. I would follow him and his friends everywhere no matter how much he begged me not to. Inevitably, I would end up getting hit with a baseball or something, and he'd have to drop what he was doing and take me home. But he did not blame or shame me for it, ever.

As a kid Eric had a lot of anger. It was probably frustration at having to be an adult when he wanted to be a child, and it came out in peculiar ways. When he was twelve he stole the family station wagon. Another time he sawed his bunk bed in half. Later he developed an impish sense of humor, a way of making light of the ironies of our situation at home. He was like the clown with a sad face. He'd make you laugh but it was a very painful kind of funny, the kind that comes from a place where you bleed.

In 1967 we moved out to Arizona from New York and Mom promised me my life's dream—a horse. Sure, it was a bribe, but I wasn't going to argue. Mom was many things to many people, some

good, some not so good. But she never promised anything she didn't deliver.

That Christmas was different. We had a live tree in a box and Eric had us all making our own ornaments—gluing pictures from *National Geographic* onto cubes made from construction paper. Dad's real estate job wasn't bringing in any real money yet, and things were very tight. I knew I could never hope for a horse under those circumstances and was sick to my stomach with guilt because that's all I wanted.

Christmas morning I tried to sleep in, hoping no one would notice I wasn't there. Eric came and got me. I tried giving presents to anyone else so I wouldn't have to think about horrible me. Eric went underneath the tree and pulled out a shoe box. Inside was a pair of cowboy boots. I tried to appreciate them. Again Eric handed me a box that he was really intent on my opening. "What's with him?" I thought. It was a headstall with Surprize, my dream horse's name, handwritten down the side and slightly chewed alfalfa stuck to the curb on the bit. I looked into Eric's anxious eyes. He knew exactly what this moment meant to me, and he wanted to share in it. I hugged him like crazy, screamed in exhilaration, and ran to the bathroom and threw up.

HOLLY FISCHL GILOTH

Eric was especially solicitous of our mother, in our daily struggle to keep her alive and sober. He was so sweet and caring. But he also developed this black humor. We both did. It was our way of surviving. Remember, this was our family secret. We had no one to talk to but ourselves. Sometimes when our mom locked herself in the bathroom and threatened to kill herself, we'd roll our eyes at each other. "Okay, Mom, fine, I'll hand you the razor. Let's just get it over with." And we'd turn up the volume on Simon and Garfunkel's *Parsley, Sage, Rosemary and Thyme* album.

I guess when those kinds of things happen often enough, you realize you don't have any control over the situation. If she'd really wanted to kill herself, there was nothing we could have done to stop her. And ultimately there wasn't. But Eric tried. We all tried. I never really got to know my mom. She was lost to me somewhere between shame and awe. She was really smart and funny and talented. She could write and paint and she knew about art. But with me she was always either a raging alcoholic or a strict disciplinarian, relatively remote and somewhat uninterested. She never really let me in. Eric was the only one who could get close to her. He was her favorite and we all knew it.

FIRST LOVE, LAST RITES

1963 – 1970

Wнen I was fifteen, my father bought a half interest in a Coca-Cola bottling plant on St. Croix, an island in the Caribbean. Once down there, however, he discovered his partner was an alcoholic, not the best influence for my mother to be around. So he scuttled plans to relocate the family and sold his part of the business at a steep loss. Meanwhile, in order to complete our education back home, my older sister, Holly, and I were sent off to West Nottingham Academy, a boarding school in Maryland.

I loved Nottingham, and especially loved being away from home. Though I was often getting into trouble, it was a perfect place for me to finish out high school. It was a small Presbyterian school with a mix of local kids, mostly from farms and small neighboring towns, and suburban delinquents from New York and Philly, and there was not a lot of emphasis on academics. I cruised with little effort, getting mostly B's and C's, and spent most of my energy trying to navigate the complex social scene. Those years were a time of physical awkwardness, embarrassment, deep longing, and constant hard-ons.

At Nottingham I met Elaine, who was a year ahead of me. She was the smartest person at school and had an aura that made her appear spectral, deeply mysterious. It was with her years later that I would lose my virginity. She dressed in black. Her long, flowing blond hair, parted in the middle, was the color of a gold ingot. It gave her a warmth and glow that her pale, sun-deprived face could not. She listened to folk music and read books by French authors I'd never heard of. I thought she was the epitome of beatnik cool, but with a pretty girlishness more like Michelle Phillips than Mary Travers. I'd watch her crossing the campus from dorm to classroom as though she were being hunted, which in a way she was. She carried her books hunched over, cradling the heavy stack with both arms and pressing it tightly to her chest. I was hopelessly in love with her; she was into some older musician who played acoustic guitar and didn't love her back.

Like many women I would ultimately date, Elaine was troubled and vulnerable, sending signals of distress that triggered in me a reflexive caretaking that she was paradoxically and bafflingly immune to. Ultimately and above all, she was unavailable.

No doubt my relationship replayed aspects of my relationship with my mother. But knowing that did nothing to decrease my helpless desire.

W HEN Elaine graduated and went away to Holyoke College, we kept up our correspondence for a while, then she went off the radar.

I hung out with an odd lot at school: other students who were smart, eccentric, gay, or athletic. They all embodied something mysterious for me, a character that wasn't put on or confused. Most of all, they were not like me.

Nottingham had lots of rules. There was a large book of codes for conduct. Each infraction came with a number of Gigs. A Gig was measured by the amount of times you had to walk in the campus

triangle Friday afternoons before you could go home for the weekend. There were very few Fridays I was not out there walking.

You would get cited for pretty much anything. Not making your bed, not tucking in your shirt, talking after lights-out, not doing your homework, chewing gum. But there were far graver infractions as well and many of these had to do with sex. The list was published daily and could be a source of humiliation. Code 2E3, for example, was for masturbating.

At night, after the day schoolers left campus and homework and dinner were finished, the school took on an entirely different character. Those of us who boarded there hung together like prisoners in a minimum-security facility, feeling unjustly accused and forever proclaiming our innocence. We bonded because we were all in it together. Kids would run away and be dragged back kicking and screaming. We cheered their running and were saddened at their return. One kid hung himself. Another kid became addicted to heroin. One beautiful girl had a breast reduction, which confused us all. Some kids were so incorrigible that they were expelled. Everyone had a story. Everyone had issues.

STILL reeling from the St. Croix debacle, my father rented a house in posh Sands Point. Unlike the traditional colonials we'd lived in, it was contemporary—linear, spare, with lots of sliding glass doors jutting precariously from a steep hill overlooking Long Island Sound and a marsh. The house was fancy but poorly built, with paper-thin walls separating close-quartered bedrooms that allowed you to hear everything. Though my parents' room was at the end of the hall, I could hear their fights and their lovemaking. The sex was perplexingly regular. Holly and I were in our last year at Nottingham, away from home mostly except for the holidays. But our younger siblings suffered the daily chaos. Our brother, John, was hit by a car while riding his bicycle. Both his legs were broken. He was in traction for

two months and then home in a cast that went from his chest to his toes. My sister Laurie discovered she could talk to crows. She befriended one whom she would call, and it would come to her bedroom window. They would sit and caw at each other for hours. Holly had a princess phone and her own number, and she was rarely off it. I was arrested for starting a fire in the marsh below our house, the result of an accident involving cherry bombs. Had the wind been blowing in a different direction, our house might have burned down. That was the time my mother got so drunk she fled the house naked and was hauled off to jail for violently resisting arrest. The carnival at school was preferable to the madhouse at home.

EARLIER in the year both my grandmothers had died on the same night, my mother's mother unexpectedly. Her funeral had been in St. Louis; when my mother returned, she seemed extremely nervous and high-strung. And she was smoking again—a bad sign. She'd been on the wagon for years; our suspicions that she'd begun drinking again were confirmed at the end of the school year. My mother drove down to Maryland to pick up Holly and me at West Nottingham and take us home for summer vacation. Driving back on the New Jersey Turnpike, she lost control of the car and began swerving across the road. After a few harrowing moments, she managed to pull over to the shoulder. She told us the brakes had seized up, but my sister and I suspected she was gassed and had probably just conked out.

My mother used the fact that my father had lost both his and my mother's savings in the St. Croix blowup to justify her new round of drinking. My siblings and I tried to reason with her, but our attempts at tough love were met with threats of suicide. She'd rather be dead, my mother said, than face the sterility of suburban life without booze.

. . .

AFTER graduation from Nottingham in 1966, I escaped to Waynesburg, a small liberal-arts college near Pittsburgh. Having no idea what I wanted to do with my life, I bowed to my father's advice and enrolled in a battery of practical business courses. But I was temperamentally unsuited to them and failed miserably. I was smoking a lot of dope and spent most of my time in the student union playing cards and Ping-Pong. I ended the year with four F's and a D.

Meanwhile, my father decided to move the family to Phoenix. My mother had contracted early-stage emphysema and he felt that the new setting and desert climate would be better for her health. But having tasted independence at school, I wasn't eager to return to living with my parents.

That summer, the so-called Summer of Love, a friend and I made a pilgrimage to San Francisco. We set up housekeeping in a Haight-Ashbury crash pad along with fifteen or twenty others. Our rather fuzzy goal was to create an urban commune—no locks on the doors, free love among the brothers and sisters. I guess I was more territorial, less comfortable with sharing, and more private than the flower-power experiment required. I ended up hating them all.

There was a huge emphasis on looking cool in San Francisco in 1968. Everyone seemed to have long, flowing hair and wear tie-dyed clothes and bright beads. When I got to the Haight, my hair was short and I wore brown plastic glasses and preppy clothes. I might as well have landed on the moon.

I tried to blend in and embrace the new world order. On my arrival I went straight to an army-navy surplus store and bought clothes. Then I bought knee-high moccasins and strands of beads and bells. But for all my efforts, I looked like an undercover cop whose cover was blown.

That first day I went to a Golden Gate free concert. The Grateful Dead were playing off the back of a truck. There were a lot of Hell's Angels around getting drunk. Before long, they started fighting. One

Angel walked up to a really stoned girl, flung her over his shoulder, and carried her back into a wooded area to screw her.

I didn't know what to make of any of this. I found myself standing next to a tough-looking girl with remarkable breasts. She wasn't particularly pretty, but she was wearing a see-through paisley shirt and I could see everything. After the Dead finished playing, she suddenly got up onstage and began to sing. She turned out to be Janis Joplin.

NONETHELESS, I couldn't shake the feeling that summer that I was living a lie in the Bay Area. The surface of things—the psychedelic colors and saccharine spirituality—held no more appeal for me than life among my dysfunctional family. I spent a lot of time observing the scene and being critical. The young people I met seemed to be having less fun than they pretended to have. If anything, they seemed less confident, less free.

I know I was.

I was doing a lot of acid, and that helped to make everything vivid and strange. But I was also falling back on the default cynicism I'd developed growing up. I already possessed the artist's habit of hanging back—spending time "behind my eyes"—observing rather than participating.

But the distance I felt toward the Haight-Ashbury crowd troubled me. Though I'd grown up on Long Island with an outsider's view, the enemy was known. The difference between "me" and "them" in the suburbs was clear. In Haight-Ashbury I wanted to be part of everything, yet I still felt alienated.

I began to reexamine the tableaux of my generation—the poses of self-styled hipsters and drug-addled Aquarians—and discovered a different version of myself reflected back at me: a nice suburban boy with goggle glasses and middle-class morals. There were girls out there screwing anyone who showed the least interest. But it seemed

like they were running from something. I couldn't bring myself to take advantage of them.

Still, the other side of the counterculture was even less appealing. Later that summer, at my father's request, I flew back to New York to pick up my mother and younger siblings and drive them cross-country to Phoenix. At a stopover in Pittsburgh I drove down to nearby Waynesburg, where I still had friends from college. We hung out and ended the evening at a Dairy Queen, where a gang of townies attacked us because, as best I could tell, one of my friends was wearing granny glasses—a symbol, I suppose, of the hippie lifestyle. I escaped with a sock in the jaw. But that punch drove home to me all the anger and resentment dividing not only the country, but also my generation. History may remember the sixties as a generational war, a youthquake that triggered social ferment, antiwar protest, free love, and spiritual awakening. But it was also a period in which clashing values fractured the national narrative, blurring beyond easy definition what it meant to be American.

I returned to Haight-Ashbury in the fall, but by then the mood had soured. Many of those who'd weathered the Summer of Love seemed wasted and washed-out. The euphoria was over. Addicts paraded zombielike through the streets, scoring methadrine and other hard drugs cut with shit. My friend had brought out his girlfriend from back East. She was underage and pregnant. We'd pretty much run out of money by then and were subsisting on boiled potatoes and ketchup. I managed to persuade them to go home, and I left myself shortly after. I'd had my fill of flower power.

My disenchantment with the San Francisco scene left me feeling more lost than I'd ever felt before. I may have inherited my parents' values, but I had no wish to follow my father into business and the arid, middle-class life my parents inhabited. I had lost my moorings, and in truth I wasn't sure I even wanted to be moored. What I really wanted was to punch through to a deeper, more hard-edged reality.

· · ·

W HEN I joined my family in Phoenix before Thanksgiving, I was at the lowest point of my life. I'd taken a job delivering lawn furniture. I had no prospects, no idea what I wanted to do. I had no friends. I enrolled in community college as a way to meet people my own age, and took an art class because—well, nobody fails art.

My initial interest had been sparked by a challenge. Bill Harris, a coworker at the furniture store, had been taking an introductory art course at the college and from time to time would tell me about the curriculum. Bill would work on projects like gluing bread to a windowpane, and in the evenings we'd get stoned behind the store and argue whether it was art or not. Bill had a sense of playfulness, a disregard for history that intrigued me.

At first, the class seemed boring. It was foundation stuff: making color wheels and gray scales and learning one-point perspective. It became more interesting when we were given materials and told to do something of our own choosing. That's when I actually started to make art, and from that moment I was filled with a kind of energy and focus I'd never known. In my cramped room at home, a converted toolshed off the carport, I'd lose myself for hours, ordering my jumbled thoughts and feelings into a world of my own making. For the first time in my life I was able to concentrate and tolerate being alone. I felt integrated and in control.

It didn't matter what I was making. We were told to carve something out of a block of plaster. I carved abstract shapes on three sides and a nose on the fourth. We were given a blob of clay, and I made a sculpture of a fat naked woman who reminded me of my grandmother. We were told to make a painting that combined solid and amorphous shapes, and I used a vacuum cleaner to move the paint around. Nothing was preplanned. Each new project was an adventure.

. . .

M Y mother wasn't faring well. Her bouts of drinking became lon- ger, more frequent, and more out of control. She still had inter- ludes of sobriety when she seemed normal and her intellect shone. She was an avid reader and delved obsessively into subjects that caught her interest. She got excited about the cowboy genre after we moved out West. She read every local or regional novel she could get her hands on, and she'd research all the historical elements in the stories.

But there was another side to my mother's mercurial nature: a scathing, subversive, perfectionist ethic that undermined any serious artistic ambitions she may have had and made her by turns moody and abusive. She was incredibly smart and creative. But she had no discipline, no follow-through. And she couldn't stand criticism. She knew a great deal about painting, sculpture, and writing, and was very witty. But she couldn't harness her abilities.

Art is a process and a journey. All artists have to find ways to lie to themselves, find ways to fool themselves into believing that what they're doing is good enough, the best they can do at that moment, and that's okay. Every work of art falls short of what the artist envi- sioned. It is precisely that gap between their intention and their ex- ecution that opens up the door for the next work. My mother lacked whatever it is that steels you from all the voices in your head that tell you how much you suck. She was defeated before she began.

Ironically, my mother's frustration served to fuel my ambition to succeed. But her dissatisfaction fed her alcoholism, creating a perni- cious feedback loop: the more she drank, the more bitter she became; the greater her sense of failure, the more heavily she drank. She was becoming progressively more violent and self-destructive.

. . .

L IVING in Phoenix was a huge adjustment. Beyond the city's obvious differences—its car culture and unchanging climate—the landscape was alien to me, the opposite of the Haight's urban hive. It was also a striking contrast to the tree-lined, leafy suburbs back East. The flat, colorful desert light, the thin atmosphere, the sense of airlessness, and the hard-edged contrasts seemed new. There was no diffusion or refraction of sunlight, just the white buildings and the shadows and the flat blue sky.

Eventually these and other physical features would influence my work, providing a rich palette and stark tonality for many of my early paintings. But at the time, they were disorienting. The way people chose to live wasn't real. Every house was a fantasy, without any sense of tradition or history. It left me feeling rootless and unfocused. Though I'd begun to transcribe my feelings of isolation into the images on the canvases I was beginning to make, I'd yet to consider a career in the arts, much less painting.

Shortly after arriving in Arizona, I received a notice to report to my local draft board. Fortunately—as I had no desire for combat—Phoenix was ahead of its quota. After I enumerated my youthful excesses—from heavy drug use to communal living in the Haight—my recruiting officer told me to take six months to straighten myself out. Like everyone I knew, I was opposed to the Vietnam War. I have no idea what I would have done had I been called. But I wasn't. An apparent communications glitch between New York, where I originally registered for the draft, and Phoenix resulted in my papers being lost; my recruiting officer never contacted me again.

T HE first time I met Lannie, she was naked. Or she would have been, had Phoenix not had an injunction against nude modeling. Instead she wore a white cotton sleeveless minidress with a zipper in back and a blue stripe ending in an arrow pointing at her crotch. I thought it was hip, stylish, and ironic, especially in context of a

drawing class. Also, she was gorgeous—tall with long, flowing dark hair, a big toothy smile, and a natural vivaciousness to match.

I was still in my first year of school and she was attending another community college nearby, earning extra money by modeling. I was one of the students she posed for. It turned out she was a friend of friends, part of a gang of art students I hung out with. We began seeing each other shortly afterward.

Alana Johnston grew up without roots. Born in Detroit in 1950, she'd moved with her family thirteen times before graduating high school in Phoenix. Her mother, locked into an unhappy marriage and driven by a restless creative spirit that had no outlet, channeled her energy into her peripatetic lifestyle, believing each new move would bring fulfillment, a way out of the arid existence that dogged her from one western city to another. Sometimes the moves were just across town; Lannie's father, an electrician, always found work. But the effects on Lannie were traumatic: new schools, new friends, and sometimes no friends. Like me, Lannie had developed a quirky, sarcastic sense of humor to mask her anomie. But unlike me, she had no brothers and sisters or sustaining circle of friends. She was an only child and a misfit who spent a lot of time alone trying to build a life.

Though she'd sketched throughout her childhood, Lannie didn't realize her facility for art until she enrolled, much as I did, in an introductory course at a junior college in Phoenix and began getting feedback from her teacher and classmates. Assigned to make a self-portrait and dissatisfied with the results—her renderings felt lifeless and clichéd—she took pictures of herself at a twenty-five-cent photo booth. At the time, the offbeat approach won her the admiration of her peers. More important, she began to think of herself as an artist.

I'D had girlfriends since I was in sixth grade. And then there was Elaine. I'd had a reunion with Elaine one night in New York on a trip home from Waynesburg, and almost as a favor, or as a reward

for years of service, she'd let me make love to her, mercifully ending my virginity. I suppose on some level I was terrified by women—the monster behind the beautiful mask. Yet I trusted Elaine. For all her wildness and sophistication, she was more insecure than I was.

Not so Lannie. Lannie had it together. We were part of a crowd of art students frequenting bars, hanging out at my professor Merrill Mahaffey's home, partying in his studio, checking out what the other students were doing. There was a healthy atmosphere of competitive camaraderie. Lannie was a far more accomplished painter than I was. She was making very beautiful, delicate geometric abstractions. The surface was smooth, feminine, and nicely composed. I was jealous of the attention she was getting and envious of her skill. It did not, however, stop us from getting together. We became friends, and then we became lovers.

The first time we had sex we were at her place, a small house she'd recently rented with a roommate in the desert outside Tempe. Some friends had stopped by; after they left I stayed on, getting stoned, listening to Led Zeppelin. We ended up on her bed, which was just a mattress on the floor. Neither of us was experienced—I hadn't slept with anyone since my encounter with Elaine—but that night with Lannie was unforgettable. In addition to the thrill of our finally being together, Lannie lost her virginity and immediately afterward I was stung by a scorpion.

THE next year Lannie and I transferred to Arizona State University and enrolled in a BFA program, where we came under the sway of Bill Swaim, a first-year grad student.

Six foot three and lanky, Swaim, a former athlete, had turned down a basketball scholarship to study art history at Indiana University. He had a hawkish face, sharp blue eyes, and an aquiline nose framed by a cloud of wavy black hair. Sauntering across campus with long, graceful strides, he looked every bit an artist guru.

The year before, Yale had recruited him for its elite graduate art program. But Bill has always marched to a different drummer. He felt he'd outstripped his student clay, that he no longer wanted or needed that kind of formative experience. Instead he accepted an offer from ASU to teach while completing his MFA. The clincher, he told us, had been the palm trees.

I met Bill his first day of teaching. Close in age, both of us had big personalities with strong opinions. It's easy to imagine us locking horns. But Bill didn't try to force his style on students, nor did he criticize their creative choices. And I was eager to learn, willing to explore his suggestions about different ways of looking at the world. He saw his job as getting students to think, not telling them how or what to paint.

Most of the magic of that pivotal year took place outside of class. There was a small group of us that hung out with Bill and his wife, Darlene, who was also an artist. Gatherings at his home had a Ken Kesey–like carnival atmosphere—fanciful and creative. Our unstated goal was to completely reimagine the world, and Bill was hypnotic as the ringmaster. He had a penchant for incomplete sentences capped off with rapid hand gestures. To follow his thoughts you always had to shift your focus from the concrete to the abstract. Each thought would start off verbally and end in a visual language, much the way painting starts with ideas and then ultimately finds its clarity expressed as an image.

Mahaffey, my art professor in my introductory course at community college, had been forward-looking with an ecumenical, at times puckish, view of art. He stressed alternative processes that demystified and democratized art and took it out of its traditional historical contexts: the academy, the museum, and the gallery. The general ethos of our generation was, Fuck history. Fuck authority.

Bill was no less audacious in his approach to making art. But he added a layer of rigor and seriousness previously lacking in my education. I realized early on that if you want to sit at the table with Bill, you better know your stuff.

Bill's teaching was rooted in history. He believed that art was an evolutionary process—one generation of artists responding to and carrying forward the explorations of earlier generations. He introduced me to the origins of abstract painting, to Kandinsky and Arshile Gorky, to the metaphysical painters and the avant-garde. He showed me that there was a higher purpose to radicalism, that it wasn't just being playful.

That higher purpose embraced a heroic sense of painting, the idea that art at its best was a magical, transformative experience. Bill captured the power of art for me. And he instilled in me the responsibility of being an artist.

My knowledge of art history had been superficial up to this point. Before meeting Bill I felt that to be radical I only had to make the "next move," not know all the moves that had come before. Through Bill, a profound, inspiring teacher stuck in the outpost of Phoenix, I began to take a harder look at the history of modernism: Turner, Daumier, Courbet, Cezanne, Degas, Manet, Picasso. Bill opened my eyes to his midcentury enthusiasm for the Russian avant-garde, especially Kandinsky. I discovered the formal, intellectual, and spiritual demands of pure abstraction. My world had suddenly gotten bigger.

That spring Bill suggested I apply to CalArts. The newly founded institute had been sending out promotional material since fall promising an incredible art experience, and I badly wanted to go. But I did not send in slides of my work until June, and then only as a lark. I figured I couldn't get into this school. It was only for real artists.

Clearly I didn't think I'd earned that title. Nor had I decided, at least with any certainty, to commit myself to making art as a profession. As a student at Arizona State, I had been painting Kandinsky-like abstractions—arabesque forms with edges of color jostling one another and changing shapes. Without a natural facility for drawing or abstraction—I had not painted or even sketched growing up—I approached each new canvas as an existential challenge, a set of

daunting conceptual and technical problems for which I had no theoretical model. I didn't know what I was doing.

Before summer I embarked on one last project that nearly defeated me. The painting was a huge journey for me, and at a certain point it ground to a halt. I had no feeling for how to resolve it, no idea for a direction. It got so whenever I'd approach the canvas, my mind would fill with a crackling noise that prevented further thought or intuition. I went through weeks of struggle that culminated in a tantrum.

Today I recognize that those feelings—a frustrating sense of paralysis and unreasoning anger—were the same feelings I'd experienced watching my parents fight, being pummeled and tossed aside when I got between them. After a while I stopped trying to intervene. I couldn't mitigate their violence, and I hated my ineffectuality or, worse, my passivity. That breach between my intentions and my ability to execute them had begun to play out in my painting. I wanted to finish the picture. But I couldn't finish. I thought about quitting several times. Then I threw my brushes at the canvas, walked over to the offending area in the middle of the picture, and swabbed it wildly with primerlike white paint.

Only when I stepped back did I recognize the shape I'd produced. In the midst of this abstract space I'd painted a white cartoon floating bed. It was so irrational, yet I didn't question it. It suggested a way for me to finish, and led me in a different direction in terms of how to handle paint.

It also introduced the element of representational imagery in my work, this weird painting with flat abstract shapes and an isometric "bed" sitting in the middle. I never understood it, but I knew it was done. Years later that bed started to appear and reappear in my work.

Without parsing its meaning too closely, I realized that the bed alludes to the womb, the birthplace of childhood memory, the place where dreams occur, the setting for sexual fantasies and encounters. The bed also resembles a canvas, the arena in which I've wrestled with

my most private demons. But it would be years before I began to explore its significance in my work.

O VER the course of the summer, I received three jolts. One was a letter of acceptance from CalArts. The second was its bill for tuition: $6,000, then a hefty sum and one I couldn't afford to pay. The third surprise, arriving after I'd relayed my regrets to the school, was the most astonishing. Paul Brach, the head of the Institute's art school, wrote me back offering a full scholarship as part of CalArts's burgeoning work-study program.

The offer delighted me on several levels. It was an opportunity to attend a dedicated art school and a chance to get away from my combustible situation at home. Most important, Brach's scholarship offer signaled to me my potential as an artist. It was the first professional recognition of my talent.

Phoenix in the late sixties was not even a regional arts center. Apart from Bill and a handful of fellow students, I was getting little feedback on or support for my work. My father, on the other side of a generational divide, regarded my painting as one more folly in what had been an aimless and unproductive adolescence. His attitude was, "Take business courses. Get a real job."

More curious was the reaction of my mother. Not only was she unimpressed by my efforts, but she seemed to actively resent them. Mindful of my mother's crippling perfectionism, I had been turning out workmanlike canvases at a steady rate. I didn't care about perfection. I would go for good enough, to try to realize something she couldn't. That approach, manifest in my earliest paintings, triggered a kind of competitive antagonism in my mother. I think she wished she was doing it. Her attitude was that serious art meant painting like Rembrandt. It sparked many arguments between us.

Meanwhile, my mother's condition was worsening. She continued

to smoke, and her frequent drinking was becoming more destructive. Frankly, I was looking forward to leaving home. The summer had been bad, and she had some pretty violent outbursts in September. But there was nothing anyone could do to stop her.

I drove out to L.A. in September a few weeks before the start of classes to prepare for the year ahead. I leased an apartment in Tujunga and found a roommate, a student in the theater department. Once settled, away from my chaotic home life, I began to think about what I was getting myself into. ASU had been a quantum step up from Phoenix Community College. And CalArts was an equally big step up from ASU. I felt as if I was in the big leagues.

Nervous and excited, I was about to begin my life as an artist. But days before classes started, I got a phone call from home telling me another life was about to end. My mother had been critically injured in a car accident. Within hours of my return home, she was dead.

M Y mother's alcoholism was my first experience with the unspeakable. Her suicide was the second.

With hesitation, I entered the hospital room where she lay dying. She was horribly battered by the accident, bruised and swollen, paralyzed, slipping into and out of consciousness. They had tried to clean as much of the blood from her as they could but her clothes were still stained and there were flecks of dried blood on her face and arms. Seeing her lying there so broken tore me apart. I had always imagined that at death's door I could say all the things I had held back from her. But I could not. A confusion of feelings poured from every wound I'd suffered at her hands throughout my life. As she lay staring at the ceiling I said to her, "Well, you've really done it this time." Suddenly her eyes turned to meet mine and she raised her hand to feebly clutch my arm. Her eyes had a look of profound regret and terror. She knew what she had done was irrevocable. I felt so helpless;

there were no words to describe my feelings: the shame, the guilt, and the sense of utter failure (hers and mine), feelings of not having been good enough, strong enough, smart enough to save her.

It was at that moment that my future was set. I vowed that I would never let the unspeakable also be unshowable. I would paint what could not be said.

W HILE sitting with my family in a private room at the hospital after her death, trying to process what had just happened, a chaplain came in to offer condolences. It can't be easy trying to say something meaningful about a person you've never met. But when he started sermonizing about the meaning of her life and death to a god not even she believed in, I broke down sobbing, then began to laugh. He had no idea of the raging, contradictory feelings we all held toward my mother. The grief of our loss was coupled with the guilt we felt over our failure to save her. Then, too, there was an almost giddy relief that it was over. After so many years, so much trauma, so much effort, so much frustration, she was gone.

The ostensible cause of my mother's death had been an auto accident. But no one doubted it was a suicide. After a bout of heavy drinking, she'd wrested the car keys away from my younger sister, Laurie, and had driven at high speed straight off the road into a tree. It was the only tree on this desert road for miles. We all blamed ourselves for not being able to save her.

My own guilt was centered on my move to California. My mother had wanted to be an artist, and I had stolen her dream. I also blamed my father, a feeling that deepened when he remarried a year later. His new wife was a "prairie" woman—hardy and practical, the polar opposite of my mother. But even before my mother's death, my relationship with my father had been contentious. When he learned I was enrolling in CalArts, he'd thrown up his hands. No doubt the creative life held unpleasant associations for him. But he had practical

objections too. He assumed—as did I—that my financial prospects in life would be bleak. As an artist I'd always need to be working two jobs. My father was deeply disappointed.

Meanwhile we contended with the funeral, a large, farcical affair staged more for show than for sentiment. We cremated my mother because those were the instructions she had left us. But after that we didn't know what to do. We weren't religious; there were so many relatives and friends, but there was no religious or emotional center. We'd hired a minister, who recited various homilies, but none of us knew how to express what we were really feeling. It forced me to look harder at the hypocrisy and emptiness behind our rituals.

Ten years later I'd draw on those feelings in *A Funeral*—a large, enigmatic portrait of a burial party set against an angry sky in a flat, rock-strewn desert that resembles a moonscape. Two men—a father and a minister, perhaps—stand in tandem near the center of the canvas sprinkling ashes over the baked earth, attended by family members who've arranged themselves at well-spaced intervals in a loosely formed half circle. No one is touching anyone else. No one is even looking at one another, much less reaching out. The father seems preoccupied, lost in his private purgatory. Only the youngest brother, poised in the foreground with his head turned, his eyes staring at the viewer, appears to be troubled by the event taking place. "What the hell is going on here?" he seems to be asking.

The picture juxtaposes the intimacy of a private tragedy shared by a family with the self-consciousness of a public viewing. I struggled with the theme of the inside versus the outside, the feelings we experience inside and the face we present to the world, and the numbing disconnect between the two.

My mother's burial was eye-opening. Like the boy in the painting, I asked myself what we do with death—a question I would return to with a vengeance many years later. I realized we didn't know how to bury a loved one—how to say good-bye, celebrate, or mourn her. We had no rituals, no way to think about what death actually meant

to us, a feeling I tried to underscore in *A Funeral* by the subjects' matter-of-fact dress. That realization led me to explore other middle-class rites of passage in my later work—birth, puberty, marriage.

At the time of my mother's burial, though, I possessed neither the craft nor the wisdom to address those feelings through my work, to render pictorially the hollow rites of her funeral or the corrosive after-math of her death. My relationship with my mother had always been complicated. She was exciting, smart, and remarkably well-read. But she was also incredibly narcissistic and self-destructive. I had spent a good portion of my life trying to reconcile those disparate sides of her, a life of so much promise and so much waste. In the end, I real-ized, *I* had been her legacy, her artistic creation. I had inherited her talent and passion for painting, as well as her trenchant view of the absurdities and loneliness lurking beneath the "picture-perfect" sur-face of middle-class American life. My mother's death actually helped to inspire my work, strengthening my commitment to my painting. On some level I wanted to make her life good.

HOLLY FISCHL GILOTH

Eric never lost his rebellious streak. Once when
we were living in Port Washington and he was
going through his hippie period, he took off
for the West Coast, just went off the grid for
a couple of months, then showed up one day at
the Waspy yacht club my parents had joined—
interrupting my parents and their friends and
their luncheon on the terrace. He was unshaven
and unkempt. He had long hair, bare feet—bells
on one foot that jangled each time he took a
step—and beads he'd made when he was high on
acid. He wanted a peanut butter sandwich. I'm not
sure if he was even aware of the horrified stares
that followed him onto that terrace. I suppose
that wasn't so remarkable for the times, with
the revolution and all, but the revolution hadn't
come to Port Washington yet—let alone to the
yacht club. I'm not sure it ever did.

West Nottingham Academy, 1964–1966

Eric and I were shipped off to a private school
for the last few years of high school. For us
it was an opportunity to seek refuge from our
largely insane and dysfunctional home life and

gave us each a chance to reinvent ourselves. No
past. Only the present and future. A blank canvas
for each of us. We ran in different circles,
which was hard to do since our graduating class
was all of thirty-three students. Once we figured
out the rules, we were pretty good at obeying
them or figuring out how to bend them without
getting into too much trouble.

We were assigned tasks/responsibilities. Eric was
put in charge of the dining hall—a job he took
very seriously. The cooks in the cafeteria loved
him and were always slipping him food. The girls
loved him—older girls, younger girls, pretty
girls, not-so-pretty girls, smart girls, girls of
questionable academic ability. All that adoration
was mostly lost on me, but I was his sister. I
knew the real Eric and didn't see him that way.

Our black humor about our mother's drinking ended
up as one of Eric's paintings. At one point in
Port Washington, we had a Mercury convertible.
Mom had driven it into town for an afternoon
liquor run and had started drinking on the way
back. We lived at the end of a cul-de-sac. It was
summer. There was a game of stickball happen-
ing just at the end of our driveway, with kids
everywhere. She pulled into the driveway and

proceeded to pass out cold—in the front seat—
with the top down and an audience. Eric and I
watched in horror from inside the house. It was
impossible to look at, impossible to turn away
from. We were both revolted and terrified by this
unbearable situation, and yet we found ourselves
dissolving into sidesplitting, pants-wetting gales
of laughter as we planned our recon mission.
"Holy shit! What the hell do we do now? How do
we get her in? When do we make our move? Do we
wait for dark?"

In *A Woman Possessed,* as he called the picture,
Eric painted our mom lying unconscious out
on the pavement. But you can still see our car
in the background. Eric is trying to pull her
into the house. She is heavy and deadlike. Only
now a pack of big dogs is surrounding her, making
his task doubly hard and dangerous.

CALARTS

1970–1971

F OUNDED by the famously conservative Walt Disney, CalArts was a curious combination of old and new, hidebound and progressive. It was conceived as a kind of vocational school, a Cal Tech of the arts—an old-fashioned, no-nonsense apprenticeship program that would bring together students from different disciplines and turn out job-ready artists (at least some of whom would go to work in the Disney studio). But CalArts took a radical turn. It became the exemplar of a new kind of art school, one that would reimagine the way art is conceived and made. It would shake up not only other art programs but also the foundations of the contemporary art world.

With its accent on professionalism—real artists working in the real world—CalArts based its admissions solely on talent. Applicants submitted portfolios and mission statements. Grades and test scores weren't considered. What's more, Walt Disney backed up his vision with money. Qualified candidates who couldn't afford the steep tuition were offered scholarships. Such policies attracted a wealth of

talent—serious, driven students, many of whom couldn't have gotten into or afforded to go to the so-called elite art schools.

Once in the program, students were allowed an unusual amount of latitude and independence. We were treated with the same respect as our teachers. In fact, we weren't even referred to as students but as young artists or artists in training. The school expected its professors to teach by engagement, suggestion, and example, not by rote or coercion. Again, students' performance would be judged by the work they made. Grades and tests were not part of the program.

Walt Disney's vision was not entirely novel. He'd already experimented with such an interdisciplinary approach when he made *Fantasia,* mixing animators, musicians, choreographers, designers, and writers under the same studio roof and getting them to work together. And even that project harkened back to nineteenth-century German composer Richard Wagner's idea of *Gesamtkunstwerk* ("total artwork"). Disney had originally conceived CalArts as a bucolic nineteenth-century crafts community—part of an entertainment complex, a kind of Disneyland of the arts, featuring roving string quartets and plein air artists in smocks and berets. But I doubt that he'd anticipated the generational clash playing out on campuses across the country in the sixties amid the protests over the Vietnam War, civil rights, free love, and the rise of the drug culture.

The school, after all, was located in Southern California—to many, ground zero for the counterculture—and its students and faculty were almost by definition misfits and rule breakers. Walt's vision never had a chance. But when I first got there, everyone was just feeling his or her way. Nothing had solidified. There were no hardened cliques, no intractable ideologies, no binding traditions. Just blue skies and optimism, as Lannie used to say.

The setting alone was revelatory. Labor strikes and torrential rains had delayed construction on CalArts's campus in Valencia, and the Institute had rented temporary digs at Villa Cabrini, a defunct Catholic girls' school at the edge of downtown Burbank. The grounds

were idyllic. The main building, a gracious example of Spanish Colonial architecture, encompassed a large courtyard with mosaic tiles and a sheltering grove of olive trees. Evenings Ravi Shankar—a visiting professor—played ragas, and the cafeteria served a sumptuous buffet. Everybody wanted to hang out there. And there was this positive energy that comes from being in a provisional place, all of us having to chip in and help out.

Adding to my own excitement was the sense of novelty that pervaded just about everything. The school had no history. Everyone was there for the same reason, and nobody knew each other. We all had this amazing shared experience of coming together to break boundaries, to form a new vision—the faculty and administration included.

That groundbreaking vision—hinted at in the school's promotional material—would entail nothing less than creating a new body of art. And our professors, some only a few years older and far more radical than their students—John Baldessari, Allan Kaprow, Nam June Paik, Miriam Schapiro, and Judy Chicago, all of whom were to become famous artists—were at the head of the barricades, daring us to overturn conventional wisdom, to take risks and separate ourselves from the pack. Everyone who came there wanted to shine, to stand out. And nobody knew what the benchmarks were. Everybody was trying to blow everybody else's mind.

A spirit of insurgent creativity pervaded the classrooms and studios and spilled out onto the campus, infusing the place with a caffeinated, circuslike atmosphere. Barbara Bloom, at the beginning of a long, successful career as a conceptual artist, strolled across the grounds with a handful of paint chips, matching her palette to the hues of a brick or the shadow of a leaf, color-coding the school. I remember thinking, What the hell is that?

And Barbara's modest visual pun was being repeated around the campus in different media. Everybody was doing stuff—performing, painting, creating all the time. Musicians, design students, film students mixed together. You'd walk into school and there'd be a concert

going on, but the strings would be playing in one wing of the building, the woodwinds in another. It was like wandering through a campus-wide symphony.

The carnival continued off campus. My roommate was very theatrical and would hang out on Sunset Boulevard dressed in a cape of feathers and wearing face paint. And there was a straight guy who'd show up on campus once a month wearing women's clothing like the Jamie Farr character in *M*A*S*H.*

That sense of fun and experimentation became part of the school's ethos, part of its program of permanent innovation. Having turned its back on the canon, CalArts was focused on freeing up and redefining art. It stressed ideas, choices, attitudes. It placed little emphasis on craft or technique, offered none of the conventional classes in anatomy or drawing. If you wanted to develop those skills, you were expected to acquire them on your own.

Even when students requested a basic life-drawing session, as my advanced painting class did from time to time, the results were anything but simple. I remember coming late to one such class; everybody in the studio was naked. Half the people were covered with paint. They rolled around on the ground on pieces of paper that they'd torn off a roll. The model was sitting in a corner of the room absolutely still, bored to tears and smoking cigarettes. Everybody else was throwing stuff or rolling around in rivers of paint, using their bodies as brushes, and sometimes as canvases. Ostensibly the point was to have us explore the primitive roots of painting, but knowing our professor, Allan Hacklin, a gonzo artist with a fierce, combative teaching style, he was just trying to shake things up. (Allan ended up marrying the model, Susan Kinsolving, a CalArts grad student who has since become an acclaimed poet.)

A few months later, Allan invited our class to his home off campus to view his latest canvases. It was one of those perfect spring days. He solicited our opinions of his work. But someone produced a bottle of tequila instead, and one woman began taking off her shirt. Then

another took off her top, and pretty soon everyone had their clothes off, and the house was filled with naked, writhing bodies. I landed in one of the bedrooms with a grad student from the feminist program who was not particularly fond of men, and I ended up angry and miserable. But the orgy and the Rabelaisian drawing class were so much at the heart of everything we were trying to do—breaking barriers, experimenting with new forms and relationships. It produced this weird kind of intimacy among the students, a sense of testing the limits of experience, even when that experience, as in my case, was hollow.

The school's administration took a dimmer view of our activities. Every week there were protests or skirmishes between the students and teachers and CalArts's conservative overseers. The administration hired Herbert Marcuse to much fanfare, then dismissed him twenty-four hours later after the board learned he was a committed communist. Halfway through the year, the Institute's board—alarmed that its school had fallen into the hands of radicals and hedonists—made a surprise inspection of the campus. Their tour began in the early morning at the Institute's pool. Dozens of naked students—and a fair number of the faculty—were winding down an all-night swim party. And just about everybody was high on LSD.

But despite the parties and almost endless social experimentation, CalArts was a deadly serious arts center. The students, freed from the constraints of provincial schooling and from the stigma of being seen as outsiders—or as dyslexic or neurotic or ethnic or gay—poured themselves into their work. Debates raged across campus about the virtues of ideas versus craft, the hand versus the eye, feminism versus the status quo.

CalArts may not have invented the "crit"—the art-world equivalent to a Skull and Bones–style peer review—but it honed it to knifelike precision. At gatherings that could last an afternoon and sometimes longer, you'd show your latest painting, then field criticism from classmates and professors intent on exposing every dodge and weakness in your work. One reason they were so brutal was our

doubts about the viability of painting. The idea was to throw everything they had at your work and see if afterward it was still moving, if it was still alive. They'd question every mark on your canvas—Why was it there? What did it add to the picture?—and if you couldn't answer adequately, if you were at all wishy-washy or ambiguous, they'd savage you and your work pitilessly, reducing students to stammers and tears. In their view, the offending student wasn't just a bad painter, but a liar and a cheat.

CALARTS never wanted to be associated with any one style of art. And it certainly wasn't trying to teach us students how to make art. Rather, its goal was to get us to think like artists. But once we settled down, we turned our new school into a laboratory in which our competing visions of art were synthesized, debated, and ultimately embraced or, more likely, rejected. It was truly a battle for survival, especially if you were a painter.

There was no shortage of styles to choose from. My painting class alone practiced half a dozen. But within the art school two camps predominated, each championed by a larger-than-life, charismatic professor. Allan Hacklin, my chief instructor, presided at one end of the spectrum. Still in his twenties, he made large, luminous canvases that employed a lot of technique. I didn't love them. I thought they were intelligent, optically sophisticated, and elegant but unemotional. Still, they were paintings, real paintings, which were as close to my way of working as one was likely to get at CalArts. And he'd had some good success in New York as part of a new wave of young painters dubbed Lyrical Abstractionists. Their works were large-format paintings of color fields arrived at in unorthodox ways: pouring, squeegeeing, spraying, and so on. At best decorative, their focus was on process and truth to materials—treating paint as an end, for example, not a means. Allan had sold fifty or so paintings out of his first show, and that gave him a great deal of credibility on campus.

The son of Finnish immigrants, Allan moved out to the West Coast to relive the childhood he'd missed growing up poor in Harlem. But I'm pretty sure he was a wild man before he got to CalArts. In either case, once there, he was the model of a hard-drinking, macho, old-school artist. He barked his opinions and his beliefs like a drill sergeant, but he never told you what to do or how to do it. He only told you what was good or bad about what you'd done. Fortunately for me, he liked the paintings I did shortly after I arrived, and once anointed I fought hard to maintain my status. But inevitably, we butted heads. Above all else I wanted to learn what made a good picture, and I found it hard to swallow all the obfuscation in modernist artspeak. I was always asking questions, trying to make the abstract concrete: Why this line here? Why that color there?

I liked Allan. He was generous with his time; he hung out with his students—maybe a little too much; he organized trips to museums and visits to artists' studios as well as parties and orgies, and encouraged us to talk back to him. Most important, he believed in painting and defended it against its detractors, of which there were many.

John Baldessari was Allan's polar opposite—artistically and temperamentally. Nearly seven feet tall with a cherubic face and a silky chin-curtain beard, he was a gentle giant, as genial and unassuming as Allan was aggressive and opinionated. I liked John. I even liked his work. But he was the enemy, a practical joker whose subversive vision of art threatened my identity as a painter.

John was a conceptualist, the force behind the radical approach to art making that CalArts became known for. A couple of years before CalArts began classes, he burned all the paintings he'd made since his student days in the early fifties, then deposited the ashes in a book-shaped urn on which he listed the titles and dates of the works—the way you would on a headstone. People had a field day interpreting that. But for me it meant simply that he didn't give a shit about the paintings anymore. He wanted to start over and reinvent an art better

suited to the times. A lot of that meant working with manufactured images—photos, movie stills, video—and sort of redefining the artist's vocabulary in terms of popular culture. (John had read Wittgenstein and the French structuralists, and I think he was one of the first to introduce their concepts about art and culture and perception into the CalArts conversation.) And much of it had to do with sending up the über-romantic, high seriousness of angst-ridden paintings—Allan's and Paul Brach's among them. But all of it had to do with idea-based art, works that didn't require much craft or need to be made in a studio the way mine did. And it was mostly art about art.

I accepted that art, and its processes, was a legitimate subject for artists. In fact, all artists have to deal with the way their art is made. Some choose to make that part of the viewer's experience. And some try to hide it. But I wanted to create an art that would do more than comment on itself or other works or on the mechanics of perception. After a lifetime of family trauma, capped by my mother's recent suicide, I desperately needed to look at and experience and make art that would acknowledge my raw feelings and give order and meaning to my emotional life.

I found Baldessari's outsize influence on my fellow students even more troubling. Conceptualism was just coming into full flower. It was the leading edge of the avant-garde, and it was attracting the smartest students, who were taking the form to what I thought were absurd extremes. One student conceived of a project where he would begin hitchhiking at the road leading out from the campus and travel as far as his ride went, and then hitchhike another ride to another random destination, and keep repeating this for a week to see where he would end up. I really liked this idea. It was how I approached painting. So I was disappointed to find out that he only traveled for a couple of hours. He defended his lack of follow-through by claiming his idea was more important than its execution.

Students like the virtual hitchhiker were making a kind of art that was not only competing with mine but also dismissive of the

essence of what I was trying to do. I was looking for experiences. I wanted to create experiences for myself and my audience, and I expected the same from other works of art.

W E all had to share studio space. I was assigned a young undergraduate painter who would become a lifelong friend. David Salle was a first-year student from Wichita. Only seventeen, he had never been on a plane before coming to California, or traveled more than fifty miles outside his hometown. But he was so brilliant and articulate that we all thought he was a graduate student. I later learned he'd taught himself most of what he knew from books, and that there were some sizable holes in his education. When he came to CalArts he was painting these incredibly lush landscapes—very Diebenkornesque. They looked to me as if they'd been painted by a master. He knew they were derivative.

But David was a quick study. He had an amazing intellectual curiosity and an autodidact's wide-ranging engagement with philosophy and literature. He devoured culture. He took advanced courses in music and theater and began to look for alternatives to painting—performance and more cerebral forms of art-making using photography and film.

Many students were learning radical new ways of making art employing then-new video technology. Nam June Paik had jury-rigged a lab with monitors, and my classmates and I, while getting stoned, ran color patterns and deconstructed images day and night. The studios were open 24/7 and we would wander through the campus at weird hours partying, working, socializing, spending time with friends in their spaces as they worked, drank, and smoked.

Almost without realizing it, I'd discovered the community of like-minded truth seekers I'd hungered for in the Haight. Art was our godhead. It was our calling and our discipline. It summoned and focused our energies, structured our time. Art humbled us. Everyone

agreed they didn't know the answers, or even the questions. Everyone was open to the new, struggling to make his or her stuff important, vying for attention. It was intensely competitive.

But it was a healthy kind of competition. Especially in those first weeks and months, our task was so daunting, our teachers so demanding, that we cheered each other on to what was a common goal. In painting class, there were breakthroughs. As you got rid of old ideas and did a bunch of paintings that were new, you'd become one of the top dogs. And then someone else would come up with something to best you, and you'd go back to the studio and try to one-up them.

ANNIE joined me in California for the second semester. We rented a cheap room on the top floor of a house in nearby Echo Park and she got a job working in CalArts's art department while she waited for her admissions application to be accepted and processed for the following year. The pay was nominal, and even with the stipend from my work-study program, we barely made expenses. But we couldn't have cared less. We rose early in the morning to do yoga on the lawn and painted late into the night in my studio close by the campus.

Still, I was anxious all the time. I'd entered CalArts as an advanced painting student. Having accumulated two years' worth of credits at my previous schools, I was able to skip classroom courses like Critical Studies and focus entirely on studio work. But I didn't feel advanced—either in my grasp of the modernist project or in dealing with the technical aspects of painting. I was mired on the one hand in my narrow admiration for the early abstractionists like Kandinsky and Mondrian and stymied on the other by my ignorance of anyone who came after them. My struggles with my own painting reflected these quirks.

At CalArts I continued painting abstractions under the tutelage of Allan. He would alternately inspire and irritate me, and we'd spar throughout my remaining tenure. But that first halcyon

year at CalArts was like a honeymoon. Inspired by the bed paint-
ing I'd made while still in Phoenix, I began working on a series of
large-field paintings—canvases primed with flat, primary colors—
where I floated squiggly tubular shapes, but balloonlike, very light
and unserious. Allan loved them, and during one studio session fore-
swore his usual brutal interrogation and silently crossed the room to
shake my hand in front of my envious classmates. Those first paint-
ings were cathartic. They came out of this spiral of anger, cutting
loose in a way that was buoyant and childlike, a complete denial of
what I was going through emotionally.

Over much of my second year, I'd try to discover an intellectual
framework in which to ground my new form of abstraction. The re-
sults would become leaden and my relationship with Allan would
fray. But in those first few months, surrounded by fellow artists and
truth seekers in the midst of this bucolic setting, challenged by smart,
dedicated teachers, I was producing my most promising work to date.
I'd become one of the top dogs.

T HE following year CalArts opened its new campus in Valencia,
a desert community fifty miles or so northwest of Los Angeles.
Designed by an architect best known for his shopping centers, the
bunkerlike arrangement of buildings had none of the charm of Villa
Cabrini. Worse, it housed the different artistic disciplines in separate
facilities, hampering the once-easy exchange of ideas among artists,
musicians, dancers, designers, and theater people.

Other fissures had begun to appear throughout the student
body. A breach, for example, had opened up between the two main
camps of art students. On one side of the divide were the hands-on
art makers—students such as myself who painted, sculpted, or oth-
erwise constructed art in the studio under the guidance of teachers
like Allan and Paul Brach. On the other side was the smaller, more
radical group of students who took so-called post-studio classes with

conceptualist guru Baldessari. These students believed that craft-based art making, especially painting, was passé, that the idea behind an artwork is more important than its actualization, and that in some cases the idea per se—as expressed in performance or a written set of instructions—*is* the artwork.

Not surprisingly, the two camps disdained each other. A few students, David Salle among them, tried to straddle the divide. But they ultimately identified with one group or the other—or they ended up belonging to neither.

The chief issue between the two sides turned on the viability of painting: Was painting dead? The conceptualists argued that painting was part of a long Western tradition, the art form most closely associated with white European males and therefore elitist, antifeminist, anti-black, and anti-Hispanic. To them, paintings were easily commodified, giving rise to the corrupt and corrupting gallery-museum-auction-house system.

But the conceptualists' main line of attack—the one I found hardest to refute—held that painting had lost its primacy, that it no longer sat at the center of culture. The popular media had taken over that function. In this view, painting was not so much dead as it was a backwater in the collective consciousness. Baldessari's acolytes—having grown up in thrall to the mass-produced images of film, television, and commercial photography—maintained that these images were more essential to their apprehension of the world than was their direct experience of the world itself. Media had literally become the message.

For artists who traveled down this particular rabbit hole, the implications were mind-altering. Why bother to draw or paint a landscape, they would ask, when the same image appropriated from a magazine or a cartoon cel would do as well—and was arguably more authentic?

At first I dismissed the controversy. I believed that painters are born painters. For them it's as natural as breathing. Painters don't

choose to be painters. They just choose to be better painters. The things that go into making a painting—the scale of the canvas, the shape of the rectangle, the texture of the surface, the length and force of the brushstroke, the selection of colors—all those things are connected to the painter at the deepest level, the way he or she orders the world.

I didn't begrudge the conceptual artists their different approach. If anything, I blamed painting for its plight—the silly endgame strategies of late-modernist painters and painting's timid response to the challenges of pop art—and I even admired Baldessari's humorous disregard for art's higher values, the way he tweaked the egoism and sentimentality embedded in painting's heroic tradition.

But then my studio mate, David Salle, frustrated in his attempts to find an authentic painting style, began to abandon the studio in favor of conceptualism. David was not only extremely smart, but in those days quick and cutting, a feared opponent in any argument. And so the Great Debate was brought home to me. It became personal.

David and I had clashed before over formal issues. We would argue about the hand-eye connection or the level of noise—how much emotional content—a painting should be allowed to contain. Then we would hunker down and stop speaking to each other for days, sometimes weeks. Art meant everything to us. We took our arguments very, very seriously.

But the existential debate over painting raised the stakes on our friendship. And it wasn't only David—after all, he was chiefly a catalyst, a foil to my humanism. The entire post-studio gang, arguably the brightest, most advanced students at CalArts, were attempting to marginalize my art.

I needed to paint. Something about the feel and smell of the materials, the very act of painting—being alone at my easel in front of my canvas, drawing lines, mixing pigment, pushing around shapes and colors—had become integral to my art and life. All the smart people who studied with Baldessari could think their way into an

experience. But I had to feel my way through a medium and a process. Only through painting could I unlock my feelings and show me to myself.

At the time, though, I couldn't explain the catharsis that I underwent while painting. I couldn't articulate why it was essential. My arguments were the typical student exchanges, just short of "Oh, yeah?" and "Well, fuck you." I only knew I couldn't let them take painting away from me. And I was combative enough to make the argument through my work, to make each painting more assertive. I was going to capture increasingly authentic experiences through my paintings, show them that painting isn't dead, that it was still capable of expressing feelings and wasn't just a disembodied idea, a parody or a formal strategy. That was my defense, painting itself.

But having said that, I also felt as if I was trying to revive a discredited medium using shopworn methods and materials.

All the painters I admired, several of my professors among them, were laboring without much success to turn the critical tide. How was I, a third-year student artist with no appreciable technical skills, going to turn things around? How was I going to make paintings that lived?

THE worst thing you could say about somebody's work at CalArts was that it was unoriginal, that it borrowed from or alluded to anything that came before. I remember Allan and Paul Brach critiquing one of my paintings as if they were competing to see who could find the most obscure references. They started naming medieval religious painters that nobody had ever heard of. I was furious—that was it for me. I stopped bringing my work to class. It was too brutal.

I was neither kinder nor less rigorous in my own criticism of my fellow students' work. I was striving to create an alternative art, a novel style of painting. And I was blindly competitive with my peers. Moreover, I increasingly clashed with the school's deconstructive

ethos, its radical break with the past, its dismissal of everything that came before. CalArts had such a narrow idea of the New. It was innovation for its own sake, a future that didn't include the past. But without foundation, without techniques or a deeper understanding of history, you'd go off on these wild explorations and end up reinventing the wheel. And then you'd get slammed for it.

My fellow painters had become almost dismissive of my work. I was experiencing familiar feelings of alienation, a deepening awareness of the gap between the look of things and their underlying reality. Only now the isolation was in my work as well as my life. My paintings felt stillborn, my feelings locked down. I was no longer top dog.

F OR the winter term, Lannie and I had moved out of our Echo Park rental into a larger house in Valencia, a short drive from campus. It had a porch with a tiki-style bamboo bar emblazoned with crossed swords that would often get used as a stage set at parties when people were feeling stoned and inspired enough to act out clichéd love scenes from B movies.

One new friend was Ross Bleckner. A graduate student from New York, where he'd studied under Chuck Close, he joined Allan's painting class in the fall and quickly established himself as a street-smart, artist-wise guy. Ross didn't like L.A.—its relentless sunshine, traffic, and hedonism. He put up blackout shades on the windows of his studio, dressed in black, and made all-black, overwrought paintings—adding to his downbeat persona. His early paintings were heavy, leaded—especially against the backdrop of California's light and surfing culture. I remember thinking: "Very definitely this guy's from New York, and he's not getting out of New York."

And yet everybody loved Ross. Short, wiry, olive-skinned with a pageboy haircut and wry, cryptic smile, he was also kind, generous, self-questioning, extremely smart and funny, and, as he later would be in New York, accessible to many different groups and cliques on

campus. Even Allan came to accept his angst-ridden urban sensibility as a kind of shtick, one more variation on the pose of the suffering artist. If nothing else, CalArts was a laboratory for the personality, a theater in which to discover and develop your voice, to try on and discard traits, styles, and attitudes.

FROM my first day on campus I felt the old existential insecurity eating at me, and it manifested itself throughout my term there as an insidious competitiveness, often mean-spirited and belligerent. Apart from the very real battles I was having over the merits of painting, I was pitting my work against everyone else's. Ross, for example, was a better painter than I was. Certainly more sophisticated. I was threatened by his work and kept finding reasons to put his pictures down. I had to find a rationale for criticizing my classmates and my instructors. Allan was the biggest target, so I focused on him.

Halfway through my second year, Allan invited our class to critique his latest paintings, which were showing in CalArts's main gallery, a two-story atrium at the entrance to the school. Big mistake. The venue alone—a busy public space full of visitors, as well as staff and students on their way to class—was provocative, hardly a place for quiet deliberation or measured argument.

Back then I didn't like Allan's work—I felt it was slick, too easy, too elegant—but it wouldn't have mattered if I did. Depressed about my own work, beaten down by months of unrelenting criticism—Allan's and others'—I was already forming my denunciations on the walk over to the gallery.

The pictures themselves were typical Allan: luminous, hard-edged forms beautifully composed (with a pink, cosmetic light) and, I thought, emotionless. I told him so. Until then I'd kept my mouth shut. But Allan had started explaining something about the spatial relationships between the forms in the paintings and how that was a metaphor for human relationships, and I heard the lie—the big lie

that always pops out when artists try too hard to rationalize their work. It was the thing I was always looking for in crits, and I jumped on it.

He took the bait and we began to argue. He kept on about the illusory spaces, insisting they were containers of dread or uncertainty or some kind of strong emotion.

"Nope, no emotions here," I said. "Just mechanics. Anyone can do what you've done."

"They're metaphors for ambiguous relationships," he said. " 'It's here. It isn't here.' *You* just don't see it."

"I do see it. I just don't feel it." I was on to him. I wasn't going to budge. His voice began to take on a prosecutorial edge.

"You see this shape," he said. "It's in the foreground, right?"

"Yes."

"Well, it's also in the background. You can't tell where it is."

"Doesn't matter. It's just a trick." We were screaming at each other now. Our voices climbed to the high-domed ceiling and returned to us in thunderous echoes, a kind of indecipherable, enveloping primal shout that in my case was filled with all the rage and fear and frustration I'd been feeling about my work and God knows what else.

M EANWHILE, I still had no idea what kind of painter I was, or who I was as a person. I masked that ignorance by channeling my emotions instead into a kind of free-floating antiauthoritarianism typical of the times. I had not dealt with the trauma of my mother's suicide, and that was about to have its consequences.

In an attempt to ignore my family experiences, I tried to paint away from them. I made pure abstractions instead that I believed were more elevated, more spiritual; work that spoke to the higher purpose of being human. But I would talk about my paintings only in formal terms. It would take some years to come to understand that burying and evading my feelings was killing any chance of transcendence in

the work. Much like Ross, I was trying to rationalize my approach to making art. I was the guy in class pressing everyone: Why this line here? Why this shape? *Explain* it to me.

I was battling along two fronts. A committed modernist, I employed a style of abstraction that stressed the formal properties of paint. According to the dogma at the time, painting was not supposed to be about anything other than itself—its materials, shapes, lines, and colors. No tricks of perspective or mimesis. No metaphors or obvious tropes. No narrative pretense, no literary or historical allusions, no quotes. What you saw was what you got—raw, direct, and authentic. The problem was I wanted to tell stories. Without really knowing it, my approach to painting was psychological and historical, not formalist. I ascribed a coded lexicon of private meaning to the shapes and colors I was using and then became frustrated when no one picked up on the hidden content.

It had been over a year since my "balloon" paintings, and I'd failed to repeat my early success. Worse, in an attempt to anchor my new work in a replicable, intellectually rigorous framework, I'd been questioning and overanalyzing my impulse to spontaneity. The results were dismal and derivative. The paintings looked like I was trying to hide the influences of two modern masters, Richard Diebenkorn and Brice Marden, by blending them together—taking one's shapes and the other's color and surface.

I was not a natural abstractionist. Since my days at ASU, painting had been tough for me. There was little fluidity in my work. Every brushstroke was premeditated, rationalized, every decision fraught with doubt. Whatever breakthroughs I'd had in my paintings had been wild, frustrated stabs at the canvas, painful and cathartic; odd reversals of method; temper tantrums. Every painting I made felt like the last painting I could do. It took everything I had to finish, to figure out how to solve its particular set of problems and challenges. And it didn't lead naturally to the next painting. It didn't flow. A natural abstract painter doesn't agonize over every decision, such as

changing the sizes of his brushes or modulating the color within a shape. He just picks up another brush. I couldn't do that. That's how silly it got. I had to have a rationale or an excuse for everything. The limitations of the form were not unlocking creativity in me. They were bottling it up.

At the beginning of the semester, a classmate of mine, commissioned to decorate a bar in L.A. with murals, invited me and a group of other students to assist her in exchange for free drinks, blank walls, and a license to paint whatever we wanted. The result was mayhem, an orgy of all-night drinking and uninhibited painting. I'd painted a naked couple; all I remember was that the man looked a lot like Nixon. I have no idea why I'd made him look like that or why I'd even made that picture. My first reaction was chagrin. The image confirmed to me what an outsider I really was in the world of art. But there was a message in it. I realized that when left to my devices, and in a spirit of spontaneity, I'd produced a representational painting—one with recognizable figures. And it was the most fun I'd had painting in a long time.

I was becoming anxious and disillusioned with CalArts in other ways. In my last year of school, I was supposed to be getting better prepared to be an artist, but the constant criticisms that had been bracing and motivational in my first year had become aggravating and repetitive in my second. I was being worn down, exhausted by the high purpose and competitiveness that kept me on the defensive and my work fragmented and incoherent.

Perhaps if I'd been happier with my work, I'd have felt less wounded by the sting of my professors' criticism. If nothing else, my experience at CalArts had taught me how to look at a painting, to measure its elements, to analyze its strengths and weaknesses, to see, for example, when an artist is being lazy, trying to fudge an area he didn't know how to resolve or trying to project his ideology onto his work. I learned how to see the whole object, to see what was really there.

With graduation looming—I'd already accumulated enough

credits for my degree—I began to panic. I was hoping when graduation came that I would have a respectable portfolio of work to take with me into the real world. But I had nothing. My paintings lay in ruins, some shredded in fits of rage, others turned to the wall. I'd lost confidence in my ability to make art. All year I'd been trying to find something with my painting that hadn't materialized. The static noise inside my head was getting louder. I rejected applying for graduate school. I couldn't take two more years of living up to other people's expectations. I had no idea where to turn or what to do next.

I reached my tipping point when an artist named William Conlon visited the school as a guest speaker. He was a hot painter in New York at the time. He'd made a series of paintings called *White Dwarf* that were canvases, mostly empty in the middle, on which he'd painted abstract shapes running around the periphery. He was talking about his work, which was cold and decorative, and he pointed to a triangle, saying, "That represented when my dog died." I thought it was the height of absurdity.

Finally fed up with my lame attempts at abstraction, I began to incorporate collage in my painting. I started gluing pictures of cowboys onto my canvases, silly images of the West meant to be whimsical and disrespectful. My professors dismissed them with an air of indifference. If I wasn't going to take myself seriously, why should they? But my classmates were more supportive, perhaps responding to my iconoclasm.

In the late sixties, imagery and eccentric materials were making their way back into the conversation. I was intrigued by some of this work. Artists like William Wiley in San Francisco were working with wry, witty narrative imagery that used puns and clichés of the West. Alan Shields, a hippie tie-dye painter, stuck twigs and beads onto his colorful canvases. Jonathan Borofsky was doing works chronicling dreams—cross-discipline objects incorporating drawing, painting, and sculpture that mixed up styles and ignored orthodoxy. They were liberating and influential for me.

But against the ethos of rigorous high art that reigned at CalArts, my latest works seemed idiosyncratic at best. I'd already felt consigned to the school's backwaters by the mere fact that I was a painter. But now, as a painter adopting nonmainstream strategies, I was doubly marginalized.

It was time for me to leave.

ROSS BLECKNER

When I first met Eric at CalArts, he wasn't a bad
boy. He was more like a scared boy. We all were
plagued by doubts and fears about our abilities.
So there was this tentative side to Eric. And
at the same time he could be assertive—direct,
funny, very down-to-earth—a lot like his later
paintings. Once I took him and Allan to see a
picture of mine that I'd hung in the student
hall. I didn't have a name for it. I had made
it using iridescent pigments so that it would
glisten, and Allan and I were coming up with all
these abstract, convoluted titles, and Eric said:
"Why don't you just call it *Pearly-Schmerly*."
And I did.

ALANA (LANNIE) JOHNSTON

I wasn't exactly a guy-magnet in high school—
Eric Fischl was my first true love. Like many
artists, I was a misfit throughout my adoles-
cence, a word both clichéd and underwhelming in
its scope. Eric was upbeat and inquisitive. His
quirky sense of humor coaxed out my own unortho-
dox humor and helped me to feel more comfortable
in my skin. Once, shortly after we had first met,
Eric and some other friends were goofing around
in my kitchen in Tempe when he just started
taking off his clothes to shrieks of laughter.
School-of-opportunity-knocks humor. Some of the
earliest art pieces Eric showed me were hilarious
and sophomoric Superman comic books that he'd
amended by giving Superman enormous erections
beneath his superhero drag.

We were good hippies in the late sixties and
early seventies, participating in marches against
the war in Vietnam. We considered moving to
Canada when Nixon invaded Cambodia. I tied an
eagle feather in his hair when we went to see
Woodstock at a theater in Phoenix, where we
lived.

Eric's acceptance to CalArts pushed me to
apply, and to be accepted also, an important
move out of the provincialism of Phoenix in

the 1970s. We lived in a small apartment in Echo Park with eight cats, abandoned by the the previous tenants. This was the first time either of us had set about making a home and sharing a life with someone without the benefit of marriage, an act that seemed quite radical at the time and went hand-in-hand with the borders we wanted to push in art. We each made about $80 a month on which we somehow supported ourselves. We read Adelle Davis and learned to become vegetarians briefly, did yoga, and checked out monitors from the audiovisual department at school so we could watch TV occasionally on the weekends. When we attended openings at various galleries in L.A., where we might encounter John Baldessari or Ed Ruscha, it seemed, at least to me, like getting to go to the ball in a fancy gown.

Eric and I thrived on the extraordinary experience-expanding atmosphere at CalArts. A gamelan concert one day, a heated argument about the censorship of a student's work employing dog shit the next. Endless conversations about art and ideas: Judy Chicago and Miriam Schapiro's feminist art program. I remember Schapiro, a motherly-looking woman, standing in front of the room saying words like *motherfucker, cocksucker, cunt,* et cetera. She wanted us young women to feel freer to express ourselves and probably didn't realize we'd been saying those things since middle school.

CalArts did not offer the kind of smock-wearing, palette-wielding curriculum that had been the status quo. Conceptual art, performance art, and other expressions without labels were the lingua franca. Questioning the continuing validity of painting was an idea that permeated the air. Eric's work swung between an early piece depicting photos of covered bridges to which he'd assigned the sort of women's names associated with prostitutes, to reductive abstract paintings with sensually juxtaposed colors and exquisite surfaces.

DAVID SALLE

Eric was the first one to have a breakthrough in Allan's painting class. We were all more or less floundering around, working out of what we were used to doing, and Allan was not impressed at all with what people brought in to the crits each week. What he was trying to show us caused a lot of frustration—it was like trying to grasp at something just out of reach. After some weeks, Eric made a largish painting of cartoony, worm-like forms—like those elongated, segmented balloons that are sold on the street in Mexico. It was simple, direct painting—outlining the forms without a lot of filling in. It was unfussy, not compromised by a lot of brushwork or any other hedging. I don't remember anyone in the studio being impressed by it—it wasn't a threat.

In that week's crit, Allan just looked long and hard at Eric's "balloon" painting while the rest of us kind of held our breath. Was he going to really let Eric have it? (There had often been tears in those crits.) Suddenly, Allan walked quickly over to where Eric was standing and took his hand in a kind of man-to-man gesture of solidarity—and congratulated him enthusiastically. "You did it! That's it!" I think the rest of us were too stunned even to be jealous: Why *that* painting? It eventually became clear: Eric's

painting didn't seem to come from anywhere extra-art, and it wasn't asking for any approval or special dispensation. It also dispensed with any predetermined idea of itself: it just was.

I think Eric was as surprised as the rest of us at his painting being singled out. At that moment there was a wonderful feeling in the room—this was the real thing, the reason we were all there. One of us had reached into himself and found the guts to make a painting that had autonomy, and that meant that others of us would likely find it too. In those days, hard-won gains often just melted away. I don't think Eric made another painting that semester with the same effect as that first one. I don't really remember much of what anyone did in Allan's class the first year. But after forty-some years, I still have a strong impression of those balloon forms.

. 5 .

CHICAGO

1972–1974

L ANNIE and I returned to Phoenix at the spring break. We went there to paint my father and stepmother's new home, to make some extra money to tide us over during the next semester. Our first night back, Lannie and I met up for drinks with Bill Swaim, the inspirational teacher who'd been a friend and guru to us at ASU. Bill had brought a young woman with him, a bright, vivacious graduate student named Laura whom he thought we'd enjoy meeting. He was right on my account. My attraction to her was instantaneous. We talked—I don't know how long; she seemed to share my fears and fantasies, all my hidden conflicted feelings about becoming an artist. And she was beautiful. Small-boned, almost tomboyish with her cropped dark hair, jeans, and big, floppy British felt hat—so out of fashion at the time—she glowed with the certainty of her self-creation.

I feigned exhaustion and took Lannie home to her parents' house, then circled back to hook up with Laura. We drove to her apartment. Her walls were full of exquisite color-pencil drawings that she'd made

of the clothes she was wearing: jeans, jacket, T-shirt, boots, hat. They looked like cutouts for this exotic hipster doll.

I was lost. Over the course of the next few days I stole away every chance I got to be with her. Finally the duplicity became unbearable and I confessed to Lannie that I had fallen in love. Strangely, I'd been getting along well with Lannie, although some of the passion had leveled off in the years since we'd begun dating. Earlier that semester we'd even tried a couples-swapping experiment. But it had more to do with the times—a CalArts free-love experiment—than with any dissatisfaction on our part. It was an adventure, not some desperate measure, and the results only confirmed to me that I was happy with Lannie.

So I not only hurt Lannie with my confession, I blindsided her. How could I have fallen in love with someone else in the space of a few days? I had no good answer. I suppose Laura offered a new beginning for me, an antidote to my frustrations at work, a return to some half-remembered time of infinite promise and possibility. I was ripe for infatuation. And I think part of my attraction to Laura was the excitement of being with someone new, with my idea of the romance of being an artist, defying expectations, following my instinct.

Over time I'd learn to confine those bravura risks to the canvas. But at that moment it seemed easier to overturn my life. I drove back to Valencia to pick up my things, file for early graduation, take leave of friends and teachers, and say good-bye to Lannie, who had returned ahead of me to CalArts, leaving me to sort things out with Laura.

But this wasn't the kind of thing you think through. You don't rationalize it. You play it out. Laura was unhappy at Arizona State, and she was bored by the provincialism of Phoenix. When I got back, she was ready to leave, to make a complete break. At that point, I'd have followed her anywhere. She wanted to go to Chicago.

I'm still not sure why I was blown away by Laura. She was very different from Lannie. Thin, small-breasted, and gamine, with a round face and big dark eyes, she was mischievous and at times ill-mannered.

When we went to swim at my father's, she would have preferred being naked, but she broke down and wore a suit—a shiny, metallic cranberry-purple bikini that barely stayed on. In any case, Laura's sensibility was more about costume than fashion, and her clothes expressed celebration and contempt, which charmed me no end.

In less than two weeks, Laura and I had completely changed the moorings and directions of our lives. I was convinced that Laura was my salvation, my beacon, my muse.

W HEN we got to Chicago, Laura and I tried to slow things down, to effect a soft landing from the heights of sexual passion. We found a large, run-down apartment on the border of an even more run-down neighborhood. It was owned by a mother and daughter who were hoarders of newspapers that they'd stacked in rows to the ceiling of their apartment just above us. They didn't go out for fear of sunlight, and I saw them only when I went to hand them the rent check or when the daughter came down to ask us to be quiet.

Life was just as strange outside the apartment. My first job in Chicago had been to work as a counselor at a camp for young adults with mental disabilities. I wasn't trained or emotionally suited for the job. My responsibilities included teaching art classes using materials the patients could safely eat.

Meanwhile, Laura and I stumbled through our own form of insanity. We set up side-by-side studios in our living room. I was reading Carlos Castaneda at the time and tried finding my space by rolling around the floor looking for a blue light. I gave up after a while and put a table over in a corner away from the windows. I'm not sure how Laura found hers.

The truth was, we really didn't know each other. Our forced intimacy only strained our efforts at communion, and our studio practices were so different that they exacerbated the already tense situation. We worked at different times and listened to different music. We

fought over wall space and offered each other benign critiques that barely concealed our lack of interest in each other's art. Worse, I was still completely infatuated with Laura, and that made her withdraw even further. The qualities that had drawn me to her—her confident, quirky style and fierce independence—repelled my clumsy, increasingly desperate overtures. Everything I said or did seemed to drive her away.

After six months, our affair ended. Laura had developed a group of friends while working in the bookstore at the Art Institute that she'd kept separate from me. She was more circumspect than I was and had for some time resisted my sexual advances. I began to suspect she was seeing someone else. One morning there was a confrontation over breakfast in our kitchen. Laura said something fairly innocuous, but so of a piece with all her recent distancing tactics that I couldn't take it anymore. Enraged, I hurled my coffee mug at the sink, but my finger caught on the handle and the mug whistled across the room, shattered a window, and crashed onto the street. She looked at me as if I was a madman and ran into the bedroom and locked the door. I guess she feared she would be the next to go out the window. Instead I went for a walk. When I returned, she was gone.

S INGLE and unemployed, I spent my days wandering through the art galleries on Ontario Street, eventually landing at the Museum of Contemporary Art. I couldn't afford the entrance fee, so I tried talking my way past the receptionist, who also happened to be an artist. When I told her my story, she asked me to wait and went to talk to someone in the office. I was invited downstairs for an interview and was hired as a guard starting the following day. It turned out to be a great gig. The MCA was a young museum dedicated to cutting-edge art, the kind of work the stuffier Art Institute would not show. My coworkers were equally young and edgy, and because the staff was small we all did more than one job. I was a guard and

a receptionist, and when the museum put up a new exhibit, I did the installations. Being surrounded by art all day was heaven. What more could a young artist want?

Because I was an artist, the women who conducted the tours were very deferential to me. All volunteers, these suburban women used to ask me questions about the origin of a work, and I would make up stories. Once I described a Francis Bacon painting of a screaming pope as an act of revenge. I told them that Bacon was a lapsed Catholic forced out of the church because of his homosexuality, and that the beam of light he'd painted, hitting the pope in the head, should be construed as a stream of urine, a golden shower. I thought I was pretty clever until I heard them repeating my interpretation to a group of Catholic schoolgirls.

The small, close-knit museum staff functioned like a family for me. The museum was surrounded by galleries, and after work we'd go see all the openings. Then we'd get together at one of the area's good, cheap restaurants and from there we'd make the rounds of the artists' bars and drink into the night. A few times a year, the board members, all major collectors, would invite us to their homes, where I saw world-class collections of surrealist and abstract expressionist works. But these board members owned very few works by artists that the museum showed, and even fewer by Chicago artists.

While Chicago was a city with impressive private collections, its art community was large enough to accommodate only one contemporary movement at a time. Back then that was the Hairy Who, a group of painters whose iconoclastic, vulgar, sexually deviant, and hysterically funny neo-pop pictures were synonymous with Chicago art. The group drew inspiration from a diverse spectrum of sources— religious icons, Mexican wrestling posters, pinball machines, comic books, tattoos, burlesque, and many other subcultures. One of its leading exponents was Jim Nutt, who did these very beautiful paintings of polymorphously perverse sexual icons, cartoony figures with penises growing out of their arms. The artists were so anti–New York,

and vice versa, that the mainstream critics refused to even review them—it would be years before the art world took them seriously. Predictably, the MCA board members owned only token samples of their work.

But I loved them, especially Nutt and Ed Paschke. Their paintings were fresh and antiauthoritarian and seemed to be saying with humor many of things I wanted to say with my abstractions.

Around that time, Claes Oldenburg, another pop artist with Chicago roots, had a retrospective at the museum. Oldenburg was known mainly for his giant, whimsical sculptures of mundane objects. His statues of overscaled lipstick cartridges, typewriter erasers, and clothespins poked fun, I thought, at our consumerist culture and, in the tradition of Duchamp and Warhol, the abstract expressionists, who were known to take themselves a tad seriously.

As part of the promotion for his show, Oldenburg painted a giant mural of an aspirin bottle on a billboard across from the museum, and I used to walk over on my breaks to chat with him. One day, noting that he'd made the bottle a sickly, repellant green, I complimented him on his color choice, mustering as much archness as I could. I wanted him to know I was in on the joke.

"Yes, it is a wonderful color," he said without a hint of irony. "I love this green."

To this day I don't know whether or not Oldenburg was putting me on. The best satire is served with a straight face, poised on a knife's edge between ridicule and respect. In this case I believe the artist was being straight. If so, it wouldn't be the last time that I'd misjudge the intentions—or fail to appreciate the significance—of a work of pop art.

I was now a year out of school and floundering miserably in my studio. I'd flirted with Hairy Who–inspired imagery but didn't really share enough of their perverse glee at the inanity of pop culture. I ping-ponged back and forth between forays into the over-the-top pop figuration I'd developed a taste for and the kind of abstraction I'd

been taught to make. Neither way felt right, and most of my paintings ended up in the garbage.

Still, as 1973 began, I had some reason to feel upbeat. Hardly a year after leaving CalArts, I'd built a life around art. I was painting every day, and I'd begun to feel as though I was gaining a modicum of control over my medium. I began teaching myself the fundamentals of drawing. And I'd forged friendships with other young artists whose ideas and work informed mine, and whose ambitions made my own dreams seem less quixotic. But there was still a sizable hole in my life. As my memories of Laura faded, I began to regret my decision to split up with Lannie. By spring I was back in touch with her, begging her to join me in Chicago after her graduation. Lannie was understandably reluctant. I'd been her first love, and my abrupt departure had hurt and confused her. But I was persistent, and at length she agreed to come back to me. This time, though, she wanted a firm commitment. On Independence Day, July 4, 1973, Lannie and I were married.

BILL SWAIM

I first met Eric in my Painting 101 class at Arizona State University. I was walking around the classroom teaching how to draw gestures, with my hands and arms measuring wildly from my nose to the edges of the painter's world. A big concept.

Noticing a tentative situation in Eric's abstract painting effort, I paused to demonstrate how placing a different color on his work would fix his problem. He would have none of it.

"You can't touch my painting," he said, grabbing my eager arm. The whole class froze. Eric's reaction was far beyond my expectations of beginning-student behavior. He had already begun to take ownership of his work. I would have to struggle with this brash student to communicate my so very important lessons. And so we ended in a stalemate: I wouldn't paint on his painting, and he wouldn't hit me.

We became friends for life instead.

. 6 .

HALIFAX

1974 – 1978

T HAT fall, Allan Hacklin called me out of the blue. He said he thought he'd got me a teaching position if I was interested. He was calling from Halifax, where he was doing a visiting-artist stint. The school had just fired its painting teacher and needed someone by the start of spring term. He said it would only be for one semester but would look good on my résumé. I hadn't until that moment considered teaching at all. But the school was the Nova Scotia College of Art and Design (NSCAD), which had been recently heralded as the best art school in North America. Its focus, like that of CalArts, was conceptual art. As far as I could tell, that was why they were willing to take a risk on a young, untested painter fresh out of college. They didn't give a damn about painting. They just needed a body to supervise a class.

I'd learned that when opportunity comes knocking to always take the chance. Taking the job turned out to be one of the most important decisions I've ever made. But it would eventually destroy my marriage.

. . .

L ANNIE and I left Chicago a few days after Christmas and arrived in Halifax on New Year's Eve. School was to begin the following week and we needed to find an apartment. And I needed to acquaint myself with the school, the faculty, and my responsibilities. I felt enough stress that upon checking into our hotel I became violently ill and was bedridden for a couple of days.

Someone recently asked me what I taught those years at NSCAD. I had to confess I remembered little about it other than I started out teaching the way I'd been taught. That is to say, no foundation exercises, little drawing, no particular painting techniques, but a whole lot of belief in the integrity and importance of making paintings. I don't think I did any serious damage to the students. I also don't think I gave them much to work with in the long term. I persevered, but with a growing anxiety that the students would quickly discover I had no clue what I was talking about. After all, I was just a couple of years older than they were. I was going through a prolonged spell of self-doubt about my own work with nothing really substantial to show for it. If they had asked to see examples of what I was trying to teach them, I would have been screwed.

I did, however, come up with one painting problem I was particularly proud of. For my first-year painting class I gave them the assignment of making a tool to paint with. At the next class I said that before they used their new tool, I wanted them to create a painting of that tool using traditional paintbrushes. When they'd finished that exercise, I asked them to make a painting of that painting using their tool. Most of the new tools were sponges and feathers and sticks—tools that were capable of making only one kind of mark. One student's tool was a typewriter. Watching him dip the typewriter in paint and try to work with it was hysterical. The resulting paintings they made bore little resemblance to their original paintings—they were

smears and globs of runny paint with no specificity or detail. When they finished making their mess, I said they should now do a painting of that painting, once again using traditional brushes. This time they made wonderful paintings of the smears and blobs. The purpose of the exercise was to demonstrate that the traditional tools of painting are far more versatile than anything they could come up with, which is why painting has lasted so long. It can reproduce anything.

ANNIE and I sublet a high-rise apartment for four months. It was unfurnished save for wall-to-wall shag carpeting. We did not buy any furniture, feeling we would be there such a short period of time, why bother? We slept on a thin foam mattress with sleeping bags, ate on the floor, and lay around watching TV whenever we were home. I had been given a studio at the school. Lannie thought she could work in the apartment, but she never did. Her days were long and isolated. I would go off to teach and then work in my studio. When we socialized with other faculty, she was relegated to hanging out with the other faculty wives, who were quite content with their status. Lannie was not. She was an artist. And the faculty's treatment of her, her lack of peers in town, and the isolating effect of the brutal maritime winters was enough to pull her down into a deep depression. The empty apartment, of course, did not help.

I'm ashamed to admit I could not really acknowledge the depth of her despair. I could not handle another woman I was in love with being depressed. Instead I was completely absorbed in my new life, trying to learn how to teach and trying to make paintings I wanted to paint, running scared, feeling any day I would be exposed as a sham. There were good days and there were bad days.

There were three faculty members who'd made the school's reputation: Garry Kennedy, Gerry Ferguson, and Patrick Kelly. They were ten or so years older than me and very much aligned with conceptual art. There were four of us new teachers, who were all about the same

age—Richards Jardin and Tim Zuck, recent graduates of the program at NSCAD and very much its products, and Mira Schor and me from CalArts. Mira was a painter who made very poetic landscape paintings—aerial views of imaginary places with fires off in the distance. Richards did photographs of himself disappearing, and Tim mounted performances in which he entombed himself for days at a time in boxes of his own making.

At the end of the spring semester I was rehired for the following year. I was given the title of associate professor and a salary that was more than I'd ever made—$13,000 Canadian, plus benefits. Lannie and I returned to Chicago that summer as planned, rented a comfortable apartment, and hooked up again with friends and the art scene. Lannie got a job and I painted. But as summer ended, Lannie announced that she could not return to Halifax. She could not bear again the misery she'd endured. We agreed that I should go alone. We'd try a long-distance relationship to see how that worked. I would come back for some extended weekends and on holidays. She would try to come up for short visits. But such arrangements seldom work with young people. By Thanksgiving she'd found someone else.

I returned to Halifax after the Thanksgiving holiday hurt but not surprised. I rationalized Lannie's leaving by thinking I deserved it. I had done this to her and now she'd done it to me. I threw myself into teaching. I also began dating and bedding students, a series of four or five roughly my age. I didn't care about my own feelings at that point, let alone anyone else's. All I really wanted to do was paint, and I was having a miserable time with that. I was still making large abstractions, working with oil and encaustic—hot wax infused with pigment—trying desperately to make something that didn't contain any Brice Marden references. Marden was the master at encaustic abstract minimalism. Any artist who tried working with that material was immediately branded a poseur. I navigated between two giants of contemporary abstraction, Brice and Richard Diebenkorn. I was attracted to Diebenkorn's luminosity and grace. He painted in such an

intimate, generous way that it seemed to leave space for another artist to expand on his themes. However, I discovered that that artist was not me. My work just felt imitative and, worse, uninspired.

Stymied in my work and stung by the breakup of my marriage, I became increasingly anxious. My years at NSCAD would prove to be a key period—perhaps *the* key period—in my development as an artist. There'd be Bacchanalian nights with a succession of anonymous coeds, a Laura-like interlude with a transfer student, and breakthroughs in my work. And I would meet my life partner, April, during my time there. But all that ferment exacted a toll on my mental stability. I was constantly questioning myself and my work. I swung violently between moments of euphoria and spells of black hopelessness. The lows predominated, rooted as they were in my conviction that I was moving in the wrong direction professionally and was lost romantically.

I N 1975, Canada was also going through an identity crisis. The Quebecois were pushing to secede and the rest of the country wanted to throw out anything American. *Time* magazine was told to put 75 percent Canadian content into its Canadian publication or get out. In response, Time Inc. sponsored a pan-Canadian art show titled *Canadian Canvas*. The curators chose paintings from all the provinces and the show traveled to each of the key museums throughout Canada. Ironically, two of my large abstractions were selected. It was my first inclusion in an exhibition. Time Inc. funded this public-relations extravaganza and put up monies for each museum to purchase a work from the show. The Edmonton Art Gallery bought one of my paintings for $1,000. But the sale instilled little confidence in me. By the time the show opened, my work on display bore no resemblance to the work I was doing in the studio.

The exhibition in Montreal opened to great fanfare. At the opening I met Bruce Ferguson, who was there in his capacity as the director of the Dalhousie Art Gallery in Halifax. Though we lived just

blocks from each other, we had not met until then. Tall, thin, sporting a beard and long hair tied back in a ponytail, he wore a rose-violet satin cowboy shirt with white piping; I think it had cacti and wagon wheels embroidered on it. Were he naked he wouldn't have stood out any more among the suits. I was immediately drawn to him. We quickly became friends, a friendship that continues to this day. A prodigious intellect tempered by a wicked irreverence for institutions and academia, Bruce has made a career of discovering artists, fostering their careers early on, curating important exhibitions, and shaping dynamic programming at the various museums and universities where he's worked.

Bruce has never stayed long at any one place. His strengths are in creating, not managing. Nomadic by nature, he's like sagebrush blown by the wind, snagged and entangled for periods of time, but never willing or able to become rooted. His gift is what he does for others. He was crucial in helping me define my art during my years in Halifax. Bruce curated my first solo show while at Dalhousie, and ten years later he would curate my first retrospective.

My years at NSCAD marked my transition from abstraction and modernism to figuration and a realist-narrative style of painting. Along the way I explored myth, archetypes, allegory, and alternative media that combined elements of music, poetry, and performance. But my progress was anything but steady or assured. I whipsawed between blind experiments and embarrassing failures; even my occasional breakthroughs were fraught with doubt and black moods. I was working toward a type of painting that flew in the face of contemporary critical thinking.

I had neither the comfort nor the confidence of knowing that my path would one day be vindicated. Or that success, if it ever came, would amount to more than a modest living and the respect of a small circle of my peers.

But I realize now that my journey was inevitable. Feelings lodged in my subconscious were driving my work toward a form of

expressiveness that was raw and graphic and troubling—and some-times cathartic. As soon as I ceded control of my brush from my mind to my hand, images would pop out that were increasingly recogniz-able both as people and things, avatars of my buried past.

The transformation began innocently. I'd been making a small abstraction on plywood. I impulsively chopped off the two upper cor-ners of the wood backing, giving the work the look of a house. I'd been thinking of a painting as an object, something you'd find in a primitive culture where a shield or a tent or a totem pole served as both a surface you could paint on and a vessel that contained a kind of spiritual content. The "house" painting intrigued me because its form was generic enough that it could be read abstractly; but it also functioned as a representation, an image that stirred up memories, feelings, and associations in me and, I hoped, in the viewer.

Until then my idea of self-expression meant finding a signature style—a voice or line that conveyed the way I saw the world. But these newly conjured feelings were coming from darker emotions, feelings of helplessness, anger, disappointment, failure, isolation, and loneliness. I worried that my work was becoming too personal. I felt naked both as a person and as an artist. On top of that, I feared my lack of painting skills would expose me as a pretender, a hack—inept and inauthentic.

I tried to disguise the personal content of the objects and images I was making by attaching them to origin myths and fictionalized rituals. And I tried to maintain some semblance of modernist abstrac-tion even as I was infusing the compositions, color choices, and sur-face quality of my paintings with a narrative rationale. This is exactly the opposite of what many modernist artists had been doing. Picasso, Braque, and Modigliani, for instance, had sought out images of Afri-can art as a way to break free of the stultifying art of the academy, as a way to instill new vitality and expressiveness into painting by bor-rowing forms from primitive cultures. I was using archetypal myths and primal imagery to mask my feelings.

Of course what I was trying to do with my painting was doomed

to fail. It was a stew of contradictory impulses and ideas. I was not at all comfortable with expressing feelings without knowing their source. I needed to connect cause and effect. I needed to be in control. I needed a narrative. At the same time, I was incapable of working within the hermetic formalism of pure abstraction. I had neither the intellectual discipline nor the spiritual conviction to pull it off.

W HILE I was up in Halifax wrestling to find my voice, there were artists in New York City whose work had begun to break away from the rigid and overcooked definitions of what constitutes modern art. Artists like Joel Shapiro, Susan Rothenberg, Jonathan Borofsky, Elizabeth Murray, Neil Jenney, and David True, all five or ten years older than me, had begun to bring imagery back into painting and sculpture. They were mapping out territories that embraced the psychological, the primitive, and the mythic while imbuing their work with either blatant or ambiguous irony. They knew that their work was a slap in the face of fashionable taste.

But for me, their work was liberating. I was becoming an artist at a time when modernism was played out and had no place to go. I kept pushing at the boundaries of the canon. Even when I failed, I kept at it. I wanted to know why those failures didn't work. Could I make them better? In part I was being stubborn. And in part I was rebelling against art-world authority. But I wasn't exactly in control of what I was doing. I was trying to locate the right balance between abstract formalism and metaphorical content. Increasingly, though, my work took on the look and feel of the physical world—images anchored in concrete reality. I was starting to tell stories.

D URING my years at NSCAD, as my work evolved into narrative, I wanted to feel it connected to something tangible, something outside of myself. I fantasized that I could make art sensitive to the

local culture, to the hardscrabble life of the fishing villages that dotted Nova Scotia's coastline. I wanted to make objects that embodied the myths of man and sea, man and nature, with all of the drama of a close-to-the-bone existence. I wanted to capture the danger and authenticity of the fisherman's life. Of course I was *not* connected to these villages, or to the details of the lives and experiences of the families that peopled them. But that did not deter me.

I created a fictional world made up of scratchy black-and-white images of houses, boats, and bridges drawn from the traditional fishing communities neighboring Halifax. I drew these images simply and naïvely—with my limited skills I didn't have much choice—and as though to further proclaim their authenticity, I painted them directly onto my studio wall, where they couldn't be sold or commoditized. My artistic purity lasted about one semester, and except for a few slides, there's nothing left to document this all-but-forgotten stage of my development. But the wall drawings produced two milestones.

On a tour through Canada, Jean-Christophe Ammann, one of Europe's top contemporary curators, saw the murals I was making and asked me to replicate them for an exhibition of promising young Canadian artists—didn't anyone realize I was American?—he was organizing at the Kunsthalle, a premier exposition hall in Basel. And before moving on to other forms, I expanded the range of the subjects of my wall drawings. I made sketches of sleds, furniture, fish, and, for the first time, human figures.

IN 1975, I began to make artworks about an imaginary family, an archetypal nuclear family with the father, the mother, the son, and the daughter. I based them on my idea of a local fisherman's family and began referring to them as the Fishers. I made the father a fisherman, a provider of sustenance, but remote and emotionally unavailable. His life was full of hazard and hard luck. His travails were a danger to his family. Over time I blinded him and made his life even

more miserable. He could no longer perform his essential duties. He could no longer be the very thing that gave his life meaning. I made the mother a nurturer and protector of her children and a believer in magic. She used sympathetic magic to ensure the father's success at sea. She would sit in the bathtub, half in and half out of the water, performing rituals to make sure he caught fish. Over time, the image of her in the bathtub became more about her self-involvement and isolation. The tub became more of a symbol of a sarcophagus than a boat. Her struggle became more about her than her family, more about vanity and narcissism than about nurture and protection. No longer a magical being, she became tragic: demanding and in need of constant attention. The children, who'd been virtual Siamese twins until puberty, grew up; the son prepared to take on the mantle and responsibilities of the father, and the daughter assumed the role of the mother.

Day after day I charted their course, making drawings depicting their evolving relationship to each other. I was creating a fictional world using a variety of art forms—from sculpture and painting to collage and performances—to represent, to animate, and to embody the lives of the Fishers. I made sacred objects, magical icons, reliquaries. I sculpted fish and painted them with words embossed on their waxy scales. I combined them with fragments of their conversations and wrote nursery rhymes, prayers, and sea chanteys that limned the difficulty of their lives. I borrowed metaphors from the kabbalah for the creation of the universe. I drew from Karl Jung's definition of sacrifice and giving. I lifted from the Assyrians, the Sumerians, and early Christians their cycles of life. The art I was making was meant to feel as if it had existed from man's earliest days.

Around that time I made a painting of the silhouette of a cat that was sleeping or dead. On either side of the cat I wrote the words *wolf* in blood red and *pig* in flesh-colored pink. The work was the result of stream of consciousness. It wasn't rational or in any way thought out. And when I stood back to assess it, I had no idea what it meant.

Chuck Close once said that when you make something that looks like art, it's probably someone else's art. My cat painting didn't look like art. It just looked like something I had made. In fact, it looked like something that only I could have made. But I didn't feel as though I'd made a breakthrough. I felt unsettled. Not only had I created a work that I couldn't relate to another style or tradition; I also couldn't explain it on its own terms. I couldn't say why I'd made it, why it resonated for me, or why I thought it was finished. I just knew it was, that there was nothing I could do to change it that would make it better.

The paintings I made in 1976 were the first works of art I created. I'd tossed aside the crutch of logic along with the theories and carefully thought-out strategies I'd used to rationalize and defend my painting. I was no longer working toward some external idea of art but was driven instead by inner necessity, and it produced these strange objects that didn't look like anything I'd studied or seen before. That was scary by itself. I'd made something that was solely my own, the purest evocation so far of my voice and my skill, and I didn't know what it was. How could I expect anyone else to gather any meaning from it?

Much later I realized I'd not only set aside logic—I'd gone beyond language. Even though I was using words as images, I wasn't thinking in words. I wasn't thinking, period. I was using a part of my imagination connected to image making. I was painting.

ALLAN HACKLIN

CalArts opened in September 1970 in temporary
quarters at a Catholic girls' school in Burbank,
California. There was a crowd standing outside
large gates on a balmy late-summer evening. As
the gates opened, we were led down a path of
rose petals by several women dressed in silk
saris. We arrived at a courtyard garden filled
with sounds and scents of sweet sensuality. It
was the beginning of a magical evening with a
raga performed by Ravi Shankar and his troupe.
We were enchanted and high for many hours. It
was quite a greeting. On subsequent days helicop-
ters dropped leaflets, people swam nude in the
nuns' pool, and others walked around with Super
8 cameras recording the events and happenings
around the compound. The stage was set for the
CalArts experience.

I was a twenty-seven-year-old New York artist
unsettled by all the goings-on. I had lived in a
loft in SoHo, and the temporary spaces seemed
confining. I asked for a larger, industrial-
type space, and one was found a short distance
from the campus. My group of mentees (we didn't
call them students but rather assumed them to
be young artists to be mentored by other art-
ists) moved to California Street and established
spaces within for individual work. All were young

and eager to discover their role in the creative world. Eric Fischl and David Salle were just two of twenty or more individual participants. Eric was, from the beginning, determined, questioning, willful, and sincere. He wandered through his interests looking for a way while producing a lot of varied styles and quality. His intensity and thoughtfulness were his real future assets. He didn't find his voice, but he found his method. His was a path of evolution with occasional revolution bound by a trust in his inner self. That is what Eric learned, and at CalArts he was encouraged in that journey. His long-term interests emerged later while teaching at the Nova Scotia College of Art and Design, a position I had recommended him for. While there, he came upon his first real steps into figuration and narrative, ultimately developing into the most compelling figurative painter working.

By contrast, David Salle was eager for new ideas, cool in his approach, and facile with his skills. He engaged new ideas—toyed with them, actually—and then moved on to other new ideas. He too would find his voice later, but his method of utilizing conflicted images and ideas started at CalArts. Every day was an adventure, with each person making a discovery shared by all. We sat and talked and laughed and engaged one another. I coaxed, cajoled, shouted, and contextualized their results. My job was to ask good questions and provide open-ended insights.

Theirs was to excite and amaze each other. It largely worked.

One day I thought a figure-drawing session might provide a break from the norm and a common experience for all to share. I arranged for a model, and what a model she turned out to be. I directed her to move continuously, stopping to take a pose only occasionally. I wanted everyone to loosen up and concentrate on the fluidity of her constant movement. She completely captivated our attention with her limber athleticisms. It was electric as she turned, twisted, and stretched. Soon, and I don't know why, I asked the class to switch roles with the model. We would take off some of our clothes and continue drawing. She put her clothes on. Within minutes, drawings were being done feverishly as clothes were coming off. Preconceived attitudes and inhibitions were stripped away.

APRIL

1975 – 1978

A PRIL Gornik was a stunningly beautiful and vibrant art student with a curvaceous, wasp-waisted figure, long red wavy hair, a broad Slavic face, rosy freckled skin, wide-set green eyes, and a small, Kewpie-doll mouth that she colored with bright red lipstick. Her expression was changeable, at times peevish, playful, or sly. Over the years she's worn her hair straight, permed, and in gently falling ringlets parted in the middle, and never used anything to hold it back or prop it up. She's casual and unfussy, too, in the way she dresses, though I tease her that on that first day we met she was wearing a shirt embroidered with mirrors and sporting a headband.

But what caught my attention was her confidence and fierce intelligence. In her last year of a BFA program, she had transferred from the Cleveland Institute of Art—a progressive school near the suburban town where she grew up—following her boyfriend, who'd been accepted into NSCAD's MFA program. Their relationship didn't last the school year. April was taking seminar courses and post-studio classes filled with French deconstructivist philosophy and conceptual

art. It was everything I hated about contemporary art. But at that point I didn't care what April's interests were. I just wanted to sleep with her.

I had watched her throughout the semester but could never seem to catch her attention. I felt clumsy around her, and, because I couldn't find a way to talk to her, a little bit the stalker. One day when I was strolling through the studios, I stopped and checked her out at a distance, unnoticed. She was gluing pieces of wood onto fancy rag paper and then stenciling some kind of intellectual nonsense meant to create an interpretive rift between the object and the image. I walked up to her. "I don't understand how anyone could think they were making art by gluing wood to paper," I said. And then to cover the ensuing awkward silence, I added: "Everyone knows paper is made from wood. It's so redundant."

"Fuck off," she said.

I stood there, mute like the Sphinx with its nose fallen off, and left. Why on earth did I think that I would make a positive impression by insulting her? It took me months—and a few nights getting stoned together among NSCAD's incestuous icebound winter community—to gain her interest. We started to spend time together, but it was complicated. She was in the midst of disentangling herself from her relationship with her boyfriend, with whom she lived along with some other students in a big old house. I could never tell whether or not he knew about me, nor how hard April was trying to break up with him.

Things came to a head at a party in one of the faculty's homes. April and I had come separately. At some point I was able to lure her away from her boyfriend and we stole up to the attic to get stoned. We kissed and humped and laughed and rolled around and kissed again to stop our laughing for fear of getting caught. Then, afraid we'd been gone too long, we got up to go. As we did, April stepped with one leg right through the ceiling to the party below. There in front of her boyfriend and the world, like some damning piece of evidence

in a crime drama, was her dangling foot, the two of us howling with laughter.

M Y portrayals of the Fisher family and their daily dramas had begun to trigger memories of my own childhood. Their home, furniture, and clothes were still generic—deliberately universal—but the relationships between them, and their individual personalities, were conjuring up the old fears and unresolved conflicts of my youth. They were loosening up scar tissue from my past.

My mother's death had left my own family in tatters. We were a disparate group to begin with. Holly, the eldest, grew up the responsible one, supplanting my mother's role. Laurie, six years younger than me, three years older than John, seemed always in search of her identity and challenged me for the title of family rebel. And John, perhaps because he was the youngest and most doted on, was the least touched by the household turmoil.

But all of us were affected, and when a family bonds around an illness, as ours did, you never have the chance to explore and develop other reasons for staying a family. So when our mother killed herself, she released us from our struggle, from what held us together as a family—our common plight, our shared purpose. We drifted apart to deal privately and separately with our grief and our guilt. Holly got married and moved to Seattle to raise her own family. I embarked on my career in art and my travels across the country. Laurie and John, still too young to leave home, stayed to finish up their schooling. But that only made things worse, especially when Dad remarried a year later.

My father tried to keep the family united by organizing holiday gatherings and keeping up regular newsy correspondence. But for all his salesman's talent, he was not good at communicating his feelings to his children. And in my case, at least, it would be years before I was able to begin addressing the trauma of my youth. Meanwhile, Laurie

moved away from home and took up a number of causes and pursuits, from organic farming to rare forms of animal husbandry. And John went to work out of high school, buying a scrap yard outside Phoenix and converting it into a thriving automobile-parts business. We met, when we met, as strangers.

O NE night at a colleague's home for a small dinner party, I smoked a great deal of pot. I don't know if it was because the dope was so strong or if I was already in a hyperanxious state, but I was overcome by a debilitating wave of paranoia. My friend was talking on and on about something that I couldn't follow. As I watched his words land short of my feet, I realized that I had to get out of there.

I made it home, crawled into bed, and threw the covers over my head, but I was not coming down from my delusional state. I felt I had crossed into madness. I had to get out, go for a walk, anything to distract my overactive mind. As I walked the streets of Halifax I became certain that the next corner I turned would take me to the end of knowable reality. I returned home. The night passed in pure hell. In the morning I called April. It was a cry for help. We had only been together a short time. We were still feeling each other out. I didn't want her to see me this way. I wasn't sure how she'd handle my madness. I was a mess, but I really needed someone to hold on to, to talk me down.

She came immediately.

A PRIL'S upbringing had been similar to mine. Happy and normal on the surface, she grew up in Mayfield Heights, a small suburban idyll outside Cleveland, and attended Catholic school, where she showed a precocious talent for art. Her mother was a bibliophile and homemaker. Her father was an accountant for the railroad who played jazz trombone in pickup bands on the weekend.

But when April was seven, Bill Gornik began withdrawing from his family, and for the next two years battled a deep depression that left him nearly catatonic, unable even to play his beloved trombone. The house fell eerily silent. It took April a long time to piece together what was happening, but home for her had become a terrifying place, like living with a ghost.

At length April's father recovered some of his faculties. But he never fully emerged from the fuguelike state that severed April's childhood; and though his symptoms abated, he still required shock treatments, no less a stigma in stiff-necked Mayfield Heights than my mother's alcoholism was on Long Island. No one talked about his therapy or the illness that triggered it. Not even within the family. Much like myself at that age, April entered into a conspiracy of silence, a pact with her mother and barely comprehending younger brother to pretend everything was all right.

Of course everything wasn't all right. Her father's illness had leeched into the foundations of their home, driving April away. She played outdoors whenever she was allowed, withdrew into the havens of her imagination and her art making. Then, when April was sixteen, her father died suddenly of a heart attack, adding another layer of grief to her already-harrowing adolescence.

In the late eighties I would paint a portrait of April looking straight out at me with a petulant, impatient half smile. She hates the picture because that expression reminds her of her battle-scarred youth. But she didn't let her misfortunes defeat her. She's one of the most resilient and resourceful people I know.

One time, April and I spent a weekend in Connecticut with Ray and Gabriella Learsey, collector friends who'd bought a country home in the tony village of Sharon, took up hunting, and joined the local gentry. The first morning's schedule called for skeet shooting. April, having grown up in the suburbs, had as much experience with hunting and shooting as she did with space travel. But April cannot be intimidated.

She showed up at the skeet site in high-heeled boots, a fake leopard-print coat, black-and-white checked sunglasses, and jungle-red lipstick. The kid who set up the traps, a country boy, looked like he was going into shock, and our hosts, outfitted in their L.L.Bean waders and quilted Ralph Lauren hunting vests, were a little conde-scending. But when it came time to shoot, April, who'd never fired a gun before, hit four out of the first eight targets, matching the best score of the day.

Ray, who had a good deal of pride in his shooting skills, con-vinced himself that April had been lucky. "The real competition," he announced, "will be next year." But when we returned the following season, April knocked off seven out of eight "pigeons," easily winning the day. I wasn't surprised. Because she's so stylish and attractive, peo-ple are always underestimating April's grit. They do so at their peril.

Falling in love may come from desire, but staying in love comes from need and the ability of your partner to handle and satisfy that need. In my experience, these are not the things you brag or even talk about. But it's the way the glue sets up. Having grown up with an alcoholic mother and having pursued a number of unstable women, I finally recognized in April what it was I'd always been looking for: strength, stability, an anchor. Someone who could accept me as I was, even at those times when I couldn't accept myself.

THAT summer April and I planned a trip to Europe together, but citing one or another unpersuasive excuse, I canceled at the elev-enth hour. I was still rattled from my recent panic attack and the last thing I wanted to do was travel to a foreign place. So April set off to Europe by herself. Armed with a Eurail pass and staying in youth hostels and discount hotels, she spent two months touring the major art centers, falling for the paintings and sculpture she'd previously seen only in posters and books. She sent me a handful of letters, pages of powder-blue airmail stationery filled with her single-spaced scrawl,

describing her discoveries. Meanwhile, convinced that letters sent care of American Express would never be delivered—at least in a timely fashion—I didn't write her back.

April returned to Halifax in the fall, angry with me. She'd toyed briefly with the idea of attending graduate school, perhaps even CalArts, but then decided the challenges of being an artist in the world outweighed the comforts of remaining in school. So she began a full regimen of work in the studio she'd rented the previous spring and ignored whatever temptation she felt to call me.

When we did speak a few weeks later, I expressed surprise that April was back and hadn't contacted me. I also apologized sheepishly for my own failure to write, and kicked into pursuit mode. April resisted for a while. And then she didn't.

AT the start of the 1976–1977 school year, I began painting on glassine, a milky, transparent paper that helped to unlock my creative process. I'd been experimenting with different materials, substrates, and processes to see what they could do. These experiments were meant to take me somewhere I couldn't get to any other way, as often happens in response to unfamiliar materials that can trigger new pathways of thinking and creating.

Glassine had a number of qualities that attracted me. First there was the way it accepted oil paint. It was sexy; it had this Vaseline-jelly feel to it, slick and viscous at the same time, and you could erase what you didn't like. So you could really work with it, and that made it fun. What's more, it came in four-foot-by-ten-yard rolls, large enough so that I could fit a life-size figure on it and use my whole arm when painting, which I discovered was my natural stroke. It freed me to paint quickly and intuitively.

Most of all I loved glassine's transparency. It allowed me to overlap several drawings at once, giving the overall image greater depth and complexity. Its only drawback was its color—or lack of color.

When I pinned the glassine to my white studio wall—because it was transparent and had no pigmentation—it disappeared into the wall, creating this odd boundaryless picture space.

But then the art-supply store I ordered from made a mistake. They delivered a roll of glassine that had a pea-soup-green tint to it. The paper was still translucent, but now it stood out against the background wall and gave the effect of being a self-contained universe, a stage set made up of intersecting planes and images that added new dimensions to my work—an illusion of depth and connectedness, spatiality and a sense of time. I started to see a way to expand the narrative of my fisherman's family.

The glassine sheets reminded me of photos, thinly sliced moments of reality. But where photography captures those moments, painting builds toward them. Working with these transparent overlays was a graphic demonstration of that process. It finally showed me the way I think, how my mind operates when I'm painting freely and unconsciously. I would draw something and start to build a narrative around it. The overlapping images of furniture suggested rooms, and the rooms triggered an associative impulse in me.

I'd start simply enough by painting the black silhouette of a chair, a table, or a couch on single sheets of glassine tacked to my studio wall. I would then ask myself, as I waited for the paint to dry: Where is this chair? Is there someone sitting in it? Are they standing next to it or walking by it? Are they alone? Who or what else is in the room? A dog? A TV? A lamp? For each answer I would paint that image on another glassine sheet and overlay it with the image of the chair. The scene would grow and a story would emerge: a day in the life of this family. Each day would present a new drama, and I would take sheets down and put new ones up. If the images worked together, I'd keep it. If not, I'd start over. Each set of drawings was begun as an ongoing soap opera. Today these people are doing these things; tomorrow someone is doing something else. Relationships developed between people and the objects that surrounded them, and

then at a certain point those relationships resulted in a dynamic moment that stopped time.

Working toward that moment—what painters call the frozen moment—led me to a new way of narrative painting. Painting is about trying to get to that instant that is pregnant with some special kind of energy. Done right, there's an exquisite tension in the picture that comes from a precise set of relationships—between forms on an abstract level and between people on an image level. Finding where to arrest the action, where to stop time, is where the artistry lives. The most dramatic moments are the moments just before or just after something happens. The viewer entering the scene at those moments rushes to complete the narrative with his or her own associations and feelings.

Without realizing it, I was working with the myths and rituals of my childhood. Though the glassine drawings were depicting relationships within a fictional family matrix, I was capturing, very circumspectly at first, my own experiences.

BOB Berlind had a studio adjacent to mine. He'd been hired to run the art program at NSCAD, which represented a tidal shift for the school because Bob was a realist painter deeply entrenched in traditional portraiture and landscapes. He was also an excellent writer on art and art theory.

We became friends at a time when I was beginning my transition away from abstraction. I would often go and watch him paint. I had never seen a realist painter at work. I had no idea how it was done. He didn't seem to mind the company, and we would chat away while he worked. I was fascinated by his direct approach—called *alla prima,* which means without glazing or underpainting, and usually done in one sitting. His rendering was simple. He drew with his brush. There was no hesitation. It's not easy to control the colors when painting wet into wet—drawing overlapping and intersecting lines before the

paint has had a chance to dry—not easy to avoid getting the colors muddy. But Bob's strength was his ability to capture the luminosity of a scene, the clarity of light and shadow. It was riveting watching his split-second decision making, culling only the essential details. He was painting eloquent and unburdened images of windows looking out onto a wintry Halifax. Modernism had rejected the painting-as-a-window model in favor of the painting as a mirror, or the painting as an object, but that didn't seem to bother Bob at all. Though he had lived, worked, and reviewed gallery shows in New York for many years, he was untroubled by his choice to be an artist outside the current trends. His ambition for his work was modest, his confidence high. His sights were set on the larger historical perspective, which I found refreshing.

I studied his technique more than I was aware of at the time. But it was from watching him paint, seeing how his direct and uncomplicated technique could produce such a rich visual experience, that I developed my later approach to painting.

I N January, April decided to return to Europe. I had the winter term off, a kind of abbreviated sabbatical, and this time I joined her. She intended to show me the discoveries she'd made the previous summer and to look anew at the work that would inspire her eventual turn to landscape painting. But stimulated by the beauty of our surroundings, spending every day and night together, we fell more deeply in love.

We retraced April's steps through the major art centers, touring galleries, museums, churches, chapels. In Paris, we spent hours at the Louvre examining great works by Géricault, Trioson, Da Vinci—the *Mona Lisa* was surprisingly small but had yet to be cordoned off and encased—and Ingres. I remember marveling at Ingres's *Valpinçon Bather*. April and I couldn't believe you could make a painting that embodied such silence. I also remember looking at Jacques-Louis

David's paintings *The Coronation of Napoleon* and *The Death of Marat* and trying to rationalize how an artist could at one moment celebrate so brilliantly the hero of the French Revolution, only to turn around and glorify the embodiment of imperialist ambition. Let's face it, artists are whores. They go where the money is, where they're loved and appreciated.

En route from Paris to Madrid, April came down with food poisoning or flu. She was feverish early on and by the time we arrived at the Atocha station, she was delirious. I found a pension near the station and managed somehow to carry her and our luggage to it and then up a couple flights of stairs. I knocked on the huge wooden door at the entrance to our hall; I could hear the knock echoing across the hard interior flooring. It took a while for the door to open. I looked in and saw no one. Then a voice bent our heads downward. A dwarf bade us enter. He looked as though he'd jumped out of a Velázquez painting. April thought she was hallucinating. "Look at that little man," she kept saying, as though he couldn't hear us, as though he truly was an apparition. "He is so small. Can you see him?"

W E spent several days in Madrid, mostly in the Prado. We studied the Velázquezes, of course, but for me the revelation was the flesh of Ribera's old men. No one comes close to rendering flesh the way he does—truly the embodiment of paint made flesh. The story of passion, torment, the pain and joy of life lived is contained in every square inch of flesh he painted.

In Valencia we met up with Bruce Ferguson, who had been traveling in Morocco, and took the boat to Ibiza to soak up the sun and indulge, and later to Majorca and Barcelona for a few days.

In Barcelona we said good-bye to Bruce, and April and I headed off to Italy. Florence was so much more than I had expected. It was here I discovered Michelangelo and Donatello; it was here I discovered sculpture. I sketched Michelangelo's *Florentine Pietà,* which is not

as appreciated as his better-known *Pietà* that stands in St. Peter's in Vatican City. Perhaps because it is a family grouping held together by tragic loss, I find the Florentine one much more moving. Christ is more mature. His body is being lifted and supported by both Mary and Joseph with another woman—perhaps Mary Magdalene— holding his feet. One of Christ's arms snakes over the shoulder of Mary Magdalene; the other, supported by Mary, hangs limply. They are impossibly long and disproportionate, larger than his legs, yet it works beautifully. I was struck by this distortion, this perfect balance of realism and expressive form. I remember thinking that had Michelangelo not left the one leg unfinished, drooped over Mary's lap, it would have been too blatantly and irreverently sexual.

I was also stunned by the wood carving of Mary Magdalene by Donatello. Kneeling, arms raised in prayer, her flesh desiccated, her hair matted and gnarled, her garments tattered and moth-eaten and her lips ravaged, Mary Magdalene, as Donatello captured her, was at the very end of her difficult life. As I stood staring at this magnificent work, I became fixated on how he had chosen to sculpt her hands, merely an inch apart, as if her gesture of prayer was in motion toward completion. I was struck by how out of reach she was to us, how outside our ability to help or save her. She was at the point in dying when there is only a moment left in this world; it was perfectly expressed by the small space between her hands. That space is the portal between Mary Magdalene and her God and salvation.

Through Michelangelo I began to understand how exaggeration expresses truth and how the body carries multiple and simultaneous meanings. Through Donatello, I began to understand the importance of knowing where to stop time. The flesh of Ribera, the silence of Ingres, the intimacy of Michelangelo, and the frozen action of the Donatellos were the revelations and inspirations I brought back with me from Europe.

· · ·

A COUPLE of months back from our travels, April and I moved in together. We took a place in an office building on Barrington Street not far from the harbor. The space had been occupied by a Scientology group and was subdivided into small windowless rooms, each with their own door and lock. Mysterious holes the size of fists perforated the walls of the cubicles, and, tacked over the entrance, an official Scientology chart mapped the different levels of consciousness, and how many Canadian dollars it cost to achieve them.

We tore down the cubicle walls and opened up a loftlike space but did little else to make the place our own. We knew we wouldn't be there long. Neither of us remembers if we'd even had a shower or a bathroom and, if not, where the hell we found one to use. Our kitchen consisted of an electric coffeepot, a hot plate, an electric skillet, and a small wet-bar fridge, but that didn't stop April from making the occasional world-class meal. For my twenty-ninth birthday she served *sole bonne femme* and a *gâteau de crêpes* with Grand Marnier for twenty, all prepared in our nonexistent kitchen. How she pulled it off I have no idea; I was not allowed in the kitchen.

Mostly, though, we went out to eat. I subsisted on fish-and-chips and learned to dunk my fries in vinegar, Nova Scotia's sole contribution to fine dining. There was one good restaurant called Fat Frank's, but it was expensive and reserved for special occasions only.

Drinking was a different story. The local hot spot was the Jury Room, a no-frills tavern with seminar-size tables, plank flooring, and an open mike. It was a serious gathering place for students and faculty from the school. People would argue about art for hours, as well as get up and sing or recite poetry or do impersonations of a pebble rolling around in a hubcap. The drinking was a defense against the long icebound winters. Halifax had a law that taverns couldn't serve alcohol past eleven P.M. on weeknights, but that as a customer you could drink until dawn. So every night at around ten of eleven there'd be a last call, and you'd get guys, myself included, ordering a dozen beers.

We spent most of our time at home. The largest room, which I took for my studio, had a long wall, a few windows looking out onto the harbor, and a black-and-white checkerboard linoleum floor that was hard to look at and impossible to ignore. April rented office space down the hall for her studio. I was teaching, she was waitressing, and we were both very disciplined about spending time in our studios painting. It was a very productive time for both of us. April had been making symbolic objects—spiral and other archetypal designs on wood fragments. She'd become interested in light and started attaching tin to the surfaces of her sculptures in a way that seemed to contain, as well as reflect, light. A month or so into the process she had a vision—one of those career-changing inspirations that some artists have and cannot explain. She saw a few shapes, like a bundle of sticks sitting at the edge of water, backlit. But she knew at once it was important.

April scrambled to reproduce what she saw. She found some one-by-four boards lying around her studio and nailed them together to form a flat rectangular surface. She was out of oil paint but managed to rustle up a few cans of house paint, and she set to work. She painted swiftly and without thought, in the grip of a nervous excitement she'd never felt before, and when the image in her mind began to emerge, she was shocked. In her haste to get the details down she hadn't stopped to consider what she was actually making, didn't realize until she'd finished and stepped back and looked at the thing that she'd constructed a straightforward, traditional landscape.

The last thing April had wanted to make was a painting. And the last painting she'd wanted to make was an old-fashioned landscape. But it was also a picture of light. She began to understand that it would be through landscape that she would be able to capture the magic and power of light.

A door had opened and she walked through it. Troubled but determined, April set out in the new direction indicated by her vision, learning the rudiments of landscape painting.

I was also moving along, pursuing an explicit figure-based art. The glassines were a major step forward for me. But, afraid to turn in my modernist credentials, I applied some overly thought-out, narrowly objective standards I thought would keep the work contemporary. I painted furniture as black silhouettes, as though they were only props. I rendered the face and head—the locus of psychology—in detail, and I painted them in grisaille and disconnected them from the body. I painted the body as expressive outlines.

Before long, I realized such contrivances were absurd. A few stylistic tics weren't enough to distinguish my work from traditional figure painting, and they were imposing a set of arbitrary limitations on my range of expression. I *wanted* to tell stories. I *wanted* to find a way back to my feelings through narrative association and evocative imagery.

Accepting my subject matter was a long, wobbly process. For me to take it further, I had to paint what I knew, not what I thought. That led me to explore my experience, social class, and family. I gave up defending my work as strictly fiction and began to incorporate more elements that were specific references to my past. I painted a sewing machine, a black Singer electric like the one my mother had growing up; a bathtub and chairs from my studio; clothing specific to the fifties.

Gradually the Fisher family narrative gave way to my family's narrative. I tried at first to deny that transformation. I still wasn't ready to fully deal with the trauma of my childhood, much less make it the subject of my paintings. I focused my fantasies instead on the seagoing father and his wife.

I tried to imagine what happens when the father goes off to fish. If he fails, they don't eat—they might die. How would the mother feel about this? Would she trust her husband to succeed? If I were her, I'd want to be part of it in some way. What would I do? I couldn't be there with him because I'd have to be home with the kids, so I'd ritualize it. I'd participate in a symbolic way.

I'd eventually realize these thoughts in *Woman in Bath,* an expressionistic monochrome oil painting on two overlapping sail-size glassine sheets. The work depicts a woman, her naked back to the viewer, hunkered in a dinghy-shaped bathtub, grasping the gunnels of the tub in a way that suggests she is trying to reposition herself or the tub in order to brace herself against a tidal force. There is something tragic and pathetic about it. The bathtub becomes a vessel of transformation, both a boat and a container for her fantasy about participation, as well as an expression of her limitations.

I painted *Woman in Bath* in 1978. By then I'd given up the romance of trying to paint for the fishermen of Nova Scotia. My simple folk tale seemed as much the depiction of a contemporary woman's struggle for psychic survival as the plight of a fisherman's wife. But it would be years before I could successfully execute a painting with the psychological depth and intimacy of *Woman in Bath.*

Meanwhile I was watching myself emerge on the canvas—my life, my childhood, my family drama. And though I felt increasingly exposed and vulnerable, I also felt enlivened. I was no longer obscuring my vision in artspeak. I was painting what I knew.

B Y the start of the new year, the atmosphere at NSCAD had become tense. Debates about the ethos and the direction of the school—much like the debates at CalArts—raged between the faculty and administration. On my arrival at NSCAD, the school was aggressively avant-garde, a hotbed of conceptualism and minimalism and all the other fashionable isms that had eclipsed traditional painting and sculpture. But in the three years since, a widening group of young teachers, myself included, had begun to challenge the school's "radical orthodoxy." A couple of these traditionalists had been products of the NSCAD system, star students who'd been hired out of the school's graduate program to pass the torch. No doubt their embrace of imagist painting was viewed by their former mentors as a betrayal,

adding to the acrimony on campus. It also signaled a generational sea change in the larger art world.

I was focused on the day-to-day routines of my job. As a student at CalArts, my decision to be a painter affected no one other than myself. As a teacher at NSCAD, my beliefs and politics had an impact on the school's curriculum, the professors it hired, and the artists it invited to visit and lecture. If I was going to stay at NSCAD, I wanted it to be the kind of school I would want to attend as a student.

But when I was really honest with myself, I had no desire to spend my life as a teacher. What I was really thinking was that it was time for me to get out of academia.

· 8 ·

NEW YORK

1978–1980

I N May 1978, April and I moved to New York to get on with our
careers. I'd lobbied for Montreal—almost any city other than
New York. I was afraid that the pace and competition and inten-
sity would eat me up. But April was determined. I could go where I
wanted; she was headed for Manhattan.

My fellow CalArts alums David Salle, Ross Bleckner, Jack Gold-
stein, Troy Brauntuch, Matt Mullican, Barbara Bloom, Mira Schor,
and James Welling had all moved to New York as well, and were
living and working downtown. And some of them were beginning
to show their art. Helene Winer, whom I'd met when she was direc-
tor of the Pomona College Museum of Art at Claremont—and was
an early friend and supporter of ours—had moved east to run Art-
ists Space, one of several alternative spaces like the Kitchen, Franklin
Furnace, and 112 Greene Street that had cropped up in the seventies
in response to the stranglehold minimalism had on the commercial
galleries. Nancy Chunn, who'd headed CalArts's admissions office—
where David and I had worked as part of our scholarship duties—had

also moved to New York, with a conceptual artist and musician, Paul McMahon.

With her nonjudgmental largesse, Nancy became the group's unofficial den mother. On Saturdays, she hosted a regular potluck dinner at the Chinatown loft she shared with Paul, a large space with a shabby, provisional feeling to it typical of the artists' lofts that freckled SoHo and the surrounding downtown neighborhoods. Less typical was the pet rat that lived in the wall and emerged looking for crumbs whenever guests came by.

At times our artists' dinners felt more like cocktail parties in the suburbs, with long, awkward stretches of strained conversation. No one wanted to seem uncool, jealous, or overly ambitious. In addition to the CalArts crowd, there was a group of artists from Hallwalls, an allied arts center in Buffalo founded by Robert Longo, Charlie Clough, and Cindy Sherman, as well as some strays like Barbara Kruger, Mike Smith, Sherrie Levine, and Erica Beckman. We were all friends and we were all trying to be polite. But the truth was that we were deeply divided over what art was or should be, and those issues, if voiced, would have ruptured the whole scene. I wanted us to be like the ab-ex artists who drank and brawled and held everyone's feet to fire, but it only felt like parody when we tried that. So we were publicly ecumenical, but privately hypercritical and dismissive.

One night, when the party had become particularly cliquish and dull, I came up with the idea for the battle of the bands. Because Paul was a musician, Nancy and Paul had all this band equipment lying around the loft—guitars, mikes, amplifiers, a drum set. All of us wanted to be rock 'n' rollers, but none of us could play. My idea was to break the party up into small groups; each group had ten minutes to write a song and figure out how to perform it. With everyone participating, no one could feel too embarrassed or too cool. Everyone went along with it, and the results were hysterical. Other than Paul, there wasn't a musician among us, so everything was pantomimed cacophony. The lyrics were parodies of love songs or absurd samplings of

advertising slogans. I remember being stoned out of my mind, playing air guitar and singing, with David doing a turn with a vacuum cleaner and Paul singing "Genius with a Penis," a title I threw out to him and a song he made up on the spot. There was so much creative energy in the room. We were all in New York because we wanted to be famous, the next "it" artists. It was very competitive and we were all watchful of each other, very wary and guarded. You know, who's going to be first? So we would go to parties and it could be very stiff. But it could also go the other way, and you'd get this stark raving mad release of tension that was wild and cathartic.

The band battles became an instant tradition. People started to come to watch. And then once we had a nonparticipating audience, it became something else. People brought real musicians, and it fell apart—that moment when it was free, creative, ridiculous, and liberating was gone.

To me, New York is where you come to be a professional, a professional anything. It is where you come to define and refine what you do. At the time it wasn't just about a product. It was more about parameters, skill, and clarity of execution. Looking back, I realize the battle of the bands inevitably followed that evolutionary track from innocence to self-conscious presentation. The years from 1978 to 1980 were a hinge period when a number of our group had their breakthrough shows and their first hint of artistic and commercial success. One minute we were full of fantasies and invention. And then art became a profession.

WHEN I got to New York, the economy was pretty flat and the establishment art world seemed moribund financially *and* creatively. Below the surface, however, the city's alternative art scene—still centered in SoHo, but soon to be spilling over into the East Village and TriBeCa—was percolating at a dizzying pace. The art world was atomizing as more and more marginalized groups (women, gays, blacks,

Latinos, imagists, slackers, nihilists, European artists) sought equal representation. There was so much stacked up at the door waiting to burst through. In my immediate crowd, the so-called post-studio artists from CalArts and Hallwalls were bouncing off the success of their landmark exhibit, the 1977 *Pictures Show,* organized by Douglas Crimp at Artists Space. David and Jack Goldstein had started painting again and were exploring pop-based imagery. Cindy Sherman, Barbara Kruger, and Jenny Holzer were staking out the feminist language of protest. Italian artists Sandro Chia and Francesco Clemente moved to Manhattan, bringing their quasi-religious, symbolist imagery with them. Julian Schnabel was crashing through painting barriers with his broken-plate-encrusted, neo-expressionist canvases. And working in the American realist tradition, April was painting enormous landscapes and I was trying to advance the cause of a new figurative style of painting. We were the next generation. Everyone was developing his or her work. There were lots of exchanges of ideas, lots of talking back and forth, lots of competition. But everyone was very cooperative. When people got galleries, they talked up their friends. Everything was still fluid. There was no pecking order. Success was still in front of us. We were all working other jobs. We had no money yet, nothing yet to lose.

But the bohemian life had its seamy side. Downtown life could be gritty and dangerous. April and I sublet a loft on Twentieth Street between Seventh and Eighth Avenues on Manhattan's West Side, in the same building where Bob Berlind lived and worked. In fact, Bob, who'd left NSCAD the year before, arranged for our rental. It was a fairly raw space with a rudimentary kitchen and small sitting area that doubled as our bedroom. The rest of the space we left open, save one small dividing wall that separated our two studios. The first night we slept there, we were awakened by something falling, like water drops on our heads and bed. We turned on the light to see hundreds of cockroaches crawling over the ceiling and walls, dropping all around us.

April got a job waitressing at Magoo's through Sherrie Levine, who worked there. That lasted a couple of months before she found another waitressing job at Christy's Skylight Garden, with better tips and within walking distance from home. Christy's was mostly a bridge-and-tunnel crowd that April found crude and demeaning. One night she was mugged by a lowlife who had followed her home from the restaurant, trapped her in our elevator, demanded her purse, and went through it, taking only the money. He handed it back to her and then had the balls to lecture her on being more alert. And there was a police station right across the street.

A few months later, we witnessed a second mugging. This time the victim was the beautiful young Scottish fashion designer Irene Maxwell. April and I, along with Bruce Ferguson and his girlfriend, Martha Townsend, were coming back from the Ear Inn, where we had gone to watch a performance piece by Mike Smith, a mutual friend. We had decided to stop off at Puffy's for a nightcap when we heard a girl screaming for help. Irene was on the ground, and her friend Stacy was yelling for someone to call the police and an ambulance. Bruce took off his jacket and put it under Irene's head. Stacy thought Irene had been punched and was just out of breath, but you could see she was struggling to breathe. A small stain of blood appeared on her white sweater; when we lifted it we could see it was a puncture wound through her chest. Stacy said that several black teenagers had been harassing them. When Irene told them to fuck off, one ran up and stabbed her with an ice pick. The cops came moments later; as we lifted Irene into the backseat she was limp. Later, when Bruce called to see about getting his jacket back, he was told that she had died.

O UR finances were tight. April made enough money from tips to cover her half of the expenses, and I'd put something aside from teaching to cover mine for the time being. But April was getting anxious about my not looking for work. Unlike me, she was

uncomfortable with completely exhausting our savings before finding a job.

Eventually I did find work painting other artists' lofts. And later I landed a more substantial job at Hague Art Deliveries, an art mover located on the ground floor of 420 West Broadway, the building that housed the SoHo galleries of Leo Castelli, his ex-wife Ileana Sonnabend, and André Emmerich, modernism's most prominent dealers. Mary Boone, a rising young dealer, had also opened a gallery there, a vest-pocket suite of rooms with some large walls and little space to move. A petite, exotic young woman—her parents were Egyptian—Mary had a prescient eye for art, an even better ear, grand ambition, and a taste for designer clothes. I would often see her as she arrived early in the morning, picking her way through empty cartons and discarded plywood in her Chanel suits and six-inch stiletto heels to get to her gallery.

E ARLIER that year, I'd traveled to Switzerland as one of nine artists selected for the exhibition at the Kunsthalle in Basel curated by Jean-Christophe Ammann. Because the murals Jean-Christophe had chosen could not travel, I had to go to Basel and re-create them in situ. Jean-Christophe was known as someone who had his finger on the pulse of the most avant-garde art. The program he put into place at the Kunsthalle was radical, experimental—and highly regarded. He not only gave me my first exposure in the international art world, but he would soon give me the harshest, most devastating critique of my work I've ever gotten.

B Y late 1979 I began to notice a change in the art world. After ten years of stagnating art prices and declining public interest, new galleries were opening with links to the CalArts crowd. And they were garnering attention from mainstream collectors—Eugene

and Barbara Schwartz, Arthur and Carol Goldberg, Jerry and Emily Spiegel, Marieluise Hessel, Edward Downe Jr., to name a few—and critics and curators such as Robert Pincus-Witten, Douglas Crimp, and Lisa Phillips eager to embrace a younger generation of artists (and in the case of collectors, to buy art they could hang on their walls). Julian was the first to really crash the establishment party and set the tone for what was to come. Mary Boone had mounted two shows for him at her space in 420 West Broadway in February and November. The second show exhibited six plate paintings—signature works whose surface images had been constructed out of broken crockery— all presold to name collectors at $6,000 per canvas. It was an astounding price for an artist with Julian's scanty provenance. Partly due to his self-promotion, his paintings were attracting the kind of attention that made him heir apparent to Picasso and Pollock. What Julian had managed to do with that work was reignite the collective memory of a time when painting had been able to express powerful emotions on a grand scale. His certainty in the way he manhandled his canvases and materials was a call to arms for me. I needed to step up.

Julian wasn't the only artist in our crowd who was breaking through. Annina Nosei and Larry Gagosian, a relatively unknown West Coast dealer, mounted a one-man show for David Salle. Shortly afterward he signed with Mary Boone, who also exhibited Ross Bleckner's paintings. Meanwhile, Helene Winer left Artists Space to open Metro Pictures—a gallery dedicated to the work of new artists of our generation—with Janelle Reiring, Leo Castelli's former right hand. Suddenly we were the subjects of intense dealer interest.

David True, a visiting artist at NSCAD, had seen my glassine paintings in Nova Scotia and recommended them to Edward Thorp, the owner of an eponymous gallery that specialized in work by new artists. Ed liked my paintings and scheduled a show—my first solo exhibition in New York—for fall 1979. From the day I arrived in the city I focused on making new glassines for the show. And then, six

months before the exhibition's scheduled opening, I changed the way I made paintings.

I'd been happy working in the glassine format and actually envisioned making a lifework out of it. There didn't seem to be any reason to stop. The glassines were formally innovative enough that I could still consider myself a modernist painter. But I began to realize that you can't tell a big story with quirky or modest means. Drawing isn't painting.

My expressionistic scenes emerged from the shadows of my glassine drawings organically, implacably—the way images materialize out of the dark emulsion on a photographic plate. But I had always kept one eye on the competition—not only my contemporaries, the conceptualists and post-studio artists who had begun to reexamine the values of painting, but also the painters of past generations: Manet, Degas, Homer, Bonnard, Beckmann, Hopper, and the abstract expressionists. The abstract expressionists were heroic in their scale and ambition. I loved that. My goal was always to make my work heroic. The glassines didn't have enough of the things I was competing with to triumph—color, space, light. My belief in painting was such that I wanted to converse with all the voices of opposition, to earn the right to sit at the table with my artistic heroes.

The last painting I made in Halifax, *Rowboat*, turned out to be the first painting of the type I would make for the rest of my life. I made *Rowboat* in spring 1978. Painted simply, almost naïvely, on a four-by-eight-foot plywood sheet, it depicts a child's model boat, the kind of toy the Fisher boy might have played with growing up. The boat extends the length of the picture and floats idly, becalmed. I made the boat a deep, vibrant red and the water a deep, dark blue. And I made the boat's oars bright yellow: all primary colors.

The string of associations that led to *Rowboat*'s final image were mostly unconscious. They not only subverted my original idea for the boat but also produced an image that surprised and transfixed me.

I want a painting to meet my expectations, to have a presence, to demand attention. I paint until I become the audience staring at the painting staring back at me. It's how I know the painting is done. But every once in a while a painting leaps past my wildest expectations. Its presence is electric and unexpected. *Rowboat* had this to a degree I had never achieved before. Without even trying to be, it was evocative, mysterious, and inscrutable.

I'd created frozen moments before, moments when all the elements of a picture seemed balanced on a knife's edge, in harmony yet about to change. But standing before *Rowboat* I felt an exquisite tension, an incredible luminosity that not only came from the arrangement of primary colors (a shift from my usual muted palette) but also from the nature of the paint, the way it conveyed shadow and light. For the first time I felt as if I'd created reality. The glassine paintings had been a giant creative step forward for me, and I would continue to experiment with them. But they would always be missing something—the formal power of *Rowboat*. Next to *Rowboat,* the glassines felt like storyboarding—depicting dramas, but not embodying them.

So I began experimenting with making full-color, traditional oil paintings. The first of them after *Rowboat* was *Sleepwalker.* Painted on a six-by-nine-foot canvas, the picture shows an adolescent boy standing naked in a plastic kiddie pool on a suburban lawn at night. The boy, lit from above—the moon, perhaps, or a streetlamp—seems oblivious to his surroundings, and a vast stillness, like held breath, is gathering at the edges of the picture frame. He may be dreaming the scene or he may have wandered there in his sleep—a condition barely distinguishable from the self-absorbed, fuguelike state that afflicts boys entering their teens. But however uncertain his path to that spot, the boy's purpose there is unmistakable. Poised at an angle to the viewer so the action is partly obscured, he's masturbating into the pool.

I deliberately chose my subject because it was taboo. Like many of my peers, I was testing the bounds of propriety, both socially and artistically, trying to get people to notice my work. What's more, I

My father, age
twenty-seven

My mother, age
twenty-three

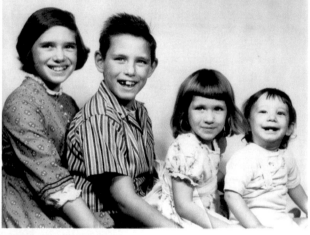

With my siblings:
Holly, me, Laurie,
and John, 1959

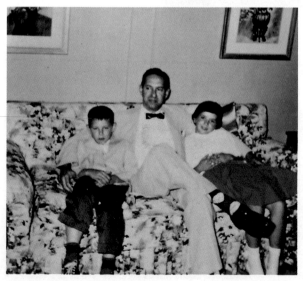

Life in suburbia:
my father with me and
my sister Holly

My mother in the
VW bus that she was
driving when she
crashed

Bill Swaim,
my mentor at
Arizona State
University

At my mother's funeral in Phoenix, Arizona, 1970

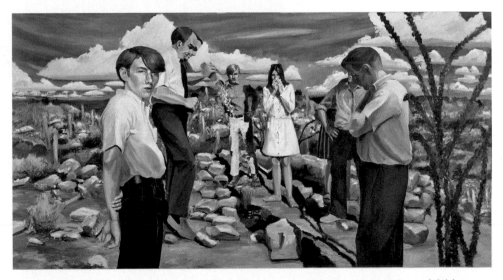

A Funeral, 1980, my painting of the emotions and tension, hidden and expressed, at my mother's funeral

With April, early in our
relationship

With April and Allan McKay,
while teaching in Nova Scotia

With my
father in
Phoenix,
mid-1980s

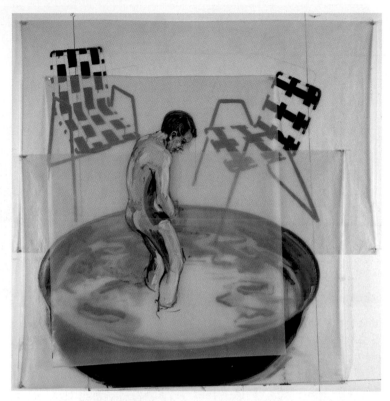

Study for *Sleepwalker*

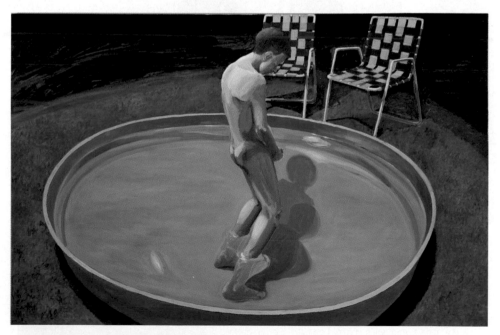

Sleepwalker, 1979, one of my first paintings to gain
notoriety and acclaim

At one of Paul McMahon and Nancy Chunn's battle-of-the-bands parties at 35 Grand Street, 1979. From left: Dan Graham, David Salle, Mike Smith, me, and Barbara Kruger (obscured). PAULA COURT

With April and David Salle, outside Barocco in the mid-1980s

With April, celebrating my birthday at our Ninth Street apartment, 1995. My costume was fabricated from gift wrapping by Mary Jane Marcasiano.

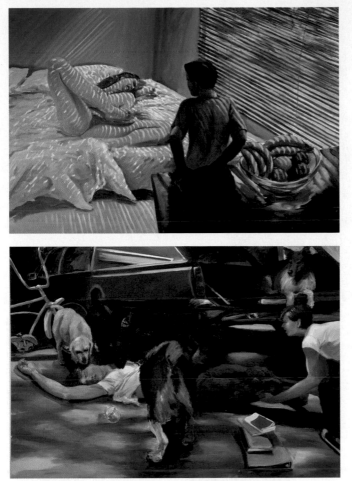

Bad Boy, 1981

A Woman Possessed, 1981

Above: With Mary Boone at the Whitney opening, 1986.

Right: (from left) Tod Wizon, Julian Schnabel, Markus Lüpertz, and Jörg Immendorff hamming it up in front of my painting *Cargo Cults* at my show at the Mary Boone Gallery, 1984

With Jean-Christophe
Ammann at my show at
the Kunsthalle, Basel,
Switzerland, 1985

Above: A beach in St. Tropez
with a muse I would paint for
many years

Left: *Saint Tropez*, 1982

didn't fully trust my painting skills and felt I had to use shocking material to make the picture live. But I was also trying to explore the emotions behind that taboo. Though I knew I was being provocative and sensationalistic, I was sincerely trying to express what it felt like to be the boy at a time of momentous change. I tried to make every detail in *Sleepwalker*—the encroaching darkness, the focused overhead lighting, the boy's ambiguous twin shadows, a pair of empty lawn chairs connoting the absence of parental controls (or the opposite), the shallow pool with its waterborne associations of birth and creativity, and the posture of the boy's body, bent to its task and turned away from the viewer—contribute to the sense of mystery, drama, and isolation that marks an adolescent's introduction to puberty.

I didn't know what the boy was doing when I started painting him. In fact, I never started a painting with a vision of what it would ultimately look like or a definite idea of what it was about. Every painting I make is a journey for me, and how I begin is never the same. I start with fragments—the gesture of a person that intrigues me or something as mundane as a bowl of fruit or a sleeping dog—and then I free-associate, respond to the image I put on the canvas, listen as the painting begins to talk to me. Every painting of mine is a search for meaning. Every painting I finish is the discovery of its meaning.

With *Sleepwalker*, I began with the image of the boy in a kiddie pool. I knew I was trying to portray that transitional state in which a boy becomes a sexual being. But I didn't know what he was doing in the pool. Was he pissing or just standing there? The painting was originally set in the daytime; the idea of masturbation hadn't occurred to me. All I knew was the boy had outgrown his toy pool, that the juxtaposition of the two images, the boy and the pool with their conflicting scales, was awkward.

The *aha* moment came for me when I changed the setting to night. That's when I realized what the boy was doing, when I made the associations between darkness and privacy, freedom and mystery,

taboo and sexual exploration. That's also when I painted in the lawn chairs, the symbols of parental or adult authority that attend the boy's rite of passage.

The chairs also impart the painting's main theme, its queasy sense of voyeurism. Without them, it's just a picture of a boy masturbating—prurient, perhaps even shocking, but one-dimensional. But with the chairs, the painting becomes personal and affective. They pull the viewer into the picture's space, force him to bear witness, to anoint or condemn or identify with the boy's action. In this sense, the chairs are the painting's seat of consciousness, the point or image to which the viewer keeps returning. Later I would explore and employ this technique—similar to an author's point of view—more intensely.

The results of *Sleepwalker* and the other realist paintings I'd begun making intrigued *and* troubled me. My dealer, Ed Thorp, was sympathetic to the new format and suggested postponing my upcoming show six months in order to include a representative sample of the work. But a number of my peers—especially Julian and David—had already had breakthrough shows. Even without a delay, I felt as if I was coming late to the party. The possibility of further postponement only increased my fears that I may have missed my moment altogether.

Worse, the content of the new paintings threw me completely off balance. I'd intended *Sleepwalker* to be sensationalistic, to shock people. I'd assumed it would get a reaction. But I wasn't prepared for the way it made *me* feel. While painting *Sleepwalker* and other pictures from that time, I employed the same associative, storytelling techniques I'd used while making the glassine works. I thought I'd been telling myself stories about an imagined family acting out instances of shocking and salacious behavior. But when I stepped back from the paintings and saw what they were really about, I realized I'd actually been painting scenes from my own disorderly past.

Since I began making art, I'd drawn on the emotional content of those thinly disguised childhood memories. But I'd always mediated

the particulars of that experience through modernist or formalist means—abstraction, collage, and myth. Now, without consciously willing it, I'd become the naked, recognizable subject of my work. Had I realized how exposed and vulnerable it would make me feel, how troubling and powerful the images were to me, I might never have done it.

I had another reservation. My new paintings swerved sharply away from anything that could be considered modernist. Gone was any pretense of abstraction or the many techniques that give precedence to an artwork's formal properties. I not only stood revealed as the subject of my painting, but I was also working squarely in a tradition that many artists and critics dismissed out of hand as retrograde.

Later that summer, the repercussions of my transformation were brought home to me. Jean-Christophe Ammann called to say he was in town and wanted to come see what I was up to. I was thrilled he'd called and eager to show him my new work. I cared deeply about his opinion. I invited him to the studio and prepared for his visit by putting up some glassines that he'd never seen, as well as the rowboat painting and *Sleepwalker,* which wasn't quite finished.

Jean-Christophe is a deeply sensitive man, passionate, articulate, and agile in his thinking about art. When he came into the studio he was, at first, stunned into silence. Regaining composure, he began a hand-wringing, chain-smoking, floor-pacing critique about how wrong and disappointing he found the direction I had taken with *Sleepwalker.* Worse, there wasn't an ounce of malice to his comments, only genuine concern.

All painters I know have a list in their heads of things they are unsure about with any painting they are working on. The list will often include anything from doubts about style or subject matter to the niggling questions about brushstrokes, edges of shapes, and colors. For me, if someone looks at my work and hits on anything on my list, I know that my doubts were correct and I need to fix it. If they don't hit anything on the list, then I know my doubts simply reflect

my own anxiety. That afternoon, Jean-Christophe hit every single thing on my list, from the direction the work was taking—how reactionary and suicidal, how poorly drawn, how poorly painted—to how thin and transparent the lines of the glassines were that they could not convincingly hold their own image. It was a scalding critique by someone who had loved and championed my earlier work and was in a position to further help my career.

When he left the studio, I was distraught. I couldn't dismiss all that he said but I didn't know what to do with it, either. I felt I was watching my career go down the tubes before it had really begun. It was an almost intolerable pressure. I was aware of the risks I was taking to make unfashionable art, but in the past my fuck-you attitude had been directed at other artists. I had not considered the risks within my career strategy. Jean-Christophe made it clear that if I continued moving in the direction of *Sleepwalker,* he wouldn't be able to support me. I'd be on my own.

Nonetheless, I knew I needed to persevere. I wasn't being brave about it. The truth is I tried to follow Jean-Christophe's advice, to repaint *Sleepwalker* in light of his numerous criticisms. I thought hard about everything he said. I tried different ways to make it more contemporary. If he didn't like the way I'd painted an arm or a bit of foliage, I tried different ways to make them better. But every idea I tried looked like someone else's idea, and in the end I went back to the way I had originally painted it. Jean-Christophe had taken everything away and left me with myself. It was brutal but liberating. I was painting the only way I cared to—or could—paint. I was painting *my* painting. And even though I continued to question my instincts, at least now I knew I had no choice. I wanted to be considered a great artist, but I felt I had to live or die by who I am.

APRIL GORNIK

I first met Eric when he wandered into my studio
in 1975. I had no idea who this salt-and-pepper,
long-haired, hippie-bracelet-and-denim-vest-
wearing guy with attitude was. He struck up a
conversation by telling me that I had no business
making art by gluing pieces of wood on paper.
He eventually sauntered off, and afterward a few
girls on my studio floor came up to me asking,
in slightly hushed tones, if I knew who that was.

No, I replied. Well, that was Eric Fischl the
painting teacher.

Didn't I think he was good-looking?

It wasn't until a few stoned and hilarious
parties later that he turned out to be the
funniest person in the room (by far). After the
first of the year we started to see each other.
I didn't approve of myself fraternizing with
someone from the painting department (I was
still convinced in 1976 that painting was dead),
but Eric was so much fun and so clever. And when
I finally saw what he was working on, I was so
impressed by the emotion in his work that all my
prejudices were turned upside down. And I fell
in love.

Eric and I both have "intimacy issues." We both come from rocky, unstable family backgrounds, and I think part of what we learned to appreciate about each other was that we knew how to give each other space. We both love to laugh and show the world what we see. We have both given to the other's work in various ways; I eventually started painting, which I had sworn off, and quickly found myself involved in landscape imagery, complete with light and space (which was something "not done" in modern art, the trajectory of which has been flat, flatter, flattest). He eventually incorporated light and space into his paintings. We talked endlessly about art and meaning and life and friends and the world. What we didn't talk about was commitment.

We moved in together for about a year and a half, and then moved to New York together in May 1978.

Eric quickly got a reputation for being a hilarious, off-the-wall party animal. We'd go out to dinner at cheap places (dives in Chinatown or places like Magoo's, where I waitressed briefly) and to friends' houses for parties. Eric excelled at something that he cocreated called battle of the bands. He would fearlessly get up and spontaneously make up outrageous lyrics, reminiscent of the taboo-breaking subject matter of his paintings, on the spot, even though he can't carry a tune.

I tend to be obsessive-compulsive about every-
thing I get excited about (a friend once said
that I don't have affairs with other people,
I have affairs with countries, gardening, yoga,
et cetera, and so forth), and Eric has been
both amused by and sweetly indulgent of my
obsessions.

No relationship that's lasted as long as ours
is without stress and strife and arguments and
traumas. But when I look at Eric I still see
the man I fell in love with. I still know him
as someone who is 100 percent committed to
painting (and sculpture). He still believes its
cultural impact and meaning are greater than
any other art form, and he still believes in
the importance of sharing one's intimate self
through art.

And he's still handsome, and he's still the
funniest guy in the room.

· 9 ·

SURFING

1980 – 1981

A s a kid I used to surf off the East End of Long Island. There's a feeling you get when you're paddling hard to catch a wave and you feel yourself suddenly being picked up, gaining velocity, and you don't have to paddle anymore. That's what the eighties were like, at least at the beginning: that feeling of being swept up and carried by something so much bigger and more powerful than yourself, something you'd worked so hard to catch, and now you've caught it and you're in it.

At first it was about the art. There was this pent-up demand for new young artists. We'd barely put our work out there and it would get snatched up. It gave us a heady feeling. We thought we were reinventing the canon, broadening the definition of what art is and who could make it. It was about liberation and empowerment. We were artists giving voice to the marginal, the mute, the invisible, the discriminated-against and overlooked people in our society. We were young, passionate, and combustible. We were having fun while trying to save the world.

I was willing to take it all on. There were no taboos that didn't bear scrutiny and reevaluation. I believed so deeply in the integrity of my self-appointed mission to make painting relevant that I thought nothing could corrupt or compromise me. And I wasn't alone feeling that way.

Then around 1982 or 1983, many of my peers and I started making money. Not a whole lot, but enough to quit our day jobs, to rent decent places to live and work in, and to enjoy some of the highlights of the city, which was rapidly gentrifying around us.

One of those highlights was the Odeon, the iconic eighties restaurant that opened—the first to do so—downtown in TriBeCa. I loved the place. The room still reminds me of fancy restaurants in old European train stations: dark wood, mirrors, banquets, tile floors, and soft lighting. The architecture of travel was resonant and transporting because April and I and our friends were on the move. The Odeon was our first fancy hangout. It wasn't a dive; it was a fantasy. From the moment you walked in, you were treated specially. It was the place where collectors and out-of-towners would have to wait while the artists were seated. There was a line to get into the bathrooms, and the toilet-paper dispensers had handy flat metal trays on top that made it easy to cut up and snort lines of cocaine. It was hysterical when you walked in to see so many legs under the stall doors, women's and men's alike.

For a year or two, everything was in balance—the art, the recognition, the money, the nightlife. It was like we were riding inside the curl of the perfect wave. Besides the Odeon there was Da Silvano, a classic Italian trattoria in a storefront in the middle of nowhere, and Chanterelle, a casual four-star restaurant that traded food for drawings, and Mr. Chow's for fancy Chinese uptown. The whole city was open to us. The way it worked, you got on some publicist's list, or several lists, and every day the invitations would come pouring in—gallery openings, museum events, preview parties, screenings. April and I would go to a dinner and typically I'd be seated across from celebrities such as rocker Peter Gabriel, whose music I loved. But I

was such a rube I wouldn't know it was him until the next day when someone told me.

People were acting out like crazy. One night Larry Gagosian locked sculptor Bryan Hunt and filmmaker Amos Poe in the Odeon broom closet—nobody can remember why. Another time at the restaurant, Richard Serra decided to take on pretty much everyone in the place, and the police had to be called in. And at countless parties and events, Julian Schnabel would come sweeping in dressed in striped pajamas with his beautiful wife, Jacqueline, beside him and an entourage of movie stars and models in tow.

Eventually the balance would tip. There'd be too much fame, too much money, too much attitude. Having tasted success, we would want more, lots more. Too many of us would become driven by commerce and status, the antithesis of art. Rivalries and cliques would spring up. Even the fun would seem forced, a parody of what had once been spontaneous. The work would suffer too. We'd all be performing under klieg lights, trying to measure up to the hype. Some of us would lose our way, drop off the radar, or become overwhelmed by celebrity and fortune. Some would succumb to AIDS or drugs. But those first few years of the eighties were golden, a time when everything was new, when creativity and adulation, cycling like a wave, buoyed us to unimagined heights.

APRIL and I started off the eighties in new digs. The previous summer we gave up the crowded loft we'd sublet in Chelsea and moved into a raw warehouse space on Reade Street in TriBeCa, then a kind of no-man's-land south of SoHo. The top two floors of the building were being developed by a couple of young artists who were hoping to get free space for themselves by renting out a few units, a scheme that was taking place all over the downtown area.

Basically, what we rented was a dark, dismal space with some rudimentary plumbing and electrical wiring. We would eventually

punch two holes for skylights into the ceiling and fill them with glass stolen from bus-stop shelters. We spent months fixing the place up, building out two studios, a living/dining/kitchen area, and a bathroom. Like our first loft, the studios were simply divided by a wall and not entirely enclosed. We had a mattress on the floor of April's studio that we would stow away when visitors came by or if she needed more floor space to stretch a canvas.

April and I were still trying to get the hang of living together. Being a couple is hard enough, but when both people are artists with ambition and egos to match, it's particularly challenging. The life of the artist is, by definition, an interior one that can appear selfish and self-absorbed. The good thing about being in a relationship with another artist is the tacit understanding of what it takes to make your work. The pressure on a relationship really comes from the outside when one person is getting a great deal of attention and the other is not. This was the case with April and me, and I often marvel at how we survived those early days. One reason was the space we gave each other. On the one hand, we were mutually supportive. We'd both chosen to pursue traditional forms of painting that the art world had largely dismissed. So we were bound by a sense of shared purpose. But we also respected each other's autonomy and tried as much as possible to avoid entanglements in each other's working and professional lives. Though we painted in adjacent studios, we put up a wall to keep our work separate. And whenever a dealer or collector came to look at either of our work, the other would turn their paintings against the wall.

Once, though, this didn't happen. Ed Thorp came by on short notice to check on my work for an upcoming show, and April, who'd been out doing errands, didn't know to rearrange her paintings. The elevator opened directly onto her space, and when Ed arrived he had to walk through it. I could tell that April's paintings caught his attention. Before going in to see my work, he paused and asked questions about hers.

Ed was still at the loft when April returned, and he asked her if he could include one of her paintings in a group show he was curating. Later he asked me if I had an issue with him representing her. Privately I thought it might cause complications. April and I were already living and working together. Sharing the same dealer added another layer of overlap and another potential for stress and misunderstanding. Relations between an artist and agent can get messy when their interests are at odds. I didn't want to be in a position in which I felt my decisions might affect her adversely, and I know April felt the same way.

But Ed had a unique ability to spot and showcase new talent, an intuitive sense for the authenticity of an artwork. You could always go into his gallery and see something meaningful, and just as often something quirky or unexpected. He'd never followed the trends, although over the years he'd jump-started the careers of many artists who were on the cusp of breaking new territory. He'd taken a big chance with me, for which I was grateful, and I wanted April to have the same opportunity.

I gave Ed's offer my blessing. But I had one more reservation that I kept to myself. As good as Ed was with emerging artists, he lacked the promotional skills to take them to the highest levels. I knew that at some point I would want to leave him for another gallery to get where I needed to go. In fact, that's exactly what happened, and it didn't take long for the art world to manufacture tales that April had been the cause of my exit. I don't know whether Ed believed the rumors or felt that April hadn't done enough to make me stay, but he blamed her for my leaving, and their relationship was never the same again.

B UT success, with all its complications, was still years away. Meanwhile I was working long hours between my day job and preparing for my first solo New York show, scheduled to open at Ed's in April 1980. It was an incredibly productive and anxious time in

my life. I was still making the glassine pictures that I'd originally intended for the show, and I was also following up on *Sleepwalker,* trying to turn out a sample of paintings in what for me was a radical new format.

The content of the new paintings—scenes depicting adolescent sexuality and adult misbehavior—summoned the most painful feelings from my youth and looked unflinchingly into emotional areas that could have easily spun me out of control. In fact, had addressing these themes not filled me with so much anger and rage, I don't think I would have had the balls to make them, much less show them.

As it was, it was a close call. Right up until the opening I was feeling raw and nervous. I was making pictures that were crude and revealing. My painting skills, I knew, were questionable. And though I was spurred on by the work others were doing, I believed I was making work like no one else's. I was alone. I wasn't asking for help. I wasn't asking to be saved. I was trying to show what it felt like to be wounded and I was pretty sure there were others out there who felt the same as I did. You had to be young—and a little crazy—to think this hyperpersonal terrain was fertile ground for art. Especially after so many years when artists made work that denied any emotional content at all.

By the time of the opening, I was feeling so anxious and vulnerable I actually remember nothing about it at all. If you were to ask me who was there, what people said, what sold, who bought what, where we went for dinner, I'd have to rely on other people's memory to fill in the blanks. To me, openings are never what you want them to be. The excitement, relief, anxiety, and anticipation are too much to process. There's no apotheosis, no pinnacle, no turning point. It's not like theater, where at the end of a performance people get up and applaud.

Nothing gets created at an opening. Nothing of artistic merit takes place. All of that important stuff happens in the studio, long before the exhibition, when you're alone. For me, anyway, openings are something to get through, an ordeal to be endured. The bigger

the event, the less I remember. I pretty much walk in, and wherever I stop is where I stay. I paint a grin on my face so fixed that by the end of the evening my jaw is sore. I remember none of the conversations. I stand there shaking hands, blindly mouthing, "Thank you. Thank you very much." Then eventually April comes and collects me and we leave.

If, on the other hand, you were to ask me what I remember about making the paintings in a show, that's a different story. Imagine touching something, stroking it, jostling it, caressing it, and as you're doing this you're creating it. How you touched it is how it came into existence. Unlike other pleasures, where the feelings fade quickly as details become blurred, with painting you remember everything. Within the details are all the bumps and the friction, the memory of when the creative instinct flowed, when you were distracted or lazy or working it too hard. It's all there on the canvas. When I look at my paintings again, years later, even, I remember it all—the victory laps and the scars.

Sleepwalker created the biggest sensation in my first show. But paintings like *Fallen Sewer, Woman Surrounded by Dogs, A Funeral,* and *Help* also triggered buzz. Each painting I made laid the groundwork for themes I had yet to identify or fully understand. I felt as if I were exploring a star whose size and shape would ultimately be determined by the way the individual works orbited around it. Critics thought these early works were commentaries on the American dream. To me, I was creating character-driven narratives set against the backdrop of suburban middle-class America. During a time when painting was considered dead by the art world, I was trying to capture the authenticity of shared experiences by painting characters that were real enough, sincere enough, and vulnerable enough to command empathy. There was no intellectualized strategy at work. I was trying to paint paintings I needed to see. I was trying to create in my art the kind of memorable experiences I found satisfying in movies and literature, something that painting had abandoned a long time ago.

Over time, the show sold out—eight or so canvases at several thousand dollars each. It brought in more money than I'd earned from all my painting to date, but I was reluctant to quit my job at Hague Art Delivery. I was profoundly insecure about my future. I was still struggling to define my work and distrustful of my audience. In no way did I feel as though I had made it. Worse, I felt sure the popularity of painting was a house of cards that could come crashing down at any moment. I worried that I'd be exposed as a fraud and forced to give back the money, which was already spent. I was taking it one step at a time.

O NE important step was the deal I made with art collector Edward Downe Jr. A financial whiz and man-about-town, Ed was known for his knack for discovering young talent and helping to refocus attention on overlooked artists such as Philip Guston and Alfred Jensen. Cynics thought him a bottom-feeder or bargain hunter, but his interest and support in a young artist's work brought with it precisely the kind of attention an artist needed to be taken seriously.

Barbara Toll, an art adviser who was a friend, brought Ed to my studio. I pulled out some paintings and he took a shine to *Rowboat,* although he didn't say much or make an offer. Instead he took April and me to a fancy French restaurant. Eating at high-end restaurants was part of Ed's ritual.

He called me the next day to say he wanted to buy *Rowboat.* I told him the price was $2,500. He offered $2,000. To my surprise, I said, "I think the five hundred means more to me than it does to you. The price is twenty-five hundred."

He was quiet for a moment. Then he said, "I suppose you're right about that," and began laughing. In the end, he agreed to the price. I surprised myself by being so hardheaded and businesslike. It had surprised him, too, and drew us closer. He became a regular visitor to my studio, and April and I became frequent guests at the running

salon he held at his apartment on Fifth Avenue and his house in Southampton.

Downe, who later married Charlotte Ford, Henry Ford's granddaughter, was one of those larger-than-life figures—charming, irrepressible, a little sharp—that emerged in the art world of the eighties. Wherever he was, it was like an open house. He seemed to be having a blast. He surrounded himself with interesting people. In addition to his business friends, he knew artists, socialites, journalists—I'd see Bryan Hunt, Jennifer Bartlett, Dick Schaap, among others, at his parties—and he had a particular fondness for politicians. Hugh Carey was a frequent guest, as were Ed Koch, Mario Cuomo, and Connecticut senator and presidential candidate Christopher Dodd. Art played second fiddle in this world. More than once I remember walking in on the backroom gin-rummy game he ran for his inner circle and being politely and pointedly asked to make myself at home—in another room.

Nonetheless, Ed was always solicitous of his artists. He didn't just buy your work. He got involved in your life. In addition to his constant entertaining, he offered me financial advice and even invested money for me, as he did for others. Years later, this ingratiating habit would land him in trouble with the SEC as the hub of an insider-trading ring known as the Society Seven. At the time, though, he seemed genuinely interested in helping me. He'd learned I was still working at Hague, crating and transporting art. He asked me what my monthly expenses were. I told him I managed to get by on $1,000 a month. So he made me an offer I saw no point in refusing. He said he would guarantee me the $1,000 a month against future sales of my work. For this he wanted right of first refusal on all my new paintings. If I sold nothing, he would pay me $1,000 that month. If I sold a painting for $2,500, he wouldn't give me any money for two and half months. If he bought a painting, he would pay half price. It was cheap for him but priceless for me. It enabled me to quit working my day job and concentrate on painting. As it turned out, I needed

his patronage for only about six months before I was steadily selling work. But for a time, his offer was an extraordinary gift. Not only did it relieve me of money worries, but Ed was also one of those collectors others watched and followed. If he bought your work, other potential buyers would come sniffing around. Ultimately, Ed amassed a significant art collection worth much more than he'd paid for it, and that trade-off was just fine with me.

My deal with Ed Downe did not make Ed Thorp happy, but he tolerated it because in raising my profile at that early stage of my career, it benefited him as well. A couple of years later, though, when I moved to Mary Boone's gallery, she would have nothing to do with it. Among other drawbacks, my arrangement with Ed Downe would have prevented her from placing some of my best work with museums and other collectors, an essential tool for a dealer looking to raise her artists' profiles. Weighing what Mary could do to further my career against what Ed had already done, I ended his privileged status. He could still buy my work, but now he would have to go through her. I don't regret the decision, but I do regret the bad blood that resulted from it. Ed felt betrayed and he let me know it. He was furious and said things to me I could neither overlook nor forgive.

I don't know what I was expecting, but certainly not that. As patron, collector, and adviser, Ed had been a big part of my life, and I was confused about what to do. Knowing I could never repair our friendship, part of me wanted to erase it entirely, and part of me wanted to honor it. I was also beginning to feel uneasy about the extraordinary returns that Ed had been making on my investments. If it was black money, I wanted no part of it. In the end I decided to donate the profits to the Whitney to be used to acquire a painting from an emerging American artist. My only other stipulation was that the inscription beneath the painting read: "GIFT OF EDWARD DOWNE JR. AND ERIC FISCHL." Ed took great pride in collecting only American artists, so my instructions felt appropriate. Then later, when I got a call from Richard Marshall, the Whitney's chief curator, saying he

was interested in using the money to acquire a Kenny Scharf, I figured I'd stumbled onto a bit of serendipity. Kenny was a young, brash graffiti artist whose work Ed detested. Donating the painting in both our names seemed like a nice windfall for the Whitney and the perfect parting gift to Ed Downe.

Ed was typical of the new, entrepreneurial collector that made the Reagan-era art world a boomtown. But whether he sparked the contemporary market's commodity-like atmosphere or was its product, I couldn't tell you. What I can say is that the art market, having emerged from its doldrums at the start of the eighties, was beginning to explode in new directions. The important dealers, auction houses, and museums—the infrastructure of the market—were still based in Manhattan. So were the painters, the critics, and the collectors, who either lived in the city or came here to look and buy. But the New York art establishment—once locked up tighter than a fort to keep European artists out—could no longer withstand the flood of compelling work from abroad. The Italians Francesco Clemente and Sandro Chia had already been living and making work in New York for several years. In 1974, Joseph Beuys had had his first show at the René Block Gallery, which set the stage for other German artists to enter the city: Anselm Kiefer, Georg Baselitz, Jörg Immendorff, and Markus Lüpertz. The first wave of Brit artists—Bill Woodrow, Richard Deacon, Anish Kapoor—and even a few French artists, such as Gérard Garouste and Christian Boltanski, began showing up. What had been fermenting in the late seventies blossomed brilliantly in the eighties. The great thing was that although you could feel it coming, no one had any idea of what it was going to look like.

Old-school curators and historians who attempted to predict the zeitgeist failed spectacularly. They underestimated or completely misunderstood our generation's embrace of irony, nihilism, and the absurd sincerity of the insincere gesture. When Barbara Rose, minimalism's

onetime standard-bearer, organized a show at the Grey Art Gallery, *American Painting: The Eighties,* she boldly asserted the primacy of abstract painting. And she was dead wrong. It was laughable. Most of the artists she selected disappeared immediately. I can remember only two, Susan Rothenberg and Elizabeth Murray, whose expressive imagistic paintings had any lasting impact.

One thing was clear: There would be no style, no overarching aesthetic that would dominate art for the foreseeable future. What was being ushered in was the chaos of the non-hierarchical, democratic plurality of individualism. Everyone was on an identity quest. There would be no agreed-upon standards for quality, which confused art dealers and collectors alike and was the death knell for art critics. Artists in the eighties were out to blow your mind. The importance of a work could not be determined outside of the significance of the moment in which it first appeared. Timing was everything. Robert Longo's coolly ambiguous drawings of chic white people who appear to either be dancing or being shot, Cindy Sherman's photographic disappearing act, Barbara Kruger's scalding satires on male authority, David Salle's brilliant, ironic takes on popular culture, Julian Schnabel's bombastic neo-expressionist canvases, my psychosexual narrative paintings, April's dramatic landscapes, Sherrie Levine's subversive appropriations, and many, many more new art forms were all bubbling to the surface, each having a moment, each creating a frisson. None of us knew what work would enter the lexicon, what would last. No one really knew if any of it was any good. All we knew was that we were the next generation.

THE leader of our generation, whether we liked it or not, would be Julian Schnabel. In April 1981, a year after my first show with Ed Thorp, Mary Boone and Leo Castelli put up a joint exhibition of Julian's work at their SoHo galleries. It was a huge, defining moment for my generation of painters, an announcement that we'd arrived.

Double shows were rare in those days. Any time two name deal-
ers got behind an artist—especially one with Julian's limited track
record—it was likely to be newsworthy. But Castelli was the gold
standard. His gallery had dominated the critical and artistic dialogue
since the sixties and had solidified the hegemony of American pop art
and minimalism. And he hadn't taken on a new artist since 1971.

I didn't go to the opening, which was, as I'd expected, a big,
splashy affair—lines around the block, both galleries jammed full of
art-world denizens competing with the pictures for space and light.
But that wasn't what had kept me away that first night. I wasn't happy
that Julian was the anointed one. I didn't like his paintings. I thought
they were messy, clumsy objects with no breathing space and a lot of
noise. I guess that was his intention. I got the spirit of his work but
distrusted the emotion behind it. His paintings always seemed theat-
rical, or, more precisely, operatic, and in that sense they felt nostalgic
for epic emotional conflict. I thought they too self-consciously recalled
the existential heroic stance of the abstract expressionists. They were
very physical, very confrontational, very alpha dog. As with much of
Julian's work, my first impression of his new paintings, when I saw
the show a few days after it opened, was my best impression. For me,
their freshness lasted only for the first bite.

I left Castelli's gallery with mixed emotions. Julian had become
the first new painter to hang on those hallowed walls, and it pissed
me off. But it also inspired me to up the ante in my own work, to
make it tougher, bigger, louder, clearer.

Actually, I found the whole event puzzling. I didn't know at the
time whose idea it was, though I never doubted it was an act of ge-
nius. Later I heard that Mary had approached Leo because her gallery
didn't have enough space to accommodate Julian's prodigious output.
And I'm sure Julian didn't mind the association. But Leo's participa-
tion remained a mystery to me. How did he think he would benefit
from doing a show of such a young artist, and particularly this young

artist? Was he worried that he would be left out of the next wave? Though he claimed to be thunderstruck when he first saw Julian's work, it was so unlike what he'd shown in the past. Leo's artists made art that was cool, intellectual, and withholding of emotion. The objects were austere and well crafted. Julian's were anything but that. It was the last thing you expected to see when you walked in the door to Leo's gallery, which was a big part of what made it so exciting. Until that moment our generation had been sequestered, showing mostly in alternative spaces and start-up galleries. We knew we could compete, but until we saw the work in the context of the big boys, we could not really be sure we were going to pull off the tidal shift we were aiming for.

It didn't hurt, either, that the show was a total success—the paintings all presold to museums and key collectors, the work almost universally praised by critics and public alike. But for April and me and many of our friends, the fact of Julian was more important than his art, the scale and grandeur of his canvases more important than their plate-encrusted content. He'd made going to see paintings—for so long an activity the art world frowned upon—once again stirring, and a little bit dangerous.

WHATEVER I thought of his work, Julian's success sparked my competitive nature—forced me back to the drawing board, so to speak. Having decided to be a realist painter, I still was distrustful of my style, my voice. To a large extent, my studio practice—the thousands of small, unconscious choices I made while painting—and my still-developing drawing skills determined the look of my work. But spontaneity took me only so far. When I stood back from a canvas to assess what I'd made, I still faced key decisions about what to leave in, what to take out, how much detail to show.

Painting was coming back into fashion, and a lot of my contempo-

raries had returned to the canvas. But as much as I may have admired their work, they weren't influencing me. If anything, I was defining myself in opposition to them.

Edgar Degas and Max Beckmann were the touchstones of my early work, polar opposites on the spectrum between realism and expressionism. I loved the cool, voyeuristic space in Degas's paintings, the detailed intimacy of the worlds he described, and the incredibly assured efficiency of his brushwork. He could create the appearance of a Limoges vase with three gestures. Degas was also one of the first painters who understood how to work from photographs. At the time, art photographers were trying to make photos look like paintings, imitating academic allegories and compositions. But Degas discovered a new kind of visual language in the unintended compositions of the snapshot, where foregrounds were distorted, figures were cropped awkwardly or silhouetted, and depth of focus felt more haphazard.

Beckmann, on the other hand, employed a psychological hierarchy, focusing more on expressing emotional details that were important to the story he was telling, and blurring or minimizing others that were beside the point. In Beckmann you might see one arm of a subject—if it's involved in a crucial action—painted with hyperintensity, and the other barely outlined.

All art is style, and in great art you cannot separate style from content. They are one and the same thing. As I was developing my painting style and techniques, I was juggling two very strong contradictory urges. What I saw in Degas's work was how he was able to socialize his invasive eye, his voyeurism, by painting just realistically enough to make the scene feel objective, to stand alone, thus absenting himself. Beckmann, on the other hand, brought his powerful emotions—his anger, outrage, passion—front and center. Beckmann's paintings scream, "Look how I am feeling!" I wished I could paint like Beckmann, but I couldn't. I have never had the confident certainty one needs to directly express raw emotions. As I'm painting, I struggle to legitimize and own the feelings that naturally arise.

I wrestle with how present or absent I am comfortable being. I don't know if it is my suburban upbringing or that I am just too uptight or polite, but even in the privacy of my studio I can be overly sensitive to how I might make others feel.

In *Departure,* an allegorical triptych he made in Berlin during the rise of Nazism, Beckmann painted the middle panel with a boat carrying an image of the Fisher King, a symbol of the Christ who captured men's souls in order to liberate them. He's holding a fishing net, but it's impossible to tell by the way he has painted the fish whether they're swimming into or out of the net. It's a brilliant visual trope, a kind of double entendre that feels entirely apiece with the work. I realized when I first saw it that Beckmann's ability to convey psychological necessity through the physical language of painting was a genius no less remarkable than Degas's craftsmanship.

In the end you have to paint your own way. Degas and Beckmann had talents and sensibilities that were uniquely theirs. But together they represented a split in me, a tendency toward two opposite directions—quiet, virtuoso design and bold, bravura gesture. They forced me to decide what kind of artist I wanted to be.

ROSS BLECKNER

Once when driving back to CalArts from a bar late at night, I hit and killed a dog that had gone off his leash. I was horrified and sad, and Eric, who'd been riding in the car with me at the time, spent the next hour talking me down, making me understand it wasn't my fault. I'll never forget his voice—so calm, steady, and reassuring. It's a voice I still hear in my head forty years later.

I consider Eric one of my closest friends, but our relationship has been complicated. At CalArts he was this really attractive young guy, and as a gay man, I didn't want him to think I was coming on to him. He never did anything to make me feel that way, but I was always a little guarded around him, more comfortable seeing him when he was with Lannie or in a group of friends. But I've found that Eric can be guarded also, that there are points in a conversation where I'll hit a nerve and he'll shut down. Then days or even weeks later, as if he'd been poring over things and decided to trust you, he'll plunge back in with remarkable candor.

In 1980 I saw Eric's first show at Ed Thorp. The full-color oils were amazing, but I also loved the glassines. They were paintings about the tissues

of identity, and because he'd made them on deli-
cate paper—one image layered over another—they
had this questioning, fragile feel to them that
I really liked. That was Eric: on the one hand
very strong and self-protective, and on the other
sensitive, empathetic, and above all consistently
loyal.

JULIAN SCHNABEL

Eric's a good man. He loves to paint. He had to
address a difficult issue—whether to make an
intelligent painting or a good painting. This
question will invariably pop up for the real
painters. Are these things mutually exclusive?
At one time the clever painting seemed to win
over the audience and be the fare of the day.
As time goes by and we grow up, as painters,
we are left to what interests us as painters;
and painting, and the ideas for some paintings,
becomes subordinate in order to accomplish
the extraordinary, which makes one feel like
a real painter. Ultimately the how and what
of the painting are inextricable. This is a
personal endeavor. It comes with the territory
of being involved with painting and the history
of painting, not always what body of work is
most known or popular, but rather the most
satisfying to the innovative ambition and
desire of the person who knows that they want
to paint for the rest of their lives. That's the
deal. And it's a miracle when the two elements
jibe in the same painting and with the public.
The goal is to be engaged and satisfied with
your work beyond your time of being popular
and until you die, and in the middle you enjoy
your accomplishments, if any, as a painter and
a person.

When I first met Eric I liked him and I liked his work. I even remember bringing someone to his studio on Walker Street to buy one of his paintings. He was making work on overlapping glassine papers; I guess, as a way to break up figurative drawing into something that would be more specific to him, his version of figuration, almost as though he was putting parentheses around what he was selecting. People were very self-conscious about their style, their approach, the way they brought the figure into reality. They were very aware that it was a moment in art history when figurative painting was making a comeback, and they didn't want to seem ignorant or imitative of the past.

As painters we all belonged to the same class. There was general agreement that painting was taking place in the arena of the rectangle, and that images not only stood for themselves, but were also part of a picture's surface. Painters from Brice Marden to David [Salle] were working with the notion of two-panel or more paintings, something we all did, and I was making wax paintings—cutting holes in canvases and gouging out grooves and then filling the backs in. Mine looked like a metal gate that you might see on a storefront, and then I painted something on top of that as if it were a found object. We were trying to invent a new painted language with the intention of making a radical new painting. But we couldn't have been more different as painters.

I didn't like being lumped in with what people were calling the neo-Expressionists. I thought it was stupid. It was just convenience and laziness to put everyone together because everyone's work was pretty different. I was working toward a new kind of freedom for myself, using any kind of ground. I was looking for something that couldn't be named or described. I still am, and probably most artists think that's what they're doing too, who knows?

In *CVJ*, a memoir I wrote in 1987, which to me was on-the-job-training notes, I referred to Eric's paintings as "anemic representations of memories." It was unfair of me. Everyone's entitled to his or her own memory. It was more a question of my needs. As a teenager I'd moved from Brooklyn to Brownsville, Texas, a tough, redneck border town. My adolescence seemed very different from the one that was represented in his paintings. My best friend killed himself while his parents watched football in the next room. I felt that Eric's images—the adolescent boy masturbating in a plastic kiddie pool or the thief stealing from a woman's purse—didn't address the violence in my life. I felt they had a yuppie-ish, suburban quality. Maybe that was the topic of his paintings that I needed to accept and not project onto.

Do I think I was hard on Eric? Yes. Have I grown up and become more appreciative of what he was

doing? I think so. I was so passionate back then. I took everything personally—the things I loved I stood up for, the things I didn't, I didn't. I remember Alex Katz standing on the sidewalk after my opening at Leo Castelli telling me that it was a very good show, and I said to him: It had to be or I'd kill myself. Then I thought: This guy's only trying to be nice to you. You can't just say thanks?

BRYAN HUNT

Even before I saw his paintings I had heard that
Eric Fischl was breaking the rules of painting.
Ed Downe, a collector and patron, had one of his
soirees at his house in Southampton. He was all
excited about a painting he had just hung by Eric
Fischl. As I walked by and scrutinized a minimal-
ist and meditational grid of an Agnes Martin, I
came upon Eric's painting *Sleepwalker,* depicting
an awkward naked boy peeing into a play pool,
painted in a loose and knowing way. It brought
you into a world of innocence and wonder, with
a touch of mischief. I wanted to see more. And
before long, Eric and I became friends.

In 1984 I had a VW station wagon that I wanted
to get rid of. I mentioned this to Eric. He knew
the car and said he was interested. So I pro-
posed an art/car trade. Eric invited me to his
studio, which was filled with paintings. They all
resonated with me—especially a large painting
of a child wearing a tutu in a washy and vague
interior with an oddly shaped mirror. The young
dancer is blissfully unaware, clearly somewhere
off in a pretend world, while everything around
her is ever so slightly out of balance. I asked
for $2,000 plus the painting for the car, and
Eric humbly agreed. Do the math—today I have a
timeless treasure, and the car, unbeknownst to
me, turned out to be a lemon. The painting hangs
in my living room and continues to kick ass.

. 10 .

BAD BOY

1981 – 1983

T HERE was a lot happening those early years of the eighties: shows, travel, lectures, debates and feuds with fellow artists, invitations to the Whitney and Venice *biennales,* and a glamorous social life I'd only read about in the magazines that were now referencing my art. It was a rush—and it was a distraction. Over the years I'd developed a set of work habits that filtered out my everyday life—money and career concerns, petty arguments, preoccupations with this person or that idea. I'd realized that left-brain thinking is not the language of painting. Anything you think you know, that you can reason with and put into words, inevitably produces images that are inert, stillborn, dead. But then again, I'm a narrative painter. I tell myself stories. That's very different from thinking.

Painting is a process that guides me back through complex experiences that at the time I didn't have words to describe or understand. It retrieves feelings and memories and brings them forward with clarity and resolution. Each one of my paintings is like a journey, a process to excavate nuggets of emotion, artifacts of memory, the treasures

buried in my unconscious. My imagery evokes feelings that were once too painful or too ephemeral or too embarrassing to articulate or even to remember.

One of my biggest struggles around that time was to find the right balance between spontaneity and preparation. It was a little like the uncertainty principle. I wanted my process to be part of my creative output, but the more familiar I got with my themes, the harder it was for me to be lost. On the other hand, if I depended entirely on my reflexes and started painting without any thought or organizing concept, I ended up with a big mess.

So I tried not to be wedded to my ideas. They're simply what got me to the canvas and beginning to paint. My desire was to make a meaningful experience, and I committed to each painting knowing that whatever reason I started with would at a certain point become dispensable like the scaffolding around a building or sculpture. Once I was into it, the painting took over. What I tried to do was create a painting environment in which accidents could occur. Discovery and revelation happened when images and relationships that were unexpected, and certainly unintended, cropped up on the canvas.

I began a painting with just enough to get me started: an image or the scrap of an idea. Nothing more. For example, I might have chosen an image of a person bending over to pick something up. I would ask myself, "What are they picking up? Is it heavy or light? What room of the house are they doing this in? What's the difference if they're doing it in the kitchen, the bedroom, or the garage?" The questions set the work in motion. The painting tried to answer them. I liked not knowing where I was going and trying to paint fast enough to catch up with where it was taking me. I wanted to be surprised and exhausted by the journey's end.

In 1981 I wasn't yet working from photos. I felt that it was through memory alone that the narrative could achieve emotional truth. I was suspicious of artists who used technology as an aid to

achieving realism. But at the same time, I rejected painting from life because it was too academic, tired, and clichéd. Painting from memory can also be incredibly frustrating because memory is highly selective. You might remember what two people in a room were doing, but you can't remember what each of their arms were doing at that moment or what the shape of the shadow under their chins looked like. As I was trying to make the scene appear real, I needed to know more details than I could possibly remember.

Alex Katz, the contemporary pop-realist painter, once told me that you have to learn to paint as fast as you think. If you paint faster than your ability to focus and concentrate, you will miss your mark—and if you paint slower than your inspiration, you'll get bored and distracted. When I was painting without the aid of photographs, I would get bogged down trying to render details I could neither remember nor see. The process was slowing me down, and it showed. There were areas in my work that were overwrought.

Then, early in 1982 while on a European junket, April and I stopped in Venice, where we met up with friends at the fashionable Lido beach. We were sitting around talking when I saw two lovely young girls taking off their tops. I immediately grabbed my sketchbook and began trying to capture the moment of their undressing. I couldn't draw fast enough, and as I became more and more frustrated, one of my friends grabbed his video camera and captured the whole scene. He then turned to me and asked why I didn't just get a camera. I protested the idea, believing as I did that it would corrupt the purity of my intentions. He scoffed, we argued, and by the time we returned to Venice I was looking for camera shops.

Working from photos changed my creative process. For one thing, it obviated the need to always tote around cumbersome sketching equipment. More important, it speeded up my brush. Not having to plumb my memory trying to recall the details of a scene, I was not only painting faster but also less self-consciously. I was letting

the painting tell me where to go next. I was responding to what the images were saying. One of the most valuable lessons I learned as an artist was how to be quiet and listen.

Painting faster, without the intrusion of conscious thoughts, enabled me to maintain a flow in my work. To some extent, that flow—an artist's natural rhythm—was dictated by my brushstroke. At CalArts there'd been a lot of conversation about brushstroke as signature. I came to understand the significance of how one holds one's brush. There are those who grip the brush tightly and use only their knuckles. There are wrist painters who begin to introduce a more sensuous gesture because of the longer stroke. By the time you get up to the elbow and shoulder painters, you're seeing larger canvases, broader gestures, longer strokes. And once you're into the shoulders, you're using your whole body, like Jackson Pollock or Mark Rothko. Understanding this somatic experience of painting helped me to define my voice and to find the natural scale of my imagery.

Unlike Chuck Close, who grids his paintings off and begins in the upper left corner and paints down to the lower right, I start with a large mess and work to refine it into a coherent image. I'm more like a sculptor with a blob of clay or a block of stone who works from the outside in. Along with discovering that I was an elbow painter and needed to work large in order to get my paintings to flow, I had to accept that I am impatient and need to work quickly.

Once I accepted this, I began to find my rhythm and voice as a painter. The rough, unresolved line with which I rendered my subjects, the speed and weight of my brushstroke, meshed perfectly with the emotional tone I was going for in my painting. That's the beauty and mystery of the creative process. Once you find a way to embrace your natural proclivities, all kinds of interesting connections and coincidences occur.

Take, for example, *Bad Boy,* a picture I made in 1981 that touched on themes of incest and voyeurism and is to date my most famous and notorious painting. Before its exhibition, I was viewed as just another

up-and-coming artist with one New York solo show on my résumé and a day job crating art. Afterward I became known as that sex painter from the suburbs.

The truth is my choice of themes was not entirely innocent. After *Sleepwalker,* I deliberately painted psychosexual subjects—the taboos of middle-class suburban life—and I wasn't altogether unhappy with the reputation it earned me. I didn't fully trust my painting skills then and felt that painting—especially old-fashioned realist painting—needed a little shock therapy to rescue it from the throes of modernist ennui. But I was also trying to explore those taboos, to express what they actually felt like and how they came to be, to expose their presence behind the prim, unexamined surfaces of suburban life, and to reveal their natural—or at least commonplace—role in adolescence.

AD BOY rendered a moment, fraught and mysterious, in the relationship between an eleven-year-old boy and a mature woman, possibly the boy's mother but perhaps his older sister, or a stranger. Set in a spare, light-dappled cottage, suggesting the anomie of summer holidays, the scene shows the woman lying naked on a large, sun-striped bed at the center of the canvas, her legs splayed, revealing the slit of her vagina amid a dark patch of pubic hair. She appears to be playing with her toes, paring the nails. But her languorous posture hints at wanton thoughts. What *is* clear among the painting's many possible interpretations is her self-absorption. She's indifferent to, or unaware of, the presence of the boy, who's standing in the foreground with his back to the viewer, staring directly at her sex.

The picture is about desire, voyeurism, appropriateness, and boundaries. It draws attention to the disjunction between the private and public spheres, between the woman's intimate movements, her indolence and sexuality, and the boy's—and by extension the viewer's—taut, penetrating gaze. The boy's age, of course, introduces Oedipal

themes that are underscored by his actions. Though painted in shadow, they show the boy holding the woman's purse behind his back, apparently stealing something from it, most likely money or a credit card.

Bad Boy equates the boy's moment of sexual discovery to a theft, with its attendant feelings of trespass, guilt, and an intense, vagrant excitement that the boy, it seems clear, will memorialize in all his future encounters. But if the boy is breaking taboos, so too is the woman. At the very least, her negligence makes her complicit in the boy's transgression. And viewed from another angle, she seems to be luxuriating in her sexuality, exhibiting herself seductively, indiscriminately, as a way of taunting or projecting power over the boy and, it seems clear, all men.

Bad Boy extended the larger themes running through my work—family dysfunction, the narcissism and careless inattention with which parents blind themselves to their children's needs and impulses, the suburban commodity culture that blurs the line between sexual and buying power, between genuine emotion and the superficial look of things. The boy is transfixed by the woman's private parts. He appears to want to possess and make love to her. But in the end he settles for a few coins.

Bad Boy re-created the troubling feelings I experienced during puberty when I saw my mother naked on a fairly regular basis. No doubt she felt it was natural, but I already didn't know how to deal with my emerging sexuality, much less the illicit impulses her naked body triggered in me. In this context, the boy is stealing from the woman's purse because he does not know what else to do, because he can't do anything else.

Bad Boy also drew on my evolving iconography. The bed that appeared enigmatically in my last painting at Arizona State, and then furnished the contemporary middle-class setting for my glassine series, now showed up as the rumpled, sun-barred arena of my adolescence, a suburban counterpart to the ancestral sea with its allusions to birth, creativity, sex, sleep, and death.

Over the years I've tried to understand the elements that contributed to *Bad Boy*'s notoriety. Certainly the shocking subject material lassoed people's attention. But I'd already mined that territory in my previous work, and many of my peers at that time employed a similar strategy, charging their canvases with a kind of prurient energy.

But all of that—the complex meanings and subtle gradations of feeling, the formal strategies, even the painting's critical reception and its practical effect on my career—occur to me in hindsight. When I recall the way I actually made *Bad Boy*—the process I went through at the time I was painting it—I remember a very different story.

Standing before the large blank canvas that would become *Bad Boy,* I had no idea what I wanted to paint. My first impulse was to make a still life of fruit, specifically bananas. The Italian proto-surrealist Giorgio de Chirico painted the greatest bananas ever, not fussy or overly naturalistic. I wanted to have a go at it too. So I painted in bananas and added some apples, and then I thought I'd put them in a glass bowl. After that, looking at it, I thought: Where is the bowl? It's got to be on something. So I painted a tabletop in the right-hand corner, and that got me looking for an interior, a room that the fruit could be in.

I still had no idea where I was going with all of this. But I'd seen an ad for bamboo curtains somewhere, and I'd liked the way they created this kind of stripey light. So I painted a room with windows and bamboo curtains and columns of light flooding in, then knocked in a wall color, a cool green color, and the combination of the bamboo and the green reminded me of a house in the Southwest—a bungalow or adobe house—at siesta time, when it's baking outside but it's still cool in the room because of the adobe.

That led me to put in a bed and people. But, who, I thought, was in the room? First I painted two people in a postcoital moment, but I couldn't get them in there. They didn't make the picture real enough. So I painted the guy out. That left the woman. But now I

wasn't happy with her position. So I rolled her over, exposing her to the viewer.

That seemed to work, but I felt she was not alone. So I tried putting different figures in the room with her. The eleven-year-old stealing from the purse started out as an infant lying next to the woman, then became a five-year-old sitting on the edge of the bed looking out of the window. He literally grew up in that room. I had no way of predicting what would happen. I just kept following it, working by intuition. I tried things that didn't work, things that seemed too forced. I painted things in and painted things out. As soon as I put in the eleven-year-old boy staring at her, I began to ask: What's he doing in there? Is she aware of him? I started seeing what was happening from his point of view, and things came together.

The creative process remains as baffling and unpredictable to me today as it did when I began my journey over forty years ago. On the one hand, it seems entirely logical—insight building on insight; figures from my past, the culture and everyday life sparking scenes and images on the canvas; and all of it—subject, narrative, theme— working together with gesture, form, light to capture deeply felt experience. But in real time the process is a blur, a state that precludes consciousness or any kind of rational thinking. When I'm working well, I'm lost in the moment, painting quickly and intuitively, reacting to forms on the canvas, allowing their meaning to reveal itself to me. In every painting I make I'm looking for some kind of revelation, something I didn't see before. If it surprises me, hopefully it will surprise the viewer too.

I FINISHED *Bad Boy* in 1981 and showed it the following spring at Ed Thorp's, where it made a splash with critics and the public alike. But I didn't stick around for the fallout. Exhausted from the effort of putting up a show, I took off to Europe with April, landing first in Venice. Later on we discovered St. Tropez.

We'd been driving around northern Italy, making our way along the coast to Aix-en-Provence, which April was eager to show to me. We stopped over in Ramatuelle, a pretty village outside St. Tropez, where an art dealer I knew had invited us to visit with his family. They introduced us to the beach life there, and we fell in love with it.

W E also fell in love with their home, a beautifully restored villa, parts of which dated to the eleventh century, with a walled-in courtyard and a gorgeous magnolia tree. Over the course of the next several summers, we rented it in exchange for drawings.

After leaving St. Tropez, we drove to Aix. But since April's last visit, the town had been overrun by condos and suburban sprawl, so we quickly headed back to St. Tropez. There our lives settled into a cozy routine, one that we would repeat over the next nine years. Mornings tended to be lazy. After late coffee, there was tennis and going to market, and around noon we'd hit the beach. It was six weeks during which April and I could be alone with each other, rediscover each other and what we were thinking. We hardly saw anyone else—1983 was still precomputer and precell—and didn't give out our phone number.

That time of year—May to June—the beach was never crowded, but there were always enough people around to make things interesting. Surrounded by unclad sunbathers, armed with my little camera, I would shoot picture after picture as the people lolled and gabbed, read and slathered sunscreen. My camera was so innocuous, they paid little attention to me. Even if they caught me photographing them, they almost never expressed concern or disapproval, perhaps because the French are inherently exhibitionistic/voyeuristic.

The beach was a revelation. Had I not experienced it, I would never have thought to paint it. We'd go every day. April would read, we'd talk, and I would photograph. I never questioned why someone doing something unusual held me spellbound. I trusted my instincts

and just took the photo. Back in my studio, months and even years later, as I went through the photographs, I would become once again entranced by that gesture. What photography did for me was capture the body in motion. I wasn't interested in big motions like running or jumping, but small gestures like someone shifting their weight or leaning forward. These small movements were the trigger for narratives. This woman twisting and bending was longing for something. This man turning away was afraid. And because these beachgoers were unself-conscious and unaware of being watched, their body language often betrayed how uncomfortable they were with their physicality. I often felt that I was witnessing minidramas between the body and the soul, the inside and the outside, being played out at that interface where skin touches the air and light.

What St. Tropez gave me was a way of painting people, of viewing their bodies as a currency of exchange—the dynamic relations that take place between people at the most basic, physical level. Naked, stripped of social indicators, they revealed attitudes and intentions hidden from everyday cosmopolitan life. I felt as if I'd stumbled into a primitive fantasy world, my Tahiti.

At other times, though, their naturalness seemed incredibly false. Their nudity struck me as so brazen and inappropriate, it felt forced, even farcical. And later, as our vacation wore on, tourists, mainly Americans—loud, obnoxious "garmentos" in their cowboy hats and bling—added another layer of artificiality and hedonism to the scene. I felt as if I was at the circus. Degas, Beckmann, and Goya had haunted places like this—carnivals, dance halls, cabarets, fantastic settings where the normal mores of society were suspended—and made paintings full of parody and pathos. It was incredibly stimulating for me.

April and I tried different beaches, but we always returned to La Voile Rouge. I loved the red-and-white color scheme of the umbrellas and *matelas*. I also liked the music, much of it a kind of pop-flamenco provided by the Gipsy Kings, whom we met and befriended. The group, which would become an international success in the late

eighties, was then playing weddings and parties, and sometimes ser-enading tourists on the local beaches. April and I brought them to New York and tried to introduce them to the music scene. But the trip was a flop. Either our timing was off or our music connections weren't very good. But we did spend one memorable day with them at a church in Brooklyn—the Kings wanted to hear gospel music—where we witnessed a spiritual rite of passage that would influence much of my later work. More about that later.

Meanwhile, the experience of being on a beach in St. Tropez and seeing nude men and women interacting socially was both an inspi-ration and an assault on my puritanical American background. I had mixed feelings about what I was witnessing: the confrontation with what was taboo, the absurdity of the taboo, and the absurdity of the scene itself. Seeing naked people behaving as though they were clothed had an undeniable element of comedy to it. There was also a racial element to it. You had these African men combing the beach, hawking baubles and approaching wealthy, fancy white women lying naked in the sun. As the men crouched down close to them to show their wares, their proximity created an uncomfortable tension with the husbands or boyfriends and even me. It's one thing to be naked on the beach with your wife. But the dynamic becomes different, more complicated, because of how Americans have mythologized the potency of black men. Later, when I painted these kinds of scenes, I thought I was capturing something that was particularly French or European, the way the foreign eye of David Hockney had captured Los Angeles.

But what it made me realize was that I'm an American wherever I go. I'm not particularly worldly or sophisticated. Though I'd painted many of my subjects naked and grown up in a house with parents who often went around without their clothes, I was shocked by my first visit to a topless beach. My mother's nakedness had made me uneasy. And I'd used nakedness in my paintings to highlight psycho-logical stress. It was very different from the open feeling the French

were expressing. They undressed to unwind, to free themselves from the constraints and conventions of everyday life. The only person who was self-conscious was me. I was the one responding to their nakedness with a mixture of irony, titillation, and disapproval.

I tried to capture this in *St. Tropez,* a large square canvas I painted when I returned to New York in the fall. The picture looks like a typical beach scene. Set against a rectangle of sky, a sliver of sea, and a broad expanse of white sand dotted with orange parasols, a chic blond woman in her thirties lounges in the foreground, her naked body propped up on one elbow and torqued at an unnatural angle. Standing behind the woman, a naked pubescent girl—likely the woman's daughter—and a tall, whippet-thin black man form a shadowy triangle with her.

The picture is trying to locate the blurry line between the private and public spheres, the natural and the artificial, the prurient and the appropriate. Though nothing much seems to be happening, the scene radiates a kind of inner tension for me. Both the child and the black man are looking at the back of the woman and she is oblivious to them both. Holding a bottle of suntan oil, her face hidden behind sunglasses, she gazes at something outside the picture frame. The girl smiles boldly but it's a forced, precocious gaiety. Her posture betrays the anxiety of her age—she's on the brink of becoming a woman— and she fusses with her ears, adjusting, it seems, a pair of earrings. The man—possibly an attendant or the woman's lover or merely a stranger—is the most disconnected of the three. Clad in a sarong— he's the only one in the picture wearing clothes—he's turned his body away from the others and placed his hands on his hips.

Despite the festive setting, this is not a jolly or even a relaxed group. (Several characters in the background—a solitary jogger, a reader, a woman unpacking her bag—mirror the principals' isolation.) No one is rollicking through paradise here. No one is luxuriating in—or even noticing—the natural beauty of the seaside. The people in *St. Tropez* may be naked, but they're not free. They're acting

according to social codes as well-ordered as the rows of evenly spaced beach umbrellas.

. . .

AFTER the success of the *Bad Boy* show at Ed Thorp's gallery in 1982, I could no longer ignore the upswing to my career. Increasingly I saw my name included in articles about where the art scene was headed. What's more, my paintings were in demand by name dealers and collectors alike. From 1982 to 1983, I had one-man shows slated for Sable-Castelli in Toronto, Saidye Bronfman in Montreal, Larry Gagosian in Los Angeles, Mario Diacono in Rome, Marian Goodman in New York, and Nigel Greenwood in London; and I was invited to exhibit in group shows at P.S. 1, the Whitney, and Sidney Janis's tony gallery on Manhattan's Fifty-Seventh Street.

Around the time of the *Bad Boy* show, I ran into Jean-Christophe Ammann walking through SoHo. I hadn't seen him since that fateful studio visit two years before. We stopped to talk and after the usual exchange of pleasantries, the conversation turned to my work. He told me he'd seen my new paintings and that he'd had time to think about what I'd been trying to do. "I misjudged [your old paintings]," he said. "I just hadn't been able to see it at the time."

It was one of the most gratifying moments of my career. The *Sleepwalker* show in 1980 had been a hit, and *Bad Boy* was a home run in terms of the reception it got. There was certainly a lot of positive energy coming out of those first two shows. But success felt uncomfortable to me. Perhaps that discomfort was a form of self-preservation, a way of countering my manic sense of hubris and guilt, the dark side of my competitiveness. All I know is that rather than creating a sense of elation, my success stirred up old fears and insecurities in me. I didn't really believe I deserved the rewards I was suddenly getting.

BUT those feelings did nothing to curb my ambition. After the *Bad Boy* show, I went in search of a new gallery, one that had the prestige and resources to carry me to the next level. I wanted to be seen as one of the artists creating the conversation of the eighties. I felt there were two galleries associated with the best of my generation. One was Metro Pictures, started by Helene Winer and Janelle Reiring, and the other was Mary Boone's. Metro was mostly showing conceptualist artists, many of them women. Mary had the male painters.

I asked David Salle to intercede on my behalf. In early 1983, David brought Mary to my small Reade Street studio to meet with me and to view my current work. But she didn't love the paintings I had up, and the tensions that are a part of almost any studio visit— the mutual expectations of artist and dealer, the desire of the artist to please, the dealer to respond, especially when the artist is friends with other artists already at the gallery—made Mary wary. She left on an inconclusive note.

THAT spring the eminent Spanish curator Carmen Jimenez put up *Tendencias en Nueva York,* an exhibition in Madrid featuring what she believed to be a new wave of American art. David, Julian, Keith Haring, Kenny Scharf, Susan Rothenberg, Bryan Hunt, and I were among the nine painters and sculptors invited to show. April did not join me on this trip. She felt hurt that she hadn't been asked to be a part of the show, and has never been comfortable as a tagalong. As soon as I touched down at Madrid-Barajas Airport, though, I regretted that April hadn't come. This was no ordinary event. The show's organizers had not only flown us first-class and installed us at the Palace, the city's poshest hotel, but they'd also arranged a series of receptions, dinners, and entertainments worthy of a state visit. Our little downtown art scene had suddenly become an international phenomenon.

One of the highlights of the trip was meeting Bryan Hunt.

Roughly my age, Bryan exploded on the New York art scene in the late seventies. Linked to a group of artists who were exploring sculpture and illusion, he manipulated materials to create images like bronze waterfalls and lakes. I'd seen and admired his work in gallery shows and at a recent Whitney Biennial.

Bryan had a reputation as a wild man—hard-drinking, outspoken, combative, larger than life. I remember hearing about him at the Odeon, where he'd had dustups with Richard Serra and Larry Gagosian. What I didn't know was how much fun he could be.

At the opening dinner in Madrid, our hosts treated us to an exhibition of flamenco—an incredible show, in the middle of which Bryan, stoned and inspired, got up onstage and started dancing, delighting the Americans present but horrifying our Spanish hosts. Not knowing Bryan, they felt he was parodying the other performers. In fact, he was only trying to show his appreciation. But it ended the evening's entertainment abruptly.

A group of us left together and decided to hit the clubs. Bryan was really feeling it now and wanted to continue dancing. It took some time to hail a cab, and by the time we did, Bryan had already become a legend among Madrid's demimonde. Our cabbie asked if Bryan wasn't the famous American flamenco dancer.

Spain was in the midst of a renaissance. Franco was dead. People were waking from a nightmare of repression and backwardness, reaching out from their forced isolation. Their economy was growing and the energy of their youth was driving the country into the future. They were eager to connect to the outside world through the arts, as well as to showcase their artists' fresh voices of liberation.

All the artists were feted for four days straight. The Spanish live their lives according to a schedule unlike anywhere else I've been. Stores open at eight A.M. and close at noon for lunch and siesta, then reopen at four P.M. and close at eight P.M. Dinner doesn't begin before ten, and more often midnight. The day ends around four in the morning. When you add to this the generous amounts of cocaine that were

handed out to us during our stay, we slept very little and ran around Madrid with a manic high.

On our last night in Madrid, a grand party was held in our honor at a private home on the outskirts of the city. Our host was a prominent commodities trader rumored to be a partner of the American tax evader Mark Rich. A fleet of limos picked us up at our hotel and ferried us to a gated enclave. The property was completely enclosed within high brick walls punctuated by lookout towers. Armed guards patrolled the perimeter, carrying machine guns.

When we arrived, our names were checked against a list and our car scanned for bombs. Finally the gates parted and we drove up a long road to a contemporary house filled with steel and glass. A glass igloo sculpture by the Italian artist Mario Merz stood in the middle of the driveway.

Our host had a penchant for exhibiting his art collection in unusual places. He'd stuck a huge steel Richard Serra sculpture in the middle of a tennis court and placed a large photo collage by the British duo Gilbert and George on a wall obscured by a steel beam. With seeming disregard for its structural integrity, he'd cut holes in the beam so that viewers could see more of the piece. Encouraged to explore the house, I stumbled into the spa; just outside a steam-room door hung an El Greco. Later I found a sublime Giorgio Morandi still life mounted to the inside of a closet.

The party itself was surreal. A glamorous crowd milled around—some dancing, others naked. The waiters carried trays of champagne and offered guests a choice of cocaine or heroin. I was never formally introduced to our host, but from time to time a short, thin man in a silk smoking jacket would sidle up to me and ask if I needed anything more. The way he said "more" made me curious what he could possibly have in mind.

I am sure there was some lesson to be taken from the scene. Commerce corrupts art, or corrupt commerce corrupts art absolutely. But whenever I ran into Bryan and the other American artists we would

start laughing, enjoying the thrill of our new success. We were on a joy ride, and the world was putting on a show for us.

And there was another sensation, one I didn't identify at the time: the queasy exhilaration and shared intimacy of a group losing its innocence. Maybe it was the guns or the audacity of the money and trinkets and drugs showered on us, but you can't rub shoulders with that kind of lifestyle, I realized later, without some of it rubbing off on you.

JULIAN SCHNABEL

Markus Lüpertz showed up in town and was run-
ning around in sweat suits, like he'd become this
superathlete, a boxer or something. One afternoon
we happened to be at the bar in the Odeon and
he challenged Eric to an arm wrestling match and
Eric said yes and beat him. I was very proud of
Eric, the way he did it—very low-key—and I don't
want to sound sentimental, but he made me proud
to be an American.

. 11 .

MAKING IT

1983 – 1984

B ACK home from Spain, I began looking for a bigger place to work and was able to rent a studio on Canal Street overlooking the Hudson. Back then, there was almost nothing in that area of the city: a bodega, a liquor store, a gas station. In the morning and at night, the streets were filled with the sound of blaring horns as rush-hour traffic jammed into the Holland Tunnel. One day I remember watching one of the West Side piers catch fire and burn down. It took several days. The city must have decided it wasn't worth saving and posed no danger to the surrounding buildings because nobody tried to put it out. It added a surreal feeling to the isolation and strangeness of the area. I remember the *QE2,* its luxurious decks filled with waving passengers, slowly gliding past the burning wreckage.

The space I rented was owned by Larry Rivers, one of the precursors of pop art, whose groundbreaking work and knockabout life crossed all boundaries and defined what it meant to be an artist in the mid-twentieth century. As a teenager in the forties, he befriended and played saxophone with Miles Davis and Charlie Parker. He took

up painting in his twenties after seeing a cubist work by Braque and studied with Hans Hofmann in what turned out to be the studio apartment that April and I would buy on West Ninth Street. His early charcoal and rag-wipe canvases that mixed realist and abstract imagery were revelatory when they burst onto the scene—a bridge between the abstract expressionists and later generations. Many artists, Warhol among them, considered him the godfather of pop art. But formalist critics thought his use of figuration and the handmade was retrograde—a critique I knew only too well.

Larry was one of a kind. Though he was deadly serious about his art, his personality eclipsed his many achievements. For me he embodied the freedom and playfulness and antic bohemian spirit of the pre-eighties art world, before it became impatient with eccentrics. It would take me years to fully appreciate those qualities, and by the time I met him he was no longer the gorgeous young man who'd had romances with men and women alike, did drugs, and carried on. But he talked openly about those days with great humor and irreverence.

It seemed like a coincidence that I was renting a studio from him on Canal Street and later would be living in the brownstone on Ninth Street where he'd been a student. But New York's art world is physically so compressed that you're constantly bumping into history, and its clock so accelerated that half the time you don't realize it. At least I didn't. As a landlord, Larry was totally hands-off and always accommodating. Though we talked on the phone, I didn't meet him in person until a couple of years after I moved in. Then he invited April and me to dinner along with his third wife, the young East Village artist Daria Deshuk.

He introduced me to his friend, the poet Kenneth Koch. It turned out that Kenneth and I shared a passion for tennis, and we ended up playing for a few years before his body gave out. Until I'd met him, I'd never read his poetry nor knew his stature in the poetry world. But after we met I did some catch-up reading and realized the character he was in life was not far from his poetic persona—erudite,

wickedly funny, and flamboyant. He was an even quirkier character on the tennis court. With his cloud of white-gray hair floating above his tall, gangly, unathletic body, he sported an ascotlike scarf and pranced around like an ostrich. I could never tell if he thought he was parodying a Waspy country clubber or if he just didn't have a clue. That said, he was a ferocious competitor (poets, I've found, tend to be extremely competitive) and quite a good player. At the start he would beat me regularly. But I never minded because he was so entertaining. He would turn our matches into epic battles between gods and mortals, making up Homeric commentary as he pummeled me with his forehand.

He invited April and me to dinner any number of times, with Rivers; Jane Freilicher, the wonderful landscape painter; Jack Youngerman, the pop-abstractionist painter/sculptor—people who had broken new ground in the art world when I was still just a child. With a better grasp of history I would have appreciated how lucky I had been to be accepted into their company. But then it wouldn't have been as much fun.

BACK then the New York art world was seasonal, and April and I plunged into the rounds of autumn openings, gallery dinners, and parties that would set the tone for the rest of the year. But over the course of the summer it seemed as if the venues had changed, as had the atmosphere.

SoHo itself was in transition. The Spring Street Bar had been replaced by an upscale eyewear store. Art shops calling themselves galleries and displaying cheap reproductions of contemporary art in their large, clean storefront windows started pushing out the raw, grungy street-level spaces where radical artists had once exhibited their work. You began to see more people pushing baby strollers, walking dogs on leashes, carrying briefcases. The city tried to restore the cobblestone streets, and that snarled traffic and kept the jackhammer noise

going for several years. The borders of SoHo were peopled with the homeless, passed out or panhandling or aggressively washing car windows at traffic intersections. But inside its precincts, SoHo began to feel like an enclave, where it once felt like a neighborhood. Weekdays it thrummed with the sound of people on schedules. Weekends, tourists and bargain hunters descended on West Broadway, turning it into a carnival thick with street vendors selling photos or incense and knitted hats. The air smelled of garlic and fried meats, and techno music threaded through the side streets and vibrated on the sidewalks outside hip boutiques and coffee shops. Artists began moving out.

New York's economy had also changed. Its suddenly booming real estate and equities markets had spawned a new class of collectors—moneyed, brash, aggressively acquisitive, socially mobile, and tuned to fashion and status—and the art world was suddenly attracting glittering first-night crowds that included stars from Wall Street to Hollywood—Paine Webber CEO Don Marron, CAA's Mike Ovitz, Sean Penn, and Matt Dillon, to name a few. Affairs at upscale restaurants and in the lavish uptown homes of the collectors were increasingly the norm.

But the glamour and excitement came with costs. Two years before, I was living on $1,000 a month. Now it had risen to several times that. I'd discovered I could defray some expenses by swapping my work—sketches and preliminary paintings—and the art world, suddenly flush, underwrote a portion of my social life. What's more, having worked to support myself since my teens, I was judicious with money. But now I was taking taxis instead of the subway, drinking wine instead of beer, fine wine rather than screwtop or Gallo. I had started out wanting just enough so I could focus on my painting without feeling I had to make work to support a lifestyle. Twelve thousand a year had been plenty. What surprised me was how fast you grow into living on more. What had once seemed a fortune to me became something I could easily spend in a year.

Cigars and cocaine were two habits I acquired as accoutrements of

success, and I indulged both enough that I actually had to budget for them. I was getting contraband Cuban cigars sent to me via Switzerland and smoking about four a day. Cocaine was also a fairly harmless pastime at first—the perfect accompaniment to those supercharged times, an extra gear at the end of long, productive days and celebratory nights out. But by 1983 my occasional use had turned into something more. I was no longer gassing up at the invitation of friends and dealers and even a few collectors who happened to be carrying. Now I was trekking uptown to Hell's Kitchen to buy my own supply from a dicey character who was clearly in the throes of addiction.

One night at the Mudd Club, the artists' and musicians' hangout in TriBeCa, I got so wrecked I began having heart palpitations. At its most serene the Mudd Club, with its live bands, cramped dance floor, and zonked-out denizens, was like the subway at rush hour—a long, narrow, airless, clanging container. I happened to be at the rear when I felt the sweat pouring down my face and neck in sheets. I felt hemmed in from all sides and doubted I would make it out of there. The faces of friends and acquaintances and one or two creeps I'd been avoiding melted—along with the feelings of euphoria and camaraderie I'd experienced only moments ago—and swam together in the corridor of dim light that led to the exit. I realized I was going to die and they wouldn't notice. My heart beat faster.

Fortunately, April *did* notice and appeared at my side like an angel and guided me out to the street, where I quickly recovered in the bracing cold air. I'd had a moment of paralytic fear, a sharp hiccup in the rise of my heady young career. My body and my brain—not to mention April—were telling me to slow down. But as I sucked down oxygen, I wasn't listening.

IKE any ambitious young artist, I was feeling pressure—both from others and from myself—to maintain my high-octane life, to cultivate the new collectors and museum directors, to prime my career in

the company of celebrities from other worlds. Often I'd be at events where everybody was a somebody and I felt I was just trying to fit in.

Lost in the shuffle was a simpler, grittier way of life—anonymous hours in the studio, nights hanging out in bars and at loft parties with other artists talking about art or, more likely, plumbing. Another casualty was friends who could not afford to keep pace with the vector of my success or, like April, didn't want to be reminded of the recognition they weren't getting. And though I tried to bridge the divide between my new and former worlds, it was mostly a losing battle.

As hard as success had been on my friendships, it was harder still on my relationship with April. Having met her when she was a student, I'd been a few years ahead of her in making and showing my art—an inequity we'd been trying to erase, or at least ignore, since coming to New York. But my early recognition widened the gulf between our careers. Sometimes at events or dinner parties she was made to feel invisible or merely an accessory to my life. She would often accompany me and be a good sport about it. But back home, she would let me feel the full weight of her misery. I couldn't blame her. I would have felt the same or worse, but I needed her to be there. I needed her to be at my side, giving me strength, keeping me tethered, keeping me real. I needed to have her there to share the experience with me so we could go home and laugh about it, about how stupid the whole thing was.

Ironically, by any normal measure, April was a very successful artist. Her work was selling well and she was beginning to stir up interest among elite collectors and museums. But she's also extremely competitive, a big talent with a big ego to match. She felt no less capable than David or Julian or me, and at times resented our hyped-up celebrity. To make matters worse, there was a perception in the art world that she was benefiting from my success, and I feared that she wouldn't be able to get out from under my shadow. It's not that I didn't want my success. It's that I didn't want it to drive a wedge

between April and me. As much as we loved each other, we had to work very hard to stay together.

Success also sharpened existing rivalries and roiled friendships among the painters at the top of the pyramid. For those who are ambitious, there's never enough success. Having a "seat at the table," my contemporaries and I began jockeying in earnest to make our individual visions for contemporary art iconic. My chief nemesis—and in some ways my prime benefactor—was Julian Schnabel.

My generation was a tipping-point generation. We were brought up on the existential drama and bohemian morality of the abstract expressionists. The heroic, gestural canvases of Jackson Pollock and Willem de Kooning—documenting the act of creation itself—and their pugnacious, often self-destructive lives bequeathed us an image of the artist as an angst-ridden, romantic rebel. The generation that followed them, the pop artists, reacted against their perceived self-importance and moved the focus of art from the anxious self to the iconography of glamour and consumption. So subtle was their humor and irony that you had no idea if their work was critical or reverential of the materialism it pictured.

But the conceptual artists that followed in the seventies were clear about their rejection of big art: the traditional forms of painting and sculpture. They'd begun not only to devalue the art object but also to dismiss it entirely. Their work was weighted to the intellectual and philosophical side of art making. The heroic artists, the makers of grand gestures, were now in retreat. Those who were still making objects were creating personal, idiosyncratic art, like gluing feathers to paintings or inserting wire mesh into gallery walls, minimalist strategies with an emphasis on art as an act of self-creation. Joel Shapiro put a three-inch bronze chair he'd made into an otherwise empty 3,500-square-foot gallery. Sol LeWitt substituted a set of instructions for the actual artwork. And then Julian came along, kicking painting back up to a grand scale. He began making huge, gestural canvases using broken plates and other overlooked materials to expand

the possibilities of picture making. He literally crashed through the cerebral nuances of minimalism or the cleverly quiet "it's just me over here making this little doodad to blow your mind" art of Richard Tuttle, Jonathan Borofsky, and others. Julian reminded you that it was once exciting to go to see paintings. And he created this over-the-top persona and extravagant lifestyle between downtown and the Hamptons. There was such grandeur to it.

That grandeur would affect me in contradictory ways. Ultimately I'd come to respect it. Without Julian, so much wouldn't have happened. He attracted so much attention that it spilled over onto all of us and gave us space to be creative and take risks of our own. But at the time I thought his antics clownish and I perceived him as a threat.

ROSS BLECKNER

I introduced my CalArts friends to Julian, and he
was always generous to them, helping them when-
ever he could. But for some reason he and Eric
didn't get along. I think Julian felt competitive
with Eric, which is crazy because they were very
different types of painters—Julian's paintings
were much more in a European tradition—and at
that stage he was more advanced than Eric. But
I couldn't even get them to talk to each other.
Once at David's White Street loft, I had to break
up a fight between them, and later when Mary
decided to represent Eric, Julian got all bent
out of shape. He felt he'd made Mary's gallery a
success—which to a certain degree was true—and
that now she was using that success to leverage
the careers of her other painters, packaging
David's and Eric's work with his new sales. That's
why Julian left her for Pace; but even before
then it was a real boys' club over there—macho,
competitive. We were full of ambition.

. 12 .

CONFLICT

1984

"I DON'T know how you make the paintings you make." The voice—reedy, plaintive, provocative—belonged unmistakably to Julian Schnabel.

I was sitting on a fifties-style couch in David Salle's exquisitely remodeled White Street loft talking with a friend. We were at a party that David had thrown to celebrate the opening of one of his early shows at Mary Boone's SoHo gallery, and I was buzzed. Partly it was the champagne that David was serving. But I was also drunk on the atmosphere. That evening marked for me a change in the attitudes of the art world. Young artists, suddenly flush with cash, were shedding the gritty bohemianism of the seventies and embracing a modish up-scale urbanity. In addition to the sleek modernist decor, David's affair boasted a catered buffet and the moneyed din of polite conversation and gently clinking crystal. Sean Penn and Madonna lounged nearby.

So I didn't react at first to Julian's baiting remark or his huge shadow spanning the couch. In my relaxed state, it took me a second to realize I was under attack. And even when I looked up and saw

him looming over me, practically straddling my legs, I wasn't sure whether he was joking or serious. But then the room went quiet and I knew I'd been dragged against my will into one of Julian's creations. I stood up, prepared for an old-fashioned Cedar Bar–style tussle. I thought he was going to take a swing at me.

Julian and I had our differences. When I first arrived in New York, I turned down an offer to exchange paintings with him. I just didn't see anything of his that I wanted. He had such a grandiose personal style—so blustery and nakedly ambitious—it felt like a pose. I didn't trust it, and it influenced the way I looked at his art, which I felt was derivative of European expressionists like Beuys, Gaudí, and especially Tàpies. It was actually shocking to me. After so many American artists had fought to overcome Europe's cultural hegemony, to develop an American voice—not only in art but also in music, film, ballet, and literature—he was handing back power to Europe, power that we'd wrested from them in the postwar years.

His work seemed nostalgic for the good old days when men were men and painters were men and their paintings, larger than life, were worth fighting over. For Julian, the history of twentieth-century art went something like this: Picasso, Pollock, Schnabel. End of discussion, period.

Not trading pictures with him was probably dumb. That kind of rebuff would have pissed off any artist, no matter how humble or thick-skinned. I can only imagine how Julian took it. What's more, I'd made no secret of my opinions. I was a lot feistier in those days and the art world a lot smaller. We all knew each other, hung out with each other, watched each other's work and careers closely. There was no way Julian wouldn't have gotten wind of my criticism of his work.

That's what I thought as I waited for the first punch to be thrown. But Julian had a different kind of pummeling in mind. "Have you ever seen blood drying in the *corrida*?" he shouted at me. "Have you ever walked alone on the beaches where Caravaggio walked?"

The short answer was no, but I let him finish his litany. It didn't

take a genius to see what he was getting at. He was saying that I didn't have authentic feelings, that I hadn't lived—at least not according to his über-romantic notion of how an artist experiences life—and that until I underwent what in his mind were essential rites of artistic passage, I couldn't paint. What he was dismissing out of hand was the suburban context of my work and what he saw as my banal family dramas. But he was really venting about his own painting. I started laughing when the allusions got too overblown, and Ross Bleckner, I think, came over and mercifully defused the situation.

It was a silly confrontation spawned by my hubris and his bluster, and it didn't lessen the enmity between us. Beneath the glittering surface of scenes like David's party, the old art world—full of rivalry and wrangle—was still alive and well, and it highlighted a fact of life that both Julian and I would have to deal with. Along with David, we represented a return to painting—what the press was calling neo-expressionism. As a result, we would be linked together through much of the eighties. It didn't matter that our personalities and painting styles couldn't have been more different. What we had in common was that we were ambitious and we were male. In the public imagination, we were three young artists swinging for the fences.

The art world as well lumps together certain artists, based on some notion of success or notoriety, and then defines and categorizes them in terms of the others' work and personalities. These groupings can seem pretty arbitrary. But the pressures they exert—both collaborative and competitive—have real effects on the artists and their work. I've always felt lucky that I was able to show my paintings in the context of David's and Julian's. Part of the reason has to do with the power of their art, my initial criticism of Julian notwithstanding. But it's also because of the risks they took at the start of their careers and the possibilities they opened up for other artists who followed. I always thought, for example, that when I was making my psycho-sexual suburban paintings in the early eighties I'd get a bad rap from the feminists for my portrayals of women, some of which were pretty

unflattering—and for a long time I wondered why I didn't. But looking back, I realize David and Julian were running interference, absorbing the shocks that allowed me to tackle a sensitive subject without prejudice. David's use of pornographic images, for example, deflected a lot of criticism away from me and made him—unfairly, I think—the misogynist. And Julian, because of his macho persona, became the male chauvinist. By comparison, I was regarded as the sensitive one.

Gratitude, though, was not something I was feeling at the time. David and Julian were already established stars when I had my breakthrough *Bad Boy* show, and their paintings were thought to be edgier or more progressive than mine. Throughout its history, modernism has evolved via a dialogue, usually conducted by the two leading artists of their time. Picasso and Georges Braque, Jackson Pollock and Willem de Kooning, Jasper Johns and Robert Rauschenberg were some of the emblematic pairs whose collaborations and rivalries resulted in innovations that drove the canon forward. In the early eighties Julian and David were those two, prodding each other, drawing from each other's work, redefining what a painting could be. I was jealous of them. I wanted to crash their conversation. Fortunately, there's a third dynamic that seems to repeat itself over time—the thrum of a slightly retrograde traditional painter who provides a baseline for the avant-garde to react against, to measure how far their art has advanced. Matisse played such a role to Braque and Picasso, as did Balthus to the surrealists Max Ernst and René Magritte, Alex Katz to pop artists Warhol and Roy Lichtenstein, and Chuck Close to process artists Robert Ryman and Agnes Martin. And I think people regarded me as the realist against the polar extremes represented by Julian and David.

I not only recognized this association but also actively sought to promote it. The main reason I was angling to join Mary Boone's gallery was because Julian and David were there. I did not want to be part of a tradition—or more specifically a gallery—where I'd be seen

as one more American realist painter. I wanted to be compared to the best young painters of my generation.

I N the seventies and eighties, my generation of artists struggled with two overriding issues. Having broken with tradition, we were all trying to define ourselves, to create a new individualistic art that was authentic and compelling. Second, we were trying to make each other believe that ours was the most iconic art, that our personal works told the most captivating, the most universal story.

Ironically, our legacy would be diversity. The very thing we fought for and won as a group—inclusion, pluralism—we fought against as individuals. Or at least I did. There were so many marginalized minorities backed up at the door—women, blacks, Latinos—each competing to make their story and their art dominant, and so little consensus about what was good or right or relevant, I felt I had to prove myself at every turn.

My main competition continued to be Julian and David. Like me they were reintroducing imagery into their paintings, but they were also making art about art. I was trying to make a more direct connection with the viewer. I didn't want him looking at the art first. I wanted him instead to enter into the world of my pictures. Once I had him inside, I knew he'd try to get out. He'd be thinking he shouldn't look at the stuff I was painting—scenes of masturbation, incest, voyeurism—but he wouldn't be able to help himself. The only way he could get out of the painting was by dealing with it.

Like Julian, David was working with fragmentation. He was layering his paintings—using stains, stencils, and bits of cloth instead of shattered plates—breaking down images to reveal where their power comes from, showing you how a painting works by taking it apart. I was on an opposite track. I was coming from a place in my background that was already broken. I was trying to put the pieces back together. I was aiming for something much more holistic.

There are two kinds of painters. One you remember for their style and energy. They're this big authentic presence. Seeing their work is a physical experience. It goes straight to your nervous system. Jackson Pollock's drip paintings are a perfect example. When you try to recall them, you remember their overall effect, their energy and power. But the paintings blend together in a more general impression. You can't remember whether that blue line is in *Lavender Mist* or *Number 3*.

Julian and David belong to this category of painters. You feel their incredible energy: Julian's impressive use of scale and David's remarkable command of the rectangle. But individual canvases don't come to mind.

I belong to the second category of painters. I try to create images so poignant they burn into your brain, not to be forgotten, like the boy masturbating in *Sleepwalker* or the adolescent voyeur/thief in *Bad Boy*.

But our differences weren't always clear-cut. There was a lot of overlap in our work. Some of Julian's images *were* memorable, and they were always sincerely drawn. And I thought David's paintings, for all his ironic posturing, alluded to relationships and events in his life. For my part, I was never a pure realist. On the contrary, one of my main preoccupations was with how factual I needed to be, how little detail I needed to include to get across what I wanted to say, how much I could leave out before my imagery tipped over into abstraction. Like Julian, I was also working with scale. And I would soon be making my own multipanel canvases, which like David's were attempts at deconstruction, a way to address the formal aspects of my painting.

All of which added to my frustration and competitiveness. I didn't possess David's graphic imagination. There were so many things going on in his canvases, so much energy in balance and harmony. I felt like a poor troubadour going up against a symphony orchestra. And I couldn't measure up to Julian's use of scale. Unlike most artists, the

bigger Julian paints, the better he is. I felt as though his work was the embodiment of my internal drive. I wanted what he wanted.

Worse was the feeling that I couldn't achieve my ambition without them. Only in the last year or so had the market for new contemporary painters shown signs of life. There was no road map for our generation's success. What we were trying to do was untried. I'd just quit my day job as an art transporter. Given the fickle nature of the market, I didn't see how the current art trends could go much further or how I would fit in if they did. But I understood my fortunes were tied to the success of my painting peers—principally Julian and David—and that I benefited each time they mounted another sold-out show and their prices bounced.

None of which eased my combativeness or smoothed over my thorny relations with fellow artists. I believed strongly in the pictures I was making and the rightness of my approach to painting. I was not as loud in my pronouncements as, say, Julian, but I wouldn't back down from anyone. Shortly after my scrap with Julian, I found myself in the middle of a screaming match with David, my close friend and the contemporary artist I admired the most.

We were on our way to his studio after seeing some downtown show. Ostensibly about art, the disagreement bled into issues of personal style and psychology and triggered a rift—the longest to date—between us. The argument started when David complained to me about critics who didn't understand his work. David had been trying to leech meaning out of highly volatile imagery—the imagery of movies, fanzines, pornography. In my view he was trying to subvert the language of advertising, popular culture, and art history by making art that had no meaning.

But David, I thought, was not being candid about his strategy, in effect stonewalling the public and those critics most interested in his art. At that time, David was not saying anything helpful about his work. Then he was surprised—and privately hurt and confused—when people didn't get it.

As we ambled through TriBeCa on our way to David's studio, I questioned the wisdom of David's inscrutability. Then, when we crossed onto the TriBeCa triangle—a traffic island formed by the intersection of Hudson Street and West Broadway—the conversation took an angry turn. It became apparent to both of us I didn't believe David's professions of randomness. I felt his work came out of personal experience and that he wasn't copping to that fact or admitting that it was part of the experience of viewing his work.

We had opposite approaches to making art. He claimed there was no emotional or personal content in his work. There was just painting and the formal problems that come with that. His paintings were lightning rods for attack by feminists because he often used images of women that were unflattering or demeaning. He insisted his work was absolutely meaningless, which is the ultimate declaration of "meaningfulness." Yet he was deeply hurt and confused by the criticism he received.

I felt there was no such thing as being arbitrary when it comes to making art. Each choice reveals something about its creator. Therefore one had to take responsibility for one's work.

He considered my ideas sentimental. And many artists at the time believed it was intellectually sexier to create an art experience that left the viewer feeling frustrated and isolated by the artist's indifference. It was more radical—a good thing—to not care.

But having known David as long as I had, I didn't buy into his professed indifference. Nor was that something I thought he was capable of. I've always seen an emotional thread in his work mirroring where he was in his life. The questions of love and loving have always been his thematic arena. Love of culture, of style, and of women has been an essential aspect to his art. Looking at his work, you could always see when he was happy in a relationship, struggling with a relationship, or ending a relationship. His paintings were expressions and celebrations of pleasure—elation from being in love when it's good; bitterness when it turns bad; anger, cruelty, and regret when it's over.

It's an honest expression of feeling and something that I've always ad-
mired about his work. But he would not admit to it.

I thought his paintings were very consistently about men and
women, objects of desire and the anger directed at those objects,
and the frustration of that desire. And I also thought there was a
self-deprecating element in the work that wasn't being talked about.
All the male players in his paintings, obvious stand-ins for David,
are comical—camel faces, drunken Donald Ducks, clowns, dancing
bears. At the time, David was going through a disastrous marriage.
His wife became clinically crazy and eventually killed herself. The
anger over that would naturally show up in his work. But he wouldn't
own up to any of it.

With traffic whizzing by as we stood on that island, we hunkered
down, me propounding my ideas about narrative art and David in-
sisting on the meaninglessness of his. It became a heated exchange.
I argued he shouldn't be making paintings like that, while he said
he was sick of me psychoanalyzing his work. In the end both of us
shouted: "Fuck you!" It was the last time we spoke to each other for
several years.

In retrospect, I believe my work had more in common with
David's than I realized at the time. One of the reasons we had such
a volatile relationship early on was that we were working the same
territory. We were both trying to figure out our relation to the world
around us. David chose to create a much bigger ironic distance to the
desperation and disappointment in life, and I thought he wasn't being
honest about that. But he was. He could take those deeply personal
experiences and create a large distance, almost a disconnect. He could
express anger in a way that I couldn't. His strategy of meaninglessness
or randomness was significant, but I had to get past my own youthful
ideas to see it.

Competitiveness in art is often unavoidable; the public has a need
to create rivalries, even where rivalries or animus do not naturally
exist. What's more, artists tend to have big egos—none bigger than

Julian's, but David's and mine run a close second—and strong convictions. We want our voices heard, our visions to prevail. But changes in the art world's ethos had raised the stakes of success and sharpened the tensions among us. Shortly after my scrap with Julian, he and David, good friends until then, fell out over their own proposed exchange of paintings. (David delivered his picture first. Julian then unveiled his offering: a cartoonish portrait of David he'd painted over David's original canvas.)

All that fighting may have been part of the times. A desire for high romance, of wanting things to mean so much even if we all feared they didn't, that we'd been eclipsed by other media, that the world was so much bigger than painting alone. I wanted a Cedar Bar experience—that triumphal moment in the New York art world when the city's legendary postwar painters gathered in a derelict tavern to drink, argue, and sometimes brawl over the big existential questions of modernism and God knows what else. It's not that I wanted to perpetuate the exclusively white, macho male domination of painting. I just wanted to be reassured that it all really meant something.

DAVID SALLE

I had a particularly explosive argument with Eric
one time at Magoo's, which was an artists' bar in
TriBeCa. I don't remember exactly when it took
place, but it must have been early—because nei-
ther of us had any money or else we wouldn't have
been eating at Magoo's, which was a real low-down
hamburger joint whose only redeeming feature was
that its owner traded food for art.

The argument, I believe, started out as a dis-
agreement over Julian's work. Julian had just
begun showing, or was just getting ready to,
and there was already a kind of hoopla sur-
rounding him and his work. Eric was offended
by something—the kind of gold-plated aura of
Julian's early success, something, I don't know.
Probably he couldn't separate Julian's ambition,
which Eric felt was self-elevating, from the
work itself. I don't think he trusted the mo-
tives behind Julian's paintings—he thought the
emotionality in the paintings was secondhand. It
was like, "If this guy is right, then everything
I'm doing is wrong." Looking back, I think Eric
was involved in a deeply personal struggle to
find his authentic voice—that's what the years
in Halifax had been about—and he had come at it
via folkloric/mythological imagery and so forth,
and it had a modesty and even humbleness to it.

And here comes Julian, a seemingly fully formed avatar from another, more heroic time.

Ross had introduced me to Julian a few years before this, and we had become pretty good friends, but he and Eric never seemed to find much common ground. I thought a lot of Eric's criticism of the paintings was personal: he was letting Julian's personality color his reactions to the work itself. But it was also aesthetic, in the sense that if you're an artist, the aesthetic is personal. For some reason I felt as though I had to take a stand against what I saw as Eric's intransigence and defend Julian's work. Instead of simply saying I liked Julian's work and letting it go, it became a point that had to be "proved"; in the heat of that moment, it seemed crucial to get Eric to see something, I don't even remember what. I guess I wanted him to see me. I tried defending the work on formal grounds, which is futile because there is no agreement on what is "real" or ersatz in abstract painting. I think I felt that Eric was cutting himself off from a whole swath of experience, and I didn't want to feel so exclusionary. I said something like, "Even if an artist makes a good painting for the wrong reasons, it's still a good painting. And there are plenty of sincere painters who make boring pictures." Which, in retrospect, was like saying, "Where has all your sincerity gotten you?" It was all about being able to tell when a gesture had real meaning—as distinguished from being a pose.

Feeling frustrated, I picked up one of the little bowls of ketchup that Magoo's put out on the tables and, after a dramatic pause, over-turned it and slapped the ketchup down on the white tablecloth. "How can you tell what the artist intended from that?" I asked. "Was that an authentic gesture? Inauthentic?" I think Eric was a little shocked by the violence of it. I think I was too. Anyway, it ended the argument, and we didn't speak for a long time after that.

In art, it's sometimes hard to separate the authentic from the inauthentic—and there is often a kind of paradox effect by which work becomes interesting precisely because of that which should doom it. But things that offend us aesthetically can also offend us morally—and that was the case with Eric in that moment.

. 13 .

VANITY

1984 – 1986

THE guest list at Mary's opening-night dinner for me at the trendy midtown restaurant Mr. Chow's read like a who's who of mid-eighties Nouvelle Society—stars from the worlds of art, entertainment, media, and business and finance. The show, which ran for three weeks in October 1984, was a success. Mary had finally agreed to represent me earlier that year and had presold all the paintings on display, the first three to museums, two to the European megadealers Bruno Bischofberger and Thomas Ammann, and the others to name collectors, several of whom were dining that night in the tinsel glow of Mr. Chow's artful lighting.

As usual I felt like an interloper at my own party. Dressed in my electric-blue suit, a frozen smile of gratitude plastered on my face, I shook hands with the city's elite and thanked them for coming. Apparently it was still bad manners to discuss art at an art party. Collectors talked about their collections, their plans to show them or even to gift them, but not about what the art meant to them or what, in the case of my pictures, it meant to me.

Remnants of downtown's renegade ethos were present that night. Halfway through dinner, I was pelted with food. Turning around, I spotted Warhol, Keith Haring, and Jean-Michel Basquiat giggling like schoolboys at a nearby table. I thought it was funny. But that whimsy—the spirit of uninhibited fun that had once marked the battles of the bands, the potluck dinners at Nancy Chunn's, the countless nights at the Mudd Club and grungy art bars—was disappearing from the scene, overrun by the high-stakes sales and professionalism flooding the art world. In fact, none of my food-throwing fellow artists would survive the decade.

Art had become a commodity. To a degree it always had been. The church, the great European courts, and the Renaissance merchant princes were not so different from the new billionaire collectors or the institutions they funded and sometimes founded. Over centuries they'd commissioned the best art of their day for their greater glory. But until recently, most wealthy patrons held on to the paintings and sculpture they bought. Today's buyers are as likely to sell their trophies—sometimes even before they're uncrated—if they can claim a substantial profit. And there's another key difference. In the past, collectors could at least try to agree on what the best art was. My generation of artists overturned the canon. We were trying to expand the definition of art, to increase the diversity of allowable styles. In the process we'd shredded the consensus of what made good art. We'd abandoned the modernist idea of progress, and for the most part severed the links between past and present.

Nobody knew what made a good painting or sculpture or performance. The so-called experts—the critics and curators and academics—continued to opine. But without history or any objective criteria in which to ground their opinions, their theories seemed increasingly personal or political or just plain bizarre. We artists sure as hell had no idea. Every once in a while someone would come up with a new style or gimmick, gather three or four acolytes, and a movement would be born. Even "bad painting," a deliberately cynical

and clunky style of painting that challenged the conventions of good taste, briefly became a movement in the late seventies.

Art, like nature, abhors a vacuum. Without any general agreement about what was good or truly new or authentic, money rushed in as the arbiter. Dealers and collectors usurped the roles of critic and curator. They organized eventlike exhibitions, bid up hand-picked artists at auction, and turned the once-discreet marketing of art into spectacle. With no other consensus, a piece of art, like any commodity—whether a stock or bond or pork belly or widget—was worth whatever someone was willing to pay for it.

Under the new system, the role of the artist also changed. As the maker of a commodity, even if he didn't see himself that way, the contemporary painter was under constant pressure to produce work that was catchy, recognizable, and replicable—in short, to brand himself. Artists who bucked the prevailing tide, who thumbed their noses at the new establishment or insisted on making small, ephemeral, or otherwise uncollectible work, did so at peril to their careers. But those who recognized the new trends—painters who conformed to the romantic vision of the traditional studio artist, dealers like Mary Boone who possessed the verve and resources to orchestrate blockbuster exhibits and red-carpet events—reaped rewards beyond what anyone had thought possible a few years before.

I had joined Mary's gallery in the spring because I wanted my work to be seen in the company of her painters. And Mary had taken me on because she'd been blown away by *St. Tropez,* the beach picture I'd made the year before and that she'd seen in a group show at the Sidney Janis Gallery. But our good intentions notwithstanding, we both understood the rules. If my work didn't sell, I was out. And if Mary somehow lost her cachet—well, that wasn't likely to happen. Not then. Thanks to an Anthony Haden-Guest *New York* cover story, Mary was widely known as the Queen of Downtown. But what Mary had actually done was bring uptown downtown. She'd moved away from the loftlike galleries typical then in SoHo, the raw, unfinished

spaces that were meant to be like the studios where the work was created. When she put down terra-cotta floors in her new gallery and installed an Empire desk out front—and she took a lot of ribbing for that desk—Mary was making a statement: "This is rich stuff. Let's not make any more pretense. This is not bohemia anymore."

Mr. Chow's was certainly not bohemia. Neither were the opening-night festivities at Mary's gallery, despite its SoHo address. Outside, rows of double-parked limos lined the street. There may have even been a cameraman or two. Quite a difference from the small, neighborly shows I'd attended in the seventies, where sometimes only a handful of the artist's friends and family would turn up for the opening. Artists then were basically making art for each other. But the show that night at Mary's, and many others that succeeded it, had the feeling of a product launch—crowded, impersonal, and seeded with celebrities whose presence seemed arbitrary. And then at a certain point the art world itself crossed an invisible divide between culture and commerce, and artists became celebrities.

THE paintings I made for my first show with Mary were mostly a continuation of my earlier work. Like *Sleepwalker* and *Bad Boy*, they explored the deviant family dynamics and taboos embedded in middle-class suburban life. But *Daddy's Girl* added another twist to the series.

The idea for *Daddy's Girl* came to me on a beach in St. Tropez with a father—the art dealer April and I had originally visited—hugging his two-year-old daughter. It was an action filled with tenderness. I felt it would be a challenge to paint it. I hadn't really ever done anything that straightforward. It was touching—physically as well as emotionally.

I also knew that people were expecting something dark and sexual from me, and I wanted to confound their expectations. I wanted to paint something innocent that the audience would initially assume

was transgressive. But in the end *I* couldn't find the innocence in myself.

I started by making two changes in the initial image. I took off my subjects' bathing suits and I put them in a private setting—a sun-drenched patio with a view of the Mediterranean. I thought making them naked and alone would reinforce the scene's innocence. In fact, it did the opposite. Their nakedness and isolation gave the scene a tension I struggled to diffuse.

I tried putting the man's wife in on a chaise longue next to them. But that didn't change anything. So I painted her out and put in a gardener going about his work, not paying attention to what was going on. But it felt like I was imposing something that wasn't emotionally true. The questions I was asking weren't being answered by the presence of the wife or the gardener. My attempts to resolve my unsettled feelings only resulted in gimmickry. There comes a point in painting, I realized, when the painting is what it is, whether you are ready to deal with it or not, and it would be dishonest to force it to be anything other than that.

The point of painting is to try to find the hidden truth. It's a complicated process that involves a lot of fears and posturing. I knew that what I was throwing at the painting wasn't making it any more real. At one point I was so lost I painted myself into the picture, at a table at one end of the patio, staring at the scene, confused.

"Whose consciousness are we seeing the picture through?" I asked myself. The father and the girl are objects in the picture. The real subject of the painting is the viewer, how he or she feels about the embrace between the man and his daughter. I didn't want the viewer to witness the scene from the safety of a vantage point outside the picture. I wanted the viewer to be present inside the picture, to be part of the action.

I painted myself out of the background and I painted a glass of iced tea in the foreground. It wasn't clear whose glass it was. It was balanced precariously on the edge of a planter barely out of reach of

the father, halfway between him and the viewer. It became a pivot point, a point of identification, like the chairs in *Sleepwalker,* something to suggest the delicate balance of the scene, something to hook the viewer into being present, where he couldn't be just voyeuristic, where he would have to confront the scene and decide what it means. Is it okay? Is it okay to feel that it's not?

When I looked at the picture, I wasn't able to answer that question one way or the other. Viewed from different angles and at different times, the scene struck me as both prurient and dangerous *and* as a natural expression of fatherly love. I'd set out to render a Hallmark moment and ended up with a paradox. I was still dealing with the queasy, not-quite-appropriate relationship between an all-powerful parent and an innocent, defenseless child. That wasn't particularly surprising. The creative process weeds out surface preconceptions in favor of deeper truths. But this time the act of painting not only yielded an unexpected outcome; it also produced one that left me in a state of ambivalence.

THE ambiguity at the heart of *Daddy's Girl* became a key element in my work. When I first began making paintings in what was to become my recognizable style, my subjects were fairly one-dimensional. The villains and victims in pictures like *Time for Bed* and *Bad Boy* were clear-cut—caricatures of my parents, their hypocritical friends, my siblings, and myself. But the act of painting them over time forced me to reexamine my prejudices and easy sympathies, to identify other points of view, to render a more complex and nuanced humanity. To my surprise, I began to empathize with the enemies of my youth. I still saw their flaws, but I no longer thought them evil.

Perhaps it's a coincidence, but around that time I was also renegotiating my relationship with my father. We'd been at war almost as long as I could remember. He'd hated my choices—my odyssey in Haight-Ashbury, my embrace of a career in art—and I'd blamed

him for my mother's illness, his inability to control her drinking, his dismissive attitude toward my work as painter. Lately, though, he'd begun to take an interest in my work. At first I attributed that to my success. But an incident that occurred a couple of years before started to make me see things differently.

In 1981 I made *A Woman Possessed,* a barely disguised portrait of my mother in the grip of one of her episodes. The painting shows a woman lying prostrate and unconscious in the driveway of a suburban home. The woman is drunk. An empty whiskey tumbler has rolled a few feet from her outstretched arm. Her teenage son, back from school—his notebooks set neatly on the ground beside him—tries to drag her into the house. But surrounding the woman, a pack of large, menacing dogs obstruct his progress.

I showed *A Woman Possessed* in Canada and got a nice review in the *Toronto Globe and Mail.* I mailed my father the review, which included a photo of the painting. He made copies of it and, as had become his habit, sent them to my siblings, eliciting a sharp rebuke from my younger sister, Laurie. I could deal with the past any way I wanted, she said in effect, but she didn't want my paintings dredging up painful memories for her.

My father wrote back to Laurie saying that my paintings laid bare the inexorable forces that had been driving our mother's alcoholism, made him see afresh what had been happening all those years we kids were growing up. They had helped him to understand his feelings about that time and to get past his guilt over not being able to prevent our mother's suicide. "I'd hoped," he told her, "they would also help you."

My father later copied me on the correspondence. He was writing out of concern for Laurie. He wasn't trying to impress me with his response to my work or its therapeutic effects on him. But I *was* impressed—and heartened too. It had taken a long time—not until I began exhibiting my work and my name started showing up in the papers—before my father appreciated what I did. Then he became

the proud papa. But though it had taken success to capture his attention, his interest in my paintings, I now realized, was not superficial. He had found an emotional truth in them and had been using that experience—much as I had when I painted them—to exorcize painful, confusing feelings he'd buried years ago.

I hadn't fully appreciated until then the enormous sacrifice my father made holding the family together, but I'd stopped viewing him as the callow businessman my mother had made him out to be. One recognition sparked another. I'd idealized my mother in life and in death as a hapless victim, too pure or sensitive for my father's materialistic world. Now as I began to know my father on a deeper level and could no longer blame him for my mother's tragic character, I had to rethink my relationship with her and my assessment of myself.

As I grappled with people and events from my past—the source of so much of my creative material—my present was taking off in ways I never could have anticipated. Within days of my joining her gallery, Mary learned that collectors Arthur and Carol Goldberg, who'd bought *Bad Boy* two years before for $7,500, were building a country home and might be willing to sell the painting. She called them and they told her they wanted $50,000 for the picture. It's worth more, Mary said. She made one phone call to Charles Saatchi in London and came back with an offer for $75,000. I made a pittance on the transaction—5 percent of the resale price. But it enabled Mary to raise the price for my new paintings. I netted $250,000 on my first show with her, and by 1985 my earnings topped $1 million.

I'd been doing well before then. The price for my new paintings had risen steadily since my first show at Thorp—from $2,500 to $10,000—and for the first time in my life, I didn't have to worry about money. But now I was getting $40,000 a painting, and I was totally unprepared for the distortive effects of my skyrocketing income. In leaner times I'd swapped my studio work—experimental

sketches, studies for larger paintings—in exchange for the services of my accountant. But sometime around 1986, when my prices were near their peak, I discovered he'd sold a sketch at auction for more than $100,000. It threatened to change my relationship to my work. Drawings and preparatory paintings began to look like money instead of studies, and it became difficult not to keep making them. The temptation to print money had entered my practice along with the cynicism to rationalize it.

Money begat celebrity, especially after the art world began confusing an artwork's value with its price. There was no way around it. As a celebrity artist you lived and died on the sales figures for your new work, or on the bids your old work commanded at splashy, status-defining auctions. When one of Julian's plate paintings—*The Patients and the Doctors*—went for almost $100,000 at Christie's in 1982, a painting that had sold for $3,500 less than three years before, the art world was stunned. People were suddenly talking more about the price than what was in the picture.

It hadn't always been like that. Jackson Pollock made the cover of *Time* and never sold a painting in his lifetime for more than $9,000. But those were different times, when there was still a distinction between high and mass culture.

Things began to change in the late seventies with the explosion in the number of artists and types of art. People were scrambling to cover it all. The number of galleries and shows multiplied. Traditional ways of writing about art gave way to the popular media—mass circulation newspapers and magazines. They were the only ones who could cover gallery shows in a timely manner. Going into those dailies and weeklies, the culture of art became populist. We were being written about and photographed on the same pages as movie stars, fashion designers, and rock stars, and by the eighties we had become the new rock stars ourselves. Julian had become ubiquitous, almost a household name. Clemente and Basquiat were doing big murals at the Palladium, the nightclub of the moment. And Basquiat appeared

on the cover of the *New York Times Magazine* in a black Armani suit and bare feet.

The Palladium also commissioned me of all people to make a wall video, and in May 1984 *Vanity Fair* ran a feature on me—six pages along with a full-page photo of me by the celebrated portraitist Arnold Newman. The writer, Peter Schjeldahl, a critic with the *Times,* focused the article on my work. But I realized the text was secondary. What was important was the context—all those Hollywood puff pieces, party pages, and jewelry ads.

Later that year I explored my contradictory feelings toward fame in a painting titled *Vanity*. A modern take on the classic nude, it depicts a naked woman sitting on the lawn behind a contemporary glass house holding a mirror in front of her face and applying makeup. Though we can't see her features, she's obviously attractive. Her body is toned. Her hair is prettily coiffed. And her skin radiates sensuality.

The action of the painting is centered on a copy of *Vanity Fair* that the woman had apparently just been reading. Its spine is cracked open to a photo of me from the recent issue and is positioned between her splayed legs so that I'm staring directly at her sex. On its surface, the painting is an obvious spoof of me, my prurient worship at the maidenhead of celebrity. But I was also making a serious effort to understand success in relation to my work.

Though the photo of me shows a mature artist, the placement of the image relative to the woman in *Vanity* recalls the proportions of the adolescent boy gazing at the sexually powerful adult woman in *Bad Boy* and other similarly themed paintings I was doing at the time. And because the photo is an image of me, rather than the actual me, people have suggested that the woman, and whatever she represents, is giving birth to my new persona, whatever that represents. I was asking myself: Who is more vain? The faceless, self-absorbed beauty hidden behind her mirror? Or her creator, the self-consciously posed artist mirrored in the pages of *Vanity Fair*?

The picture would have been more humorous if the same

hall-of-mirrors effect hadn't also been playing out in my life. On the one hand, I was glad for whatever fame I'd achieved, along with the recognition and perks that go with it. More important, I believed in the work I was doing and was willing to promote myself to make sure it got seen. On the other hand, I didn't feel comfortable in my skin. And much of my work was about skin, stripping away the layers of pretense in which my subjects clothe themselves, exposing the naked or unguarded truth of their lives, the posture beneath their meticulously arranged poses.

The truth is I felt like a fraud. I felt I didn't deserve the recognition I was getting. And part of me wanted even more. And of course the greater the hype surrounding my work, the more distanced I felt from myself.

I tried to obtain some balance. But celebrity isn't something you can control or measure out. At a certain point it attaches to you, no matter what you do to deflect it. And at other times, as the impresario Sol Hurok once said, "If the audience doesn't want to come, there's no stopping them." In 1984, the audience definitely wanted to come. That spring Mary featured *Vanity* in our first show together and, for all its self-satirizing, it sold quickly. (Years later it would top out at auction for more than $1 million.)

And so the cycle continued. The higher the prices my paintings commanded, the greater the demand for them. And of course the greater the demand, the more my prices increased. Dealers and collectors from around the world were clamoring for new work—that is, for paintings that looked like the paintings I'd been doing, the paintings I was known for. Having spent the bulk of my career trying to sell my work, I found it hard to turn them down and even harder to meet all my obligations.

To stave off the pressure, I made two fast rules. I'd only commit to new shows that were far enough away that, even at my slow speed, allowed me plenty of time to make the work—and even then, only after I'd completed half the required number of paintings. And I

wouldn't let my public tell me what to paint. I felt I was best served by an audience interested in following what I was doing, not determining what I was doing. I would continue to develop my themes—desire, connection, damage—but I would find new ways to express them.

I began making multipanel paintings, pictures composed of two or more abutting or overlapping canvases. I was trying to deconstruct my painting process, to show how I arrived at my narratives at the same time I was creating them. I wanted the viewer to see that for me, the act of discovery and the act of execution were simultaneous. I wanted the viewer to participate in the re-creation of a scene, piecing it together from fragments and impressions, almost like a crime scene. These paintings were inspired by the glassines I had done earlier, in which I would just start with an image and then keep adding layers of images until I arrived at a dramatic moment. With these new paintings, I would buy several blank canvases of differing sizes and have them lying around the studio, ready to go. As the narrative developed, I would add a new canvas, leaning it against the others, extending the picture plane. The size and shape of the final scene was never predetermined. I was trying to make it develop organically and become the size and shape it needed to be in order to tell its story.

Though there was a lot I liked about the new series, I ultimately abandoned working in this way because the results, with their sprawling, hanging, leaning, cantilevered canvases, were finally just too inelegant and clunky.

What I did like about them was that they were a break from what I'd been doing before, something new, which is how I keep painting interesting for me. And it enabled me to explore connections in my work that I hadn't seen before—links between time and memory and between physical and psychological space. I was trying to highlight the element of time as essential to the interpretation of the narrative's meaning. And in some of the paintings, like *Bayonne,* I think I was able to achieve that.

Bayonne is made up of two panels, facing portraits of a

middle-aged woman and a girl in a ballerina costume. The woman—I took her from a Bill Brandt photograph—sits gracefully on a plain wooden chair, her naked torso swiveled toward the viewer. Her expression is pensive. But her gaze is fixed on the girl in the opposite panel. Their relationship is unstated. The girl, stepping awkwardly toward the woman, her upturned palms pressing the air in front of her, may be the older woman's daughter, her pupil—or, as pictured in several studies for the painting—a sylphlike apparition.

The settings for the paintings show two halves of the same room, and viewed straight on, the panels dissolve into a single frame. But the canvas containing the portrait of the young girl is cantilevered out from the wall, and when seen from even a slight angle to the painting of the woman, the two images separate and become isolated in their own spaces. The break reads like a caesura—a slowing or an interruption in the flow of time that suggests the woman is lost in thought, maybe conjuring a memory of her younger self.

Viewed from this perspective, the girl's raised hands become a gesture of resistance, a barrier against memory. It's about the sadness you feel when you can no longer gain access to the past, not because you don't want to, but because memory won't allow it.

Like most narratives, *Bayonne* has many interpretations. All are valid, though only a few are consciously intended. Seen from the girl's point of view, for example, the woman may be a vision of her future self, a specter of age and infirmity the girl is trying to stave off, like a dancer defying gravity. Or the woman's casual elegance—in contrast to the girl's stiff, clumsy movements—may indicate hard-won experience, a worldliness drawn from the buoyancy and innocence of youth. Seen straight on, *Bayonne* depicts a more or less conventional relationship between grown-up and child, mother and daughter, teacher and student. From an angle, the panels separate; the relationship erodes; time slows down or stops altogether and an irreparable, traumatic break occurs.

The multipanels introduced new themes into my work—aging,

memory, and narrowed possibilities—that stood in peculiar relation to my souped-up life outside the studio. Perhaps I'd made the multi-panels in an effort to slow things down, to try to separate the hype from the emotional core of my paintings.

But whatever was going on with my work, it had little effect on the craziness going on in my career. In addition to my shows with Mary, I had pieces in exhibitions at the Modern, the Whitney, the Carnegie in Pittsburgh, the Hirshhorn in Washington, the Museum of Contemporary Art in Montreal, and in the biennials at the Whitney and in Venice, Paris, and San Francisco.

Then, in 1985, at the suggestion of Allan MacKay, the chief curator at the Mendel Art Gallery in Saskatoon and a former colleague of mine from my Halifax days, Bruce Ferguson organized an exhibition of my work for the Mendel. I was flattered. I liked working with Bruce, but I didn't really focus on what this show could mean. I took it lightly. It was a show, I thought, that would be seen by few. I honestly did not think much about it. It turned out, though, to be the most important show of my career, a snowball rolling down a slope gathering size and weight as more and more important venues became attached to it: the Van Abbemuseum in Eindhoven, the Kunsthalle in Basel, the Institute of Contemporary Arts in London, the Art Gallery of Ontario in Toronto, and the Museum of Contemporary Art in Chicago. Ultimately, the show culminated in a full-blown retrospective in New York at the Whitney Museum of American Art.

AROUND that time I took out a mortgage on a small farmhouse in Sag Harbor, a historic whaling village near the Hamptons on the East End of Long Island. As a teenager I'd surfed off of neighboring Montauk, and the last few summers April and I had rented in the area with friends. The house—a steal, or so I thought—was on a roomy three-quarter-acre lot that backed up onto a sixteen-acre field our broker said could never be developed. Naturally, within six

months of the closing, bulldozers arrived and construction began on three houses. Ten years later there were a dozen.

Besides the short-lived feeling of space the property gave us, there was a dilapidated cow barn, which meant it was possible to build a studio on its footprint. Having studios was, of course, essential if we were going to spend any protracted time out there.

The house was in a working-class neighborhood with schoolteachers, heating and plumbing mechanics, retirees, theater volunteers, and fishermen. Our neighbor across the street, Tom, a bass fisherman and clammer, was a pack rat, and his property was full of car shells, outboard motors, buoys, lawn ornaments, nets, hoses, whirligigs, and so on. The inside of his house was so cluttered there was little space to move about. There were channels or corridors cut out of piles of papers, clothing, boxes, and God knows what else that snaked through his cramped saltbox home.

Tom was a Bonacker, the name for local families with deep roots on the East End of Long Island. Since the state banned haul-seining—trawling with a widemouthed net—he hadn't been able to make a living from fishing. But that didn't stop him from leaving early every morning to meet up with his pals, drink coffee, and reminisce about the old days. I asked him once who his friends were, and he scratched his head. He said they all just call each other Bub. "Hey, Bub. How's it goin'?"

Tom was a gifted carver of wooden duck decoys. He picked up the hobby after the fishing dried up. I was impressed by how good he'd become in such a short time. I would follow the progress of some of his pieces. His skill at getting the details of feather colors and patterns was mesmerizing to watch. The better he got, the more he'd up the ante by adding complex movement or pairings. He was one of those old-world artisans who loves carving, loves sharing his knowledge, but would never think to call it art. The decoys had to meet several criteria, some practical, some aesthetic. They had to float and be perfectly balanced. They had to look closely like the duck you

were trying to attract. And though for the purposes of hunting their features could be broad and generic, Tom gave each decoy a detailed, realistic caste. His goal was to make a male and female of every duck species along the northeast migration corridor, and he came pretty close.

At the same time he was making these precious small master-pieces, I was across the street making paintings that I was struggling to define the criteria for, struggling to figure out which parts of a painting had practical value and which parts were purely aesthetic— that is to say, decorative. And yet *I* was the one becoming famous.

THAT year I had a show that was traveling to three venues in Europe, and April and I were going back and forth for the openings. After one opening at the Kunsthalle in Basel, we drove with Mary Boone and Michael Werner, her husband, to visit Grünewald's Isenheim Al-tarpiece in the French town of Colmar, just over the Swiss border. On our way we passed Auberge de l'Ill, one of the finest restaurants in Europe. It was lunchtime and Mary thought we could just pop in for a bite. It was an absurd notion—Auberge de l'Ill was booked months in advance, but Mary insisted we give it a shot. Michael and I waited in the car, too embarrassed to go in. Of course they told Mary and April that it would be impossible to seat us. But having worked many years in restaurants, April knew that if a customer is polite but re-fuses to leave, the chances of getting a table are pretty good. And sure enough, ten minutes later we were seated.

During the extraordinary meal, we drank a great deal of wine. Michael, a German art dealer who almost single-handedly brought his country's postwar generation of artists to international acclaim, turned argumentative. He dismissed American contemporary art as decadent, meaningless, and overly clever. And he trained much of his criticism on David Salle, although he knew that David was a good friend of April's and mine and a favorite of Mary's. Our voices became

so loud, management asked us to leave. We offered instead to take our coffee and dessert in the garden, to which they agreed. But once served, we resumed arguing with even greater ferocity.

Michael laid it on heavy. He lionized the artists A.R. Penck and Georg Baselitz, who were both from East Germany and had, until they were able to get out, made art at great risk. Michael used to go meet them in Prague or some other Soviet bloc city that he would smuggle money into, then smuggle the rolled-up paintings out. How could we Americans compete with that kind of authenticity? Against that backdrop, all the high-concept art in New York seemed ludicrous. You can't top a genuine liberation narrative. It's our most powerful myth and has been a part of our culture, our religions, our sense of self, for as long as history. The postwar generation of German artists were exemplars of that myth. No matter what they did in their art, it took guts for them to do it.

I agreed with a lot of what Michael was saying. He believed that America was in decline, that in the midst of so much prosperity and ease its culture had become decadent. I also thought we'd lost our way; much of my work was about the disconnect between the country's public profile—its stated myths and values—and Americans' private thoughts and desires. But Michael wouldn't leave it there. He argued that David and most American contemporary painters, with their strategies of appropriation—using pop imagery as a substitute for craft—and claims of nihilism, not only failed to address America's broken narrative but were a demonstration of its culture's decadence.

That's where I drew the line. I'd never seen a painting of David's—no matter how ironic or iconoclastic—that didn't strike me with its emotional content. Many of them evoked feelings of loneliness and isolation, but that was the point I thought Michael kept missing. David wasn't making meaningless paintings. He was making paintings about meaninglessness. At some level we all were. What Michael didn't get was the slippery terrain a painter at that time and place had to navigate. Here we were—Michael and Mary and April and I—in

the garden of a three-star Michelin restaurant, yelling at each other about authentic struggles for self-definition. And these contradictions were becoming increasingly commonplace. You couldn't make a painting, living the way we did, without a little irony or distance.

I SPENT the rest of the summer trying to simplify my life. When I wasn't traveling, I was at home in Sag Harbor. I worked well there. I loved the beaches and felt relaxed. For the first time since arriving in New York, I was beginning to think that maybe I didn't need to live in the city full-time.

And yet that fall I was back in New York and out on the town every night, drinking, sometimes hitting the SoHo bars as early as four in the afternoon. I convinced myself it was a form of celebration, that I was being incredibly social. But in fact I'd drink to disappear in front of people. Worse, I'd disappear in front of the people I cared most about. It got to a point where I said to myself: either stay home and drink or go out and socialize with your friends and be present and sober.

By 1986, I was snorting cocaine regularly, often while drinking. And as with success, the drug had begun to affect other areas of my life. My cocaine use introduced me to a world far removed from my friends and fellow artists. And yet I couldn't stand the cocaine crowd.

Worse, I saw that the craziness of my success was continuing to drive a wedge between April and me. People were sidling up to her to get close to me. Paparazzi would take our pictures, and then magazines would crop her out. It was also tearing at us as a couple. And the wounds were serious. I attempted to do triage, just to stop the bleeding, but I felt helpless to protect her from the slights she experienced on a daily basis. Maybe that's why there aren't a lot of artist couples. I knew that if the situation had been reversed, if her success had overshadowed mine, I would have been out of there. And that feeling shamed me. When we were alone I tried to downplay

my excitement, disown my success, pretend nothing was affecting our relationship. But that only created greater tension. How we made it through those years is a mystery and a miracle.

As it turned out, I should have been less troubled about April and more concerned about my increasingly volatile behavior. Coke and drink were coming between us. I was neglecting her. Anyone who says they love having sex on coke is lying. April tried to get me to cut back on my drinking and cocaine use, but I wasn't paying attention.

And then I ran into Mr. Laughter.

MARY BOONE

In the early 1980s, my gallery was a boys' club.
Painters in those days were almost exclusively
men and nearly all my artists were painters.
There were plenty of young women artists around,
but they tended to embrace the new technologies,
which they used as platforms to snipe at the
traditional macho painters.

Whatever the reason, the gallery was full of
testosterone, everyone jostling for his place in
the pecking order. Julian Schnabel was the un-
questioned kingpin. His rise to prominence had
helped to lift the gallery, and he'd had a good
deal of input as to who I took on—and didn't.
Still he squabbled with his gallery mates like his
friend David Salle, and even bridled at my status
as owner, which I think led to his decision to
leave, much to my disappointment, in 1984.

Anyway, you can imagine Julian's chagrin when I
decided to represent Eric, an artist with whom
he'd had his differences. One day shortly before
his exit, he was in the gallery with several
other artist friends, Jörg Immendorff and Markus
Lüpertz among them. I'd hung Eric's *Cargo Cults*,
a large, beautiful, dramatic beach painting, in
the back room of the gallery, and I could see
Julian was put out. The next thing I knew, he'd

stripped down to his waist, got his pals to
do the same, and had someone snap a photo of
them bare-chested in front of the painting. The
point he was trying to make, I think, was that
Eric's painting was just scenery—the others
thought they were part of a practical joke—and
he sent the photo to some art magazine, which
published it.

What impressed me was the way Eric handled
the whole thing. Instead of making a scene or
confronting Julian at an opening, the way Julian
would have done if their roles had been reversed,
Eric used the photo—in which Julian was puffing
on a cigar—to caricature Julian smoking not one
but two cigars. It was a very funny painting and
I'm sure Eric could have sold it for a ton of
money, not to mention the revenge factor. But
in the end he decided to take the high road. He
knew that showing the picture would only invite
reprisals and he didn't want to get in the mud
with Julian, and to this day I don't know where
the painting is or if it even still exists.

. 14 .

HANGOVER

1986 – 1990

THE morning after the opening of my show at the Whitney, I woke up with a ferocious headache, trying to recall the highlights, or any lights, from the night before. But a vague memory of Mr. Laughter darkened my mood. Was he real, or part of a drug-fueled nightmare? Could I have really provoked such a reckless confrontation and put April in jeopardy? And over what? Had Mr. Laughter pulled out a gun or a baseball bat, what would I have done? I'd just celebrated a retrospective at the Whitney. I had a woman who loved me and good friends who were happy for my success. Even my family had made the trek to New York for my show, continuing the long process of reconciliation that began after my mother's suicide had torn us apart. Yet my personal world was in free fall. I wasn't willing to take my foot off the gas when it came to drugs and booze, though it was clear I didn't have my hands on the wheel. I needed to get sober. Now.

I'm extremely stubborn. It's very difficult to make me do something I don't want to do. On the other hand, once I do decide to do

something, my stubbornness kicks in in reverse. Then it becomes almost impossible to stop me.

I made a vow that day never to take another drink or do drugs again. And since then I haven't taken a sip of alcohol or a hit of cocaine. I don't want to make too much of it. I know what alcoholism, addiction, and abuse are, and I wasn't there yet. But I was on my way. Still, I didn't drink when I was alone or painting. I drank to smooth out the rough edges in my social skills, to dull my fears and insecurities. I drank mostly because I felt I had to perform around other people, had to always be on, and if I didn't lubricate myself, I couldn't do that. The irony, I realized once I'd quit, is that almost all of my friends were drinking as heavily as I did. Nobody seemed to notice the difference when I stopped.

TWO years before, the Reade Street building was sold to another business that had occupied the bottom three floors as long as we'd lived there. The owner had wanted to expand the store and develop the top two floors, probably into posher apartments. Much to his surprise, he found he couldn't legally evict us or the other tenants because the artist-in-residence laws had grandfathered us in. I told him I'd be willing to move, but I needed to be reimbursed for the money it had cost me to renovate the loft. He told me to go to hell and began a series of harassing actions that had the tenants up in arms. Coming home one day, I saw our street blocked off and smoke and flames engulfing the upper floors of the building. April had been at home, smelled the smoke, grabbed some stuff, and felt her way down a pitch-black stairway. I found her in the crowd that had gathered to watch. The fireman I talked to told me it was a disaster, the worst he'd seen; I should figure everything would be lost.

When we finally were able to get back into the place, it *was* a disaster. Miraculously, none of April's or my works were damaged by fire or the water used to put it out. But the fire had shot through

the middle of the living space and exploded through the bus-shelter skylight, destroying everything in its path. We found several pieces of the art we owned floating in the wreckage—a beautiful Troy Brauntuch pastel and a painting of Ross Bleckner's that I found under some rubble with a tennis ball melted to the surface. The Brauntuch was beyond restoration, but I asked Ross if he could repair his painting. He reluctantly agreed, but said he really liked it better with the ball stuck on it.

My initial reaction to the fire had been shock and, once I saw that April was safe, relief. An FDNY fire inspector told me the fire had been set intentionally. Though the authorities were never able to determine who set the fire, I had my suspicions.

The nightmare of the fire would drag on for some time as we looked for a new place to live. Finally, the owner ended up paying me nearly three times as much as I'd originally asked for. Meanwhile, April and I moved into my studio on Canal Street and tried to make it habitable, while we began looking for new places to live and work. April found a small but serviceable studio a few blocks west at Varick Street, and I joined a group of investors that bought a fabulous warehouse on Ninth Street between Avenues C and D in Alphabet City—then a slum at the frontiers of the Lower East Side and the East Village.

In 1986 you could still find cheap space downtown if you were willing to leave the relative safety of SoHo, and artists were banding together to convert disused and abandoned buildings in downtrodden areas. Typically, one investor—in this case Jim Merrell, an artist I'd known since Chicago—put the deal together and performed the basic renovations in exchange for free space. When it worked, it was a great deal for everyone, including the city. The artists got affordable workplaces, New York got an improved neighborhood, and the homeowners benefited from rising real estate values. But things rarely worked that smoothly. Our neighbors were mostly renters and squatters who'd eventually get driven out by the gentrification we helped

to start. And because we were among the first settlers, we spent years surrounded by filth, crime, and suspicion.

My partners in the deal included Ileana Sonnabend, a top SoHo dealer and the former wife of gallery owner Leo Castelli; Patricia Hearn, a young art dealer who'd pioneered the Lower East Side art scene; and a ragtag group of artists who colonized the upper floors. I bought two floors with about 7,500 square feet of raw space. It was my dream studio, but I couldn't get past the squalor of the neighborhood. The contrast between what I was painting, what I was thinking about, who was coming to see my work, how much my work was selling for, and the terrible no-exit life of the street outside was so stark, so irreconcilable, there were days when I found it hard to pick up a paintbrush.

I'D JOINED Merrell's Lower East Side project because I couldn't afford a studio with anywhere near as much space in SoHo. But I still fancied myself a pioneer artist, not just in terms of the work I was doing but also in the way I was making my work. Moving to Alphabet City was a kind of scout badge, proof that I hadn't deserted my bohemian ideals, that I'd chosen a life outside the mainstream—unconventional, gritty, and a little dangerous.

Of course it wasn't true. April and I had a comfortable life. What's more, a lot of our friends, not a few of them artists who'd only been scraping by a few years ago, were now living in conspicuous luxury—fancy cars, first-class travel, homes in the Hamptons. Like myself, many of them had grown up in the suburbs, part of a materialist culture that we'd rejected unequivocally in the sixties. Later, when success came, I wondered at how easily we'd jettisoned the proletarian ethos we'd adopted and begun displaying the symbols of wealth.

I personally felt as though I needed a degree of safety, a sense of control over my life in and out of the studio. Some of that I found in my routine, which was pretty invariable. Some of it I got from having

a small but devoted audience that encouraged me to be adventurous in my work. And a large part had to do with feeling I had a safe place I could retreat to, a nice home in a nice neighborhood.

The question for me became: What does it take to feel safe enough to explore things that aren't safe? How much comfort do I need—or is justifiable—in order to keep bleeding on the canvas? These were not abstract questions for me. They were concrete realities that slammed me on my twice-daily walks between the tree-lined West Village neighborhood where I now lived to the shabby tenements and rock-strewn lots along Avenue D.

Part of the romance of the Lower East Side studio was its impoverished location. I thought I could drop down into uncertainty and then climb out of it at the end of the day. Ultimately I couldn't. I realized that unlike many of my artist friends who grew up as outsiders in the suburbs, I didn't want to rebel or live unconventionally. I wanted to belong, to pull things together. The suburban dream of comfort and safety, if not upward mobility, was also *my* dream.

E ARLY on in my life I wanted to embrace the margins, but as I grew up I came to realize that so much of my life has been a search for normal. I have consciously tried to make work that took fragments and pieced them back together—impressions and bits of memory collaged into foreign lands or suburban settings, all with the purpose of making them appear seamless. I was reliving my experiences as I was painting them, always at the point just before things fall apart.

Collage is the most important innovation in art since perspective was discovered in the fourteenth century. It's one of the defining techniques of modernism, especially for the surrealists. Perspective is a mathematical construct that creates the illusion of deep space. It enabled painters to move art away from the religious icon and into the realm of realism. Perspective imitated how we see. Collage, on

the other hand, is an artificial construct that imitates how the mind works. It breaks down the world of images into fragments of memory torn from their original context. It's ahistorical, which is why avant-garde artists embraced it. My colleagues eagerly employed the collage technique and made it central to their art. They experimented with how far apart—at what distance both physically and intellectually—you could place two disparate images on a canvas and still create a formal composition that had dynamic tension, even if the juxtaposed images were essentially arbitrary.

I was uncomfortable with fragmentation and meaninglessness even though I appreciated it in other artists' work. I needed the world around me to make sense, though not in a stultifying or overde-termined way. Rather, I felt an obligation to give my audience the impression of a coherent moment that was emotionally charged and fragile, but still holding together long enough so viewers could reflect on what it meant. Except in the case of the multipanel paintings, I did not want to make my audience put something back together in order to understand what it means.

CRACK had become epidemic in the city, and our block was one of the epicenters for the drug trade and its devastation. The lot across the street from my studio was vacant. It was used to dump and strip stolen cars. Derelicts burned tires around the clock and gathered there for warmth. The building next door to us was a crack house full of wasted squatters. Every now and then an ambulance would pull up to cart off someone who was OD'ing or dead.

One day, in 1988, a film crew came to shoot a scene for *Slaves of New York,* a Merchant-Ivory movie about struggling artists who can't afford to leave their lovers because of the city's steep rents. In the scene, Bernadette Peters was supposed to arrive via limo to a gallery opening. The movie crew had been prepping for the shoot all night. But unbeknownst to them, a local crack addict had barricaded

himself on the roof, and when the director called, "Action!" and Peters stepped from her limo, the crackhead began shouting, "I want to fuck Bernadette Peters!" He had one of those piercing voices, like a wounded animal's, and he chanted his appeal like a mantra over and over again.

The director shouted, "Cut!" The crew set up the scene again. The director, bullhorn in hand, begged the guy on the roof to keep quiet, then called, "Action." And of course the crackhead began again. This went on until the cops were called in. It took them hours to get him down from the roof, and I will never forget his incantation. I loved it. There was a raw honesty in his tone. He was not being disruptive for the hell of it. He was just incredibly lonely. And let's face it, who didn't want to fuck Bernadette Peters?

OUR apartment on West Ninth Street was on the top two floors in a townhouse with large French doors opening onto a tiny balcony. (As I mentioned earlier, we discovered later that it had once belonged to Hans Hofmann, the German abstract painter and teacher.) Hofmann had used the space as his studio and as a classroom, where he mentored a generation of American modernist painters such as Lee Krasner, Helen Frankenthaler, Larry Rivers, and Red Grooms. Since then it had been occupied by Joan Sutherland and John Belushi. The apartment was flooded with light, cozy, and precious. On my way to the studio at the other end of Ninth Street I felt as if I was walking downhill, and when I left my studio for home I felt like I was climbing out of a hole. Eventually the experience became so jarring that I began to look for another studio in a better part of town.

Meanwhile, we began renovating the duplex. When a space heater fell onto some paint rags, the apartment caught fire. The accident not only set us back a year but drove us out of the city to Sag Harbor, as we'd given up our loft on Canal by then. But the forced exile turned out to be a blessing.

I'd been on a career treadmill for the previous eight years and, without realizing it, I'd hit a wall. Though I couldn't identify what exactly had gone wrong, my paintings felt as if they'd lost something. I was getting bogged down in the studio. I'd attempt to remedy the lifelessness in an area of a picture I was painting and nothing would work. Everything I attempted to resolve the problem felt like a device rather than a revelation. The juice was gone and I was exhausted.

During the next year and a half out in Sag with April, I rediscovered playing. Being away from the hustle of the city, with the phone not ringing as often and no one dropping by the studio, I had an abundance of time and lots of quiet in which to experiment with new forms and techniques.

Having come to the end of something in my work, I thought I'd do something I hadn't done before. I decided to make little sculptures of the characters in my paintings. I'd been painting these subjects for years, but since they were based on photos I'd taken, I could approach them from only one side. How well did I really know them? Could I imagine them from angles not shown in the photos? I began making rough clay studies of the human figure from memory, and when I finished one I'd set it on a table and make another. Then, when the table was full, I'd look at what I'd done and realize that I'd re-created my experiences on the beach in St. Tropez.

With that scene in mind, I set up some dramatic lighting effects and took black-and-white photos of the figurines. I was trying to make unusual compositions, shooting some figures in silhouette, focusing fully on others, and so on. I was having a blast arranging and rearranging these doll-size statues, making up scenes and narratives and, as children do with dolls, imagining them very much alive.

Next I made some small paintings based on the black-and-white photos I took. I had been looking for a way to untether my color from strictly local descriptions (blue sky, green grass, and so on), and trying to project color onto the black-and-white scheme seemed like a good way to do it. Also, the sculptures were already distorted by my rough

renderings. I thought this would help me free up the way I'd been painting figures, which I felt had become too tight, too naturalistic. I wanted to be more expressionistic but I didn't know how.

It turned out not to matter. I'd stopped caring if these improvisations would lead to something bigger. I viewed them as a diversion, a source of pleasure and amusement. It was an attitude that had no place in the competitive art world.

Still, the work accomplished a couple of things. It led me to explore sculpture in a deeper, more considered way and it freed me from the paintings I felt I was expected to make. The sheer pleasure of using the hand with clay is irresistible. I also found that it informed my painting because I had to think about the object and the image in a different way. I had to use a different part of the brain. In painting, your hand follows your eye, and in sculpture your eye follows your hand. In sculpture and in modeling, the hand has a lot of information you didn't know it had. The hand feels the form, and then the eye looks to see if the form appears the way it felt. The hand has such an intimate understanding of the shape of the body because it has touched the body so much that you start to unlock all kinds of memory from just touching.

I haven't released the works I made from this time, though I have shown them as examples of my creative process. They remain diversions, toys that helped me recapture the joy and possibilities of making art.

I N 1987, I was invited to show in *Documenta 8,* a prestigious triennial exhibition based in Kassel, Germany. It was a huge honor and I was thrilled to be part of it. The show opened in June, and April and I decided to go there by way of Spain to visit Bryan Hunt at his house in Mojácar. Bryan was hosting Jerry Saltz and Roberta Smith, who were also heading up to the *Documenta* show in their capacity as critics for the *Village Voice* and the *Times.*

In those days the art world, centered in New York, was small and incestuous. Artists, critics, dealers, collectors, curators, administrators, advisers, and historians rubbed shoulders at gallery openings, museum shows, benefits, and seminars. I had known Jerry since Chicago. He and his friend Barry Holden had run an alternative art space there called the N.A.M.E. Gallery. At one point when Jerry was transforming himself into an author, I'd hired him to help me write *Sketchbook with Voices,* a kind of textbook survey I was doing about the artist's process. He conducted interviews with the artists I included in the book, and later parlayed his work on the project into a book deal of his own, the first in what has become a prolific and very successful career. April and I had known Roberta through friends of friends. At the time, she and Jerry had just become a couple.

Mojácar is a small southern village set into the parched brown hills above the Mediterranean, a jagged, inhospitable terrain that falls off sharply into the sea. The blue color of the Mediterranean is so lush it slakes your thirst just looking at it. We spent four or five days with Bryan in his home overlooking the village and settled into an easy holiday rhythm: late mornings, drives into town or along the coast to buy fish from the local fishermen, lunch, reading, swimming, siesta, and then to the beach for dinner.

We also spent intervals around the pool talking about everything but art, occasionally picking a centipede out of the water or spotting constellations and shooting stars in the crystal night sky. For a time it seemed as if we were defying the odds, cementing a rare species of friendship, the camaraderie between artist and critic. But it was not to be.

There's an innate distrust between critic and artist. It has nothing to do with whether the critic loves what the artist does or not. It has to do with them knowing that at some point they will disappoint each other, and the tension that results.

To try to form a relationship separate from art does not work either. There will always come a moment when an artist will expect

his friend to write about his work, and anything less than a laudatory review will be seen as a betrayal. Even a recusal may result in bad blood. Guidelines about whose work a critic should or shouldn't cover inevitably seem like easy excuses for avoiding saying something nasty or hurtful.

That said, Jerry and Roberta and April and I maintained very friendly relations for a while after Spain. We socialized regularly, shared meals and holidays, and Jerry and Roberta visited us in Sag Harbor. In 1990 I even did a portrait of them, based on photos I'd taken in Mojácar.

It was my first portrait, really, though I'd made some portraits of imaginary people. Roberta is shown standing and Jerry seated, nestled into her thigh and smiling. Like many portraits of couples, it expresses explicit dominant and recessive traits in the relationship that create a kind of tension for the viewer. None of my portraits are flattering per se. But I think they are revealing and honest. Neither Jerry nor Roberta was comfortable with the way I portrayed them. I don't think that is what precipitated our falling-out, but it didn't help. Perhaps they felt like I'd given them a bad review.

What did end our friendship several years later was Roberta's failure to give more than a passing mention to April's work in the 1989 Whitney Biennial. She claimed she couldn't be objective. It was a plausible explanation, though critics, Roberta among them, frequently reviewed artists they knew. The art world was still small and Roberta was fairly ubiquitous. In any case it *felt* like a betrayal, and friendships, I've realized, are rarely based on logic.

F AMILY, however, is a different story. Your parents and your siblings know you in ways that others can only imagine. It had been nearly twenty years since my mother's death, shattering our tacit, unself-conscious intimacy. And it had taken that long to recover our

ease with each other and, more important, to deal with the trauma that had been the cause of our estrangement.

But the journey had been worth it, one of the most satisfying in my life. I'd reunited with Holly, who'd been like a twin growing up, and become a doting uncle to my nieces and nephews. Like my father, John had become involved with the local arts scene, becoming a member of the Phoenix Art Museum and, with his wife, Lisa, administering a scholarship program that I'd founded at the community college where I first took art courses. Even Laurie and I got past our youthful competitiveness and developed a friendship that brought us closer than we'd been growing up.

IN January 1989 I had a show at Waddington Galleries in London. I'd shown in London a couple of times before, but I never seemed to get much traction there. This show didn't help my cause. For one thing, the timing was wrong. I was segueing out of the multiple-panel paintings back to the single rectangular format, and the pictures I showed were a mixed bag. There seemed to be no unifying theme in terms of form or content. Also, although I didn't realize it at the time, I filled out the exhibition with substandard work, sad and lonely pictures where the paint handling was uneven.

As I said, I was in a period of transition, a horrible place for an artist to be in public. But it's hard to know what's progress and what isn't until you've put the work out there and viewed it through other eyes, other sensibilities. It's a little like changing your golf or tennis stroke, or making adjustments in anything you're used to doing. You almost always backslide before you get better, and you never really know where you stand until you've tested yourself in competition. I'd been searching for new ideas and experimenting with the way I applied paint. I hadn't realized how inconsistent the results were. In some paintings my brushstrokes were loose and dripping. In others

they were tighter, more descriptive. And a few pictures were a mish-mash of styles, with some areas more focused than others.

April had flown in with me from Rome for the opening, and as if things couldn't get worse, she picked up a nasty flu that kept her bedridden the entire time we were in London. I tried to cheer myself up by going around to museums and galleries, but my mood, like the paintings in my show, remained inescapably dreary. It seemed to match the English weather—a chill gray drizzle.

A couple of days after the opening, Francis Bacon came to see the show. I happened to be at the gallery, and seeing him walk through the door was like seeing an apparition. Though we'd never met, he was an icon to me, a master of abstract figuration whose powerful and perversely witty portraits were as familiar to me as many of my own. That my work evinced any interest from him seemed miraculous to me, and I could hardly hide my wish for his approval.

I let him browse around for a bit before introducing myself. I could tell by the way he was looking at the paintings that they weren't making much of an impression on him. Nothing seemed to be hold-ing his attention. Still, he was polite and offered me some vague com-pliments. When I tried changing the subject and asked him what he was working on, that didn't go anywhere—apparently he didn't like talking about his work—and we spent an uncomfortable few minutes searching for neutral topics before he excused himself and left.

Many years earlier, when April and I were first in Paris, we went to an opening of his at the Claude Bernard Gallery. Bacon, already aging, was there. But that time I didn't bother to introduce myself. I hung back instead and watched him while he tried to fend off all the well-wishers and sycophants who pressed him against the wall. Drink (and who knows what else) had taken a toll on him. His head looked like a jack-o'-lantern and stuck out awkwardly from the neck of his trench coat. His actual features took up only a small portion of his bloated face. He was small to begin with, and now the dispro-portion of his head to his body and his face to his head made him

look ghoulish and cartoonlike. I felt terrible for this great artist who clearly didn't want to be there.

When the pressure from his fans became too persistent, he let out a laugh—a howl, really—like the sound you imagined coming from one of his screaming popes. I'd never heard anything like it. It was piercing, like the screech of a wild animal. It made people shut their eyes and turn away, and when they looked again, Bacon had disappeared.

Artists make work that represents their best selves. Maybe that's the reason some of us become artists, to create a persona or a world that replaces or puts straight the messy, painful lives we inhabit outside the studio. That's how I want the public to perceive me, as the author of true and compelling images. *They* represent my true self. Everything else feels sloppy, awkward, and disappointing. You could see Bacon would have rather been off drinking with friends or even at home alone. Anything was better than being in that room, trying to be as engaging, as eloquent, as passionate in person as his paintings on the wall were.

When Andy Warhol made a date a few years before to visit my studio, I was terrified. I imagined him as this glamorous, weird, detached presence who'd sit Buddha-like in my studio wrapped in a silence so inscrutable and profound that I'd become unhinged and perform doglike tricks to try to amuse and please him. I'd never met him. My impression of him came entirely from the way I thought about his paintings and films, and from stories I'd heard about goings-on at the Factory. Like Bacon, he was an icon for me. I also thought his vision of art was antithetical to mine: all style, no substance. I had no idea why he wanted to check me out. I felt my work must have seemed square to him, drearily sincere and unstylish. I couldn't imagine him being interested in it or in me.

Of course, he was not like any of the things I imagined about him. He *was* eccentric, but in a charming way—also witty, bright, and surprisingly present. From the moment he arrived at the studio,

he was talkative, downright gabby even, covering a wide range of topics—almost none of them art-related. In the short time he stayed, he drifted around the room, glancing at work I had up, but made no comments I can remember. On the other hand, I couldn't stop observing him. With his soft voice and translucent pallor, he was like a perfect work of art himself, totally self-created and unique.

Warhol's visit had the opposite effect on me from the one I'd expected. I was still at the beginning of my career then, struggling to find my balance, to find my place in the art world, to see where I fit in. Warhol clearly knew who and what he was. He exuded confidence in his singularity, in the choices he'd made to go it alone.

BY 1989 I'd wound down the multipanel series and was trying to think of what to do next. April and I had been invited to India in the spring as part of an annual exchange aimed at developing links between Western artists and local artisans. I was reluctant to go—I'd never shared my generation's fascination with Eastern mysticism.

But April was keen on seeing India and the invitation had come from the Sarabhai family, a prominent textile clan whose generous hospitality and stature in the art world made their offer difficult for me to turn down. For almost fifty years, the Sarabhais had been hosting cutting-edge artists from Europe and the United States. Beginning in the fifties, Alexander Calder, Robert Rauschenberg, Merce Cunningham, John Cage, Roy Lichtenstein, Frank Stella, and John Baldessari among others had made the pilgrimage to the magnificent Corbusier-designed villa that anchored the Sarabhai compound in two hundred acres of parkland in Ahmedabad, an industrial city northwest of Mumbai. Many of them had collaborated with area craftspeople on projects that would materially influence their work.

My host, Anand Sarabhai, a microbiologist, then forty-eight, lived with Lynda Benglis, a sculptor and feminist whom I'd gotten to know in New York in the late seventies. April and I stayed in a

guesthouse tucked in by the back wall of their property. At night you could hear the monkeys running along the top of the wall and occasionally jumping onto our roof. We were warned to keep the door shut at all times or they would come in and help themselves.

During our stay Anand introduced me to the local tradition of hand-tinting photographs and organized a round of picture-taking trips throughout Rajasthan. The results—a pastiche of mostly black-and-white animal scenes that delighted Anand—held little interest for me. But my encounter with India was a different story.

BRUCE FERGUSON

The thing you wouldn't know about Eric Fischl
if you weren't a friend, or an acquaintance, or
hadn't ever met him, is that he is just about
the world's funniest storyteller, maybe ever.
When he begins a story it is usually ordinary
in some very ordinary sense. It is not dramatic
or magical or surrealist, nor is it peopled with
weird costumed characters or clowns or mutants.
It is always an anecdote, usually based on some-
thing he has seen, read, or watched on TV, and is
almost always recent and often self-deprecating.
He could have invented Twitter if he hadn't
been otherwise occupied, as the one-liners are
legendary.

As one of his stories unfolds, one or two small
mental mutterings or narrative stumbles are
introduced, which heighten the credibility of
the setting or the characters. Or perhaps they
suggest, always in retrospect, a hint of an
exaggeration, even a small fantasy, or perhaps
an existential query. But that comes later, as
the Fischl telling machine is always generous
in its descriptions to ensure a robust audience
environment, as they say.

There is a painting called *The Day the Shah Ran
By,* one of his smaller Côte d'Azur beach scenes,

that does the same thing. The figure fleeing
the picture on the right may or may not be the
Shah of Iran, and it doesn't really matter to
the image one way or another—but somehow, in
the way that nineteenth-century novelists first
showed, the detail hovers over our interpre-
tation. We become invested in it, and a good
storyteller does just this: he seduces our imagi-
nation and sets the stage for the unexpected
conclusion.

So one night after a French summer, we sat in
a New York restaurant listening to Eric discuss
how difficult it was for him to learn French,
unlike April, who had picked it up with her usual
uncanny ability to learn quickly and appropri-
ately. After a lengthy set of stories about his
inabilities, his failed attempts, and then his
sudden understanding of how the French language
worked—a kind of phonic epiphany that had come
late in the summer—the subject changed and
we went on to something else. As dinner ended,
Eric called for the check, snapping his fingers
and calling to the waiter . . . "Croissant!
Croissant!"

. 15 .

INDIA AND JAPAN

1989

Traveling through India was as close to being in another world as I could get. I knew right away that I would never understand it. I couldn't read the body language. Things seemed sinister or threatening that weren't. I saw beautiful dancing, heard entrancing music, and sat mesmerized as bands in mismatched uniforms led elaborately decorated animals in wedding processions. I watched out the window of our car as a young boy, horribly deformed from birth, chased after us on all fours. I saw the mutilated back of a proud teenage boy who made his living break-dancing on broken glass. Nothing made sense to me. I couldn't believe the warmth and sincerity in the smiling faces of kids living in the worst possible conditions. The contrasts between beauty and wretched existence were so constant and stark that I was dumbfounded.

As though things couldn't get stranger, driving back from Bharatpur to Ahmedabad on a trip to a bird sanctuary, I saw a guy hitchhiking with a bear.

More than an incredibly rich sensory experience, our trip to India

triggered a new direction in my art, a seismic shift in my career, and, though I didn't realize it at the time, the first tentative steps in what would become my exit from the New York–centric art scene. When I began painting, I resolved to keep pushing back the boundaries of my work. Developments in the studio—the glassines, the first full-color oils like *Rowboat* and *Sleepwalker*—carried me into the realm of narrative realism. Later, the nude beaches of St. Tropez broadened my cultural horizons and helped me to define my American roots. India sparked my first full-fledged encounter with the Other.

The Other is a philosophical concept that has a very specific and important meaning for artists. It's that which you are not, but which helps to define you. The Other brings your life into relief precisely because it is not you. For example, the French artist Pierre Bonnard painted his wife, Marthe, almost every day. He painted her bathing. He painted her reading. He painted her working in her garden. He painted her in her life, going about her business. You get the sense looking at his paintings that were Bonnard not to exist, Marthe would still be doing all of the things he painted her doing. But were Marthe not to exist, neither would Bonnard. Bonnard's life was defined by a very precise measuring of the space between Marthe and his observations of her. He defined himself by those observations.

With its odd rituals, cacophonous music, and indecipherable body language, India was an alien landscape. But it was also the counterpart to my strange, disordered psyche. India was my Other *and* it was me. All I had to do was paint what I saw.

April and I had been invited by Anand to be artists in residence for a month. While we were there, Anand arranged to take us to several sites and temples within the immediate surroundings of Ahmedabad. Anand thought as a painter I would find the tradition of hand-tinting photos stimulating. Unfortunately, I did not. The difference between painting and tinting photos is that when I paint, I create. When I tint a photo, I'm coloring.

We visited a slum and saw things I thought New York had pre-

pared me for. But nothing I'd seen compared to the squalor, the dehumanization, the desperation. And yet as April and I walked through the narrow, filthy alleys, the people who lived there greeted us with the biggest, warmest smiles I'd ever seen. They bade us join them and in some cases offered us food, even though they had nearly nothing.

Kids with terrible birth defects and barely working arms or legs hobbled up and surrounded us like hungry cats begging for food or money—but with smiling faces that seemed so sincere you could not help but cry at the cruelty of life itself. It was way too harsh and desperate to have even the slightest sentimental response to. The contrast between the conditions they lived in and the warmth of their greeting was profoundly confusing. I did not feel in danger as I would have were I in a slum in the States. Though they begged for food or money, they did not treat us as though we owed it to them.

It being wedding month, every day and every night there was at least one procession snaking through the congested streets accompanied by a motley, ragtag band, like a pickup basketball game in the inner city, with everyone wearing a different uniform. The same could be said for the musical instruments. Sometimes the wedding band was overloaded with trombones, and sometimes they'd be heavy on the drums. You really couldn't call it music. To my ears it was sound—chaotic, festive, and jubilant.

There were also funerals proceeding daily. The dead were being carried to the riverbed to be cremated. We learned quickly that the bodies draped in red were women, and many of them, we'd been told, had been murdered, set on fire by husbands who wanted out or wanted another dowry. You would read daily in the paper that some hapless woman had accidentally caught fire trying to operate her kerosene stove.

I took lots of photos. I hadn't gone there with any clear sense of what I wanted to do. I didn't think I'd be interested enough to make paintings when I got home. I didn't know what to expect. I was there mostly because April wanted to go. To some extent, I think India

appeals more to women than men because it's so sensual—the smells, the fragrances, the fabrics, the colors, the jewelry. Where we stayed there was also beautiful clear light that at dusk turned to rust. They have a name for it, *kowdoolie*. It's when the cattle are brought back to their pens and they kick up dust as they go. Mixed with the red sunset, it produces a color I'd never seen before. I did a painting of this light.

From Jaipur, our guide drove us to Agra so we could see the Taj Mahal. We arrived at night, and a large section of the city was without electricity. As the car inched through the dark, teeming streets, a wedding procession approached like a scene out of a Fellini movie. The men had found a generator and loaded it into a wheelbarrow, which they'd hooked up to fluorescent lights that they carried on their heads like antlers. They were followed by another phalanx of revelers holding lanterns on their heads, who were followed by the groom, who was wearing a sparkling outfit made all the more glittery by the jumping lights from the lanterns. He rode on an elephant painted with bright colors in cheerful patterns. The whole parade was surrounded by a band that was bugling and bellowing and dancing. The procession passed and disappeared into the blackout. It was a vision, which in India is a daily occurrence.

Driving back to Jaipur was terrifying; the road was littered with burning cars, overturned trucks, smashed motorcycles, and rusting chassis. The roads are not quite two lanes and there is a definite, though not always attended to, hierarchy of right of way. Animals are always first, followed by larger vehicles, then middle-size, smaller cars, and carts, and finally pedestrians. I asked our driver, "How do you drive in India?"

"Eye contact," he said.

We passed women laying track for a railroad. April had the driver pull over. She was appalled that the women were doing all the heavy labor while the men sat around drinking tea. She was also amazed at how dressed up and bejeweled the women were even though they

were working such a grimy job. We were told that if the women left their finery at home, they'd be robbed.

We actually saw very little of the country. Our trip was too short and too limited geographically for April and me to take in all its vast strangeness. But every day that we were there I saw at least one thing that amazed me—a rite, a ceremony, a social construct that took a leap of imagination in order for me to grasp it. India was the first time I experienced living in someone else's normal.

T HE paintings I made when I got back to New York were like no other paintings I'd done, and in many ways they were the reverse of my earlier work. Because the body in India is so hidden, clothing there becomes the same thing as nakedness in our culture. Before, I'd been stripping people naked, trying to reveal character beneath the surface. Here I was clothing people, making these extraordinary, abstract shapes of women in their saris.

And India is so much about the senses—smell and taste and the visual. Unable to penetrate the rich, intricate culture of the East, confronted by its stark otherness, I painted the surface of what I saw— the sinuous shapes and luminous, saturated colors of Indian street scenes.

In my painting *On the Stairs of the Temple,* I portrayed a woman swaddled head to toe in a flowing, rose-colored sari ascending the steps of a temple, followed by the gazes of a crippled, prostrate beggar and his minder, a swarthy, piratical figure dressed inexplicably in a blue-and-white-striped rugby shirt and a gold turban. Occupying the foreground are a family of monkeys, indifferent to the scene behind them; a figurine—part lamb, bull, and human—staring directly at the viewer; and a brass bell, suspended inertly from a rope.

In *Dancer,* an Indian woman is dressed in traditional garb, veiled and bejeweled, and assumes a dynamic position; her precise, balanced posture contrasts with its ambiguous meaning.

By the River shows two sari-clad women, their backs turned and carrying brass pots on their heads, walking away from the unseen river in the foreground. The profile of a camel's head, its expression unreadable, stamps the upper-left-hand corner of the picture plane. A woman wearing Western dress stands in the middle distance, her head obscured by the camel. A fakir, his face cast in shadow, hunkers on the riverbank. And completing the group, an androgynous figure, a prostitute perhaps, strikes a slatternly pose and stares directly at the viewer.

In all these pictures I tried to make the images succinct, striking, and opaque. I wasn't trying to define their relationship to one another or to the viewer. At first I thought I was making portraits, but they're actually landscapes—scenery, not psychology, the raw material of a foreign culture, the natural forms and colors that the eye records without judgment or interpretation. I was painting light.

And shadow. The dancers, beggars, and holy men I painted now not only blocked the interpretive gaze but also turned it back on me, exposing my expectations, biases, and desires. *I* was stripped bare by their gaze.

EARLIER that spring, Kathan Brown, the owner of Crown Point Press in San Francisco, had invited April and me to go to Kyoto to make wood-block prints with a master printer named Toda. We were flown first class and stayed in the most exclusive *ryokan* in Kyoto, where each morning a woman came into our room on her knees to gently wake us, ask us about our breakfast, and prepare our baths. Our shoes were ready at the door when we left for our day's outing. We visited the most beautiful and sublime gardens and forests, temples, and restaurants, where the cuisine is a picture of pure imagination.

Watching Toda work using the traditional Japanese techniques was astonishing. I had sent him a work on paper I wanted to translate into a print. It was a sketch I made with oils of a woman sensuously lounging on a mattress on a beach and a young girl prancing

past her. I was curious to see if it would be possible to translate the loose, gestural quality of my drawing into a print. The wood-block process is antithetical to the direct attack of painting. In translating my sketch, Toda had to create several color separations, each requiring its own block. I had sent the drawing ahead so he could get a head start in deciding how many blocks and how many color separations, and begin to make the blocks.

It was like watching a magician. You saw what Toda was doing, but you couldn't see how he did it. He sat cross-legged in the middle of his small studio floor for hours, a block of wood on his lap, lightly sanding areas where the color would pool or drain to create densities and transparencies. What blew my mind was that in my sketch I'd left fingerprints where I'd smeared paint around, and Toda somehow managed to re-create the effect of the fingerprints.

One of the last nights we were in Kyoto happened to be April's birthday, and our host took us to a restaurant unlike anything we'd experienced. We'd already tasted whale and the hallucinogenic meat of the Japanese blowfish. The restaurant served only two things: sea bream and lobster. We were asked to choose one from a huge aquarium in the middle of the restaurant. We chose the sea bream. And from the counter where we were seated, we watched the chef prepare our meal. He scaled and then flayed the flesh, paper thin, from the side of the still-living fish. He placed the flayed flesh back onto the fish, arranging it in an abstract pattern that mimicked the fish's original scale pattern. Then, propping up both the head and the tail to create a bowl-like shape, he served us this not-quite-dead fish and bid us to please begin our first course. With beautifully lacquered, nail-thin chopsticks, we began to pick off its flesh while the sea bream lay there, eyes flickering, mouth agape, gasping for water and comprehension. When we had finished this course the fish was removed, killed, sushi'ed, sashimi'ed, sautéed. Every part of it was prepared and eaten. All that remained at the end of the meal were its bleached bones.

We Americans prefer to buy our food in shapes and cuts that

bear no resemblance to the animal or bird or fish they once were, so that we don't have to confront the idea or be reminded that its death ensures our survival. At this restaurant, the chef went to the opposite extreme in not hiding the source of our nourishment and pleasure. He abstracted the fish not by chopping it into unrecognizable bits, but by creating a facsimile or replica of the original fish we'd selected.

I've never resolved the complexity of my feelings about this event, or Japanese culture in general—its ritual beauty and brutality, its rigid forms and excessive politeness. But unlike India, which was no less strange, Japan didn't inspire me to make any pictures. Actually, my experience of Japan was the opposite of India. Its culture was so aestheticized that when I visited a store, it took longer to get something wrapped than it did for me to choose it in the first place. The Japanese would anguish over the color of the paper and the kind of string they should use to make the package. Some stores would even use wax seals. Everything was about presentation, and because of that there was no way in, no way for me to penetrate what they had already predetermined to be the right way to experience Japan. It was not because it was foreign but because it was meticulously ritualized. The only visible crack I found in the otherwise perfect presentation was all the drunk businessmen vomiting and passing out on the streets at night. But there was no mystery to that, no complexity. It just seemed sad, and I wasn't interested in painting it.

Years later, when it opened its borders, I began to visit China as part of an international art exchange. Despite their proximity, I was struck by the dissimilarities between their people and the Japanese. Even though their government is more controlling, the Chinese seem so much looser, their sense of humor easier, their creativity less precious. I don't know why that is—whether it has to do with Japan's island mentality, its limited space, or its feudal traditions. But I do realize that in terms of culture, freedom and democracy are not the same thing.

. . .

T HAT spring when April and I got back from India, the art market was beginning a sharp decline. Ever since the stock market crashed in October 1987, my friends and I had been waiting for the other shoe to drop. Remarkably, our prices held or continued to rise. I was selling new work at $350,000—more than a hundred times what my paintings had sold for at the start of the decade. It felt unreal. I was sure it couldn't last. And then of course I was shocked and unprepared when it didn't.

The reasons for the plunge were legion. The economy was uncertain, money was tight. Investors fled the inflated art market for the relative safety of equities. Within the art world itself, the so-called neo-expressionist movement I was associated with had lost not only favor with critics and collectors but also its iconic status among the youth-obsessed, celebrity culture. We were no longer the It-boys and -girls. We were no longer hot.

Our little community was beset with panic and paranoia. Artists aren't known for their thrift or business acumen, and it seemed like every conversation was about the coming retrenchment. The warehouse and factory loft conversions that had been such a solid investment when real estate prices were rising had suddenly become money pits. People were living beyond their means. Other, more prudent artists discovered they might not have any means at all.

April and I were dealing with three mortgages, but though we lived comfortably, neither of us was extravagant. So I didn't feel the pressure some of my friends did. Still, no one knew how bad things would get. The sales from my Waddington show had been disappointing (the first time a show of mine hadn't sold out). And that was before the market had started its downturn.

My India show, the first real test of my prices, opened in May 1990. The initial signs weren't good. Mary gave an after-party at her

apartment in the East Sixties and invited the usual roster of art stars and celebrities. Tom Wolfe RSVP'd that he was coming, then canceled after he discovered John Guare would be there. Painters, it seems, don't have a monopoly on rivalries and grudges. More troubling were the reviews, which were mixed at best. Mary said she thought people weren't able to connect the pictures to my earlier work, but that one day the paintings would be seen as very important and among my very best. Still, it was the poorest reception I'd gotten in New York.

But I didn't really start to worry until sales of the India paintings began to stall. Taking the weak market into account, Mary had priced the big canvases at $250,000, a healthy cut from my high. But apparently that was still too steep. As was her custom, Mary called me about the latest bids and asked me what I willing to take for this or that picture. Only this time she wasn't talking about a courtesy discount.

All our conversations around that time took the same form. "What do you think we should sell these for?" she'd ask.

"I don't know," I'd answer. "You're the dealer."

"No, what do you want for them?" Meaning what was I willing to accept.

"I don't know. What are they worth?"

"I don't know. Give me a number." We'd go back and forth like that, and finally I'd throw out a figure, name something totally made up.

"Too high," she'd say.

In the end, the show sold out. All the paintings went to name collectors, and the big ones fetched $150,000. I don't know how Mary did it. But then, I've never understood the business side of art. How do you put a value on a piece of art?

For me, no price can be high enough. My paintings are my life. They're not just what I do. They're who I am, how I want to be remembered. On the other hand, any price is too much. Given no other choice, I would make my paintings for free.

With those parameters, any valuation is going to be arbitrary. But the volatility of the market during the eighties made no sense to me. A painting valued at $2,000 in 1980 might have sold for $500,000 five years later at auction, and for $50,000 five years after that. How was that possible? How could a work's true value change so much, so quickly?

These weren't idle questions for me. I wanted to know what my paintings were worth to the world. I think every artist—van Gogh was no exception—wants to know that. And arguably every artist from Michelangelo to Warhol has battled for commissions and actively promoted his or her vision to the gods of fashion and posterity. But I doubt that art's value had ever been so tied to pure dollars and cents, nor subject to such intense financial speculation.

I wasn't complaining. Well, actually, my friends and I were grousing all the time. Still, I knew that the same market forces that were threatening my livelihood had also made me financially secure beyond my wildest dreams. And although those dreams were now in jeopardy, money wasn't the lens through which I saw or prioritized things. It just wasn't that important to me. If it had been, I wouldn't have become an artist in the first place.

However, price was a different story. People in the art world didn't take you seriously if you couldn't sell your work competitively. And collectors, no matter how much they loved your art, were mainly interested in investment. Mary used to tell me that when she took collectors to see artists' work, their questions were always about marketability. Would the pictures—in those uncertain times—hold their value?

The India paintings were apparently a poor bet. Nobody was using the term *branding* in those days, but the art world—dealers, museums, collectors, and their art advisers—were increasingly promoting artists whose work was recognizably their own, not only in terms of content but also signature style and format. Although years later they *would* become my most sought-after work, the India paintings were

a break at the time from what I'd been doing—snapshots of middle-class angst, roughly rendered explorations of sexual and social taboos.

In short, they weren't "Fischls." At least not what the art world perceived as a Fischl. They were experiments, indulgences—Michael Jordan taking a year off to play minor-league baseball—and they didn't fit most investors' business models. It might have been different in the seventies, when prices were depressed, and through most of the eighties, when the market was relentlessly upbeat. But now buyers were playing it safe. Before they plunked down hundreds of thousands or more for a painting or an object, they wanted to know they were getting a sure thing.

I couldn't guarantee that. I was on a journey to foreign lands—digging up feelings, artifacts of memory, the psyche's buried treasure. Turning back now would be—well, turning back. My recent travels to the East, mainly India, had brought me new ways of seeing, new possibilities of making art. If I had to rejigger my approach to painting, learn new techniques, try new materials, then so be it.

More troubling would be my estrangement from the art world. Over the next few years I would edge out of the New York scene, spending greater amounts of time on Long Island. It was not a conscious decision. I'm not even sure I was aware of it, and to the extent I was, it filled me with trepidation. After all, the art world was the only world I knew.

. 16 .

MALAISE

1990–1992

B Y 1990, the wild ride was over. It wasn't an issue of money. I'd reached a point of exhaustion. The unexpected success and innocent fun of the early eighties, the adrenalized years that followed, the traveling and partying, the critical attention and lionization by institutions that had once felt impossibly remote, and of course the constant battle to create work that was relevant and cathartic: all of that had taken its toll.

It was a new era, a new generation coming to the fore. The art was different too. I was beginning to see a lot of work by young artists that employed cartoons, comic books, toys, dolls, mannequins, *Playboy*-style pinups, scatological jokes, sports figures, athletic equipment, candy, kitsch—the fantasies and detritus of adolescence. Where this art came from and what purpose it served, I couldn't say. But it seemed more childish than childlike.

When I'd go to Chelsea to see shows, I felt as if I'd wasted a few hours. Rarely did the art I saw move or transform me. What I'd often see in the galleries was work that was so hermetic it was as if the

artists were talking to themselves. I felt like I was peering over the artist's shoulder looking at the work he'd done, allowed to watch but not invited in.

Jeffrey Deitch's gallery was around the corner from my studio. I'd walk by it almost daily on my way to meet my friend Ralph Gibson for lunch. Deitch was among the first to really promote this kind of work. Going into his gallery was like going into a day care center for artists with their art toys strewn everywhere. Deitch, who'd served for years as an art consultant to Citibank and would later become the first dealer to head a major museum, was also the host of the first art reality TV show, *Art Star*. It reduced the creative process to name-calling, crying, and making silly costumes for silly parades.

The AIDS epidemic brought out the best in many artists at the worst of times. Through the eighties, gay artists were trying to cope with the terror of this silent killer at the same time that they were being blamed for it, accused of spreading the work of the devil and told that it was God's punishment for their sins. They watched their friends dying. Some were dying themselves. But they were still trying through their art to make sense of it all. Their emotions were real; the pain, anger, resentment, and tenderness they conveyed in their work were authentic emotions beautifully and touchingly articulated. Their attempts to humanize the victims of the AIDS scourge were heroic.

One of them, my good friend Ross Bleckner, had begun making paintings that were memorials to those who had died, and it was this work that gave me a handhold for dealing with my own fears and sadness. They were profoundly moving paintings about the palpable weight of absence, and they were made without an ounce of self-consciousness. They were unapologetically sad, serious, eloquent, painterly, and beautiful. They held you spellbound as they gently pried open your heart.

But by the start of the nineties I was seeing less of this kind of art and more of the campy cartoon stuff that seemed to skate over the surface of American consumer culture. I do respond to artwork that

deals with the darker and more complex side of childhood. *Untitled (Candle),* a small sculpture by Robert Gober of an unlit wax candle standing proudly erect, knocked me out when I saw it in 1991 at the Matthew Marks Gallery in New York. At the base of the candle, perversely and wittily imbedded in the wax, are actual pubic hairs. The piece for me captures, simply and eloquently, the last stage of male childhood where virility and virginity temporarily coexist.

And I'll never forget the first time, in 2001, I saw *Him,* Maurizio Cattelan's life-size sculpture of a young schoolboy. He's kneeling, facing the wall, dressed in gray wool shorts, a white shirt, a gray wool jacket, white socks, and black shoes. He appears to be praying. When I walked around him to see his face, my jaw dropped. It was the face of a mature Adolph Hitler. I can't tell you how upsetting I find this piece, the way Cattelan conflated innocence and evil.

But those kind of tough, penetrating works were becoming increasingly rare. I can remember the day I realized my sensibility—my interest in art that had a sense of urgency, inventiveness, and risk, and that was full of anger, anxiety, and outrage—was totally out of sync with art-world fashions. I was looking at a show of paintings by a young female artist named Elliott Puckette. She'd made paintings of very delicate, beautiful calligraphic arabesque lines floating on backgrounds of limpid washes of colors. From a distance her lines seemed both languid and certain. But up close they revealed their obsessive-compulsive nature. Each line was painstakingly etched into the background. What appeared as fluid, elegant lines of varying width turned out to be painfully slow and stiff acts of discipline and concentration. Her lines, her gestures, did not express emotions. They denied them. Her work helped me understand the sea change that had been taking place in the art world. For Puckette and her generation, whatever anxieties they might have, they were not going to make them the explicit subject matter of their work. Emotion was going to be expressed only as the tension created by the discipline it takes to execute a work.

One of the key signatures of modernism has been the fully

charged, emotionally wrought brushstroke. It's the unencumbered expression of modern anxiety and has been at the core of almost all the art that had been made in the last hundred years. Beginning in the fifties with pop artists like Rauschenberg and later Lichtenstein, the brushstroke became a source of parody; painters have not been able to shake a certain level of doubt or self-consciousness since then. It signified emotion instead of embodying it. By the nineties, one could declare that the age of anxiety was now officially over. There was now a generation of younger artists for whom making art about your existential angst was no longer salient content. You cannot express anxiety—or any hesitation or doubt—when you're etching perfect, sinuous, graceful lines.

As I began looking around at other new art, I saw the arabesque everywhere—along with the obsessive processes and the lack of sentiment—in the works of younger artists. Everything from the twisting sculptural columns of Bonnie Collura, the cascading painted diagrams of Matthew Ritchie, and the sinewy mannerist nudes of John Currin to the Dairy Queen swirls in the candy landscapes of Will Cotton had the arabesque form. Clever, witty, playful, sexy— yes. But emotional? No.

DURING the eighties, work was being made and shown in the city that was challenging my work. I felt that in order to compete with it, I had to become a better painter. I felt I had to be clearer and more assertive, to stretch the limits of what I was doing. I felt there was a healthy argument going on. Even with artists whose work I didn't like, I respected the clarity of their positions. It made me refine mine.

I was responding to the feminist critique implicit, and sometimes explicit, in the work of Cindy Sherman, Barbara Kruger, and Jenny Holzer. And I had to deal with my latent suburban racism in the face of the assertions made through the works of Jean-Michel Basquiat,

Lyle Ashton Harris, Fred Wilson, Glenn Ligon, and Latino artists such as Andres Serrano, Vik Muniz, and Rafael Ferrer. Everything was about identity issues and entitlement.

These artists pushed me to reexamine my work. They inspired me to make paintings that could stand up to and at times challenge their best art. I was trying to be provocative, but I didn't want to be sensational. I was trying for something real, truthful. I was looking over my shoulder at the Italians—Francesco Clemente, Enzo Cucchi, Sandro Chia—whose work seemed freer than mine. There was more poetic lyricism to their imagery. They were dealing with religion, Catholicism, Buddhism, sex, death. I was starting to delve more deeply into those themes in connection with faith and aging, but I was using more realist imagery.

I saw shows all the time, and they almost always featured themes of sex, the body, relationships, desire, identity struggles, personal values. And I was always thinking: Oh, God, is this artist being clearer, more eloquent than me? How do I make my work braver? More complete? More competitive?

The art world had turned away from that kind of art and now was focused on another model that I didn't understand or relate to, and I stopped asking those questions. It wasn't inspiring me. It was confusing me.

I WAS having a tough time in the studio too. I hadn't had any big, good ideas since my India paintings—big works weren't selling well in this market anyway—and clearly I wasn't getting much stimulation from the art I was seeing around me. I'd been through periods like this before—it's part of the creative cycle—and I was confident that I'd break out of my funk sooner or later. More troubling to me was my mood outside the studio. The demons that drove my art—unchanneled and unproductive—drove me into a fairly constant depression that in turn drained my energy at work.

I wasn't the only one suffering. April had put up a show in 1989 that had been panned, and she'd been viciously attacked in the reviews. The degree of disdain expressed toward her and her work came out of nowhere and was incomprehensible to me. Her work and career had been progressing steadily. Her paintings were in prestigious collections, including those of important museums. She had just been on the cover of *ArtNews,* the subject of a glowing profile, and had been included the year before in the Whitney Biennial. None of us could figure out what had brought this on. But the consequences were huge. She sold little work from that show and even less over the next few years. Worse, she fell into a depression a good deal blacker than mine.

I n the summer of 1991 Matthias Brunner, the partner of Thomas Ammann, invited me to be a judge at the Locarno Film Festival, an annual competition for first-time directors. I told him I really didn't know much about film but he insisted, saying that the organizers wanted to incorporate artists on the jury not specifically from the movie business. First-time directors, first-time jurors.

Locarno is gorgeous—ancient and picturesque. Nestled into the base of the Swiss Alps on the shore of Lake Locarno, the entire town gives itself over to the international film industry for the ten-day festival. Movies are screened nightly in the central piazza. My first night, we sat at café tables watching a remix of *Citizen Kane* projected on an enormous outdoor screen with the silhouette of the nearby mountains and star-filled heavens as a backdrop.

Unfortunately, the drop-off in quality was quite steep after that. And one disadvantage of being a judge was that you couldn't leave the showings early, even if you knew that many miserable hours of viewing lay ahead. Most of the films were of the earnest, black-and-white variety—more like mission statements than movies. *Johnny Suede,* however, an American film by Tom DiCillo, was different. Featuring

Catherine Keener and Brad Pitt in his first starring role, it was beautifully shot, lush in its use of color, very postmodern in its look and ironic tone. I can't remember much of anything that happened in the film, other than Pitt playing a comically pathetic character without a shred of self-awareness. And that he wore the most exaggerated pompadour you've ever seen—his only source of pride. But after being force-fed an endless stream of third world, crudely constructed, heartfelt narratives, one more depressing than the next, *Johnny Suede* was my clear-cut choice for the festival's top honor, the Golden Leopard.

To my surprise, not all the judges agreed. In fact, we were sharply divided between *Johnny Suede* and a bittersweet Chekhovian drama, *Oblako-ray*. Set in some godforsaken Siberian tundra, the movie opens on a dreary Sunday morning with the protagonist sipping coffee and smoking at a picnic table of his apartment complex. He is soon joined by his buddies, and they commence to bitch and moan about this or that irritation or injustice. The protagonist then rashly announces he's quitting and getting out of there—it's apparent he's done this before—and this time his friends take him seriously. Clearly he was only complaining and had no intention of leaving, but it is too late. In the final scene a crowd has gathered at the edge of the only road there is, an unrelentingly straight road stretching from horizon to horizon. The bus pulls up, and he reluctantly boards it. The last thing you see is his face peering out the rear window like an astronaut looking back at earth.

Michael Ballhaus, the great cinematographer, and I were the most adamant about the freshness and sophistication of *Johnny Suede*. We pushed hard and ultimately were persuasive. Yet for all its sophistication, style, and appeal, I can remember almost nothing about it save Brad Pitt's hair and the general look of the film. On the other hand, I cannot forget *Oblako-ray*. It's as if every detail of the narrative has been indelibly imprinted on my brain.

I realize now how lost I'd become in my artistic instincts. I in effect voted against myself, against my own conviction that strong

empathetic narratives top style for style's sake. This was very much at the heart of the arguments raging in the art world at the time. Somehow I'd forgotten who I was.

THE contemporary art world has never been an easy place to navigate. Its market, relatively small until recently, is largely unregulated and its forays into the avant-garde have often been opaque, to say the least. As a result it's attracted no shortage of scoundrels, aesthetes, poseurs, eccentrics, and plain old fruitcakes. My success in the eighties masked a multitude of sins and sinners, and Mary's gallery was like a cocoon for me when it came to the business side of things. But whether it was coincidence or the cynical way I was seeing things, I was becoming increasingly disheartened with the city's downtown scene.

Shortly after my India show, Tony Shafrazi, a New York–based contemporary dealer, invited me to be in a show he was curating about the eighties. I told him I wasn't interested. Sixteen years before, in February 1974, during a brief trip to the city, I'd gone to see if *Guernica,* the celebrated Picasso antiwar painting on loan to the Modern since Franco seized power in Spain, was really a masterpiece. It was the first time I'd seen the painting in person and the experience was overwhelming. An hour later, Shafrazi, then a struggling artist, had walked up to the all-but-unguarded canvas and spray-painted the words KILL LIES ALL across its surface.

I was shocked when I heard the news. It had seemed inconceivable to me at the time. My take was that Shafrazi's stunt was an attempt to keep pace with his more successful friends, a group of highly regarded artists that included Richard Serra, Pat Steir, and the late Robert Smithson (who'd recently died in a small-plane crash that Shafrazi had canceled out of at the last minute). In fact, he defended the act as a conceptual gesture, claiming that he loved Picasso and felt no one, in light of the war in Vietnam, was paying attention to this great and important painting. To his twisted way of thinking,

defacing *Guernica* would somehow bring it back to life. (Fortunately, the paint he used could be removed from *Guernica*'s heavily varnished surface without causing permanent damage.)

Ten years later, while in Madrid for the *Tendencias* show, I revisited *Guernica* in a gallery near the Prado, where it now hung behind bulletproof glass guarded by uniformed men with AK-47s. In an extraordinary coincidence, I discovered I was there once again on the same day as Shafrazi. Only this time I actually spotted him. He was leading a group of art collectors past *Guernica* while regaling them with his story of the attack. I was appalled that he felt a proprietary right to this masterpiece when all he'd done was ensure it would be removed behind thick glass that precluded any direct experience of the work and would be shown under armed guard, contrary to its spirit.

Now Shafrazi had become a respected dealer. But in my mind he was still the defacer of *Guernica,* and I didn't want to be associated with him. Tony was a close friend and associate of Larry Gagosian, and I'd run into him over the years at various parties at Larry's East Hampton home. On those occasions I'd found him charming, a genuinely sweet and intelligent guy. But there's something of the moralist in me, and I couldn't forgive his trespass against one of my favorite paintings, or that he'd refused to publicly apologize or try to make amends for his insane act. And I told him as much. We made a deal. I would loan him a painting, which wouldn't be for sale, on condition he would publicly apologize for defacing *Guernica*. He even signed a letter to me agreeing to the terms. So I sent him a painting, which he featured in the exhibition. I'm still waiting to see his apology.

But the art world's machinations took a more personal tack in my dealings with high-profile agents like Enrico Navarra. In early 1993, for example, my dear friend the author Frederic Tuten asked me to collaborate with him on a limited-edition portfolio of my etchings based on his text. He sent me a chapter from an unfinished novel he was writing. It was the story of a doomed fictional love affair between

Vincent van Gogh and a woman even crazier than he was, and I thought it so beautiful I immediately began work on a set of studies for the etchings. A week later I asked Fred to come by the studio to see what I'd done. It hadn't occurred to me to check first with him before going to work. If something inspires me, I just go with it. It's why I rarely accept commissions and the reason that even when I paint portraits, I never insist the sitter take the work. In this case, I figured if Fred didn't like the studies, I could always do something with them myself. But that wouldn't be necessary. He said he loved my proposal.

Fred's publisher turned out to be Navarra, a newly minted Paris-based dealer who was trying to raise his profile by working with name artists. Navarra had burst onto the scene several years before, a Gatsby-like figure who seemed to live a rich life among the fast international crowd. But for all his fashionable clothes, styled hair, and bling, he struck me as a stocky middle-aged Italian trying to be the Euro version of Larry Gagosian.

Like Larry, Enrico had started out selling posters. And like Larry, he seemed to have a knack for cultivating key collectors—one of his first coups was Marc Chagall's widow, with whom he produced a steady stream of prints of her late husband's paintings. But he didn't have Larry's natural charm or sophisticated taste in art. Still, he'd apparently done well with the Chagall prints and now wanted to do something similar with more contemporary artists. That's where I came in.

Because Mary doesn't like to deal with multiple editions or any works on paper, I was free to make whatever arrangements I wanted with other dealers. The print market is highly specialized and has an entirely different collector base than paintings and sculpture. Also, Mary feels it takes the same energy to sell a $2,500 print as it does to sell a painting for $250,000. So I was on my own with Navarra.

But for all my natural suspicions, Enrico made me what seemed like a very fair offer. He agreed to set up a studio close to St. Tropez

so I could work there while April and I were on our annual sojourn, to bear the costs of printing, publication, and distribution, and to pay me $150,000 plus expenses up front. I should have taken the money but I didn't. I didn't want the pressure of working on something that I'd already been paid for.

I'd already agreed to the deal when I arrived with April in the south of France, but Enrico seemed determined to court me as if I was a prospective client, or more likely, for reasons I still don't understand, to impress us with his high-octane life. The first thing he did was lend me one of his cars—a sleek, siren-red BMW sports car that they don't make for the U.S. market, with gull-wing doors that opened from the top. When I drove it back to St. Tropez and parked on the square, it instantly drew a crowd of gawkers—the kind of thing I hate. I tried to hustle out of there, but the car was built so low to the ground the door banged against the curb and wouldn't open. I should have just driven away. Instead I reparked and started to get out, re-alizing too late why BMW didn't offer this model to the American market, or more specifically to plus-size American drivers like me. I could hear the laughter of the crowd ringing in my ears as I crawled out of the cockpit on my belly.

I returned the car the next day to Enrico's chateau (complete with helipad) in nearby Draguignan and rented a boxier—and far more dignified—Peugeot for the remainder of the trip. But that didn't end the courtship. Every weekend, it seemed, Enrico would whisk April and me to some place or event—a chopper ride to the island of Porquerolles for a lobster lunch in a five-star restaurant, a Eurotrash party at his estate, a foray in his very fast, very noisy cigarette boat to eat and swim at the Eden Rock Hotel. I don't know how April felt about all this—probably appalled—but I was my usual ambivalent self. On the one hand, I was happy to be treated like a big shot; on the other hand, I knew this had nothing to do with art.

With all the fast cars, boats, and planes, I should have known that Enrico was—well, taking me for a ride. But I didn't. At the end

With Mary Boone
at the opening of
Krefeld Project,
Krefeld, Germany,
2002

In India, as we
passed a man
hitchhiking
with a bear

*On the Stairs of
the Temple,* 1989

Gorgeous April

Thanksgiving at Sag Harbor. From left to right: me, Michele Pietra, Bruce Ferguson, April, Freya Hansell, Miani Johnson, and Robby Stein.

*Once Where We
Looked to Put Down
Our Dead*, 1996

Above: April and me on
our wedding day, 1998

Right: With April
in Rome on our
honeymoon

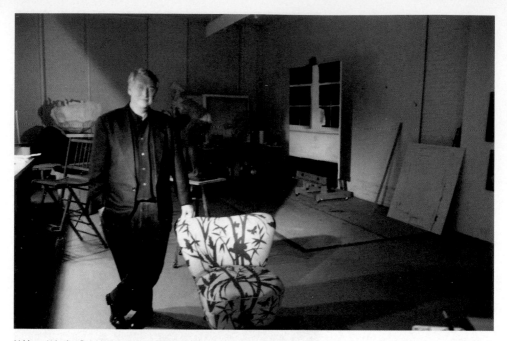

Mike Nichols in my New York studio. He later became a subject for several of my paintings, including *The Bed, the Chair, the Sitter*, 1999.

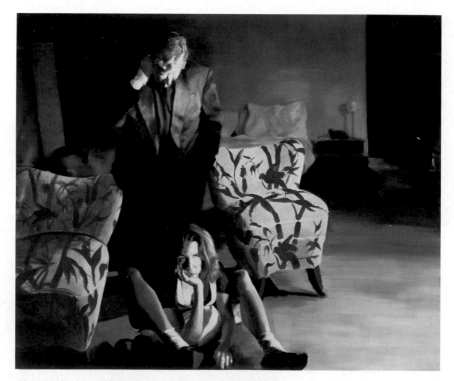

The Bed, the Chair, the Sitter, 1999

With John McEnroe, viewing art at McKee Gallery. John and I exchanged painting lessons for tennis lessons.

Soul in Flight, my sculpture of Arthur Ashe for the opening of the Arthur Ashe Stadium at the USTA National Tennis Center, 2000

JUNE HARRISON

Oklahoma Museum. The inauguration of the installation of my sculpture, *Man Carrying Child,* a gift commemorating the tragedy of the Oklahoma City bombing.

Krefeld Project; Living Room, Scene #2, 2002

Tumbling Woman, 2002

Steve Martin on St. Barth's

With my siblings today.
From left: John, Holly,
Laurie, and me, 2011.

With Chuck
Close at the
opening of
my portrait
show at the
Mary Boone
Gallery, 2011

Most of the gang in front of my painting *The Gang*, at the Mary Boone Gallery, 2012. From left: Judy Hudson, Jack Stephens, Sally Gall, Nessia Pope, Mary Jane Marcasiano, me, April, and Ralph Gibson.

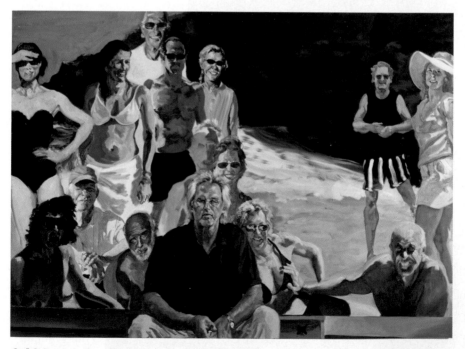

Self-Portrait: An Unfinished Work, 2011

of the trip, Enrico reneged on our deal. The market for prints had crashed, he said, and he couldn't possibly afford to pay me what we'd agreed on without "taking a bath"—an argument that would have been more persuasive if he hadn't already spent my retainer on champagne and charter fees.

Fortunately, the printmaker had already shipped the prints to my studio in New York, so I had some leverage in the ensuing negotiations. But I didn't want the hassle of trying to litigate a handshake deal in the French courts. What's more, Navarra's bad behavior had already hurt Frederic, who felt responsible for getting me into this mess, and our friendship meant more to me than the money. In the end I accepted reimbursement for my travel expenses and, I think, half the edition, most of which sits in my warehouse storage bin. But the real damage was to my diminishing faith in the art world.

MARSHA NORMAN

When he is the host at dinner, the food disappears as Eric conducts the symphony of the conversation. You don't notice Eric eating. Your own plate empties, but the meal is like the biblical loaves and fishes, the substance that appears almost magically but actually, due to the hard work by April, provides the setting for the talk and the laughter, the festival of the friendship. I never had a meal at his house that didn't feel like a feast.

RALPH GIBSON

For a couple of years during the nineties, Eric
and I would meet for lunch almost every day at
Lucky Strike, a bistro on Grand Street in SoHo.
It got to the point that they'd call me in the
morning to make sure we were coming in. Eric's
and my conversations during these lunches were
almost exclusively about art, and sometimes
afterward we'd head up to Chelsea for a gallery
hop. One afternoon we went to a de Kooning
show at Larry Gagosian's. During our discus-
sion of the work, I mentioned to Eric that the
later paintings did not seem so intense when
viewed at a distance but became stronger as
one drew nearer. So we walked closer to one of
the paintings, and he said: "If you stand here,
where de Kooning was standing when he painted
it, you see that the canvas was limited in size
to the reach of his arm. You can see it in the
thinner brushstroke as he reached toward the
corners."

Another time we were at a show of David Salle
paintings. The first thing Eric said was: "He's
using three palettes here," and indicated one
series of colors David used for the background,
another for the figures, and still another for
juxtaposed imagery. I had seen the overall
image as a totality, whereas the first thing

Eric did was evoke the syntax used to create my impression.

This is how a painter sees. As a photographer I am more inclined to reduce images to shapes rather than tones. But the scale of the photograph is usually much smaller than a painting. Where the dialogue became really interesting was when he took his own photographs and reconstructed them into paintings, mixing perspectives at will—a freedom that I'm still extremely jealous of.

. 17 .

NEW DIRECTIONS

1992 – 1995

At the height of the art-market crash, sometime around 1992, April and I had dinner with friends at Orso, a show-business restaurant along Theater Row. Harrison Ford had the table next to us and pretty much everyone who came in stopped by to say hello and pay their respects to him. But while most of the well-wishers nodded at or exchanged brief handshakes with Ford, they seemed to make a much bigger fuss over his dinner companion, a slightly built older man I didn't recognize. In fact, they treated this stranger with such deference and obvious admiration, I was reminded of my own brush with rock-star celebrity and my subsequent decline.

I'd been having a bad day—nothing in particular, just a gray afternoon into evening when the world seemed inhospitable—and as the night wore on, my spirits sank lower. My friends and April tried to kid me out of it. But I couldn't help myself. I was thinking about the ghosts of my own past success versus the warm plaudits now being bestowed on my anonymous neighbor. By the end of dinner I'd fallen into a self-pitying funk.

As I got up to leave, the stranger also stood and asked me if I wasn't Eric Fischl. I admitted that I was.

He extended his hand. "I'm Mike Nichols," he said. "I'm a big fan."

Mike Nichols had been an idol of mine since I was nineteen and first saw *The Graduate*. Even before then, I'd grown up listening to the albums he made with Elaine May, those pitch-perfect routines that captured and ridiculed the neuroses of modern American life— almost a template for the themes I'd take up decades later in my painting. He'd had a huge influence on me, and the fact that he knew my work, much less admired it, floored me.

That night we merely exchanged pleasantries; over time, Mike would become a dear friend. But our meeting made me realize just how sensitive I'd become and how thirsty I was for the good opinion of others. And it reminded me that there were brilliant, creative people who were not part of the art world and its fashions who still valued my work.

The two years since my India shows had been difficult. The market had crashed, causing me to amend my studio practice. I made lots of smaller works on paper—drawings, prints, watercolors—that were relatively cheap and easy to sell. I actually enjoyed working in the new formats, although they didn't give me the same kind of charge—or critical affirmation—as painting large canvases. What's more, I felt myself sliding into irrelevance. Even prior to the crash, the so-called neo-expressionist movement had lost its cachet. Critics and curators, tired of praising and writing about the return to figurative painting, tired perhaps of painting itself, turned their attention elsewhere.

In the absence of serious criticism around my work, I started to measure the value of my art based on its market performance. It shames me to admit it, but it was the only way I could gauge my status in relation to my peers, the only way I could see where I stood in the pecking order. I felt as though I was in free fall.

I'd turned forty-two in 1990. Without quite knowing how, I'd

become that thing that every artist dreads: a midcareer painter, no longer a young Turk or old enough to be considered a living master. In between was not a good place to be.

Laboring in the studio, I couldn't attribute all my pain to bad timing or time of life or the fashions of the art world. The truth is, I'd stumbled into one of those periodic funks most artists experience. I felt burned-out. I'd lost my place in the art world's conversation. I'd lost my mojo, my inspiration, and my youth.

B UT then almost from the date of my dinner at Orso, my long dark mood lifted and my life changed. I wouldn't say that night was the cause of it. But it did mark the low point of my two-year sulk; meeting Mike turned out to be a catalyst for a number of ideas and plans I'd been working over.

The first plan—and it wasn't really much of a plan—was to move out of New York. I'd sold my albatross of a studio the year before, and April and I bought side-by-side lofts in an old cast-iron manufacturing building on Greene Street in SoHo—again part of a real estate project put together by our old friend Jim Merrell. Also, we'd finally finished renovating our Ninth Street apartment and begun living there. Oddly, though, between traveling and long stays in Sag Harbor, we were spending less and less time in the city, and I discovered I didn't miss it.

Though I didn't realize it then, the time I spent out of Manhattan was part of a larger move away from the New York art scene. The proximity of art and artists, of galleries and exhibitions and dealers and collectors, no longer seemed important to me. Those things produce pressures that I'd once found challenging and enlivening, a constant prod to my work. But now that the art world was focused on work I didn't relate to, and I no longer felt as though I was part of its conversation, those pressures seemed beside the point.

I didn't articulate this—partly, I think, because April wasn't

ready to give up the city. She used New York in a way I never did—foraging the cultural landscape, knowing where all the good shops were, meeting with her wide network of friends. Meanwhile I wore a rut between studio and home.

Many of my friends, ones whose work I still felt connected to, had moved at least part-time to the Hamptons—David, Ross, Bryan Hunt, Ralph Gibson. But the biggest advantage to Sag Harbor was its distance from the city. My encounter with Mike Nichols at Orso made me realize not only how miserable I was in the precincts of the new market-based New York art world but also how confining, stultifying, and corrosive that world had become.

One of the advantages of being a fairly well-known artist is you get to meet interesting people at the top of their fields. I'd certainly had access to these people during the eighties, but I was so focused on my career, I mainly hung out with other artists, dealers, and collectors. (There were other issues too—issues of shyness and trust—and I tended to stick with old friends, mostly artists, that I'd known going back to CalArts and Chicago.) But now in a more open, relaxed state, I began to foster interests and friendships outside of the art world.

Although Ralph Gibson and I had met in the eighties, it wasn't until I moved my studio to Greene Street, near Ralph's studio, that we became best friends. Ralph, in my view, is photography's foremost exponent of the body. There's not a painter around who can do what Ralph does in his photographs. The way that he captures the female body, eroticizing it and at the same time abstracting it, finding a geometry to the human form that is both intimate and objective, has never been done as successfully in painting. We'd talk for hours over salade niçoise and flank steak about, say, the contemporary nude or the way photography freezes its moments and painting builds toward them—picture taking as opposed to picture making. I'd been using photos, snapshots really, as a tool in my studio practice for years, but I was illiterate when it came to understanding what I was looking at and looking for in a great photograph. Ralph taught me new ways of

seeing, using the camera lens as a dispassionate and quick-witted eye that can stop time and parse reality into its most basic units or images. But Ralph also brought my attention to the differences between the way I used perspective and the camera's limitations with respect to focal length, how painting allowed me to alter the mechanics of seeing by adding more than one point of resolution to my canvases.

I MET John McEnroe around that time through Bryan Hunt at a dinner party in the Hamptons. We quickly discovered we had a mutual interest in each other's professions. John was an art enthusiast, and I'd taken up tennis a few years before and developed a full-blown obsession for the game. So when Mac offered to hit with me the following morning, I not only jumped at the chance but also spent a sleepless night anticipating it. Naturally it rained the next day, but Mac came by our house anyway to visit my studio and talk about painting. At some point we agreed to exchange tennis for art lessons.

The first thing I noticed playing with John was the incredible variety of his shots. I'd hit with a lot of club pros, some of them former tour players themselves, but none could match John's subtlety, his ability to change the speed and spin, the angle and elevation of each ball. When he wanted to, he could break your rhythm, put you off balance like that. His is a game of almost unimaginable finesse.

So when Mac came to my studio for his first art lesson, I expected him to draw the same way—with great touch and finesse. But it turned out to be just the opposite. I started him off drawing from a nude model, which probably was not the best idea. Developing the eye-hand coordination necessary to draw well is hard enough, but to try to learn how to see the shapes of the body abstractly while staring at a beautiful naked woman is more than a little distracting. In Mac's case, I should have started with a bunch of fruit. Though I don't think it would have changed his approach. He attacked the canvas boldly and aggressively, not in the nuanced way I'd thought

he would. Still, I was fascinated watching him draw. He was fearless. He jumped in without hesitation. And the result was extremely expressive.

Eventually his impatience got the better of him and he stopped drawing. But his confidence in his abilities has never altered. After more than twenty years of friendship with Mac, I see the same fearless, unhesitant approach he showed the first day in my studio in everything he does.

Instead of trying to teach him to draw, I began taking Mac to see shows and to look at art in museums and galleries. I was impressed with his eye. He has a great instinct for what's authentic. Maybe it has to do with his tennis reflexes or maybe it's just something innate in John, but he can look at a painting or a drawing and tell you whether or not the artist's on his game. Even with art he doesn't like—minimalist abstract painting, say—he can still point out the strongest pieces. You can't teach that. You can train someone to look at art more closely, more analytically. But you can't make them see.

John hadn't been collecting all that long when I first visited his home. Though it would evolve, the artwork was eclectic, from some sentimental standards like a middling Renoir to some edgier contemporary painters, like Susan Rothenberg and Jean-Michel Basquiat. Mostly he owned paintings, but he also collected photographs and a few sculptures. At first I couldn't see what connected them, and then I realized that almost all the works contained images of either headless bodies or bodiless heads. I'm sure it wasn't intentional, but it seemed apt. Mac was famous for either losing his head on the court or using his tennis genius to outsmart his opponents.

There are interesting parallels between tennis and art. Both require great eye-hand coordination and use a tool that extends your reach. And both are about creating winning or expressive patterns within a rectangle. (The connective tissue is competition. Art may be a solitary pursuit. It may claim to be a spiritual calling. But the way artists operate in the real world—myself included—involves looking

at another artist's work and saying, "I can do better." Tennis players also start out trying to dominate. But evenly matched against talented adversaries, they end up creating sequences of pure dance as beautiful and artistic as any ballet.) Another thing they have in common—and this I learned from watching Mac play at tennis events—is that your primary audience is not the public that comes to watch your matches or view your paintings. They're either rooting for or against you, or they come to see some exceptional feat of athleticism or virtuosity, or a tantrum or shocking bit of behavior. Your main audience is the guy across the net from you, or in my case the voices inside my head, the voices of my heroes and rivals. They're the ones who are going to suss out and exploit your weaknesses. They're the ones who are going to feel the force of your best shots and bow to your strengths.

What I've learned from Mac is how to get comfortable with being competitive. Though I am, and always have been, competitive, I have never been honest about it with myself. Getting to know a great athlete like Mac showed me how instinctual and hardwired competitiveness is: a survival skill.

I would often quiz John about his tennis strategies and rivalries. I wanted to know how you play against an opponent that is better than you. I wanted to know who his great rivals were, and if he felt they were of equal weight. I wanted to hear from a champion about how to compete at the highest level. He talked a lot about his rivalries with Björn Borg, who became his good friend, and Jimmy Connors, with whom he famously quarreled. He said they both made him a better player. He did not feel that way about Ivan Lendl or Mats Wilander or Boris Becker, each of whom came into his own when Mac was starting to slow down and take time off to be with his family. He told me it had been too late for him to adjust to the new style of game they were playing.

At that time the ground was shifting in the art world. Young artists like Jeff Koons and Damien Hirst were making work that I didn't respect. What's more, I couldn't understand why anyone else

did. But people not only seemed to be drawn to the work, it was all they wanted to talk about. I completely underestimated their impact on the art world. With Koons and Hirst leading the way, the art world was fast becoming the art market. And I had been sidelined.

I realize sports and art are not really the same. Athletes have a life span that is far shorter than most artists'. An athlete inevitably reaches a point at which he must retire from his sport, at least at a professional level. An artist never has to retire. But the two do have a common fate. They both have to come to terms with the issues and feelings that emerge as they become less relevant. One of the great lessons Mac taught me was how to lose—or, more precisely, how losing is a natural part of every competitor's life. He told me about his own struggle to understand this and develop ways of letting go and moving on. Being afraid to lose and letting go of loss have always been extremely difficult for me. But hearing Mac's story—and whose will to win has been stronger than his?—made it easier for me to accept the inevitable changes that time brings.

I MET Steve Martin in 1993. Steve is one of my favorite entertainers. Much like his good friend Mike Nichols a generation earlier, Steve revolutionized sketch comedy by confounding his audience's expectations, exposing the creaky mechanics of timeworn joke telling by delivering the punch line on the offbeat or withholding it altogether. I had been working with similar techniques in my painting, using irony to update traditional forms or, as in the case of the multipanels, making the process of picture making an element in my work. But even without our reciprocal interests, I would have wanted to be friends with Steve—he's so smart and funny, so unconventional in his approach to things. He's also a serious student of art, an aficionado and lifelong collector.

A few months after our first meeting, Steve invited April and me to visit him on the island of St. Barth's. We gladly accepted and

have been returning ever since—an annual two-week pilgrimage that serves as the one real break in my work routine.

More than a chance to kick back in tropical paradise, Steve's holiday gatherings have introduced us to another circle of remarkable friends, including Martin Short and the late Nancy Dolman, Hollywood impresarios Walter Parkes and Laurie MacDonald, Chevy Chase and *SNL* founder Lorne Michaels, Billy Joel, the late Nora Ephron and Nick Pileggi, Mike Nichols and Diane Sawyer, and, of course, Steve's wife, Anne Stringfield. Games are the official order of business chez Martin—card games, board games, word games, charades. But the real activity is being funny—not just mildly funny but laugh-out-loud, can't-stop, tears-in-your-eyes funny. Conversations around the dinner table, or pretty much anywhere, are a series of rapid-fire comic routines—stories, puns, impersonations, and one-liners—inevitably capped by one of Steve's hilariously wry and eccentric observations.

On one of those heady evenings, after clearing the dinner plates and before pulling out the cards, Marty Short asked: Who is the smartest person you know? Without hesitation the crowd unanimously answered Mike Nichols. Mike *is* a genius, and he'd had an impact on all of us sitting around the table. But had Marty asked: Who is the most talented? I would have said Steve. I have never known anyone with his range of abilities. He does magic tricks, stand-up, and physical comedy. He acts, tap-dances, sings, plays the banjo, and writes songs, essays, screen and stage plays, and novels.

But my awe of Steve's talents has less to do with their breadth than with their generous spirit. Anyone who's spent more than the space of a weekend with friends, even good friends, knows how tedious the roles of host and guest can become. Among Steve and his friends, however, boredom is an enemy vanquished. Watching him and Marty frolic in the ocean, Steve reprising his role from *The Jerk,* Marty playing his famous Ed Grimley character; or listening to Steve read from his latest *New Yorker* piece or compose a song with Edie Brickell, or jam with concert banjoist Alison Brown, who happened

one year to be in St. Barth's—you're constantly being brought into a brilliant entertainer's creative process, being uplifted, made to laugh, ponder, and, yes, perform. Because unlike some comedians or actors who are always on, Steve welcomes you to participate.

Ever since I was a kid I'd been a performer—the class clown, the stoned rapper, the comic at the dinner party—and thanks to Steve's encouragement, I joined in the merriment at St. Barth's. It's not a role I sought. In fact, I've always been conflicted about that part of myself—the persistent need to be funny or entertaining, to justify my being there, to draw attention to myself and the insecurities and shallow anger that jokes are supposed to channel or mask or make fun of. I already exposed enough of myself in my work—too much, if you asked me. It's the reason I didn't make self-portraits, or made them ironic or cartoonish when I did. Away from the party, I'm still almost pathologically private. Friends know not to ask me personal questions. I don't show people my unfinished work or allow them or even my assistants to watch me paint. In my ideal world I'd be an invisible eye, observing and unobserved. But Steve's gracious humor—witty and inclusive—doesn't allow that kind of exposure or embarrassment, only the feeling of being part of a good time.

I've been searching for a sense of wholeness and belonging all my life, trying to reconstruct Paradise before the Fall. If there's been any theme uniting the stages of my life and my art, it's been that theme of redemption—the recovery of openness, intimacy, and trust.

Our annual pilgrimages to St. Barth's have never lasted more than a few weeks, and they are, after all, holiday excursions, hardly what you'd call real life. But increasingly these gatherings have become touchstones—reminders that it's possible, if only for a little while, to strip away the armor of everyday life, to lose yourself with others in the spirit of fun and camaraderie—and they've inspired me to make portraits of Steve and his remarkable guests and to record in a series of beach paintings that include old and new friends alike the happy sense of community that eluded me for so much of my life.

The genre of portraiture is one of the most difficult of the modern idioms because it's essentially nonverbal. With narrative painting there's a text that generates the work and therefore a rationale to fall back on. Whereas with portraiture—and it's the same with landscape—you make a painting of a person, and if you're successful the person is there. What more can be said?

Many of the people I met and painted those years were creative and really good at what they were doing. So I think the portraits had been a way of acknowledging that they should be remembered. I felt that part of a painter's job description should include recording history in some way. It's not the realm of painting, per se; it's the realm of representational painting. And part of the job description of representational painting is that you look at and record life, its history, its people, and the objects that surround you.

Painting people you know is terrifying. If you have good friends, the idea of not letting them see how you see them makes no sense. You naturally move into the realm of feeling. In a portrait you go through many likenesses because a person doesn't look one reducible way. These likenesses can be radically different, which you see when you take a lot of photographs of somebody; they move slightly, they animate themselves in a different way, and all of a sudden their face changes shape, their body changes size—it's amazing how mutable these things are. So which person do you arrive at? Which one sums up how you see them and feel toward them and how you see yourself in relation to them? With just a flick of the brush the mouth changes shape and somebody who was relaxed becomes tense, develops a snicker, or becomes startled. As the brush goes this way or that, you have to ask yourself which one is true.

I did a portrait of Lorne Michaels. I'd never met him, and we had a terrific few hours in the studio while I was taking photographs. Later, when I was looking at them, the one inescapable sense that emerged was that a kind of world-weariness had come over his life. So this simple portrait of him sitting in this chair is not about power

or being upbeat. Something has weakened him. He came back to the studio to look at the portrait and was really freaked out. We talked for a while, and we talked specifically about that aspect of it. What was interesting was that as we talked he couldn't take his eyes off the portrait. He might not have been comfortable seeing it, but he knew this thing had a kind of magnetism. So he ultimately became very excited and happy.

The thing about people wanting their portraits done is that it's not unlike kids who play hide-and-seek with their parents. They close their eyes or their parents close their eyes, and then they say, "Ah, I see you." The thrill you get from that has to do with a deep, deep need to be seen in the world. My job is to make sure they feel seen. Of course, there are things people don't want to be seen, but if you handle them in a nonjudgmental way, they eventually become comfortable with them.

Steve influenced my work in another important way. Watching him gracefully segue from one discipline to another in his creative efforts, and let go of the forms that had made him successful and test himself in untried fields, made me realize how rare his protean talents were. I could hardly think of another artist who didn't cling to the forms that had worked for them in the past, including myself. Seeing Steve at work, which resembles play, made me want to explore new territory and break free of the constraints of conventional oil painting.

I N 1994 I made *The Travel of Romance,* a series of five paintings that portray the stations of an adult woman's life. It was, I feel, the best, most coherent series of new work I'd done since my India portfolio, and I have no doubt that its evolution was sparked by my exposure to new creative disciplines.

As usual, I began with the sketchiest of ideas. I'd taught a master drawing class in Como the year before, and the model we used intrigued me. I took hundreds, if not thousands, of photos of her during

the sessions. She seemed totally self-contained, untouched by the activity around her, and I wanted to explore the nature of *her* isolation.

I'd intended the paintings to be a single scene, a study of the young woman hunkered down in a bedroom, actually a likeness of the guest quarters where April and I had stayed in India. I'd painted several portraits of April in the same setting, which I loved for its baroquely dramatic light. But in those pictures, ground and subject seem intimately connected. Here, the woman's balled-up posture, the look of distance on her face, and the pillar of late-afternoon light reflecting off her pale, naked body, set her apart from her otherwise church-dark surroundings.

I painted in the figure of a black male dancer, a symbol of potency and presence. He's trying—without success—to engage her, to rouse her out of her trancelike fugue. He's so animated. He's the opposite of her, the quintessential Other. Together they form a kind of circle, yin and yang poles apart.

And then something strange occurred. As I was looking at the finished painting, I realized that even though I was looking at two people in the closest possible proximity, I couldn't see them both at the same time. They inhabited such different realities, and each was so absorbing for me, that the moment I looked at the woman, I couldn't see the man; when I saw him, I lost her. I started thinking: Where are these people, and what is this a meditation on? There was a suitcase in the background, so I thought about travel. Did they travel to this room, or were they trying to leave it? Who were they in relation to each other? Was one a figment of the other's imagination?

The painting seemed to ask more questions than it answered. That's not necessarily a bad thing, and in the past I might well have accepted it for the enigma it was: a meditation on the ambiguity of desire, the Other as not only unobtainable but also unknowable. But I was still curious about who these people were and what their relationship was, and I decided to address those questions by making a series of paintings.

Movies had been my first big cultural influence. *The Graduate, Nashville,* and *Easy Rider* were the touchstones of my youth. After I started painting, art became my primary image source, and the issues involved in making a painting became the issues I cared most deeply about. Lately, though, thanks to conversations I'd been having with Mike Nichols and Steve Martin, I was thinking a lot about movies again—not so much their content, but the techniques of storytelling.

The Travel of Romance became a kind of theater piece expanding the pictures' narrative through time as well as space, and, much like the glassine works, superimposing the images of one scene onto the lingering images of earlier ones.

In the last four paintings, the figure of the black man disappears. But he retains his presence through various totems or motifs—a mask, a tapestry, or in some other way. Meanwhile the woman cycles through the stages of her life. She starts out in the shape of an egg, then reappears crawling, standing, and bowing before returning to a fetal position. Viewed purely as a vector of desire, she's fated to be alone, her taboo erotic fantasy unfulfilled. Despite the title of the series, she never travels more than a few feet, never leaves the prison of her room, and even her dream of romance dwindles in the last picture's blinding, obliterating light.

I SHOWED the *Travel of Romance* series at Mary's in 1995. It was the first time I'd linked paintings together like scenes in a play. A few weeks before the exhibition, Mary brought Roman collector Carlo Bilotti by the studio to preview the work. Bilotti was one of those art-world characters you weren't quite sure about. Was he really a collector or, as was increasingly the case those days, a dealer posing as a collector?

Bilotti liked the paintings, especially the first one, which he offered to buy on the spot. Both Mary and I made it clear to him that all the paintings were part of a set and could not be separated. He took the news in stride, and after regaling me about his plans to create

a museum in Rome, asked me if I would subtitle each piece with the Italian word for "scene"—*Sogno 1, Sogno 2,* and so on. I said I would.

After they'd left, Mary called to tell me that Bilotti had agreed to buy all five paintings. But he was asking for a discount because he was buying them as a set for his museum. As often happened, Mary and I argued about the final price. I reminded Mary that the set already included a discount. I thought the paintings' price—$75,000 for each picture—was already low. Eventually we compromised at some nominal rate, most of which Mary, to her credit, absorbed out of her commission.

I've come to learn the hard way that many collectors love the art they buy only until it gets them what they love more: money. Shortly after the show, I discovered that four of the five paintings (all but the first one) were at the Gagosian Gallery and were being offered individually for three times what Bilotti had paid for them. When I told Mary, she was horrified and angered. She felt personally betrayed and embarrassed because she'd pushed so hard for the sale. Always a tough businesswoman, she went into tiger mode, calling Larry, who claimed he'd had no idea of the conditions of the original sale. Ultimately, he bought the missing painting from Bilotti, although at a higher price than Bilotti had paid for it—I was also compelled to sell Bilotti another picture in its stead—and then sold all five paintings to the eminent Los Angeles collector Eli Broad, who has kept the suite together ever since.

MIKE NICHOLS

When Eric painted portraits of Steve Martin and
me, we both loved each other's and our own.
Since it was too embarrassing to buy our own
portraits, but we did want them, we bought each
other's. After about six months Steve had a place
to put his and conquered his embarrassment, so
we exchanged them again. This left me with mine.
I could imagine after my death my children say-
ing to each other: "No, really, you take it, we
just don't have the room!" So to spare them this,
I gave it to the Metropolitan Museum.

But I've kept one of Eric's Rome paintings—*How
Exciting Would It Be to Hear . . . (the Confessions
of a Mafia Don)*—which I sit opposite many hours
a day and on some evenings. Also early mornings
and sleepless nights. It is more and more remark-
able to me and mysterious and beautiful.

MARSHA NORMAN

In a social situation, Eric uses his body to screen out what you can see and what you can't, to compose the picture for you. I'm not sure he does this on purpose, but he always manages to be where the situation is most balanced, the place your eye goes first when looking at a still life. You never have to look for him. When you come into a room, he's who you see. I suppose it could be his height or his shock of white hair. But I don't think so. I think it's some natural sense of composition, putting himself in the picture you're seeing. And I don't know if it's conscious on his part.

Eric seems never to move. He just appears somewhere else—across the room, coming from the kitchen, now at the grill, now at the end of the table. I don't know how he does it. On a few occasions, I've sat with him for a few hours, talking about *America: Now and Here (ANH)* [Eric's program to bring art to the American heartland], mainly. And I was so aware that I was changing positions, getting up to get water, turning around in my seat. But Eric was absolutely still. Another time I sat with him on one of the ground-floor decks at his house, discussing the playwrights' part of *ANH*, as a house tour was going on. People streamed by, sometimes

speaking to him, asking him questions, and of course I was trying to get clear on a couple of questions I had come to ask. It was at least two hours, and I swear, the man did not move. I don't know why this seems worth mentioning. I guess maybe because everybody else I know is always on the move. Maybe Eric is the only one actually watching.

JOHN McENROE

Over the better part of the past twenty years,
Eric and I have become intertwined through
our mutual love of tennis and art. It started
innocently enough, deciding to trade tennis
instruction for art lessons, after we met
through a mutual friend on Long Island. After
having played on the tennis court a couple of
times, it was Eric's turn to return the favor.
We met in SoHo and were greeted in his studio
with a naked model to draw. Now (I thought)
I realized why people became artists in the
first place. I was a lousy draughtsman, but I
started liking it a whole lot more! Over the
next ten to fifteen years, Eric and I embarked
on numerous art expeditions, whether it was
to see the latest Guston show at McKee, Neo
Rauch's work at Zwirner, or, as was often the
case, openings of mutual friends of ours, or of
Eric's shows. On almost every occasion, I learned
a little bit more about art, because Eric liked
to tell it like it was. He made no bones about
hiding his feelings of what he had just seen
(sound familiar?). Both of us had fallen off our
respective pedestals of the eighties and were
trying to find our identities as we maneuvered
through our professional minefields. The fact
that we could lean on and learn from each other
helped not only our friendship, but also made

us happier and better people, I believe. It is because of this unique friendship with Eric that I would like to think I had an impact on the United States Tennis Association sculpture that has become so iconic at the U.S. Open. I was also proud to include a commissioned artwork by Eric upon my induction into the International Tennis Hall of Fame in 1999. Eric can be very easygoing and funny, but like most of us, also has a darker side, which I saw in a lot of his eighties paintings, an edginess that I am really attracted to. Over the years he has become a more accomplished painter, but perhaps without the angst of his earlier work. . . . I guess he is like me in this respect. We are happier, but maybe we have both gone a little soft! Although when he painted a portrait of my family almost five years ago, I remember my kids saying, "Can't he make it seem that we are a little happier and look a little better?" Well, I thought, that's Eric, but you could not ask for a better friend.

. 18 .

THE MEANING OF LIFE

1995−2002

T HE Oklahoma City police chief strode across the lawn of the museum's sculpture garden, passing my statue—a bronze, life-size rendering of a naked man hugging a naked child—with barely a glance. The chief was huge—beefy with a brush cut—like a guy who might have recently played linebacker for the Oklahoma Sooners. He didn't look happy. His expression was solemn, grim even, and he was advancing at a brisk military clip toward me. Here it comes, I thought.

Before today's unveiling, the museum's director had warned me something like this might happen. I'd donated the statue to com-memorate the rescue efforts of the first responders to the recent 1995 bombing of the Oklahoma City Federal Building. The director had thanked me for my gift, then added a reservation. "This is the Bible Belt," she told me. "Your figures being naked might be an issue for the people out here."

I'd flown out to Oklahoma City the day before for the open-ing ceremony. The museum had given the piece pride of place in its

sculpture garden, and I was curious to see people's reactions. Most of them were museum patrons and local dignitaries, and their response was subdued and polite. But a contingent from the uniformed services had also attended along with their families, and of course there was the chief. He planted himself in front of me, his broad back blotting out the sun. I waited for the drubbing.

The funny thing, I remember thinking, was that I'd never intended *Man with Child* as a memorial. I'd completed the sculpture in 1992, three years before the bombing. Whatever the chief or his colleagues thought, I wasn't trying to debase the Oklahoma City heroes. Or anybody's heroes.

Actually, *Man with Child* began as a meditation on an aspect of male identity. I was especially interested in male sensitivity, a theme that had been largely ignored by artists over the centuries—there are few images of men with children in the canon (the most famous one occurs in Jean-Baptiste Carpeaux's *Ugolino and His Sons,* showing the Italian nobleman as he's about to devour his sons and nephews)—and one that I felt needed a fresh look in the wake of feminism. In *Daddy's Girl* I'd tried to convey a touching moment between a father and his daughter, but that painting ended up raising questions about privacy, social norms and boundaries, and the appropriateness of a parent's physical intimacy.

Whatever my motives, I began making *Man with Child,* a straightforward rendering of a naked man standing and hugging a small child to his chest. Unlike my previous sculptures, the statue would be large, over six feet tall and weighing well over four hundred pounds. I was making a statement here.

Toward the end of 1991 I instructed an assistant to build a chicken-wire armature attached to a superstructure shaped like an L-beam and made out of three-inch steel pipe. Then I slathered on great swaths of wet clay to approximate the form I'd modeled.

And then disaster struck. When I returned to the studio one morning, the statue was collapsing. We'd failed to build the armature

correctly, and it had buckled under its own weight. The soaking-wet clay extended too far out on the arm to hold itself up and had bent the steel pipe as if it were a paper clip. The figure was bent forward and sliding to the floor, pooling around the base before my eyes. It was like the Wicked Witch of the West after Dorothy poured water on her.

My assistant and I did what we could to save what was left of the work. But we couldn't restore it to its fully upright position. One of the man's knees stayed stubbornly bent where before it had been straight, and there was a kind of lean to his posture now that I hadn't intended. But it was *better* than I had originally intended. Somehow we'd managed to animate the sculpture. Mysteriously, it had jumped to life. I'd like to think that something about my design—the bones of its makeup, the relationships of its parts—made it respond well to chance forces. But I can't assume that. I can only say that accident is part of the creative process—as it's part of life—and every living work incorporates unintended effects.

The piece didn't sell. I showed it at Mary's with little response, and later it was included in a show about walking that my friend Bruce Ferguson curated for the Louisiana Museum in Denmark, where it seemed to garner somewhat better reactions but still no bids. So I shipped it back to my warehouse, where it was sitting on April 19, 1995, the day of the Oklahoma City bombing.

One of the iconic images to emerge from that tragic event was the photograph of a firefighter holding a dying infant. Although *Man with Child* predated the Oklahoma City disaster, the uncanny resonance between my sculpture and the photo did not escape Larry Gagosian, who suggested I donate the statue to the Oklahoma City Museum of Art as a sympathetic gesture of support. Larry's idea made perfect sense to me.

Until now. I was sure I was about to get lambasted by a police chief for playing fast and loose with the revered image of one of the bombing's brave responders. I dug in my heels as the chief shot me

a measuring look. And then he stuck out his hand. "I want to thank you for making that statue naked," he said.

"I thought you were going to object to it," I said, shaking his hand.

Noting my confusion, he told me the story behind the photograph. Apparently the firefighter had *not* rescued the child he was photographed carrying. A policeman had brought her out of the wreckage and handed her to him. But all the good publicity garnered by the picture had gone to the firefighters, bringing down morale among the chief's men and sparking ill feelings between the two departments.

"Making the man naked strips away all the uniforms and politics and brings it back to what it is—a timeless human tragedy," the chief said. I could have hugged him. This is exactly how I believe art should work and how I wanted my art to work. Unfortunately, it doesn't always happen that way.

I N the early nineties, I seriously underestimated the staying power of the young artists who displaced me and the other so-called neo-expressionist painters. With so many different kinds of art being made and so little consensus about what art is, much less what was good or bad, new movements claiming the future were emerging all the time, before they mutated or disappeared altogether. But two things happened that I hadn't anticipated. First, the art market became globalized, bringing into its ranks staggeringly wealthy Russian, Brazilian, and Chinese plutocrats looking to diversify their investments. Then around 1992 the Internet lit up, giving access to a whole new tier of collectors. That and the booming world economy inflated the market to unheard-of levels, raising almost every artist's prices and minting the decade's first art superstars.

I wasn't going to be one of them. That insight was made clear to me by a man whose taste and intelligence I have the deepest respect for.

Stefan Edlis, a great supporter of my work, has long been one of my major collectors. He's also a good friend. A tall Austrian Jew, the scion of a wealthy family that fled Nazi Vienna at the start of World War II, Stefan landed in America as a child with diamonds sewn into the hems of his clothes. He eventually rebuilt his family's fortune, founding Apollo Plastics, a pioneer high-tech manufacturer based in Chicago. A well-known philanthropist, he's been a longtime avid art collector and serves on the boards of several major art museums, where he's brought my paintings to the attention of other influential collectors. Stefan has bought some of my toughest canvases over the years, works not easily accessible that challenge a viewer's patience, acuity, and sense of decorum. Stefan is also one of the few people I know who always says what is on his mind, unedited—a quality I love about him.

Over the years I've spent a lot of time with Stefan and his equally formidable wife, Gael Neeson, skiing in Aspen (April hates the cold weather and usually begs off these trips) and celebrating Gael's birthdays in St. Barth's. Like most collectors I know, Stefan gets excited when talking about the marketing strategies and big-time deal making that goes on in the contemporary art world.

Stefan is extremely generous, not the least bit pretentious, and utterly frank. I don't know if it's his Germanic background or his businessman's view of things, but he sees the world with diamond-hard clarity. I find his plainspokenness a blessing in a world where too many rarely speak their mind. But that candor can sometimes knock me for a loop.

About ten years ago while I was in Aspen for a show, Stefan and I were having one of our customary conversations about art. Stefan was reviewing the market's latest ups and downs while I bitched and moaned about the obscene prices being paid for work by Jeff Koons and Damien Hirst, then the darlings of the art world. "Why would anyone choose a ten-million-dollar shiny balloon bunny over one of my paintings?" I asked.

Stefan shot me a leveling look. "You've got to face it, man," he said. "You didn't make the cut."

My question had been rhetorical. I knew Stefan owned several Koonses and Hirsts, so I hadn't expected any sympathy from him. But I also hadn't expected such a blunt assessment. He wasn't saying that my work wasn't good—I had only to look at the walls around me to know that he believed in my work. Still, he caught me off guard, and it stung.

The spotlight in the art world had shifted away from me, as I fully knew. But the way he said it—so matter-of-factly, like a businessman reading from a report, and with such finality—was like a cold shower.

"You've got to face it, man."

I thought I *had* been facing it. I'd been battling for my vision of art. I'd been trying to be an exemplary artist, to make public work and take on the tough, challenging themes. It killed me when all these big, shiny balloon sculptures and clever, simplistic dot paintings became the darlings and must-haves in every fashionable contemporary collection. It stung to hear other collectors talk to me enthusiastically about such faddish new work, and not with the same reverence or enthusiasm about mine. It reduced me emotionally to the level of a neglected or abandoned child. I knew I was being petty and childish, but somehow that didn't help.

When Stefan said I hadn't made the cut, he wasn't talking about my art. What he was talking about was the art market. And the art market had *become* the art world. It had begun to dictate the fashions of what is good and what is hot, and to promote the idea that there wasn't any difference between the two. And that change in the way art is valued felt so arbitrary—and yet final. Critics and curators might rail against the system, and artists might continue to make important new art, but the significance of art was now going to be measured by its performance in the market, and any artists who didn't believe that were deluding themselves. More and more you saw

artists—some cynically, some without even realizing it—conform to the insidious dictates of what sells. You began to see more and more art being made that was clever, obsessively well crafted, often a genuine spectacle, and completely devoid of emotional content.

I still sold, and in fact made a very good living. But I hadn't "made the cut"—at least not in the nineties terms of "artists who matter." Moreover, I knew things weren't going to go back to the way they used to be for me in the eighties. I had to accept that and figure out what I wanted to do about it. Did I want to go on being the artist I'd become? Did I want to stick to the principles and processes I'd developed over a lifetime, or change in some way I couldn't yet even imagine? I didn't react at the time of our conversation. Stefan wasn't trying to be hurtful or even revelatory. In his mind, he was just stating a fact. But inside, my emotions were roiling. When I called April that night, she told me she felt he'd been wrong to say that. The relationship between artists and collectors is a complex one. You want them to love your work unreservedly, without regard to its investment value. At least Stefan was honest; and I believe he loved my art. But he also knew to the penny what it was worth.

I N such an environment, art inevitably took a backseat to commerce. The values I associated with art, the significance of the painting I loved, no longer applied to the new paradigm. With its sensational events, extravagant projects, blockbuster shows, and record-setting auction prices, the art world was becoming more and more like the entertainment business. And like Hollywood it favored product that was splashy, replicable, and attached to an A-list, brand-name artist.

Nothing fit this bill better than the work of Jeff Koons. A former commodities broker, Koons makes kitschy sculptures of objects lifted whole from the detritus of popular culture—epic metal toy balloon bunnies and flower-encrusted terrier puppies, ceramic thrift-shop busts of Michael Jackson with his pet monkey, and faithful

reproductions of Nike sneakers and pinup girls. He wraps them in a Warholian or Duchampian rationale to give the work some ballast or credibility. To me, the Koonsian "handshake 'n' smile" is all smoke and mirrors. It affects innocence and warm wishes that are disarming but to me shockingly insincere, and his meticulously cultivated boyish enthusiasm and wide-eyed wonder is more reminiscent of Eddie Haskell than Beaver Cleaver.

By the mid-nineties, a surprising amount of the new art in galleries and museums consisted of shiny plastic materials, blinking lights, beads, sequins, and actual mirrors, as artists moved away from making content that invited you to reflect on your life to making objects in which you can see your reflection. And I thought maybe that was the point. Maybe I'm supposed to see some shallow part of myself reflected in the objects' mirrored surfaces, some narcissistic facet of contemporary consumer culture. But if that was the message, it just seemed so literal, so earnest and on the nose. Koons himself was saying there was nothing ironic about his work, that there was no distance between his images and their meaning. According to Koons, your first response is the meaning. In other words, what you see is what you get. I found it disappointingly slight, but Koons was selling in the millions and young artists wanted in on that.

If Warhol buried the corpse of high culture, Koons is satisfied to make the gravestones (or have them made, since, according to his own claims, he doesn't touch the work he produces). His objects commemorate the loss of a meaningful existence without ever addressing how that loss came about. His artworks, as if made by Hasbro or Mattel, are graves without gravitas.

Certainly Koons's images are sensational. He uses the full contemporary neopop tool kit—scale, virtuosity, and improbable content— to create big, shiny objects to fill viewers with awe and nostalgia. He blew up his animal statues six stories high. He consulted with a Nobel Prize–winning scientist to help design some of his trickier

constructions. And he's hired an army of old-world artisans to turn out his products with Apple-like precision.

To me the danger of making art that parodies itself or the culture is that it can be too one-dimensional, too much the thing it portrays. I would argue that the strategy of subversion that has been such an important part of modernism—a strategy that used the context of art against itself (e.g., a urinal passed off as a sculpture and placed in a museum)—no longer applies, because the context for art has become overexpanded, so flaccid that nothing can subvert it. The distinction between sculpture and signage has become negligible. A Koons balloon dog in an art gallery is art. But put it outside a doggie day-care center, and is it still art? Today buying kitsch from a gallery is no different from buying it from Tiffany, except you pay more in a gallery.

THE question of whether art has intrinsic value is always reexamined when forgeries are discovered. In 1996, Sotheby's invited me to Geneva to speak to a group of collectors about my work. Simon de Pury, Sotheby's director at the time, greeted me on my arrival and told me that Sotheby's was auctioning off a "fine piece" of mine in London in the coming days.

Eager to show me the painting, he pulled out the catalog. I looked at a photograph of the work: a large black oil-wash study on paper for *Bad Boy,* my most notorious painting. It was my image, all right, but I couldn't remember making it.

It looked exactly like something I would do. The brushstrokes were uncanny imitations of my handwork. The distortions and the clumsiness were identical to those in the painting it was copying. I began to feel uneasy. Then it hit me. I didn't make this drawing. At that time I didn't make preliminary sketches of my work—especially ones that had all the details of the finished painting. With *Bad Boy,*

I did not know until it was finished what the painting would be. And I don't do sketches after I complete a work.

I informed Simon and double-checked with my studio assistant, who found no record of the sketch. Simon called London and had the work removed from the auction. He then told me he would have to verify that it wasn't mine.

"But I'm the artist," I said.

He told me that, strange as it sounds, Sotheby's couldn't take the artist's word for it. There had been too many cases where, for reasons often involving an angry spouse or mistress, artists tried to disown their works.

Sotheby's eventually returned the work to an auction house in Berlin—Villa Grisebach. I went online and discovered that Villa Grisebach had more works attributed to me, all in the same style— and none of them authentic. So I hired a detective in Berlin to find out if the source could be unearthed. It turned out that the works were made a decade before and that the trail was fairly cold. Still, he was able to determine they'd come through a gallery that had gotten the work on consignment from an art student who claimed his father had gifted them to him. The father, the story went, had visited me in my New York studio and bought many paintings, and I had given him the works as tokens of gratitude.

It was all hokum, of course. There was no father/collector, there had been no studio visit, and there certainly was no gross purchase. But Germany has a statute of limitations on this kind of stuff, and it had run out. Germany also has a law saying that even though a work of art has been forged or copied, it cannot be destroyed without the "creator's" permission. So I traveled to Berlin to write on the backs of the works that they were not painted by me, and then sign the statements. I realized after signing the first one that I had only succeeded in making the forgeries true collectibles worth more than before. I left the others unsigned, and I'm pretty sure they're circulating once

more through the art world, products of a marketplace where the expression *caveat emptor* is an understatement.

Oddly, I had mixed feelings about the whole affair. I was flattered that someone thought enough of my work to copy it. But I was also angry and ultimately resentful. Taking one of my best-known paintings was easy. I wished the forger had chosen some of my less successful pieces and made them better. That at least would have been interesting.

I N 1996 my father died of congestive heart failure at the age of eighty. He had been sick for two years, but before then he'd led an active retirement, traveling extensively with his second wife, Marion, often coordinating his trips with my shows around the world. Finally I was able to see him clear of my mother's skewed perceptions and the generational tensions that had made us enemies through much of my youth.

It had taken me a long time to fully appreciate the extraordinary sacrifices my father had made dealing with my mother—her madness and resentment—supporting us and holding our family together. Most men today would have been long divorced and out the door. I know I would have been.

There were parts of my father that I'd never fully understand. He belonged to another America. He was a veteran, a businessman, a salesman, part of a generation grounded in sacrifice and service. He subscribed to a postwar ethos that was materialistic and conformist. He was stoic and uncomplaining, optimistic and stern. He didn't show us kids much irony or sympathy. He just soldiered on, and expected us to do the same.

But he also took great joy in things. He had a broad, self-deprecating sense of humor, and he enjoyed being teased. He liked to tipple, too, despite a diabetic condition, which drove my stepmother

crazy; and he had a taste for life's small adventures, a genius for practical jokes. Once when he'd rented a house near April and me in the south of France, he took me for a visit to a neighboring nudist colony. He knew it was exactly the kind of expedition I would love—ordinary *and* surreal. There was a café, a toy store, an ice cream shop. People were playing volleyball on the beach. Women were getting their hair done. And everyone was naked. We sat down for a cappuccino and the waitress was wearing only a hairnet and an apron. It was like one of my paintings come to life.

While there were many things my father and I didn't share, we enjoyed traveling together to museums and galleries, seeing the buildings, shops, and cobblestone streets of old Europe. My dad even began making art toward the end of his life—collage. The work he made was mainly cutouts on colored paper, but it had a surprisingly wide range. He made satirical pieces—newspaper clippings of politicians and big-breasted women in strange postures—and he created travel posters of exotic, imaginary worlds of incredible lushness. He'd put figures in them, then paste on the heads of friends and family members. They were whimsical and sweet, an expression of genuine love. It was so important for him to keep his family and friends close at hand, even in fantasy.

Of course Dad being Dad, he tried to turn them into money-makers. He got the idea that they'd make good place mats and had them laminated, then tried to sell them to local stores. When that didn't pan out, he made the rounds of galleries specializing in folk art. He didn't have much success. But he had a sophisticated sense of composition and his work, though naïve, was visually active—and I understood it in a visceral way that I'd never been able to understand in his attempts at verbal communication. How ironic that we were finally having conversations—about our mutual hopes and fears and feelings about each other—but it was through the language of art.

When his death drew near, the family gathered at his bedside. Dad and I didn't say much to each other, other than exchanging the

predictable declarations of love. I tried to let him know that we—his children—were going to be okay, that he'd taken us a long way and we could manage from here. Death moves from the extremities to the core. His toes and fingers went yellow, then his arms and legs turned blue. His earlobes sagged. I stroked his head. It was the last place where the heat left his body. I felt it until it went cold.

Twenty-four years had passed since my mother's suicide, and I'm not sure I understood or was any better prepared to mourn my dad's death than I had been hers. But one thing was certain. The rites of interment, the way the culture dealt with illness and mortality, had only gotten worse.

Dad was cremated. After the service, my stepmother tasked my siblings and me to find an urn for his ashes and shop for a burial plot for him and the family. You'd have to know Phoenix to understand what that was like. We looked at urns in the shapes of dolphins, cowboy boots, golf bags. There was nothing there that would honor his life, nothing that would aid our memory when we needed to recall the man he was.

Then we went to the cemetery and were taken around in a golf cart by this cheerful, buoyant young woman who couldn't wait to show us the incredible range of things you could do with a headstone. You could, for example, etch a photo of the deceased into the stone. She took us to the grave of a twenty-year-old girl who'd been killed in a car accident by a drunk driver. There was an engraved photo of the young victim smiling at a party with friends, and there were images of streamers and martini glasses around the border of her tombstone. There was no sense of irony or the hereafter, nothing to suggest that her brief life had any deeper meaning.

It made me laugh, not the tragedy of her death but the perverse distortion of the values for which she would be remembered. It spoke volumes about a part of American culture I'd come to detest. My family and I were trying to bury our father, seeking meaning and solace through society's sanctioned rites and institutions to help us

process our sense of loss, and all we were getting back was nonsectarian homilies, golf-bag-shaped burial urns, and disco headstones. Trying to deal with the pastor, the casket-and-urn maker, the cemetery salesperson, I realized the culture I'd grown up in didn't know how to mourn or celebrate or even attempt to grapple with mortality in any emotionally honest way.

A month later I traveled to Rome, still mourning the loss of my father. It turned out to be the perfect place to do that. Unlike American cities, where the past is an encumbrance, Rome is all about memory, one culture built on top of another over millennia. It's the embodiment of memory. The past keeps coming forward. Every time street workers pull up a cobblestone, they expose strata of other cultures, layers of history. The culture of Rome is invested in memory. Its people are not quick to forget or deny the past.

I'm not a religious person, but you cannot help but be inspired by the religious architecture and iconography in Rome. You can see the differences between European and American culture—their attitudes toward aging and mortality—in their architecture. A Roman cathedral houses our smallness within its grandness. It's a heavenly space with vaulted ceilings and soaring columns that hold up the suffering martyrs who've become saints, now surrounded by angels and watched over by God. The iconography is so thoroughly integrated into the architecture that you understand it without knowing anything about it. And Rome's architecture is thoroughly integrated with its art, theology, and sociology. In Phoenix you walk into a building that you think is a bank but is actually a union hall or a McDonald's. You often can't tell the difference between a Burger King and a church. How architecture represents us is entirely different from our European past.

At the same time Italians, especially Romans, have such a natural way of relating to their churches. You go into a cathedral and there's a wedding going on, but there are also busloads of tourists walking around and people taking photographs of the wedding in progress.

Rather then anyone stopping and saying, "Hey, could you leave, this is serious, it's a wedding, and this is a house of God," their attitude is: of course there are people everywhere, and everyone is doing something different. They don't have the same reverence we have about priests and nuns—they treat them like people. In Rome, people even bring their animals into church to be blessed.

The life in the church feels a lot like the life out on the street. People do not change radically upon entering church. They are the same person inside the architecture of their God's symbolic universe as they are outside in the real one. It made me wish I was a believer. It made me wish I belonged to that community where the ideal of holiness did not exclude human frailty: the eccentric, the needy, the halfhearted. The bottom line is that everyone was trying to get it right. But mostly I longed to find someplace where they knew how to bury their dead.

On my return to the States, I made a series of paintings set in a Roman cathedral and ruins. Their palette is somber—marble toned, almost sepia in its effect. Shadows and dark soaring spaces shaped by the architecture express the longing and profound loneliness I was experiencing at the time. The canvases address the various themes I had long been preoccupied with: grief, loss, male identity, the empty rituals and infantilizing authority of formal religion. And most of them are imbued with a pervasive, matter-of-fact spirituality, an articulation of the Romans' comfortable relationship to pleasure, aging, and mortality. But with loss so fresh, at a point when I felt for the first time I was on the downslope of my life, the work expresses a new urgency in my search for answers.

One of the first pictures I made was *Once Where We Looked to Put Down Our Dead,* a painting of a naked man carrying a naked woman across the floor of a cathedral. The image of the couple was taken from an 1885 photograph by Thomas Eakins of himself and a model. In my painting I have him walking along a narrow path of

sunlight, looking straight ahead as though searching for a place to unburden himself.

I might well have appended a question mark to the painting's title. At its most literal, it mirrors my predicament at the time: I was looking for a place to lay down my father, to bury the burden of my grief. One place was the church. But the nakedness of the man and woman and the rawness with which I've rendered them seem at odds with the baroque formalism of the setting. Clearly religion was not the answer for me.

Whatever their subjects, the paintings use opposing motifs to suggest this complex death-in-life sensibility: the contrast between massive architecture and vast empty spaces, classic stone statues and a comic balloon animal, baroque ornament and raw flesh, clerical vestments and naked bodies, and most conspicuously shadow and light—the chiaroscuro I found so inspirational in Italian baroque painting.

I 'VE experimented with rendering light since I first picked up a brush. But you don't paint light. You feel light. You paint toward a kind of illumination, both literally and metaphorically. Color is how light works; cool and warm colors set against each other create the illusion of light. How you capture light is also how you create drama.

There's such a difference between something that is spotlit and something that is luminous. You're always trying to engage an audience, to pull them in. Light is very seductive because it contains mystery and revelation simultaneously.

Years ago, a friend and I were wandering around a show of the baroque painter Bernardo Strozzi. We were talking about light and shadow and I began a lamentation on the problem with contemporary art. I said it has reduced the world to a shadowless environment, and in doing so got rid of that part of the mind that can be scary and sudden. It has caused a whole part of our imagination to atrophy, that

place in the shadows where evil and terror lie hidden. By the time
I went to Rome I'd become thoroughly disenchanted with the late-
modernist ethic of self-referential irony and flatness. In order to really
play around with light and shadow, you have to get past the flatness
that is part of modernism. You have to get beyond surface.

During my two months in Rome, I became inspired by the ba-
roque painters, especially Caravaggio. His use of light and shadow is
not only dramatic, it's metaphoric. Though he uses contrast, it is not
simply the stark contrast of light and dark. There is a third light, an
umber glow of a netherworld inhabited by our thoughts and emo-
tions, sparked by the events we're witnessing. The scenes are taking
place so fast we don't fully grasp them. Our feelings are fluid and
unresolved, emerging but not yet illuminated.

All this was on my mind when I happened into San Giovanni in
Laterano, a cathedral, known in the Catholic Church as the Mother of
All Churches, that had in part been designed by the great baroque ar-
chitect Francesco Borromini. It was late morning in early November,
and as I was looking at its magnificent sculptures of various saints I
noticed that the church was growing very dark except for a shaft of
sunlight streaming through the transept window above me. The light
rays were like spotlights, and as the sun passed overhead one sculp-
ture after another became perfectly framed and illuminated. The
white marble lit up like I'd never seen before, almost too intensely
to stare at. The sculptures felt as if they'd suddenly been awakened,
come to life. It was a perfectly architecturally choreographed moment
that could only happen at certain times of the year when the sun
was in exactly the right position in the sky. I took many pictures
and later, back in New York in my studio, I began a painting titled
Anger, Remorse, Fear or Incontinence. The painting is of an old man
hunched over and urinating in a cathedral before the statue of a saint
who's lit up by a laserlike beam of light and whose outstretched hand
seems to be either consoling him in his confusion or reproaching him
for his desecration. The man's identity is unclear but he seems fragile,

confused, and disoriented. Perhaps he's pissing on the church as an attack for having us believe there is a higher purpose to life outside of a social contract. Or maybe he's saying fuck you to God for creating life in the first place. Either way, it doesn't matter. The gesture's harmless, more pathetic than destructive—though I find his anger and confusion justified and his irreverence brave.

I can accept that life may have no greater meaning outside of life, but nothing terrifies me more than the thought that a life could be altogether meaningless, which is in large part why I became an artist. Art gives experience its meaning and its clarity. The Rome paintings were a way for me to give back something I'd taken away from my father a long time ago: how truly meaningful his life was for me.

LAURIE FISCHL WHITTLE

The funeral services for Dad were like none I
have ever attended. Here's where Eric's humor
melted the mask from the clown's face. His eulogy
celebrated Dad for the wonderful way he really
was, the way I didn't know him to be, because I
had felt betrayed and never trusted him enough
to be . . . human. Eric spoke of Dad's awkward
ways, defining with twisted hilarity who our
father really was. I laughed down to the soles
of my shoes and up again. I came away feeling
uplifted from the sadness that was sure to be
mine. I forgave Dad that day. Ever since then I
have often wished that I could return the favor
to Eric, so he could forgive Mom.

HOLLY FISCHL GILOTH

The Funeral, 1995

Our father made three passes at dying and was eventually successful in September 1995. He had miraculous recoveries the other two times, and each time we were summoned from around the country to be there for his dying breath. We knew he wanted to be cremated, but we were unclear about the rest of it. Our mother had been cremated and we had scattered her ashes on a cactus-laden plot of land outside of town that is now a major tract housing development. We didn't want to make that mistake again.

We were all assigned tasks. Eric and I were dispatched to the funeral home and cemetery— our mission was to figure out what to put Dad's remains in and where to place them for eternity. We had an appointment. We were met by a young dark-haired woman with a thick Brooklyn accent who sounded as much out of place as she probably felt. She showed us urns that, among other things, were shaped like golf bags and tennis balls. She put us in a golf cart and gave us the grand tour. She proudly showed us the indoor columbarium with its rows of marble vaults and very tall ceilings. Open and spacious, it had a bronze statue on the wall of a cowboy replete with hat, boots, and lasso for his "last

roundup." And all the while she talked to us
and told us her story. A recent newcomer to
Arizona, she lived with her mother and hated
it. She missed New York and her boyfriend, whom
she called Big Bird. I think it had something to
do with duck or game hunting. She was terribly
lonely. She drove us to the crematory and showed
us, I kid you not, the ovens and the button they
would gladly let us press to send our dearly
departed on his final journey.

Eric and I could not get to the car fast enough,
and then we could not get out of the parking
lot. We literally laughed until we cried. We were
uncontrollable. Dad would have laughed, too, at
the total insanity of the place. Once we regained
our composure we made two decisions: NO golf-bag
urns and NO columbarium.

Dad was one of Eric's biggest fans. He collected
all the press clippings and magazine articles—
anything with a mention of his artist son. He had
cut out a picture of one of Eric's sculptures and
taped it to his office door. It is a sculpture
of a pair of crossed feet. I don't know if they
were models of my father's feet or Eric's feet
or just some anonymous feet, but my father loved
them. When Eric and I came home from the crema-
tory and discussed it with the others, Eric took
charge. He offered to make several additional
bronze casts of the feet—one for each of us—to
house some of our father's ashes. And he devised

an inscribed bronze plate with our father's name,
birth date, and date of death. We would each have
a beautiful sculpture and a part of our father.
We could decide later if we wanted to scatter his
ashes and, if so, where to do it.

ROBBIE BAITZ

In 2001, I lost my father after a slow and
chaotic battle with cancer, which claimed him
in bits and pieces. I stood over him with my
brothers, helping him die—you could keep the
morphine going and your loved one would slip
away. About ten days later, the neighborhood
I lived in was rendered uninhabitable briefly,
in the aftermath of September 11. At the time,
I was a blocked writer, exhausted from death
and ashes and smoke and uninhabitable homes,
and the accompanying deflation that follows such
events, like pilot fish around a shark. My heart
was breaking, and I was breaking up with my
partner of twelve years, both of us lost in our
own wounds. One day soon thereafter, I stood in
Eric's studio, before *Once Where We Looked to Put
Down Our Dead.* I spent the next week looking at
the Rome paintings, which Eric had executed in
a state of what I could only imagine as searing
male grief, of which I, at age forty, was having
my first bout. The colors matched my interior
life precisely; the darkness and dark browns and
deep grays occluding the light, the dog lying
on the cold floor, the naked man carrying the
naked woman, and so on. And, you know, this odd
and very rare thing happened to me in response,
from my standing there and looking at these
pictures. I started to write a scene about two

men at lunch, dealing with secrets and their
long, odd, cracked friendship and their sheared
and denied male egos, at lunch at Chanterelle
in TriBeCa. I built an entire play out of those
men, out of that scene, directly from my access
to the very bold and tragic paintings Eric had
made that spoke to me from some atavistic male
place. That play is *The Paris Letter.* Next time
it's reprinted, I am going to ask the publisher
to change the cover illustration to one of
the Rome paintings, because the play comes
out of a very old desire for emulation, but
in a different form. Eric and April, however,
have held their friends very close around them,
and the darkness that lives in those paintings
is somehow exculpated by the bonhomie and
conviviality of their lives, and how much love
they have to spread around. I see myself in his
life, you know, and he's slightly lit the way
for me in terms of being a few years older and
a few degrees braver about what it costs and
takes to make something awful and beautiful out
of nothing at all.

· 19 ·

SOUL IN FLIGHT

1997 – 2002

A ROUND 1997 Mario Diacono, my dealer in Boston, encouraged me to make a painting that addressed my relationship to Edward Hopper, the great American realist painter. Mario's suggestion intrigued me. Throughout my career, critics and art writers had likened my work to Hopper's. He had been, and is still, an inspiration for my work.

Even so, he triggers mixed feelings in me. Hopper is somebody I've always admired, yet found fault with. His painting style, or lack of style, expresses something profound about the American sensibility. It has to do with his reductive painting technique, the directness and plainspoken honesty of it, and with his talent for painting poignant narratives that seem at first glance to be snapshots from daily life—ordinary scenes that feel extraordinary while still appearing ordinary. Hopper's a great and compelling artist, but he's also an awkward painter. He's not very good at rendering figures. They often seem overworked and turgid, and as such they reveal his puritanical anxiety about flesh; it's as though he wasn't in control of his medium.

His hang-ups spill out in a way that I don't even think he was aware of, or at least couldn't finesse. For example, *A Woman in the Sun,* that wonderful painting of a woman standing naked and looking through a window—she's parallel to us in this plank of yellow light, and Hopper just couldn't resist his need to see both her nipples. So he actually extended her left breast, even though that's not the way the body should be.

I had another concern in identifying my work with Hopper's. A contemporary of the Ashcan school, Hopper was eclipsed by the abstract expressionists and became labeled a regional artist—the second tier of artist hell. And for the longest time, that was my worst nightmare. I wanted so badly to be an important, influential painter on the international stage. If I was seen as an American artist, I wanted my America to be understood as a metaphor and my narratives understood as identity quests set against the backdrop of the American middle class. I did not want my native roots to be seen as a limitation or a weakness.

But the deeper I got into my own work, the more present Hopper seemed to be. He was like an imperfect father you can't get away from. He'd staked out a territory in painting that I was going to have to move through rather than around. I really didn't want to be like him. I didn't want to be singular and off to the side as he was, especially in the last years of his life. But he captured something in me and something about the experience of being American: a bone-deep loneliness, a sense of alienation and anxiety that's the flip side of self-reliance, the counterpart of boundless freedom, mobility, and self-invention.

Diacono had very astutely suggested that I enter into dialogue with two paintings: *Summer in the City* and *Excursion into Philosophy,* which Hopper had done ten years apart. They both embrace themes central to my work: the difficulty of coupling, commitment, and satisfying needs. *Summer in the City* shows a woman in a red dress, her arms crossed, sitting on the edge of a bed. Behind

her a naked man lies facedown, his head buried in a pillow. Sunlight streams into the bare room through a mullioned window, forming a checkerboard pattern on the dark wood floor. *Excursion into Philosophy* reverses the scene. It shows a now older, slope-shouldered man clothed and sitting on the edge of the bed in a different room—this one in the country—while a half-naked woman sleeps facing the wall, her back turned to him. An open book—a book of philosophy—rests next to the man, and he's staring at a rectangle of light reflecting off the floor in front of him.

The paintings are about distance. Their subjects are either asleep (unconscious) or isolated in thought, and because their actions take place in the moments after sex, a time usually associated with intimacy, their air of disconnectedness seems especially poignant. The sitters' demeanor, heavy, forlorn, and abstracted, in contrast to Hopper's warm, diffuse sunlight, seems to suggest not so much about how unhappy everybody appears but how happy Hopper seems to be saying they ought to be; how distant his unhappy lovers are not only from each other but also from life itself.

I circled around the project for several years before I came up with my response, *The Philosopher's Chair,* a bedroom scene that attempts to heighten the tension in the Hopper paintings. It shows a young woman putting on or taking off her slip. She is partially hidden by shadow, standing in the foreground on one side of the room, and across the room behind her is an old man, fully clothed but with his pants zipper open. The woman is facing away from the man, accentuating the distance between them. The man, the presumptive philosopher of the title, strikes a contemplative pose, hands in pockets, gazing away from the woman and at a chair that stands between the couple in the center of the room.

The painting, like the two Hoppers, is about distance and estrangement—the inability to connect, to find satisfaction in relationships or to realize sexual desire. But there are differences too. I've made the man in my picture older than his counterparts in the

Hopper works and much older than the woman in the room with him. He's apparently concerned about his performance. But we can't locate the source of his anxiety, whether he's apprehensive or embarrassed, because we can't tell whether he and his partner are in the process of dressing or undressing. I've made him wizened and professorial. The relatively young man in *Excursion into Philosophy* is neither. He's an avatar of Hopper's preoccupations—his fear of intimacy, his ambivalent attitude toward flesh, his obsession over the split between mind and body, the incompatibility between physical desire and romantic or spiritual love. His excursion into philosophy may be an attempt to understand these problems. But it's still just an excursion—like a weekend in the country.

Finally, I eliminated Hopper's window views from my painting. Hopper connects his subjects to the broader world through hopeful slices of cityscape and wheat fields, and his glorious sunlight is generous and redemptive. My couple is pressed in on each other. The light between them is dense, moody, sallow. Their predicament allows no escape.

As I worked on *The Philosopher's Chair,* some surprises emerged. I'd added a chair to the room that should have increased the painting's air of compression or claustrophobia. Instead it seemed to absorb the emotional tension in the room, leaving a beautiful empty space between the man and the woman. As a philosopher, the man is an exemplar of human intelligence, an expert thinker, but his concerns are mainly physical. He's getting old. His sexuality is diminishing. His equipment doesn't work as well as it once did. The chair makes this material, gives form to these fears and insecurities.

One of the great things about painting is that the artist can make conscious something that wouldn't necessarily be considered animate. I got excited about that idea while I made *The Philosopher's Chair.* I painted a French slipper chair from the thirties with this orientalist pattern done in red against raw linen; bamboo with birds, very decorative and beautiful. But the way I ended up painting the pattern was

more like a circulatory system, so the red bamboo had a feeling of blood and veins. I wasn't particularly aware of this, but several people pointed it out to me and I think it's true. It acts as a kind of pulse or wound.

After I finished *The Philosopher's Chair* I made a series of paintings based on similar themes. Throughout my career I'd revisited familiar settings—the beach, say, or the suburban backyard—to see what I could do to them now. Are they still alive for me? Do they still hold meaning? The bedroom's a very loaded psychological space with associations to birth, death, sex, fantasy, procreation, and so on. It's also a very intimate, private domain, so a viewer comes to it with heightened attention and anticipation. You can create a very fraught, powerful experience by bringing the viewer directly into the room.

In what became *The Bed, the Chair . . .* series, I returned to a setting I'd used throughout my career, beginning with the so-called bed painting I'd made before entering CalArts. But I also tried to do something new. I used a theatrical or cinematic device to advance the themes I was working with. In each picture—eleven in all—I placed different subjects in the same room. In other words, the place functioned like a motel room, housing individual dramas over time. Each painting had a different motif—waiting, sitting, changing, turning, touching, crossing, playing, watching, dancing—but seen altogether, the series's principal characters became the bed and the chair.

For the most part, the paintings are variations on Hopper's narratives, meditations on the many different ways and reasons why couples disengage. And with each canvas, the chair seems to gather psychological weight. Alone or paired with a twin, it witnesses the comedy of lovers not quite connecting, registering and mediating their desires and frustrations through subtle shifts in color and perspective.

The series makes no great statements about the human condition or the so-called battle of the sexes. I'm asking questions, not trying to tell the viewer what to think. But it helped me clarify my previous ambivalent feelings toward Hopper. We both were dealing with

a particularly American loneliness—secular, existential, and visceral. And unlike our chief European influences, Manet and Degas, we both treated flesh, and perhaps paint itself, with a kind of American gruffness.

I'D NEVER fared well with the business side of things and was fortunate to have Mary to look after my career. But Mary could do nothing about the art that had become fashionable among collectors and that was increasingly occupying the public conception of what was good and valuable. My gripe with a lot of the work I was seeing was its self-conscious ambition to be totally unlike anything that's been seen before, and the art world's obsession with the literalness of that sensation. Quoting Ed Ruscha, Steve Martin describes what happens to him on seeing many of these shocking canvases. "First I go, 'Oh, wow!'" he says. "Then after a few minutes viewing, 'Huh?' What you really want is a painting that does the opposite. You want it to make you go, 'Huh?' And then, 'Oh, wow!'"

The great practitioners of this kind of shock art were the Young British Artists, or YBAs, a group of thirtyish artists who'd attended Goldsmiths College in London in the late eighties and emerged on the scene several years later. Inspired by the British pop artists David Hockney, Peter Blake, and Michael Craig-Martin, the group was actually less cohesive than initially presented. What they did share was highly refined technical prowess, iconoclasm, and melodrama. The British are essentially a language-based culture. Their visual art has never come close to the impact their skills at literature, theater, and film have had on the world. Perhaps that is because painting is essentially nonverbal. British painting (which would also include object making) comes too closely attached, for my taste, to the ways of explaining it. It can be tediously earnest.

When it is great, it's because the British have an obsession with physicality, a fixation that borders on morbidity. Lucian Freud is a

great example of that with the way he paints flesh. His overwrought surfaces become grotesque as the paint thickens, takes on the semblance of flesh, and then decays before your eyes. His work feels like anxious meat. And as with many Brit realists, the tension in his painting comes from the feeling that this literal physicality is bound up in repressed rage. You can hear him saying: "Look at this, you pathetic thing. Take a closer look. You disgust me."

Damien Hirst, the YBAs' standard-bearer and Jeff Koons's successor as the art world's darling and enfant terrible, works in that tradition. Unlike Koons's warm, fuzzy animal statues, Hirst's images are often hair-raising and repellant. His best-known works—vitrines of dead animals, dead flies, maggot-infested meat, and butterflies stuck to paintings—are about the humiliating fact that things once living rot when dead. He was not the only YBA working in the arena of the grotesque. Marc Quinn, who had the placental blood from his child's birth molded into a portrait of him as a child and cryogenically frozen, and Ron Mueck, who makes hyper-realistic sculptures with synthetic skin and real hair, are others. My essential experience of these works is that the detail and literalness of their physicality override any emotions they might have elicited from me. I find myself trapped in a cycle of attraction/repulsion.

In *The Physical Impossibility of Death in the Mind of Someone Living,* Hirst's most famous installation and arguably the most iconic image of the last twenty years, the artist had suspended a fourteen-foot tiger shark in a glass-and-steel tank. Seen head-on, its jaw agape, its rows of razor-sharp teeth exposed, it easily passed the "wow" part of Steve's shock test. It definitely got my attention. But that's all it got. It didn't engage my intellect or my emotions. It was, after all, only a shark's cadaver—what you might see in a natural history museum or, were it alive, an aquarium. In a gallery it took on symbolic value, death incarnate; but despite its pretentious title, it offered me no insight about its subject.

I'd dedicated my career to exploring life's passages—adolescence,

sex, and, increasingly, aging and death. I was still mourning my father, trying to understand and articulate my feelings about his death and death generally. I'd looked to ritual, religion, architecture, and of course art, my own and others', to help me come to terms with its meaning. But Hirst's glib treatment of the theme—here it is: take it or leave it; what you see is what you get—irritated me. It seemed more cynical than Koons's approach. Hirst had created a powerful image. It stirred up primal fears in me. But then it failed to resolve or even engage them. Its promise was greater than Koons's schmaltzy sculptures, and so its disappointment was greater too.

THE history of *The Physical Impossibility of Death in the Mind of Someone Living* points out my underlying problem with the work. Charles Saatchi, the world-class collector and advertising magnate, commissioned the installation in 1991 and eventually sold it in 2004 to hedge-fund founder Steven Cohen for $8 million—the most money, I believe, ever paid for what is essentially a fish trophy. But the shark hadn't been properly preserved and began decomposing and muddying the tank barely a year after its manufacture. Saatchi then made the situation worse by adding bleach to the formaldehyde solution. Before long he had the shark gutted and its skin mounted on a wood frame. But Hirst, who rarely touches his work and delegates its construction to assistants, didn't like the result. He felt the shark now looked hollow or artificial—anyway, less frightening. When Cohen bought the piece, Hirst replaced the old shark with a new one, raising the issue of whether Cohen owned the original artwork or a copy—and because Hirst had made several replicas in the interim, merely one of a series of sculptures.

Hirst, arguing that he was a conceptualist, claimed the physical object—or its replacement—didn't matter. In other words, what counted was the idea of the thing, not the thing itself. I'd been debating this issue since my CalArts days. To me, artworks are specific.

Ideas belong to the realm of philosophy. Art is more like alchemy, a magical, transformative process that can't be reproduced. There's only one *Mona Lisa*. All her other images—whether on postcards or museum-quality prints—are imitations. We travel to the Louvre to see Leonardo's *Mona Lisa,* not his idea of the *Mona Lisa.*

At the end of 1997, Charles Saatchi organized a blockbuster exhibition at the Royal Academy of Arts in London that featured Hirst's shark installation along with a hundred or so other works, mainly by the YBAs. I had to laugh when I heard the title of the show: *Sensation.* It perfectly captured the shallow, nerve-ending quality of Hirst's art and the spectacle-obsessed cultural zeitgeist in which it thrived.

All the art for the show was taken from Charles's private collection of contemporary art. Charles had discovered the YBAs at a series of alternative shows curated by Hirst when he was still a student at Goldsmiths in the late eighties; he bought their work in bulk and promoted them to the art world's top ranks through his influence, connections, and marketing genius. Showing his private collection in a prestigious public institution such as the Royal Academy was another example of that genius.

Sensation was also a conflict of interest. At the very least, the show enhanced the value of Charles's art—and of course that of the artists featured in it. The kind of cronyism it promoted among collectors, dealers, curators, and museum heads became even more obvious when the tour moved to New York and the Brooklyn Museum disclosed that Charles had underwritten the exhibition with a gift of $150,000, and that Christie's and several dealers who sold the artists' work had chipped in another $60,000. I know that kind of backroom dealing isn't supposed to affect the way you look at the work, but commerce has become so much a part of the art, I found it hard to separate the two.

Of course the forces I'm describing were already in play by the eighties, when my generation were the stars of the art world, but we had spent long apprenticeships outside the market dealing with issues that were exclusively art related. We had no expectation of commercial success, and much art made during our formative years was trenchantly anticommercial—videos, performances, installations that couldn't be hung on the wall or sold through the traditional gallery system.

But the next generation, following our success, was only too eager to duplicate it. And they entered the hyped-up market before their styles were fully formed. I remember David Salle telling me that when he used to give talks at art schools, the questions the students asked were almost never about art and almost always about career-related topics like branding—a term unknown to us when we were at CalArts.

With one foot in the studio and another in a market that was turning young unknowns into multimillionaires, even the most ascetic student-artists had to be influenced by commercial considerations. I know a lot of the new work I was seeing seemed tailor-made to collectors' tastes—high-concept art, art with a hook or a visual jingle, something, anything that grabs the viewer: elephant dung, sharks' heads, giant metal cartoon rabbits. I like some of this work—Ron Mueck's minutely observed human sculptures, Marc Quinn's *Bloodhead,* Chris Ofili's watercolors. They are shocking, provocative, or gorgeous. Or they are clever, smart, interesting, and witty. But they never seem to get beyond themselves. David Salle had invested a large part of his career appropriating images and techniques from mass culture and advertising to make art. But many of the new crop of artists seem to be using the styles and techniques of art in order to make advertisements for themselves.

· · ·

I N spring 1998, April asked me what I wanted to do for my fiftieth birthday.

"I want to get married," I said.

My reply stunned her. We'd been living together for more than twenty years. During that time I'd not only resisted the idea of marriage; I hadn't fully accepted that I was in a relationship. I used to wake up every day and think: "Okay, it's over. I'm out of here."

By evening I felt differently. By then my love for April was imbued with a warm, gently glowing patina. What happened in between?

The issue wasn't commitment. It was intimacy. And if you're already in a profound, monogamous relationship, getting married pushes the issue of intimacy to the forefront.

I remember several years back watching a program on John Lennon's murder. The moderator was interviewing the girlfriend of Mark Chapman, Lennon's assassin. During the interview she confessed that she still had feelings for him, which confused and shamed her. She then said she had never told anyone about this, including her closest friends, because she thought she'd be reviled. I was stunned by the irony that she had just told millions of people what she couldn't tell her most intimate friends. At first I rejected her statement as absurd. Then I realized the truth of it. It's what I'd been doing in my art all along.

Knowing that April would always be responsive to my emotional needs didn't make it easier for me to voice them. It's a mystery how this could have been, but perhaps it was more obvious than I thought. I emerged from childhood savaged, suspicious, and armor-plated. The real mystery was why something that no longer existed should still inhibit and control me. How powerful were the phantoms of my family's history?

For as long as I could remember—except during brief periods of infatuation—I'd told myself that I valued my independence. But it wasn't independence I prized; it was space—dream space, fantasy

space, breathing space. I equated independence with being alone, and that's the last thing I wanted to be. When April and I became a couple, I found exactly the right balance for the space I required, and the certainty that she would be there when I floated in from my imaginary realm. Because April is an artist as well, she understands the demands of the creative life. She knows how much time inside your own head you need to spend, what the pressures can be, and how disciplined you must be to shut out the world—to get quiet, calm, and focused. When we were younger, our struggle to become artists was greater. The studio was more consuming and the creative process an emotional roller coaster. But over the years it evened out into routines that made our life together easier, more stable.

It's almost impossible to make a long-term relationship sound glamorous. Tender, trusting, growing old together, being there for each other—all the ingredients that go into a lasting love affair do little to ignite the imagination for anyone looking in from the outside. As in art, depicting hell is so powerfully, terrifyingly vivid, the imagery sparks our imaginations in ways that a life of tranquility can't. But April and I both came from hellish pasts. We were scarred and damaged in ways that made us not want to live that way ever again. We had a tacit understanding that we wouldn't be violent or out of control. We wouldn't even run the risk that the bad blood would skip a generation. So terrified were we that these demons might reemerge, we decided against having children.

April's paintings are both spiritual and psychological. They are metaphoric and specific. They are about nature and about bearing witness to a metaphysical conflict between earth and sky, light and dark. She believes that there are powers greater than ourselves, and that's where we differ. For me, the gods created life and death. Everything in between is up to us, and our quality of life depends solely on our imagination and our will.

When we got together, April was just graduating and I was only four years out of art school. Over the next few years we'd both undergo

seismic shifts in the kind of art we were making. April would shed her preoccupation with conceptual art and take up landscape painting. I would undergo a metamorphosis as well, giving up my pursuit of avant-garde abstraction for narrative figuration.

Like Pierre Bonnard watching his wife, Marthe, I'd studied April's every move. I'd watched her as a way of measuring the space between us, hoping to define myself more precisely by it. I'd stare at her sleeping, her face barely visible under the pulled-up sheet, and become filled with desire when her leg would slip out from beneath the covers. I'd study the routines she performed in every room of the house. Watching her bathe was sheer delight.

When I used her as a model in my early work, I tried to hide April's identity as much as possible. I did this as well with friends who would show up from time to time. But I was more anxious and uncertain about how recognizable April should be, more sensitive about overstepping boundaries, treating her privacy irresponsibly. So I altered her features in ways that prevented even friends from recognizing her. I used her the way a director uses an actress. She became a character, a type in the various narratives I was painting. She was an irresponsible mother in *Bad Boy*, a self-absorbed hedonist in *The Day the Shah Ran By*, an oblivious matriarch in *The Old Man's Boat and the Old Man's Dog*, a young lesbian lover in an untitled bedroom drama. Her characters were women who were the center of attention but who did not return the attention.

Over time, I began to make paintings that were just about her and the pleasure I derived from observing her. Like someone watching a changing landscape, I painted her sunbathing, showering, painting her toenails, doing yoga, lounging around naked. Unlike the mannerist painter Alex Katz, who immortalized his cherished wife and model, Ada, as eternally young and beautiful, I painted April growing older with me. I'm not capable of romanticizing life. I find it harsh, disappointing, and challenging. I'm interested in character and the ways it is built by facing reality.

That summer, April and I were married in Rome. The wedding, a civil ceremony, took place in a small farmhouse just past the Circus Maximus. Fourteen close friends attended; the ceremony was presided over by a petite woman judge wearing a huge tricolor sash and flanked by two carabinieri in full regalia. The service was conducted in Italian. We had an interpreter, but neither April nor I paid much attention to her. We simply smiled into each other's eyes and held hands. When the judge asked me if I took April to be my wife, I said, "*Certo.*" Then when she asked April the same question, April said, "*Multo,*" which cracked up the judge and carabinieri.

I still don't know what set of factors triggered my wish to get married. I didn't think much would change in our lives. Much like art, marriage is an act of public commitment that makes visible and concrete what had until that moment been nebulous, undefined, and unspoken. But that simple act of public commitment enriched our relationship in ways that are still unfolding.

IN late 1998 I began *Soul in Flight,* a fourteen-foot-high statue of a tennis player commemorating the life of Arthur Ashe. Commissioned by the board of the United States Tennis Association after a yearlong competition, the statue was placed in the main plaza of Flushing Meadows between the Unisphere, a twelve-story-high globe, the symbol of the 1964 World's Fair, and the recently built Arthur Ashe Stadium, center court for the U.S. Open.

When I presented my proposal to the association's search committee, there were two things I stressed as essential to my concept that I would not compromise on. I was not going to make a portrait of Arthur. That had already been done in Richmond, Arthur's hometown, and its Disney-like realism had disappointed, among others, Jeanne Ashe, Arthur's widow and my friend and supporter throughout the thorny selection process. Jeanne is an artist in her own right, a wonderful photographer who appreciated what I was proposing to do.

Second, remembering my experience in Oklahoma City, I decided to make the subject naked. I wanted the work to be timeless, and superficial details like the cut and length of a player's shorts are time specific, more about the style of the times than the timelessness of life.

What's more, I didn't want this to be a statue solely honoring Arthur's achievements on the court. I intended instead to commemorate a man who used his stature as a world-class athlete to draw attention to the consequences of poverty and racism at home and around the world. I'd thought hard about Arthur's life, the significance of his life outside of sports—his activism and status as a role model—and using tennis as a metaphor came up with the idea of the serve. It seemed to work as wordplay—*to serve* the greater community. But I think it's also the game's most beautiful stroke—graceful, powerful, aspirational in form.

I made a maquette, an eighteen-inch model of a naked athlete coiled in a service motion, and presented it along with my other ideas to the search committee. I also told them that because I play tennis, because I love tennis, I felt I was born to make this sculpture. I was emphatic, passionate, and fully believed my own vision. But the tennis world, like other sports', is not known for its liberal values. I really didn't think I stood a chance in hell of getting the commission. I was wrong. They loved it.

And then the real process began. Shepherding the plans through the various city boards and the parks commission was a nightmare of bureaucracy and egoism. One member of the New York Art Commission, a classically trained sculptor, fancied himself my collaborator and tried to vote his ideas into law. Fabricating the statue was the easier part of the process, though still challenging. I'd never done anything of that scale before. Getting from the maquette to the fourteen-foot sculpture required all kinds of unexpected adjustments. I was working mostly on a scaffold, trying to make larger forms feel gestural while slathering on clay with my thumb. One

knotty problem involved the figure's genitals. The maquette had de-emphasized Arthur's penis; I'd just put a lump of clay there to suggest the masculine form and not stand out. But blown up twenty times to the new scale, that lump became a very large blob, imposing *and* distracting. The whole theme and thrust of the statue was ascendancy, upward motion; and the idea behind its raised figure was that viewers would start by looking at the feet and work their way up to the head. The blob stopped the eye dead.

I took a more naturalistic approach after that and nobody seemed to notice, much less care—until the unveiling on the eve of the 2000 U.S. Open tournament. Even then the ceremony seemed to go well. I made a speech in front of the piece explaining my vision and the crowd in attendance applauded politely. But then the media began to interview me, and I could tell by their questions that they wanted to focus on my use of nudity.

When their articles came out, it became clear they were trying to excite controversy. It didn't take, but the TV network covering the Open didn't quite know how to deal with the nakedness. Situated where it is—in front of the entrance of the stadium—the figure's pretty hard to ignore. But the cameramen managed to avoid the offending member by shooting skyward so you'd see an innocuous fragment of forearm or shank of leg. Then John McEnroe put the whole matter to rest by making his colleagues interview him smack in front of the statue, and after that it became part of the texture of the grounds.

But the experience contained a warning about making public works that I would have done well to heed.

A YEAR later, almost to the day, I watched the Twin Towers in Lower Manhattan topple on TV from Sag Harbor. I watched with horror and anger, and also with fear. I had a friend who worked in the World Trade Center, although I had no idea whether or not

he was in the buildings at the time. Later I learned he'd died in the attack.

September 11 was a defining event in our history, a national trauma. So much death and destruction in such a short time—just a few ticks of the clock—changed the way we imagined ourselves and what it meant to be an American: our shimmering structures and ideals, our new sense of vulnerability. It left us feeling terrified, helpless, and alone, and the effect that this had on our country could not have been more insidious. The one brief moment when we came together in a show of solidarity, caring, and support, we soon smashed into millions of pieces. Clinging to anything that offered us certainty, we sought safety and protection increasingly in smaller and smaller groups: regions, towns, neighborhoods, families. We became tribal. You either belonged or you didn't.

And yet the numbing awe and dread I felt that morning was not unfamiliar. Having grown up in Eden before the Fall, I had firsthand experience with how fragile the illusion of Paradise is, how devastating its loss. The suburbs were my utopia, a vision of prosperity, harmony, and optimism. My friends and I ran around freely, with no locked doors, two cars in the garage, pets off their leashes, bicycles lying where they were dropped, dads out washing their cars, moms cleaning up skinned knees and sewing angel wings on Halloween costumes.

But then I discovered my mother's alcoholism. I opened a door and saw my mother lying on the floor helpless and inarticulate, and in an instant my world cracked open, swallowing all semblances of order and safety. Since then I'd been picking up the pieces, trying to restore Eden, trying at least to save my mother from greater damage. I couldn't. But now, watching the planes smash into the towers, buffeted by feelings that had once been too painful, too powerful to process, I recognized the paralyzing fear and annihilating guilt I'd been grappling with most of my life. I was still scared, still defensive. But I'd survived this chaos before. Art had saved me once, and I was certain that art could save us again.

I had a clear feeling that if ever the country needed its artists, now was the time. There was such profound confusion about what had happened. I felt we needed art to help us understand, to help us mourn. The more I watched, the more I was filled with the certainty that all my hard work becoming an artist, learning how to express what it took to deal with the denials, assaults, and disillusions—the trauma—of my childhood, had prepared me for this moment. My absolute belief in the healing power of art, knowing how it helped me, further convinced me that my life as an emotional warrior had come to this moment. I was needed.

Boy, was I wrong.

I wanted to make a statue, a public work that I hoped would help people to cope with their feelings in the wake of the attack. I wasn't trying to build a monument. The focus of the media made everyone at Ground Zero a hero that day, and I wasn't buying it. I knew that what we'd experienced was not a resolved event. You can't have a monument to an unresolved event. My feeling was more of *victimization*. It was about vulnerability. And it wasn't just about the people who died: it was about the vulnerability of our country. We were all in this kind of free fall, and that's what gave me the idea for the form I wanted to attempt.

Over the course of the next year I made *Tumbling Woman,* a life-size bronze figure of a woman in free fall. I'd considered making a memorial to the responders—the police and firefighters and ordinary civilians who rushed to the site to administer triage and dig out survivors from the rubble. That would have been the safe way to go. But the most indelible images for me that fateful morning were the people who jumped or fell from the towers, in terror and out of sheer desperation. Those images were so profound to me because they drove home the message at the heart of the tragedy: how horrible it must be to have to choose one death over another. It was the place for me to begin.

It was also the place that triggered the most resistance among the

public. Except for the first few minutes of its coverage, the media had suppressed those images of people falling. More than three thousand people died, but they never showed the bodies. It became a disappearance. People transferred the human loss to the loss of architecture. It became all about the buildings. We had to replace the buildings. I felt it was important to reassert the human tragedy. At a time like this, who gives a shit about concrete and steel?

In terms of the sculpture itself, I wasn't interested in being graphic. I didn't want to show the violence or even the conclusiveness of death. I felt that those of us left behind were still falling. The jumpers' fate was certain, but ours was still unfolding.

One image that occurred to me was a tumbleweed—the kind you see outside Phoenix rolling across the desert, unable to stop, unable to control its path, just being blown from one spot to another. I liked the idea of tumbling as opposed to falling because I wanted to have a feeling of lateral motion rather than falling to one's death. I wanted a feeling that we're in motion, that we're going somewhere. We don't know where we are going, but we're not in a state of equilibrium, we're rolling along.

I also felt that the figure should be a woman. I see women as mothers and nurturers, more vulnerable than men—and it heightened the tragedy for me. Also, among the heroes there weren't any women, so it seemed like an appropriate way of addressing another part of the experience. Still, I made her female, not feminine. I made her small-breasted and her torso muscular, and set her against buildings that represented the male principle. I wanted her image to be universal. Everything was about re-erecting this tragedy again in all its dimensions. To create a memorial, you must give people the chance to touch it. Those who sacrificed and died remain present if viewers are able to touch the objects that represent them.

Finally, I worked on the woman's expression. I made her face so it's not contorted in fear, and so her eyes are closed. There's almost the feeling of dream space, an incomprehensible floating sensation. I

didn't want her to express horror or fear or even anger. I didn't want to distance her from the viewer. I felt what we needed was engagement, a face that says, This is us, and we're all a part of this suffering and pain. It was something we needed to embrace. So my intent was one of inclusion.

I wanted to show *Tumbling Woman* as part of the first anniversary of 9/11. Mary found a space for it in the lower concourse of Rockefeller Center, and it was unveiled in a small, unremarkable ceremony the evening of September 10. And then the next morning, all hell broke loose. The concourse was filled with commuters by eight A.M., and *Tumbling Woman* just stunned people. And not in a good way.

People were offended. They didn't want to come face-to-face with a sculpture that embodied death and vulnerability. It was also probably a bad idea showing it the way we did because we didn't prepare anyone. People just bumped into it on their way to work; for many it must have summoned unwanted painful memories. I thought maybe if we'd exhibited it in a different context—in a gallery or a museum—it would have gotten a better reception. People generally like to see art in arts institutions, not in public places meant for something else. But I also felt there wasn't anyplace in New York City that wasn't affected by the events of 9/11. On that anniversary day, the mayor announced the names of those who'd died in the attacks, and you could hear them being broadcast all over the city—from car radios and in front of pizza parlors, on bar TVs and office computers. It was as if the ghosts of the dead were rising in every street and park and building entrance. So from the point of view of appropriateness, I didn't think it mattered where you put my statue. I chose Rockefeller Center because I wanted to address the widest public possible in the most direct, unmediated way.

But even this intention was badly misinterpreted. *New York Post* columnist Andrea Peyser wrote a piece saying that I'd made paintings

earlier in my career that were deliberately sensationalistic, and that once again I was cynically using the pain and suffering of others to promote my work. It was clear from details she attributed to the sculpture that she hadn't actually seen it. But in the gangland of New York controversy, the cleaver, not the switchblade, is a critic's weapon of choice.

Two days after the article came out, I got calls from Mary and Jerry Speyer, the head of Rockefeller Center. Jerry wanted to move the piece. I was in Europe. I tried to talk him out of it. I told him to hang in there: The insane people will go away. "I can't," he said. "I'm getting bomb threats. I can't take the chance."

I called Diane Sawyer for advice about dealing with the media. She told me not to respond, that I'd only add fuel to the conflagration. "Wait six months," she said.

But by then *Tumbling Woman* had long since been removed from public view.

I came away from this experience deeply hurt. It saddened me to feel my help wasn't needed, but it was far more wounding to be misunderstood. It also made me realize there was a profound disconnect between art and our culture. The public didn't turn to its artists to help sort out complex emotions like those triggered by the 9/11 attacks. And I thought there was a surprising lack of response on the part of artists to those attacks, an indication of how alienated they'd become from art's traditional role. Those realizations would lead me to my recent project, *America: Now and Here,* a traveling exhibition meant to open up a dialogue between artists and the larger community.

Meanwhile, my experience with *Tumbling Woman* underscored themes I'd begun dealing with in my work: the culture's preoccupation with youth and health and, conversely, its stubborn refusal to address issues of aging and mortality. In a way I'd been fighting against that kind of resistance my entire career. As far back as my early suburban paintings I'd been trying to get my viewers to look beyond the

surface, behind the ersatz imagery of American culture, to peel back the myths of advertising and popular media—from material perfectibility to eternal youth—and face the messiness, complexity, and fragility of everyday life.

But in America we've become so terrified of death that we don't know how to deal with it. We just can't process it. We have a tremendous problem with the aging of the body. We're in denial about it.

What's more, I believe art itself—the modernist tradition—had abandoned the body. What began in the late nineteenth century as a break from academic figuration and an embrace of the advances made in science and psychoanalysis hardened into an orthodoxy. Art, moving forward, would work to capture not what the world looked like—its outward appearance—but how we felt and thought about it. Over time, any reference to the body would be eliminated in favor of abstraction. And pure geometry, representing the rational, the objective, ultimately triumphed over the abstract expressionist gesture, which was messy, individualistic, and a constant reminder of the body's limitations.

For me, Rodin represents the end of the body in art as flesh, as muscle, and as a sexual, physical being. The next great sculptor is Giacometti, whose work is about anorexia, anxiety, and the denial of the body. With Giacometti the soul becomes unable to express its pain or even its pleasure. Emotions turn inward, gnawing on the flesh. The body can no longer twist, turn, reach, touch, or hold another; cannot represent emotions of any kind except as the result of the damage they've done.

If the representation of the body can no longer be an expression of the soul, what is the point of representing it? What is the body good for? These were questions I was struggling to understand. Underneath whatever intellectual rationale artists had been using to justify modernism's advance—its rejection of realism, of narrative, of the literal representation of the human form—there was a more disturbing truth: the further art got away from the traditions of telling

and retelling our dramas, reinvigorating our understanding of what it means to be human, what it means to us to be alive, the more it relinquished its central primacy in the culture.

As modernist artists became more and more focused on their own uniqueness, either as an idealization or as an existential tragedy, the language of art became more and more arcane, more private, and now can no longer claim to serve society the way it once did. Art is cultural glue. It binds us to each other by revealing what it is we share, what we have in common on the most intimate levels of our being. But in order for art to work, an audience has to be able to see themselves represented in the artist's creation. The notion that artists make art only for themselves I reject totally. It is the kind of bullshit an artist tells himself when he is in his studio alone. Of course he wants to see himself in his own work, but that is not what he hopes will be the end result. He is looking for other people who will see their selves in his work. Artists create art because they are seeking resonance for their thoughts and feelings. They are seeking connection. Any artist who tells you otherwise also believes that an astronaut goes to the moon only to satisfy his own curiosity.

Similarly, our need to see ourselves represented in some kind of corporeal form was not going to go away. So painting was still referred to in very physical terms; people talked about materiality, the skin of the canvas, the bones of the painting. But as modernism progressed, the body became more and more problematic. When van Gogh chopped off his ear, no one considered that art; only when he painted the scene of his amputation did people accept it as an appropriate subject for art. But in 1971 when performance artist Chris Burden got somebody to shoot him in a gallery, people thought that was art, not the documentation of it. Artists had begun literalizing the body, using it as a canvas. Vito Acconci bit himself and others. Gina Pane lacerated her tongue, and Rudolf Schwarzkogler, according to myth, castrated himself. How did we become so overwhelmed,

so hopeless that we would accept self-mutilation as a mainstream art form rather than what it is—an aberrant expression of alienation?

In the eighties, painters brought back figuration and imagery. But few of them brought back the body with it. They just brought back the image of the body. So you had dolls, mannequins, cartoons—surrogates that represent the figure but don't embody us.

To rehabilitate the importance of the body in art, we have to come to terms with sex and with death. We have to come to terms with mortality, with how the body ages, with how our relationship to our needs and our fantasies and our dreams changes, with how our body deteriorates. We have to figure out what it means to die.

It took something as horrible as 9/11 to highlight how ill equipped we were to deal with something that we should have been able to handle. I think it's sad because I believe art is heroic. I believe that it helps us to deal with issues of what it's like to be human on the most compelling and highest level. And over the history of culture, it has figured out unbelievable ways of doing that.

JOHN FISCHL

After Mom died, the family kind of spiraled out in different directions. But over the years we came back together, and Eric was a large part of that. He was always extremely generous and inclusive about his work. Any opportunity, he'd invite us to shows he had in New York, Paris, Germany. In Rome he rented a villa overlooking the Circus Maximus. I brought my wife and kids.

STEVE MARTIN

Eric, Once a Year

Every January for the last eighteen years, Eric
and I have taken long walks in the blazing sun of
St. Barth's, walks made doubly hard because it's
almost all downhill and we discuss important life
matters through the lens of art. These discus-
sions are so important that neither of us can
remember anything we have ever talked about over
the years, or even by the time we reach the bot-
tom of the hill. But these talks have been the
way Eric and I have become friends. We are both
on the shy side, or were, and being thrown to-
gether eighteen years ago with nothing to do but
talk art and dodge reckless rental cars has led
to a mutual trust and ease.

When you know a talented person long enough,
there comes a time when you impose on him. It's
just a law. Fifteen years ago it was my turn
to ask Eric to do something for me. Would he,
I asked, do a poster for a play I wrote about
Albert Einstein and Pablo Picasso, and he agreed.
Starting a sketch while I watched, he loaded his
brush with some flesh-toned watercolor and held
it above a sheet of paper. He lowered the brush,
held it there momentarily, lifted it—and there
was the face of Einstein.

I knew this was not a magic trick, but a culti-
vated skill that eventually took on the appear-
ance of a gift. In our talks, I could sense the
struggle in bearing this hard-won artistry. Most
of the struggle was manifested in the artist's
interaction with the art world: the galleries,
the collectors, critics, and auction houses.
These forces impinge on an artist in devastat-
ing ways, except when they are giving an ego
boost so great that it rivals the occasional
congratulations one can bestow on oneself.
Eric's aspirations lie with the history and
traditions of great art, but for every artist
who is wired to the world there is the gnawing,
biannual judgment of the auction hammer. I am
impressed with how Eric manages to ignore the
latter to the point that he has never discussed
it, ever. And if I ever bring it up, it seems
to evaporate, ignored, into the St. Barth's air.

As Eric entered his sixties, I knew what he
was undergoing, because he had more or less
told me: a mental evaluation of his art and
career. Since Eric's arrival on the scene in
the early eighties, the art world had changed
drastically. New stars working in new mediums
were playing to entirely new audiences who
didn't necessarily care about what had come
before. Amidst a cacophony of PR about the
newest thing, blockbuster art shows, fairs and
vodka-sponsored parties—as well as a developing
rainbow of genuine talents—it was natural for

him to wonder just where in the pantheon his
long career lies.

So, in January of 2012 last year, on one of our
blisteringly hot downhill walks, his comment
stayed with me when he said, "There's a part
of me that would prefer I be remembered for my
sculpture." I may not have the quotation exactly
right, as there was nothing in it that implied
an egotistical desire to be remembered, but I
think he was talking about a longing to escape
from painting and flee to sculpture. Yet every
stage of Eric's painting history has been a suc-
cess: the early "psychological" paintings, where
he established his name, then the beach pictures,
the India pictures, the Rome pictures, the bed-
and-chair series, the Krefeld series, the bull-
fight paintings, and now his recent portraiture
show. So why would he divert his life's work of
painting away from the bull's-eye and turn toward
sculpture as his real accomplishment, even if his
remark was a one-time, off-hand utterance?

Occasionally I would be invited to visit April and
Eric in their studios to see works in progress. I
compare the invitation to my testing a movie in
front of an audience for the first time. Whatever
I think of a film before its first screening does
not matter; soon it will finally and forever be a
new thing: it will have been *seen*. With obvious
limits, I can see a parallel with painting. As Eric
showed me new works, I sensed we were looking

together, sometimes uncomfortably, sometimes not,
as we tried to search for what to say or even the
language of how to speak about something that
takes more than five minutes to digest. But always
in the studio was a sculpture being worked on, and
Eric never showed any discomfort about it. He was
never waiting for an opinion about the sculpture;
it was just something he was doing. There was
never evidence of struggle, because, I believe,
sculpture was not what the world expects from
him. Eric is at peace with sculpture.

An artist's central work is the work that eventu-
ally wears him down. In spite of success, every
criticism, personal failure, instance of neglect
or flattery, erodes pleasure. Facing the blank
canvas, the brush gets heavier through the years
because it is stacked with challenges from the
near and distant past, both subtle and overt.
Eric meets the challenges. But over in another
part of the studio is something he has managed
to wall off from the stings of the beehive art
world. Like his paintings, his sculpture is shown
in galleries around the world, yet I believe his
investment in it remains romantic. Here in the
studio, he is not waiting for our reaction; he is
hardly even curious. The only thing I can sense
is that perhaps he is borrowing our eyes to look
at it fresh, as he stalks around it with us.

When Eric made the comment, he was weeks away
from opening his portraiture show, and I could

sense the apprehension that goes along with the
premiere of anything, in this case, a two-gallery
show that represents work of the last twenty
years. To add to the anxiety, portrait painting
always implies unhappy subjects who can't under-
stand why Eric includes their inner hound dog.
Now that the show has opened and has pleased
Eric's artist heart, I'm guessing that painting
has retaken its place alongside sculpture as a
fount of redeeming goodness, and for a while at
least, all is forgiven.

I'm anxiously awaiting next year to find out if
I am correct, and am preparing for our next talk,
maybe this time with tape recorder in hand, and
getting in shape by walking down the most gently
sloping hills I can find.

. 20 .

SUMMING UP

2002–2012

IN 2004 April and I moved out to Sag Harbor full-time. I'd bought some land bordering a beautiful marsh outside the village in 1997, and with the help of my friend and architect Lee Skolnick, we had begun to design and build our dream house—me enthusiastically, April a little reluctantly. April doesn't like change, and she especially didn't want to leave her garden, which she'd worked on for years and was finally reaching maturity. But we had outgrown the house on Harrison Street. I'd had to rent a studio away from the house, and April took over the space I'd been using. We moved into our new home in 1999, and by 2000 we were already spending more than half the year on the South Fork.

Since then we've segued easily into country life. I wake up to birds singing outside our bedroom, play tennis most days, paint in the afternoon. April gardens, does yoga, and works rigorously through the day. I've learned to bake, April cooks, and we have quiet dinners, often with friends, at home. We catch B thrillers whenever they play at the local movie house.

April still arches her eyebrows, drinks wine with a raised pinkie, holds her paintbrush midneck, favors bristles that are worn and stiff, and applies paint with short strokes and a locked wrist.

Her studio is a nest with materials scattered everywhere. A cleared path leads from the door to her painting area and several miniature toys and trees for when our cats come to visit. She loves painting with them around while she talks to friends on the phone. Most painters, I've found, paint in awkward positions because it helps their concentration. April will paint for hours squatting over her bent knees. She practices her yoga everyday in front of the TV and for a time watched shows about abused or endangered animals. I'd walk in while she was in a pretzel pose, crying.

IN 2002 I was invited by Martin Hentschel, the director of the Kunstmuseen in Krefeld, Germany, to propose a project for the Museum Haus Esters, originally designed by Mies van der Rohe in 1928 as a private home. The only stipulation was that the project had to be site specific—that is, the exhibition had to in some way engage in a dialogue with the building's architecture or its history. My proposal was simple. Because it was originally built as a house for people to live in, I'd furnish the empty galleries as if they were still a modern residence, hire a couple of actors, make up a bunch of narrative fictions about who they were and what they were doing, take photographs, and then go home and paint them. The show would be the paintings installed back in the empty rooms, as if they were the memory of what had happened there.

I chose two actors, a man and a woman both forty-something, and over a four-day period photographed them performing different scenes in different rooms. At the end of the process I had more than two thousand photos, which I had digitalized and uploaded into my computer back in New York. Using Photoshop, I edited the photos into ten scenes that I made into paintings.

I'd never worked with actors before, and I went to friends of mine who are playwrights and actors and directors and asked them: What do you do with an actor? How do you talk to them? Mike Nichols told me, "Give them a problem. They like problem solving."

I asked him what a problem was. "Little things," he said. "She wants a thousand dollars from him but she won't tell him why."

So I set up these situations in which I would tell only one of them something, and then the other one would have to figure out what was going on. I was shooting stills and there was no scripted dialogue. Basically I would set them off and they would just go with it and make up the dialogue. What amazed me was how fast I could tell when nothing was happening. The opposite was also true: how riveting it was when they made me feel as if I was in the middle of a real thing. Sometimes I found what they were doing so gripping I forgot to take pictures.

The process was full of surprises. I wasn't leading the actors in any direction. I'd give them just enough information to get them going, then I'd stand back and watch events unfold. I had no pre-conceptions. I started each painting with the same basic questions: Whose house is it? Are they married? Who are they? Is it an affair?

With each painting I sought to answer those questions, and yet each painting brought me no closer to understanding who they were and why they were together. Each scene was full of emotion and drama that left unresolved the questions that had inspired the scene. What emerged instead was the dark portrait of a middle-aged couple whose relationship was defined by ritual, ennui, missed op-portunities, and tense, quirky sex. As I was making the paintings, I kept asking myself: "Why can't I paint happy people in a nice, happy relationship?"

When the actors saw the work at the opening show a year and a half later, they freaked out. It turned out they were upset because they felt the paintings reflected exactly what was going on at that time in their private lives. The man had just left his wife and child

a month before we began shooting, and the woman had also been in the midst of a painful breakup. Absent a script or well-defined roles, they'd obviously cannibalized their lives for material. Without their intending or even realizing it, the anger and the sadness they were feeling had seeped into their performances. The camera had picked those feelings up; their body language betrayed them. The Photo-shopping process magnified and distilled the dynamics when I sifted through the images.

Krefeld Project synthesized the storytelling devices I'd been ex-ploring throughout my career. In the glassines of the late seventies, I'd overlaid transparent sheets to create a sense of narrative space and time. Then in the mid-eighties, I'd gone to the multipanel format to break down the narrative elements in my paintings and invite the viewer to participate in their reconstruction. In the nineties I fanned out the multipanels into a series of paintings to tell stories sequen-tially. With their single sets, dramatic lighting, and tight focus, *Travel of Romance* and *The Bed, the Chair . . .* series functioned like theater pieces. In *Krefeld Project* I used multiple points of view and montage to produce cinematic effects. But the paintings still had to work on their own—not only as snapshots or interrelated scenes in a larger narrative, but as intense individual dramas vividly capturing the wounds and disappointments of a troubled relationship. Though I was still manipulating color, form, and gesture to create mood, conflict, and mystery, I was drawing my inspiration from outside the cloistered art world—outside painting in particular, which had long ago abandoned the dramatic narrative—and drawing on techniques from the other arts.

I FELT untethered from the art world. And I was still reeling from the public's reaction to my response to 9/11—my attempt to under-stand, to come to terms with, and to express my feelings about that terrible tragedy.

In 2006, while sitting in my studio, I began thinking about how quickly the conversations I was having with all my friends turned anxious and unsettled. It wasn't just politics; it was in all the places they were looking for comfort, solace, and certainty. It seemed that everything had become toxic and everything was endangered, including life as they knew it. I couldn't deny I shared those feelings, but I wasn't going to allow them to defeat me.

Out of these musings I developed the idea for *America: Now and Here,* a traveling arts fair that would set up in small towns and regional centers across the country and try to spark a national conversation through art about the fears and longings I felt were dividing America. If ordinary Americans couldn't—or wouldn't—turn to their artists at a time like this, I thought I'd try to rally America's artists to reach out and engage with them. My plan was fairly simple: I'd ask the best American artists I knew to make works for a mobile, grassroots exhibition. The only rule was the work had to be about their experience of what it was like to live and be in America now.

After nearly forty years of studying, making, teaching, promoting, and writing and lecturing about art, April and I had developed a pretty broad network of friends and contacts in the art world. But I wasn't optimistic they'd embrace my idea. Artists tend to be individualistic. They don't like their work being identified with subjects everybody else is thinking about. They want to be seen as creating outside the box, ahead of the zeitgeist. So I was overwhelmed by the response I got. Not only did almost everyone I approach agree to make work for the exhibition, but they also offered to travel to the sites where it would be shown and interact through seminars and informal events with local artists and community groups.

And those were just visual artists—painters, sculptors, and the like. When I mentioned what I was doing to the playwrights Marsha Norman and Jon Robin Baitz, they also wanted to get involved and even developed a form—a kind of five-minute flash play—that was perfectly suited for the project. And from there things snowballed.

Marsha curated twenty other great playwrights, and friends from other arts indicated they wanted to participate. The poets Carol Muske-Dukes and Bob Holman suggested a collaborative form based on a Japanese *renga* and recruited fifty-four colleagues to make *Crossing State Lines: An American Renga,* a powerful epic poem about America. Soon singer-songwriters had jumped on board, followed by filmmakers and performers of every stripe.

As the project continued to evolve, I thought about using trucks as a means of transport. I'd originally planned to use trains and even found a company in Ann Arbor, Michigan, that chartered boxcars and arranged traveling exhibitions. But at their suggestion, I realized that trucks could get us deeper into the country, and that you could design them like mobile museums to link up to create exhibition space once you got where you were going. Plus, trucks signaled a certain kind of message.

I didn't want *America: Now and Here* to roll into town like a bunch of big-city artists trying to show up our regional counterparts and foist our vision of America onto the local populace. I didn't want us to be perceived as proselytizers or hipsters or bullies. Showing up in trucks, hauling culture in big rigs, went a long way, I thought, to dispelling that image. Trucks are part of the American road tradition, from medicine shows and rum-running to the circus and the rodeo and NASCAR. I figured people would see us pull up at some fairground or warehouse district and start to unpack, and they'd be curious about what's inside. Americans love trucks. They're not intimidated by them.

We began seeking donations. Someone who knows about those things came up with an initial budget of $16 million. It sounded like a lot to me. But it covered the design and construction of the trucks, transport costs, salaries, insurance, events, publicity—and it was, after all, going to be an exhaustive two-year exhibition that visited every region in the United States and included the enthusiastic participation of more than one hundred of America's best-known

artists. What's more, back then the economy was booming, and the art economy in particular was over the top.

Meanwhile I hired professional fundraisers and administrators and trotted myself out to meetings with arts groups, corporate sponsors, and wealthy patrons. Everyone seemed receptive. April and I hosted a series of dinners at our loft in the city—salon-type events with artists and art lovers that I thought went exceptionally well. Everybody was excited. Everybody was into it.

But then something strange happened. Nothing. Despite assurances to the contrary, the fundraisers came up empty. The anticipated stream of donations was barely a trickle. Part of the reason was the economic crisis, which exploded a year or two into the project. The powers in Washington and on Wall Street decided that arts funding had become a frivolous expenditure. But I feel it's exactly in times of crisis that art is indispensable. So too did the many artists involved in *America: Now and Here.* Nearly all the funding from the project was coming from them, from art they auctioned and from outright cash gifts.

To reject a project that many of the nation's best-known and most highly regarded artists so wholeheartedly endorsed and were willing to work for set the public's alienation from serious art and high culture in its sharpest, most troubling relief. I'm not entirely naïve. I know that Americans have always borne a populist, anti-intellectualist streak, and a reflexive dislike for abstract and contemporary art in particular. And I blame the art establishment for ignoring, and thus exacerbating, that animus in recent decades. But these were the financial and cultural leaders—the ones who lavished millions on their private and corporate collections and who contributed freely to museums and other public institutions—who were saying no. It didn't make any sense to me. Was the project ill conceived? Was their usual largesse only tied to buildings where they could curate their possessions and see their names emblazoned over the door?

I felt more than ever like an outsider—and in a world where I know April and I are already regarded as consummate insiders. But mostly I felt sad. *America: Now and Here* was an opportunity to have a conversation, to begin to overcome resistance and partisanship, to get people to stop yelling and screaming at each other, to identify and focus on the source of their anxiety, to demonstrate that they are not alone in their concerns. That's how art works in the culture. It gives us a common language.

I<small>N</small> 2008 I made a series of eight bullfighting paintings. The series was prompted by Rafael Jablonka, my German dealer, who wanted me to comment on a tradition going back to Goya. I told him I'd never seen a bullfight and had no idea what I thought about them. That didn't seem to faze him. He arranged for me to attend a corrida at Ronda, north of Málaga, the site of Spain's oldest arena, and the paintings I did were based on that one encounter—one day, six bulls.

What I came up with were my simplest and, I think, most powerful images to date. Part of that has to do with the subject. It's hard to make a painting of a bullfight that isn't dramatic. But a large part had to do with my stripped-down, existential approach to the themes of death and dying and a young man's coming-of-age. I was painting more efficiently and with a surer hand than I'd shown before. All the paintings take place within the arena. You don't see the stands. You don't hear the crowd or the vendors. There are no sideshows, no distractions. The action is centered on the bull and its adversaries, and even then there are none of the classic fight tropes—no heart-stopping passes, no billowing cape work, no kills. All the tension is in what's about to happen or what has just happened—the narrowing down of the moments before death, the formal arrangement of color, light, and shadow.

The pictures were a departure for me. On the one hand, I was dealing for the first time with the relationship between man and

animal, defining a rite of manhood, the danger and the violence. But the series was also a sustained meditation on dying, a fascination as I progressed through the paintings in trying to find some meaning in the last few minutes of life. What I discovered instead was how utterly incomprehensible life is. Nothing prepares you for its end.

I was drawn into the beauty and artistry of the spectacle—the athleticism, the thrill, the risk. And there was another compelling experience of a bullfight that we don't have in America, which we gave up long ago: the highly aestheticized ritual that's attached to such brutality.

The last painting in the series depicts a torero facing a fallen bull in the last moments of its life. The way the light bleaches the sandy ground and the wall of dark-blue shadow in the background make the setting look like a moonscape, isolated and otherworldly. The bullfighter is showing the bull the sword that's killed him—it looks like an icon, a crucifix—balancing the hilt on one finger. I was struck by how young the bullfighter looks, like a boy, and by the mixture of religious symbolism and innocence and sadism.

The one thing I don't hold against the corrida is its ritual function, the remarkable way it dramatizes the rite of passage of a boy into manhood. The whole community comes out to bear witness and in some way participate in this reenactment, and the fight is an elaborately staged, extremely elegant cultural rite. It's pure dance, pure opera. The level of detail—the iconography, light, fabric, color—amazed me. This rite of passage has been part of my art from the beginning. I've been trying to find where it's okay to be a man, the point of transition where that happens. My own transition didn't have the excitement for me it should have had. Rites of passage used to be short pants to long pants. Or it was bar mitzvahs, or you got confirmed.

There are other passages—birth, marriage, having children, aging, dying—as confusing and hard to negotiate. What holds a culture together is knowing how to visualize and honor and celebrate

those times that are ineffable and intrinsic. That's when you need society, for those difficult transitions. America doesn't have that. Religion may have provided some of that once. But if you don't have religion, then you need something to replace it.

When April and I brought the Gipsy Kings over to the States, they wanted to hear gospel music. So we arranged to take them to a church in Brooklyn renowned for its singing, and it turned into an incredible day. The choir had just gotten back from a tour of Europe and the way they were being welcomed back, it was as if they were returning astronauts. The whole community came out, and there was amazing energy in the room. They started off one song by handing the mike to a five-year-old girl with an incredible voice, and after a few choruses she handed the mike to a ten-year-old, and she went prancing up and down the aisle and then handed the mike to a fifteen-year-old, and so on, all the way up to an eighty-year-old. They were all women, and you actually saw the lineage. You actually could see the initiation process taking place—how the community brought a child into the adult world.

By making a series of paintings that are thematically related, I was able to deconstruct the actual bullfight and highlight its ceremonial dimension. Unlike, say, the *Travel of Romance* paintings, which cycle the stations of a woman's (fantasy) life, the *Corrida of Ronda* series collapses narrative and drains the bullfight of its bloodier, violent features, its what-next excitement (the essence of sport and combat). That's what ritual does. It's a process that turns, for example, the literal execution of Christ into the stations of the cross, which becomes the symbol of the crucifix that's enfolded into the Communion sacrament, which transforms the blood of Christ into wine. Or, in the case of *Sleepwalker,* that condenses a boy's sexual awakening into a surly, semiconscious act of masturbation.

In the end, neither the fetishized gore of the Spanish corrida nor its sanitized American counterparts work for me. The murder of a living creature is too real, too blunt, too artless—the dead shark

in the tank. But the shrink-wrapped, emptied-out rituals of ersatz consumer culture—the shiny, the cartoonish, the pop—aren't real enough, either. In the capstone painting of the bullfight series, with its lunar light and shadows, the impossibly young bullfighter and the dying bull face each other in mutual incomprehension across an alien divide—the bullfighter trapped in his aestheticized ceremonial garb, the bull trapped in his looming death. Sometimes I think only art can save or redeem them.

A RT isn't psychology. For one thing art deals in images, not language. Images precede language and are closer to feelings. They summon feelings before they're named and categorized, when they're still fresh and sometimes hard to recognize or identify.

For another thing, to translate his vision an artist uses materials that are, for lack of a better word, alchemical. Paint, for example, has this wonderful, mysterious quality—a smell and a sensuous, velvety feel and an ability to hold color and light—that unlocks and speeds up one's creative metabolism. And paint captures my every impulse—from my broadest conceptions to the tiniest tics and tremors of my wrist.

There are literally no words to describe what occurs when an image suddenly and unexpectedly appears on the canvas. Sometimes it's serendipity, the result of a fortunate brushstroke. Sometimes I think it has to do with the inherent qualities of paint, or the slickness of a surface, or the fullness or acuity of a brush. And sometimes when I've got a good rhythm going and everything comes together, I feel as though it produces the purest expression of who and what I am and how I perceive the world.

Think of the Magic 8 Ball that you played with as a kid. You asked it a question, shook it, and an answer bubbled up. Only in the case of painting, it's not words but an image that emerges.

Not every image comes to life. In fact, very few do. Often my

resistance is too strong. I grip my brush too tightly. Or risk too much. But then there have been those moments when I've felt as if I've broken through. Like when I made the violent swipe of white primer in the "Bed" painting. Or realized that the action in *Sleepwalker* was taking place at night. Or that the eleven-year-old in *Bad Boy* was stealing from the woman's purse. These moments are not the result of genius or any kind of rational intelligence. They're more like flashes of epiphany, a desperate surrender to voices from within, usually after I've exhausted every other option.

Resistance is often key. The resistance of an effect to my technical skills. The resistance of critics or other artists to the idea of a painting. And most important, the resistance of my mind to an insight or an image that contradicts my understanding of who I am. That's when I know I'm on to something.

When I first began traveling in Europe, I wanted to believe I was worldly, equipped like David Hockney with a protean sensibility; capable of Olympian observations, of tripping over the surface of things, of picking up this and that and constructing brilliant, seductive worlds. Painting *St. Tropez* taught me that I wasn't any of those things. It made me realize that I was an American painter, rooted in a certain time and place and tradition, a composition of soil, light, climate, and culture. I continue to travel, to try to broaden my reach and absorb foreign perspectives and the strategies and hard-won knowledge of the great painters of the past. But the kernel of my vision is always local and specific.

P HILIP Guston once said that the problem of modern art was that it demanded too much sympathy. The modern artist has to first develop a style all his own, then invent new content to go with it and make up new narratives in the absence of old ones. Then the viewer has to decode everything, figure out how to decipher the private language the artist has invented just to be able to decide if it's worth

spending all this time and effort to understand what the artist is trying to say. And all that effort just to decide if that artist is any good. That's what Guston meant by demanding too much sympathy. I often get the sense the artist isn't meeting the viewer halfway and is blaming the viewer for it. I can't tell you how many times I've heard artists saying, "Fuck the audience." But I thought: Why fuck the audience? Why not involve the audience?

My whole career I've been trying to make paintings that people can relate to, respond to emotionally—not stand in front of scratching their heads. I wanted people who looked at my work to know what they were looking at.

I felt contemporary art had failed its audience on a basic level. It had stopped addressing the ordinary lives of people, the rites and passages of birth, puberty, marriage, and death. And when it did try to explore those themes, its iconography was often so subtle, so convoluted or individual and eccentric, that no one besides the artist and maybe a few acolytes had any idea what they were looking at.

So I set out on a journey to make recognizable images, to tell stories and use symbols, metaphors, and motifs that drew on my audience's shared cultural and psychological heritage. I wasn't trying to make art that was pat or easy. I wasn't trying to make art that was literal or simplistic or purely illustrative. I was trying to make art that was accessible—but yet complex and expressive enough to yield emotional rewards after its first viewing.

IN 2011 I made *Self-Portrait: An Unfinished Work*. A very large seven-by-nine feet, it shows me sitting in front of a painting almost the same dimensions as the painting that contains it. The picture within the picture portrays me and a group of my friends on a beach in St. Barth's. It harkens back to several other group portraits I'd made in a beach setting where everybody's relaxed and smiling—evocations of enduring friendship and communal joy.

At a friend's suggestion, I took myself out of the group picture and made a self-portrait, placing myself outside and in front of the picture of my friends instead. I hadn't made a painting of myself in a long time, and the ones I had made were mostly spoofs, ironic or comic renderings of myself as a dealer, a cheap arts-fair vendor, a Shriner, and, once projectively, as an unseemly old man. I felt that I already exposed so much of myself in my work that making a conventional self-portrait was overkill. Also, I didn't think the way I looked said much about who I was. Other artists had made portraits of me and I liked the paintings, but I didn't think they got underneath the surface. I always had this Clark Kent look about me.

But that's just my case. I love the self-portraits of Bonnard, Beckmann, and Rembrandt, especially Rembrandt's studies of himself aging. Every ten years he'd take a hard look and reveal himself unflinchingly. That inspires me a great deal, because what more can you ask of a painting than for it to tell you what it's like to be alive, or in this case what it's like to become old? Ironically, making himself vulnerable, exposing the physical and psychic transition he's going through, gives me strength—the strength to acknowledge my own feelings and fears about what we all will come to know.

In *Self-Portrait*, I cast myself as a work in progress and likened my self-definition to an unfinished painting. The challenge was to make a painting that felt unfinished without my being sloppy and slapdash in my attack. I wanted it to be well painted *and* incomplete.

To achieve that effect, I made most of my subjects a little indistinct. I left one of them—my original image before I took myself out of the painting within the painting—featureless. Everybody else is recognizable. And a few of them seem fully realized, though none are as sharply drawn as I am in the completed picture. I was trying to create the impression of a canvas teeming with variegated life, a jumble of subjects, themes, and connections calling for the artist's organizing mind and hand.

. . .

THROUGHOUT the making of *Self-Portrait*, I went back and forth on the question of whether or not to erase the sketch I'd originally made of myself from the painting in the painting group. I decided to leave it in. But I couldn't come up with a logical explanation why.

Now when I look at the painting, I'm satisfied I made the right decision. My unfinished self-portrait is the focal point of the picture, the image my eyes eventually fasten on, the point of departure for my ruminations about the possible meanings of the work.

My image's blank face resembles a fitter's dummy sitting dead center in the picture. But the key to understanding the painting, I think, is in its relationship to my finished portrait. Its ghostly image hovers above my realized head like an emanation from my brain—a spirit or a doppelgänger, an alter ego. It enters into an Escher-like dialogue with me, its presumed author.

What is my relationship to my friends? What is my responsibility to them when I'm painting them? What is my responsibility to April? To any subject? Am I part of the world I'm painting? Or as an artist, do I stand outside it in some privileged way? And if I do, am I less present in my life? My relationships? My marriage? These are just a few of the questions I heard echoing between my painted selves.

WHEN I began making art almost forty-five years ago, painting furnished me with a way out of my aimless youth, a chance to get control over my chaotic emotions, to begin to put back together the fragments of my broken childhood. Then, years later when I moved to New York and made the transition to realism, painting became an exploratory process. It loosened the knots of my memory and dredged up buried feelings, challenging me to deal with stubborn conflicts,

moral and ethical ambiguities, and complex questions about identity. I was painting, and still paint, to explain myself to myself.

These days my work is more about making connections—shortening the distance to my subjects, narrowing my angle of vision, reducing the level of irony. So much of my early painting had conflated past and present, overlaid everyday domestic scenes with old fears and anxieties. No wonder I couldn't make happy pictures. Now I'm painting in the moment, rendering people and events as they cross my vision, making images that are the palpable extensions of my world. My themes are simpler, too, more essential—the joy of friends gathered on a beach; the frustrations of aging; even a wary acceptance of mortality, the certainty of an uncertain death.

Meanwhile, my art and life seem to be converging. The line between them, always blurry, is disappearing. It's become harder for me to distinguish between the rites of my days and nights—working, traveling, playing tennis, breaking bread with friends, making love to April—and their tableaux on my canvas. In *Self-Portrait* I wanted to make a record of myself to define who I am. But before I could do that, I painted in an ideal setting—my closest friends in one of my favorite places—and left a place marker, an embryonic image of the person I started out as, to remind me that I'm no longer alone.

ACKNOWLEDGMENTS

FIRST I want to acknowledge my great debt to my coauthor, Michael Stone, whose crazy idea it was to write this memoir. Having never collaborated with anyone over such a protracted period of time and with subject matter that was so intimate and at times painful, the learning curve for me was very steep, but his intelligence and honed journalistic instincts not only convinced me that there was a story here but he then showed me how to get to it.

I also want to acknowledge the roughly two thousand words that are included in *Bad Boy* from my interview with Arthur C. Danto and Robert Enright that are featured in *Eric Fischl: 1970–2007*, published by the Monacelli Press. I felt that my responses to their questions about my creative process couldn't be improved upon.

I want to extend my deepest gratitude to all those who have been my handholds, footholds, bridges, and ports in the storm of my life, including my grandmother Grammy, whose corporeal abundance was always a source of comfort and protection; and my art teachers: Merrill Mahaffey, who stripped away my preconceptions about art and in doing so ignited my passion for making it; Bill Swaim, who deepened my experience by exposing me to the mystery of the creative process; Paul Brach, who saw paintings like no other; and Allan Hacklin, who pushed and pushed me to the breaking point and then years later got me a teaching job that changed the entire course of my life.

I want to thank Lannie Johnston, David Salle, Ross Bleckner, Julian Schnabel, Allan Hacklin, Bruce Ferguson, Mary Boone, Bryan Hunt, Ralph Gibson, Robbie Baitz, Marsha Norman, Mike Nichols, John McEnroe, Steve Martin, and my brother and sisters, John Fischl, Holly Giloth, and Laurie Whittle for their contributions, the essays and anecdotes that have enlivened and enriched this book.

I am grateful for all the art dealers, collectors, curators, and critics who have nurtured and shepherded my career, promoted my work,

and wrote deeply and thoughtfully about it. The list is too numerous to mention them all, but I would like to highlight a few: Roger Belmare, who gave me my first gallery show; Jared Sable, who expanded my presence in Canada; Edward Thorp, who introduced my work to New York City; Allan McKay, Bruce Ferguson, and David Whitney, for curating my retrospective; and Peter Schjeldahl, Robert Pincus-Witten, and Robert Enright for making me appear smarter than I am. I especially want to thank Mary Boone for her commitment and devotion to my work over all these years and Rafael Jablonka who has sensitized Europe to my particular brand of "American" art.

Many thanks to my assistants, Catherine Tafur and Christian Johnson, for their help in locating and organizing materials for this book.

Michael and I would also like to thank Steve Martin, Dirk Wittenborn, Missy Hargraves, Ellen Ladowsky, and Juliet Faber for reading the manuscript and being such good sounding boards; our editor, Roger Scholl, for his enthusiasm for the material and his editorial acumen; and our agent, Mark Reiter, for finding us such an enthusiastic home at the Crown Publishing Group at Random House, Inc.

And last, where words fall short, I hope a bold font will proclaim my profound love and gratitude for all that she has done for me and all that she means to me—my wife, **April**.

INDEX

Note: Artworks are by Fischl unless otherwise noted.